WOTTON-UNDER-EDGE

WOTTON-UNDER-EDGE

MEN AND AFFAIRS OF A
COTSWOLD WOOL TOWN

E. S. LINDLEY

AMBERLEY

First published in Great Britain by Museum Press, 1962
Reprinted by Alan Sutton, 1977
This revised edition first published 2008

Amberley Publishing
Cirencester Road, Chalford,
Stroud, Gloucestershire, GL6 8PE

British Library Cataloguing in Publication Data.
A catalogue record for this book is available from the British Library.

ISBN 978-1-84868-034-0

Printed in Great Britain by Amberley Publishing

Foreword to the 2008 Edition

This is the first paperback edition of the classic town history by E. S. Lindley. It was first published in 1962 by the Museum Press, and a limited edition of 400 copies was published in 1977 by Alan Sutton. Following in the scholarly tradition of the post-war years, the book is well-researched and extremely well-written. In the original 1962 edition Mr Lindley dedicated the book as follows: 'To Dr Joan Evans, President of the Society of Antiquaries of London who inspired and has continued to guide this work'.

There is no merit in trying to update the work, and the text has been left to stand as it is. Therefore there are references in the text to 'the present' which are now half a century out of date. This should take this into account when reading the work.

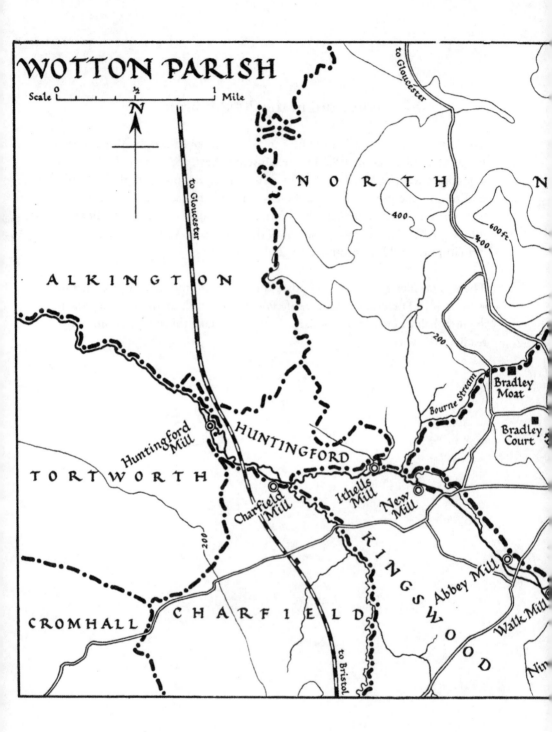

WOTTON PARISH

Scale 0 — ½ — 1 Mile

N

to Gloucester

to Gloucester

ALKINGTON

NORTH

400

600 ft

400

200

Bourne Stream

Bradley Moat

Bradley Court

Huntingford Mill

HUNTINGFORD

TORTWORTH

Charfield Mill

Ithells Mill

New Mill

200

KINGSWOOD

Abbey Mill

Walk Mill

CROMHALL

CHARFIELD

to Bristol

Nin

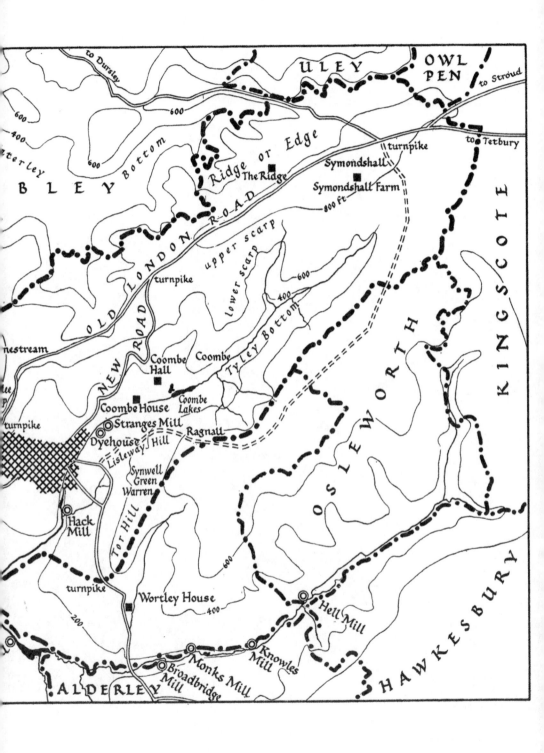

Preface

THIS work caters not only for the local general reader, who will find some of his traditions confirmed, or corrected, or even contradicted, and who will (I hope) be interested in the minor scraps of human interest which have come to light, but also for readers from a wider circle who will also, with patience, find points of more than local interest and pointers to social and other trends.

Though the pages are not loaded with references to sources, the account is factual: every statement, unless specifically qualified, has authority. I give a bibliography of the principal sources of information. Some of these are documents or contemporary accounts: the best of the latter give full references. Any who may want them can obtain fuller notes of sources in the Gloucestershire Records Office.

A full catalogue of acknowledgements would be too lengthy. My thanks cannot be withheld from Mr. Stanley Grimes, who ought really to have written this himself. The source of his interest is shown by the names of his forebears who led the Beating of the Bounds; he has both read widely and accumulated the recollections of older people, so that I have often found him to know already what I have found or proved with much labour. Mr. Irvine Gray and his assistants in the County Records Office have not only been unwearying in solving conundrums and answering questions, but have constantly drawn my attention to documents in new accessions which were relevant to my subject: Mr. Gray has also edited my whole text for me. Mr. A. H. Jotcham and his staff have, from their familiarity with local estates and affairs and documents, shown the most kindly toleration of my constant questionings. Dr. Joan Evans is responsible for my undertaking this work, and has been a kindly and experienced

7

nurse during its gestation. Last, there are all the owners of properties who have given me access to their documents, and shown me over their houses from cellar to roof-space, often repeatedly. I am sorry if some of them find that the struggle to save space has left their houses with less mention than they would have liked and thought suitable.

My thanks are due to the Ordnance Survey Department for permission to base the map of the Parish on the Ordnance Survey map (Crown Copyright).

STOKE BISHOP. E. S. L.
 December 1961.

Contents

3. HOUSES AND FAMILIES 119

4. THE CHURCH AND THE CHAPELS 157

5. CHARITIES AND SCHOOLS 207

6. WORTLEY AND THE AVON MILLS 259

7. THE OTHER TITHINGS AND MILLS 295

Illustrations

PLATES (FOLLOWING PAGE 344)

MAPS

I

The Parish

WOTTON UNDER EDGE is in Gloucestershire, half-way between Bath and Gloucester, close under the Cotswold edge from which the town gets its Cotswold character.

The parish extends over diversified terrain, from the upland of the Cotswold plateau to the upper levels of the Severn plain. The north-eastern part is plateau of the Great Oolite, open down with thin soil eroded to a scarp too steep to be cultivable and therefore densely wooded. The Inferior Oolite which comes next forms another plateau ended by a similar scarp; but this plateau is more indented than the upper one, and at the heads of valleys the two scarps merge in one. At the foot of this the Cotswold Sands form a gentler slope, after which there is a shelf of the Marlstone, with a stratum of Upper Lias Clay overlying it in parts. The body of the plain is Lower Lias, tenacious clays with occurrences of sandy beds.

The less pervious Fuller's Earth gives rise to a horizon of springs from the base of the Great Oolite, but these are relatively unimportant and generally do no more than form local swamps. The base of the Cotswold Sands is a far more important horizon of springs which account for the location of most of the areas of habitation and of many of the formerly important cloth mills on the Marlstone shelf. There are also scattered springs of less importance in the lower areas.

The first appearance of Wotton under Edge in records is in a Saxon royal charter of A.D. 940. By this King Edmund of Wessex leases to the thegn Edric four hides of the land in *Wudetun*, and specifies boundaries by which it has been identified. Allowing for some cursoriness in the description, and the impossibility of

15

identifying some of the landmarks of a thousand years ago, these boundaries still confine the parish with slight differences. The whole of the Wortley tithing is excluded. Where the boundary with Kingswood now diverges from the stream, the adjustments are of later mediaeval date, to avoid splitting Kingswood Abbey mill properties between two parishes. Huntingford, now a detached portion, was then still joined to the main body by parts of Bradley manor which were in 1605–11 sold and incorporated in Nibley; and roughly, the whole south slope of Waterley Bottom, now in Nibley, was then included in Wotton.

Starting at a mark ash tree near Ashel Barn at the extreme east angle of the parish, the boundary ran down the ridge leading to Tor Hill, past the area where stone tiles were already being quarried on Great Tor, down Tor Hill and past the fields still named The Mears, to the Wotton stream. This is at least roughly the present parish boundary, exactly excluding Wortley. From the last point, near the present sewage works, it followed the streams to Huntingford, ran round that tithing and the lands later transferred to Nibley, to the stream coming from Bournestream, and up that stream to the spring at which it rises. Then, instead of continuing north-east over Westridge and round the spurs of the south of Waterley Bottom with occasional inclusions of the lower slopes, it turned north-north-west at the spring up the sunk way by which water was carried from the spring to the Iron Age camp of Brackenbury Ditches, and continued in the same direction to Nibley Knoll. There it turned eastward and more or less followed the Doverle brook till it eventually climbed the Dursley ridge near Ridge Farm, rejoining the present boundary. Ridge Farm, where the boundary attains the plateau, must be on the site of *Turlan homme* (Turla's enclosure): only absence of a few mere scraps of paper prevents this farm from challenging the claim of Berkeley Castle to be the oldest recorded continually inhabited site in the country. The present boundary then includes some area of the upland, but the charter boundary specification is uncertain.

Of earlier occupation before records there are few signs. In the

Tile Pitt area the site of a denuded long barrow has been planted with trees; a round barrow two furlongs south of this has been ploughed flat; the trigonometrical point on the west point of Great Tor was a round barrow; a quarter mile east of Symondshall Farm is what is marked as a pair of tumuli, though Mr. O. G. S. Crawford suggested that it might be a long barrow with the central portion removed. Small flint implements have been found on the Symondshall downs. Over the Nibley boundary though within the Saxon boundary is a small but strong camp, with a single simple but effective defended entrance, in the best of all positions for watching the Severn Vale. On Combe Hill there is a triple earthwork circle called the Ring of Bells, which I have not detected myself.

Of the Roman period there is even less to report. What was thought to have been an inhabited site in the upper part of Tyley Bottom was excavated, but nothing found beyond the bowl of a Roman spoon. A coin of Gallienus (A.D. 259–68) has more recently been found in a garden at Holywell, on the outskirts of the town. The nearest larger Roman finds are a villa in the Chestles at Kingscote, and another in The Tessers in Stancombe Park. The road on Rushmires Hill is marked as Roman, and some of the lanes seem to have been earlier tracks.

The "Jubilee Clump" on Wotton Hill is said to have been a landmark for shipping in the Bristol Channel: it was cut down in 1856 to make a bonfire for the Prince of Wales's marriage: for the 1888 Jubilee it was replanted and walled by Lord Fitzharding, and leased to the borough by a deed in their archives.

In the Domesday survey *Vutune* appears only as a *berewic* (hamlet) of the great royal manor of Berkeley, for the whole of which Roger de Berkeley was bailiff and paying a rent of £170 *arsas et pensatas* (assayed and weighed) quoting from a plea *Quo Warranto* of 1287, John Smyth gives this rent as £500 17s. 2d.: this figure may be his estimate of the "present" value of the £170. In 1140 £234 13s. 4d. was being paid. As the manor was royal demesne, no separate details are given except hideages: Wotton was of fifteen hides and half a virgate, Symondshall was a separate

berewic of two virgates, Nibley was not mentioned in the survey, so that matters seem in this respect to have been as in A.D. 940.

There is no record of boundaries, or of perambulations before 1800: after that date two have been noted by Vincent Perkins. Of the first, in 1805, he lists the two noblemen and the gentry who with "many others" took part on the first day, and the much smaller number on the second day. The "beaters" were members of the Grimes family which is still foremost in local knowledge and interest. There is hardly any mention of the actual bounds, beyond a list of the adjacent parishes. The first day's march began at a point in Huntingford and ended at "Bumbarrow House" where I presume that refreshments had been offered. Perkins was not able to find out what house this was: as the second day's march, continuing from that point, next followed the boundary of Bagpath, it must have been Ashcroft House. This is a quarter-mile off the boundary, but there is no possible alternative except Ashcroft Farm adjoining it. The second day's march naturally closed back on Huntingford. Another perambulation in 183(8?) was led by Perkins's father the vicar, with the same beaters, "escorted by local gentry and tradesmen", and taking all the boys of the Blue Coat school. Again two days were occupied, the only difference being that the start was made at Monks Mill, and the boys were given refreshments at The Ridge: there was "excitement and amusement" at having to cross to an island near Broadbridge Mill, but the description is not clear.

The first of these was initiated by the notorious Frederick Augustus, Earl of Berkeley, in a letter to Humphrey Austin. He pronounced a perambulation "absolutely necessary", fixed the 25th March, a month ahead, as the date, asked vicar Tattersall to give notice in church, and asked Austin to muster the recollections of old inhabitants in advance. He proposed that they two should provide cakes and ale to be given the boys at extreme points, and "taking care to have a jocose fellow ready upon a wink to throw some ale or water in the faces of some of them, or bump their arse against a tree or wall".

These bounds seem to have been as now, including Symonds-

hall but excluding Nibley. Both these were for long chapelries of Wotton parish. Nibley has now been separated in every respect, as an ecclesiastical and a civil parish, and as a manor. Ecclesiastical separation dates back in essence to 1562. At the first chance of granting a new lease of the tithes, Christ Church made a separate lease for Nibley, and did the same on all subsequent occasions; the incumbency has become an independent perpetual curacy. Actually, the ecclesiastical separation seems to be only *de facto*, and *de jure* Nibley is still a chapelry. Separation and even origin as a civil parish is indeterminate. The conception of one is not really ancient: the inhabitants may have come together informally as a vestry before 1562, but this is unlikely. When in 1634 a prospective new curate made an agreement with the inhabitants to supplement the stipend legally due from the lessee of the tithes (there referred to as the "parson", though neither lay rector nor vicar), there is still no mention of a "vestry" or churchwardens. It would perhaps come about gradually as civil duties were laid upon the inhabitants, such as control of vagrancy, destruction of vermin, and so on: it would begin to be more crystallised by an Act of 1572 which created the appointment of Overseers of the Poor independent of churchwardens, and even more by an Act of 1597 which ordered their appointment by the Justices. No records of Nibley Overseers' accounts are extant before 1711, so that they may have been appointed for a combined Wotton-Nibley parish until then. Manors were a matter for the landowner: John Smyth records that Lord Berkeley in 1591 secured a decision that the Chief Rents of Bassett's Court, well within Nibley, were due to the manor of Wotton fforen, and were so paid at any rate till 1609; and as late as 1887 a Court Leet and Court Baron was held of Wotton fforen in which Nibley was included: so it would seem that the manorial division expired rather than was extinguished: now at any rate it is complete.

The first name recorded above for the town, *Wudetun* is likely to be the unmodified original, and its meaning is clear: the "enclosure", "homestead" or even "village" (*tun*) in or near the wood (*wude*). The numerous clearings (*-ley*) in the vicinity

(Alderley, Wortley, Tyley, Nibley and so on) suggest that the wood then extended up to the hills, so that "in" rather than "near" was the correct word. They also suggest that the place was more than a mere enclosure.

The Domesday name reflects the fact that the Norman clerk had no "w" sound in his vocabulary: and it is not surprising that the "d" was lost when this foreigner had a crowd of natives bellowing into his ear to make him understand. Since then the present form of the name has been standard but for minor variations of spelling. The qualification "Underedge" (cf. Aston sub Edge *et al.*) appears later, also with spelling variations. An absurd example of this is that William Seward, alias Cheddre, instituted vicar of "Wotton under Hegge" in 1375, was in 1386 displaced by the king's presentation of John Dautre to the church of "Wotton Undyrheg". However, Seward appealed to the Court of King's Bench and was restored in 1399. When the qualification was finally more or less standardised, there was still the question whether it should be one or two words: there are some grounds for preferring the former, crystallised in "un-drij" (with no stress on the last syllable) which is the pronunciation of the aborigines.

According to a widely accepted legend, the vast manor of which Wotton was a part had for centuries been in the hands of a Berkeley nunnery: Earl Godwin coveted these, and secured its suppression and obtained the estates by engineering a mass seduction of the nuns: the legend rests solely on an amusing though salacious story by Walter Map. An interesting modern research has shown that there was no nunnery, only a small abbey not far away; and that this is likely to have been destroyed and not merely suppressed by the Danes in 910. Possession of the royal demesne had thus been long and undisturbed. Within a few years of the Conquest, William FizOsbern, the Marcher Earl of Hereford, put Roger Berkeley in possession as royal bailiff, and King William shortly confirmed this. The king treated Roger with favour and spent Christmas, 1080, at Berkeley: so the region would seem to have enjoyed a peaceful transition to Norman rule. More radical change followed over the conflict

between Stephen and Henry II, though there is no specific mention of local damage.

After the Conqueror's death came the struggle between his eldest son, Robert of Normandy, and William Rufus, followed by Henry I. In 1088 according to the Saxon Chronicle "all Berkeley Herness was wasted and the town burnt by the barons in arms against William Rufus", being a royal estate, and Roger de Berkeley being an adherent of Rufus. Within a year Rufus had succeeded and the country was at peace, though Robert of Normandy did invade once again and was not disposed of till his defeat and capture by Henry I at Tenchebrai in 1106, and his eventual death in captivity.[1]

Peace in the area is also suggested by Henry I's having spent Easter, 1121, at Berkeley, with his second bride.

By this time the original Roger Berkeley had been succeeded by his grandson Roger III. According to Dugdale he was an adherent of the Empress Maud, but John Smyth represents him as an active and consistent partisan of Stephen. The latter seems the less likely in view of his relationships and estates, and it remains a fact that some of his pro-Matilda relatives, trying to compel the surrender of Berkeley Castle, "caused him to be drawn up and down in front of the castle with a rope round his neck".

The struggle between Stephen and Matilda, on behalf of her son Henry II, from 1138 to 1153, was carried over the country with savagery even by the standards of the time. Bristol was never mastered by Stephen, and the Severn valley between there and Gloucester saw several operations, but one gets the impression that Wotton was never directly affected, though it can hardly have escaped foraging and looting parties.

In Bristol Henry, at first only nine years old, is said to have formed a friendship with Robert Fitzharding that later brought him his social and territorial advancement: but as Robert was

[1] A fact that I have come upon is worth recording because apparently unknown, though not bearing on our subject. The hard-hearted Henry I seems eventually to have suffered some qualm about his treatment of Robert: granting the manor of Rudhall to St. Peter's Abbey, Gloucester, he charged it with provision of a waxen candle burning day and night before the High Altar in memory of Robert Curthose, Duke of Normandy.

some twenty-four years his senior, it is more likely that these were rewards for political and financial support.

In 1153 Henry came to terms with Stephen by which he secured the succession that came to him a year later, and meanwhile a share of power. Acting on this, Henry in the same year made Fitzharding a grant of a manor, and of a plot of land at Berkeley on which he undertook to build him a castle. Later in the year, after his marriage had added the Duchy of Aquitaine to his titles but still before his succession, he granted him the manor and whole of Berkeley Herness for the mere service of one knight. This involved dispossessing Roger Berkeley of that property, and in consequence that family became the "Berkeleys of Dursley". The ground for the dispossession was their real or supposed support for the Stephen faction, but may have been no more than their failure to support Henry actively. Roger does not seem to have shown much animosity for his earlier ill-treatment. On formal dispossession he found himself forced to vacate Berkeley Castle, but continued a guerrilla war against the succession. When other efforts to get the decision reversed failed, he intensified his attack and came near to ousting Fitzharding, but at this point Henry intervened, brought the opposing parties together, and arranged a marriage contract by which the heir of each was to take in marriage a daughter of the other. This effectively scotched a future family feud: in fact in 1278 the transfer was confirmed between subsequent generations of the two families, and by subsequent kings. These marches and alarums must have disturbed the area, but there is no record of specific incidents.

Henry subsequently in 1155, when he confirmed the grant as king, raised the rent to five knights, and this is what is specified in the confirmation by his widow-queen shortly after his death; but three knights was the service which Berkeley in 1276 acknowledged as due. This considerable land grant implied barony by tenure, which was formally claimed by Robert's successors.

The area had peace during the reign of Henry II and also under Richard I, but for his prodigal financial demands, and also during

the first ten years of John's reign, though his vicious ways were
trying the public temper. His exactions were not confined to the
Jews, and in about the fifth year of his reign he had to arrange
some famine relief. Then in 1210, on his return from a campaign
in Ireland, John suddenly seized Berkeley Castle and estates for
no known reason, except perhaps a refusal to render feudal service
in an invasion of France: for their restoration he demanded a fine
of 2,000 marks, plus 100 marks more "to have a reasonable trial
by his peers". This had to be paid in instalments which outlasted
both King John and Robert II Berkeley, but by 1213 the pay-
ments plus a specific undertaking for present feudal service with
ten knights secured Robert a limited release of his property: but it
had been allowed to fall into a poor state.

Robert II then accompanied the king to France as arranged.
On their return discontent had mounted to such a degree that the
barons, with Berkeley one of the leaders, met at St. Edmundsbury
to formulate and swear a pact to demand reforms. On the king's
refusing they in 1215 took up arms at Stamford, marched to
Brackley, again presented their demands and entered London:
Runnymede followed.

John Smyth's account to the above effect over-estimates the
importance of the Berkeleys among the barons: his loyalty to
them leads to his identifying as Berkeley the final meeting place
a month before Runnymede, which was really Brackley, near
Northampton, where the king had yet again been evasive.
Altogether, though Smyth quotes Pipe and other rolls for some
facts, he is dependent on the biased Wendover and Matthew Paris
for the atmosphere of the struggle.

John, however, quite shortly retracted, secured the moral
support of the Pope, and devastated the barons' lands a second
time. The Berkeley lands are specifically mentioned, and the
castle was garrisoned. This probably supports a tradition ignored
by Atkyns and not recorded till 1779 by Rudder, that Wotton
Old Town was burnt down in this reign, accounting for the name
The Brands still attaching to the modern house which stands on
the edge of the area so named.

Thus John Smyth, though he does not mention the burning: actually it is doubtful if the king campaigned in the region and was personally responsible. In his mounting discord with the barons John had given his foreign mercenary captains supervision of regions: it was Gerard d'Athée who was put in charge of much of the Welsh Marches, including shrievalty of Gloucestershire when he deprived William Marshall of it. Gerard was so conspicuously ruthless that he is specifically named in Magna Carta: John was forced to promise to remove and not re-employ his relatives and adherents, Gerard himself being by that time dead. So a devastation by Gerard probably accounts for the tradition: this would not be confined to the area now called the Old Town, but would include all the original settlement on the stream, and the "capital messuage" on whose site Berkeley very shortly built his manor house; nor is it likely that a predecessor of the present church (consecrated 1283) escaped the devastation surrounding it.

The action of the barons in then calling in the help of the French Dauphin was described as "desperate and treacherous" even by the pro-Berkeley John Smyth. The distrust which Robert II's share of the proceedings had aroused lasted long after King John's death in 1216, being perpetuated by the young Henry III's regents. It included Robert's brother and successor and presumably fellow conspirator Thomas I, and seems to have died only with the succession of the latter's son Maurice II in 1243.

Robert II did on John's death secure writs from the nine-year-old king ordering restoration of his property: but Berkeley town and castle were excepted, and a "great fine" was added to the balance of the 1213 fine. It is not certain whether these writs had been acted upon before Robert II died in 1220: as he was childless his whole property was taken into royal wardship, pending proof of the legal succession. After only two months several manors, including Wotton, were released to his widow, presumably in dower; after a further month Thomas I was allowed to perform his homage; but release of the lands to him was delayed by a suit brought by the regents, to hold him responsible for the balance of Robert's fines. Meanwhile Henry III had made a four-day stay

in Berkeley Castle which was still in his hands. Only in 1224 was the matter of the fines settled, and the properties including the castle at last restored to Thomas I; but even then two nephews were exacted as hostages for good behaviour and one more check was still to follow. In 1234 Henry III asserted his independence of his advisers. Being in trouble over his appointments of officers, and about to start a campaign in Wales, he demanded delivery of the castle for preservation of peace in those parts "so long as it shall please him". Its eventual release is not recorded: in 1241 he was still on the alert and ordered Berkeley and other lords to survey the defensive state of all castles in the county. Two years later Maurice IV succeeded, and confidence seems at last to have been restored.

In spite of the general effect of these intense disturbances, which can be seen in the great number of copyholds that were surendered, Thomas I Berkeley not only relet these holdings at such rents as he could obtain, but improved the husbandry by enclosing common lands of which he secured the releases, by "paring the skirts of Michaelwood", and by much consolidating of scattered holdings, his own and tenants'. The improvements were also helped in 1228 by Henry III's disafforesting the whole area from Huntingford down to only four miles from Bristol.

These disturbed years also led to what was the most important change of all time within the manor, the elevation of one of six mere Saxon hamlets into a market town. Excluded from his castle at Berkeley, Thomas I had built the original manor house at Wotton on the site of a former capital messuage near the church, and had often lived there. His widow Jone de Somery secured confirmation of this manor as part of her dower, and resided principally there. In 1252 she obtained royal licence to hold a weekly market and annual fair in her manor, with the usual liberties and free customs. The next year she made an agreement with the inhabitants which in effect set up a borough according to the custom and usages of Tetbury. In 1273 the burgesses were allowed to nominate three of themselves, one of whom the lord of the manor would appoint as mayor. At a date which is not on

record, the market house and place and other property, with the profits of the market and fair, were funded for the benefit of the borough. The fund was at first held by the manor and leased to nominees. In 1659 the lease was made a perpetual one, to "feoffees" for the borough, and this continued until the extinction of the borough in 1886, when a town trust was formed for the administration and application of the fund.

The manor was in 1420 defined as consisting of the hamlets of Synewell, Symondesale, Nybbeley, Worteley, Combe. John Smyth's list recorded in 1639 was Nibley, Sinwell, Combe, Wortley, Bradley. The later definition divides it into Wotton Borough or Marchant or *Intrinseca*, and Wotton fforen or *Forinseca*, which were two separate manors. The latter consisted of the remaining five hamlets; Huntingford was added to the list apparently when it became a detached portion of the parish; Symondshall was part of the parish but not of the manor, till it more or less came in. These parts will be dealt with separately, except that there is nothing relevant to add to what has been recorded about Nibley: here I deal with what concerns the whole.

The conflict between Henry III and the barons led by Simon de Montfort, between 1233 and 1267, does not seem to have put any strain on the Berkeleys and their estates beyond periodical calls for aids; there does seem to have been some residue of the status of royal demesne, with liabilities greater than those of an ordinary holding in chief. There were also minor and sub-manorial grants. Maurice II continued his father's policy of improvement. Of the usual crop of lawsuits in his time the only one that concerns Wotton was a dispute over access and common of pasture between Lady Joan his mother and the Abbot of Kingswood. The compromise finally arranged, by the Bishop of Worcester does not call for record here, but has been shown in my history of Kingswood Abbey.

Wotton must have continued to prosper under the careful husbandry of Thomas II Berkeley; in his meticulous supervision he toured all his manors when not employed in wars or embassies. In Nibley, which was then part of Wotton manor, he

assarted (cleared) some hundreds of acres of Michaelwood Chase. Though he lived through two-thirds of the reign of Edward II he escaped involvement in the growing disorders. Though there is nothing to show any family residence at Wotton at this time, his third son and daughter-in-law John and Hawisia were buried together in Wotton church in 1316 this couple were posthumously granted very liberal masses and benefits by Kingswood Abbey, for their *"immensa beneficia et largas elemosinas"*, being childless. The storm broke over the next two generations, with more damage than yet to the family estates.

Thomas II's son and heir Maurice III Berkeley was essentially a young warrior-knight. Married by his father at the age of eight, and by fourteen himself a father, he was by that age already following Edward I in his Scottish campaigns. He continued to serve Edward II, earning high honours and rewards. A growing resentment at the king's policies under Despencer influence was restrained by his father, while his second marriage into the de Clare family in 1316 was an opposing influence. Immediately on his father's death he answered Mortimer's call to action (he had married his son to a Mortimer daughter), raised forces on his estates, joined in the rising and the despoiling of Despencer properties and the rebellion against the king. At an early stage of the fluctuating struggle the king broke a safe-conduct he had granted, for negotiation, and imprisoned Maurice III in Wallingford Castle, where he died five years later, and began seizing all his properties after inquisitions, one of which was held at Wotton. He at least made arrangements for continuing husbandry of them. Maurice's son Thomas III was also imprisoned, but was released only four months after his father's death, when Queen Isabel's landing led to a general rising and the complete collapse of Edward II's cause.

Thomas III joined the queen's forces at Oxford and marched with them in pursuit of the king to Gloucester, to Berkeley, and to Bristol. At Berkeley he took possession of his castle, and of the goods that Despencer had there, and cautiously provisioned it for a siege in case matters again turned against him. The queen

restored to him his possessions: the tenants of his manors are said
to have welcomed him with voluntary "recognitions" of 20–40s.,
but there were also complaints by the various reeves and bailiffs,
including that of Wotton, of wanton looting and damage by the
armies. At Bristol the elder Despencer was captured and butch-
ered, but his son escaped with Edward II and was pursued through
Wales and captured at Hereford. Despencer was killed and the
king confined at Kenilworth.

The queen summoned a parliament, at which Edward II was
formally deposed in favour of his son Edward III, and the con-
fiscations of property by the former annulled. On his way to this
parliament Thomas III had his first meeting since his release with
the wife whom he had married six years before, who had also been
imprisoned. Edward II on his deposition abdicated: he was sent
by stages to Berkeley Castle, there taken out of the custody of
Berkeley, and soon foully murdered. A local tradition has it that
his last halt before Berkeley was made at Bradley Court; actually
that house was not built till 1568, so the halt would have been at
the older house or castle in Bradley Moat. But Bradley was not
even on the way from Bristol to Berkeley.

At a parliament four years after the murder, Mortimer was
found guilty of treason, including responsibility for the murder,
and was executed. Thomas III was called upon to answer a charge
of complicity, pleaded absence at Bradley at the time, sick, and
was acquitted by the oath of twelve knights. This was not accepted
as full clearance, but that ensued in further proceedings some
years later. The plea of absence is disproved by facts disclosed later
by John Smyth. There too Bradley Moat was the place involved.

Seyer quotes, from old chroniclers whose works I have not
seen, accounts of a famine in 1316 and the succeeding years, so
severe that it led to cannibalism in Bristol prison, and the price
of corn rose to ten times the normal. John Smyth makes no more
than a general reference to times of dearth and scarcity: and he
quotes prices of a number of commodities before and after that
time which show no signs of famine.

Again, of the Black Death of 1348, to which Seyer adds an

equally deadly murrain of sheep, Smyth's only mention is that in Ham manor in 1349 paid labour to the extent of 1,144 man-days had to be engaged to do the harvesting over which copyholders had defaulted by death or flight.

John Smyth records how Thomas III in 1327, after five years of royal mismanagement and warring, found buildings and gear all ruined, stores exhausted, and stock run down. In fact estate accounts show how for two years the whole revenues had to be applied toward recovery. The new king within a fortnight of his succession ordered that Berkeley be reimbursed the value of any confiscated goods that had come to his father. Like his grandfather, Berkeley oversaw management himself, attending markets and furnishing his manor houses so that he could make regular circuits more easily (when not at war or at jousts). A sign of one of his visits to Wotton is the birth there in 1351 of his fourth and youngest son, John. In 1346 he spent £100 on repairs of the Wotton manor house, and similar amounts in other years.

From this generation dates one of Wotton's outstanding benefactions from the Berkeley family, the endowment of the grammar school in 1384 by Katherine Lady Berkeley, the rich widow of Sir Peter de Veel of Charfield, whom Thomas III had taken as a second wife. That foundation will be described in more detail at the appropriate point.

Thomas III's son Maurice IV was another young warrior, who accompanied his father to the Scottish war when he was only seven, and was knighted. At twenty-six he was with his ageing father at Poitiers, was captured in a picturesque incident, and so severely wounded that he was permanently affected. Succeeding to his father at thirty, he died only seven years later in 1368. He had been too much at war to do much for his estates, and had lost them a heavy ransom of £1,080.

Maurice IV, permanently enfeebled by his wounds, took precautions against dying before his son Thomas IV came of age by arranging his marriage. This saved him from wardship of his person, but not of his estates. Fortunately the king granted this guardianship to his father-in-law, Gerard Warren de Lisle. He

had his share of warring, taking part in Agincourt. He, too, added largely to his estates by purchase, and took all opportunities to impose more favourable terms on renewal of leases. He was also a great sportsman, and kept a stable of "great horses" at Wotton, where he died. He was buried there under a great altar tomb, decorated with the well-known pair of brasses (Plate 15), beside the translated bones of the wife who had predeceased him twenty-six years before. But for the considerable estates acquired by his grandson William Berkeley by marriage, Thomas IV had held what was till then the widest extent of territory.

Now the worst trouble of the Berkeley family started and lasted for nearly 200 years. Thomas IV, dying in 1417, left as heir-general an only daughter, Elizabeth, married to Richard Beauchamp, Earl of Warwick, who needs no introduction: but in 1349 the then Berkeley estates had been entailed, and the heir-male was the nephew James. Beauchamp claimed the whole inheritance. Being on the spot, while James was away, he invaded Berkeley Castle and seized a mass of indispensable title deeds and copied others. He also obtained custody of the estates from the king while they were in royal wardship.

James was at first quite helpless: he was deprived of his deeds, and his tenants were intimidated by his all-powerful opponent. As a first step to recovery he secured the help of "good Duke Humphrey" of Gloucester by promise of a very liberal bribe if successful. He began to take legal action, but a welter of conflicting decisions blocked him. Warwick's wife was looking after his interests while he was in command in France. In early 1421 she had been living at Berkeley, and moving to London she stayed a week-end at Wotton. Two months later she made a hurried journey back: she spent only one day at Wotton, did not go to Berkeley, but only on her more leisurely return to Kingswood, as a dutiful daughter of the abbey in which her husband was to bury her only eighteen months later. What principally concerns this narrative is that immediately after the second visit to Wotton, Lady Warwick petitioned the king's council complaining that James Berkeley had put an armed force of soldiers and archers

into the rectory house at the manor of Wotton under Edge to prevent her entering there, and that his men had fired arrows and shouted obscenities at her as she passed through the place. This shows James at last beginning to assert his right. The "rectory house" which Elizabeth was expecting to occupy is now "The Court" where she actually stayed when prevented is not stated or to be inferred. At Henry V's direct command Warwick did vacate the disputed estates; but on the king's death soon after, in 1422, Warwick besieged the castle, attacked the manors, and ravaged the country. At last the Bishop of Worcester managed to mediate and initiate arbitration. Several times the opponents entered into heavy bonds to accept any award, but not till 1426 was there a compromise decision for the lives of the two principals, by which Beauchamp was to hold part, including Wotton, and James to have the remainder. This stood till Beauchamp's death in 1493, when the quarrel was revived even more fiercely.

The pedigree on page 32 shows the persons, descendants of Richard Beauchamp, who figure in the ensuing 200-year fight.

Beauchamp's three daughters were his co-heiresses and, by their marriages, mobilised a most formidable array of powerful families against Berkeley. In the lead was the eldest, Margaret, married to the "valiant Talbot, Earl of Shrewsbury", who proved herself notably implacable and vindictive. It was James Berkeley who actually opened the battle. For his first moves he was sent to the Tower till he entered into a £1,000 bond to keep the peace. The cause was that the *Inquisitio post mortem* had found Beauchamp to be seized of property including Wotton: and when a Talbot servant served a subpoena on James at Wotton, he forced him to eat the parchment, seal and all.

That the Talbots were in residence in Wotton is at least suggested by entries in the brokerage book of Southampton in the autumn of 1443, given me by Dr. Olive Griffiths. At that date the entries cannot be of more than pack animals, and each passage pays only 8*d.* brokerage and 1*d.* bridge toll: most of the entries are of entry with wool (for export) though once with calf skins: the few entries without entrance are of loading towards Wotton

SUCCESSION TO CLAIMS OF RICHARD BEAUCHAMP

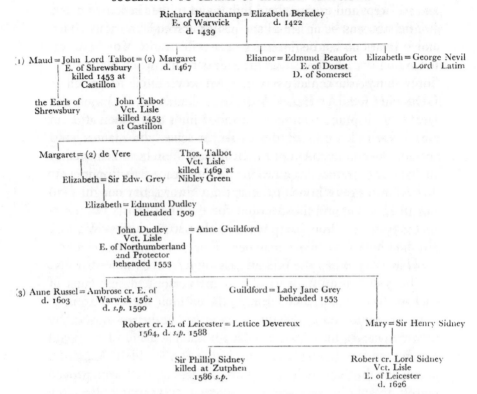

Richard Beauchamp = Elizabeth Berkeley
E. of Warwick | d. 1422
d. 1439

(1) Maud = John Lord Talbot = (2) Margaret
E. of Shrewsbury | d. 1467
killed 1453 at
Castillon

Elianor = Edmund Beaufort Elizabeth = George Nevil
E. of Dorset Lord Latim
D. of Somerset

the Earls of John Talbot
Shrewsbury Vct. Lisle
killed 1453
at Castillon

Margaret = (2) de Vere Thos. Talbot
Vct. Lisle
killed 1469 at
Elizabeth = Sir Edw. Grey Nibley Green

Elizabeth = Edmund Dudley
beheaded 1509

John Dudley = Anne Guildford
Vct. Lisle
E. of Northumberland
2nd Protector
beheaded 1553

(3) Anne Russel = Ambrose cr. E. of Guildford = Lady Jane Grey Mary = Sir Henry Sidney
d. 1603 Warwick 1562 beheaded 1553
d. s.p. 1590

Robert cr. E. of Leicester = Lettice Devereux
1564, d. s.p. 1588

Sir Phillip Sidney Robert cr. Lord Sidney
killed at Zutphen Vct. Lisle
1586 s.p. E. of Leicester
d. 1626

underhegge, "*cum diversis rebus*" for Lord Talbot: the rest are of
exit for the same, though once a load is a cask of wine.

In 1448 the failure of a one-sided attempt at arbitration led to a
renewal of open warfare with both sides collecting rents by force,
and destroying villages and devastating the countryside. James
was then so straitened that he had to pledge some chapel fittings
with Nicholas Poyntz to raise a loan of twenty-two marks. He
also attacked Wotton manor house where Margaret then was and,
according to her account, methodically damaged it to the extent
of 4,000 marks. Margaret retaliated by suborning the gate-keeper
of Berkeley Castle, surprised James and his sons in bed, im-
prisoned them for weeks, making them sign various bonds and
deeds; then made them repeat these before the mayor and people

in Bristol (who had a centuries-old feud with the Fitzhardings), and still kept and carried them hither and thither in fear of death.

The suit was being simultaneously pursued in various courts and on various counts. James's dear wife Isabel Mowbray was defending one of these at Gloucester for him, when Margaret of Shrewsbury found means to get her committed to prison in Gloucester Castle, which shortly killed her in 1452. Only a year later fate hit Margaret: her husband Talbot and their son Lord Lisle were killed near Bordeaux. In the same battle James had a son killed and one taken prisoner. Under these bereavements the quarrel died down. A further factor for peace was that in 1457 James, then aged sixty-three, married a Shrewsbury daughter-in-law of Margaret and thus secured peace till he died six years later in 1463. In 1467 Margaret died too, after some skirmishing with the next Berkeley.

That was James's son William, a haughty and domineering man of thirty-seven, aspiring to high dignity: the new opponent he had to meet on Margaret's death was her twenty-year-old grandson, Viscount Lisle. William first wisely bought off his Talbot stepmother's rights of dower which might have helped the opposition, and he obtained a royal pardon for "intrusion" into his castle and lands. Lisle was in occupation of the Wotton manor house, repaired since James last sacked it, and opened operations by trying to suborn the porter of Berkeley Castle. Betrayal of this manœuvre irritated him into sending Berkeley a swashbuckling challenge to battle, to which the latter replied in like terms. Berkeley's brothers and contingents from Bristol and the Forest of Dean rallied to him. Next morning, lying in the skirts of Michaelwood, they watched Lisle's force marching down the hill, with the local population watching from trees and vantage points. In the opening phase Lisle was struck in the face by an arrow, and despatched with a dagger: even his body was not recovered. The Berkeley force hotly pursued their routed opponents into Wotton, sacked and pillaged the manor house, and both recovered the deeds stolen from his family in Berkeley Castle and secured deeds of Lisle's own possessions. Among the Berkeley Castle

3

muniments is a roll of 107 charters, which Richard Beauchamp had had copied, and William Berkeley had recovered on this occasion. The disturbance caused the unfortunate Lady Lisle to miscarry, extinguishing all hope of continuance of the male line of the rancorous Margaret of Shrewsbury and avenging the death of James's wife Isabel.

Though William had bought off Viscount Lisle's widow after the battle of Nibley Green, the claims were three years later taken up by Sir Edward Grey, husband of the viscount's niece, and related to Elizabeth Woodville whom Edward IV married. Though the claim was sharp, it was compromised after a few years, and manors including Wotton were admitted as William's.

Pursuit of the dispute over the estates did not prevent manœuvres to secure the dignities William considered due to him: a mere baron, but first cousin to the premier duke and earl marshal, senior in that his mother was the eldest child and in her right entitled to vast Mowbray estates of the duke. His lands were the means by which he hoped to secure advancement. Their value was no doubt diminished in his eyes by the malignant struggle they cost all the time. Also, his heir in the absence of children was his brother Maurice, who had offended his sense of nobility by marrying the daughter of a mere Bristol alderman, a widow with three children: this weighed more than the fidelity with which Maurice had come to his support on Nibley Green and elsewhere. It irked William to think that the ancient Berkeley lands should descend to persons of base blood: his titles would not be similarly degraded, as Maurice was not heir to them.

First, in 1477, he conveyed to Edward IV's younger son his imminent reversionary right to the Mowbray estates. The reward was a viscounty and, more valuable, a promise of release from the bonds which his father and brothers had been forced to sign thirty years before. When Richard III seized the throne in 1483 and the "Princes in the Tower" were murdered, these Mowbray estates reverted to William. Only six days after his coronation Richard III created William Earl of Nottingham: the price was conveyance of thirty-five manors of the Mowbray estates. It was

not long before Richard III was killed at Bosworth, and the property again reverted to William.

He had obviously kept a foot firmly in each camp, for two months after Bosworth and four days before his coronation, Henry VII created him earl marshal and four months later great marshal of England. It cannot have been coincidence that on the same day as the later appointment, William granted to the lord chamberlain his large block of estates in North Wales. His ambition was still not satisfied. He proceeded to pledge or convey to Henry VII even Berkeley Castle and the home block of estates including Wotton; a solid block to Lord Stanley, and the rest of his land to other persons, till at last he was created marquess. When he died, still without achieving a dukedom, there were no lands left to pass to his heirs, and he even cut them off with derisive bequests. He had deprived his brother not only of all his lands and home, but even of the ancestral title of baron by tenure.

William had retained a life interest. On his death in 1491 Henry VII took possession and stayed at Berkeley for ten days. In preparation for this his disloyal widow is said to have dismantled the hall of Wotton manor house, to make the roof of the great kitchen at Berkeley, adding five "fodder" ($19\frac{1}{2}$–24 cwt.) of lead, leaving mere ruins which Leland recorded some forty years later. This assertion of Smyth's is contradicted by Lord Berkeley in his corrections to Baddeley's account and analysis of the castle. In July 1548 "the site and capital messuage of the manor of Wotton under Edge in tenure of Thomas Knevett and all lands" with specific mention of Westridge Woods, were granted by Edward VI to Protector Somerset, but will have reverted to the king on his deposition and attainder in 1550. What William had given Henry VII, including Wotton, in 1553 reverted to the family on the death of Edward VI for want of an heir male: most of the other estates also reverted in the course of time. But the disputes had not ended.

William's despoiled successor, his brother Maurice V, was of a diametrically opposite disposition. He systematically attacked the titles of his former estates, and by his death in 1506 had succeeded

in recovering some fifty manors in different counties, but not
including the Berkeley-Wotton block which was still in royal
hands by William's grant. John Smyth writes of this Maurice V
"with a milk-white head, in his irksome old age of seventy years,
in winter terms and frosty seasons, with a buckram bag stuffed
with law cases, in early mornings and late evenings, walking with
his eldest son between the four Inns of Court and Westminster
Hall, following his law suits in his own old person, not for himself,
but for his posterity". In his ingenious, pertinacious and success-
ful litigation, he showed a worth not exceeded by any of his more
magnificent ancestors.

None of the three succeeding generations made any further
change in the estates, though Henry VIII favoured the two last
by making them successively Constables of Berkeley Castle.
After the death of the last of them in 1534, and that of Edward VI
in 1553, fresh complications arose in the claims to the estates, and
there was ineptness in meeting them.

Thomas VI died leaving his widow Anne Savage with an infant
daughter, and a weakly son Henry born nine weeks later, to
whom Henry VIII stood godfather. The widow was opinionated
and quarrelsome; a minor war was conducted between her and her
brother-in-law Maurice, each side breaking down the other's mill
dams and havocking the deer parks. John Smyth relates an inci-
dent in which Maurice set fire to a rick close to her house at Yate
Court, rather hoping to burn her and "her werish boy".

In major affairs, by the death of Edward VI in 1553, the estates,
including Wotton which William Berkeley had granted to the
crown, reverted to Henry Berkeley: incidentally, this restored his
barony by tenure. Henry was only nineteen and a ward of Queen
Mary. She was well disposed toward him, probably in part for his
mother's religion, in part for his prompt and loyal support
against the Wyatt and other rebellions protesting against the
Spanish marriage. He had joined up promptly with a force of
500 men, raised at the cost of pawning his ancestral plate and
raising a heavy loan from his tenants. She showed her favour by
granting him a special livery of his estates two years before coming

of age, estates worth upward of £687 per annum, which had then been in royal hands for sixty-one years. Unfortunately the self-willed widow had the livery phrased to cover only William's grant to Henry VII and his heirs-male. This did not cover the claims descending from Richard Beauchamp, which soon boiled up again, in a more dangerous form than ever.

Sir Edward Grey, who had sold his personal interest in the claims, had a daughter married to Edmund Dudley, who made himself so hated by implementing Henry VII's financial policy that Henry VIII at his accession in 1509 threw him to the dogs. Edmund's son was John, Viscount Lisle, Earl of Warwick, created Duke of Northumberland. By intrigues he ousted Somerset and had him sent to the block, and succeeded him as Protector to Edward VI; then he married his son Guildford to Lady Jane Grey, and at Edward VI's death tried to put her on the throne. When the attempt failed, Queen Mary had all three beheaded in 1553. Also condemned, but pardoned, were Guildford's brothers Ambrose Earl of Warwick and Robert Earl of Leicester.

Northumberland's claims came to the crown by his attainder: but Mary took no action till a year before her death. Then Elizabeth, too, allowed the case to dawdle in the courts without being particularly pressed, till 1572. In that year Elizabeth had to execute Thomas Howard Duke of Norfolk, for planning to marry Mary Queen of Scots as part of the Ridolfi plot to place her on the throne. He was brother to Henry Berkeley's wife and that affected her attitude.

Henry Berkeley had in 1554 married Katherine Howard. He was a gay young spark who, with his like-minded sixteen-year-old bride, lived in court circles, a gamester who became quite clever with the dice, and with hawk and hound toured the counties from one to another of his great seats. Four years of this reduced him to having to lodge with his mother-in-law for 10s. a week for themselves, with 4s. more for her gentlewomen and 3s. for their gentlemen and yeomen.

Katherine Howard's family was looked upon with little favour by the court: her father Henry Howard had been earl marshal at

Anne Boleyn's trial in 1536. Involved in serious intrigues, he was in 1547 executed on a charge of quartering the royal arms, boasting of his royal blood. His father, Thomas Howard Duke of Norfolk, was equally involved, was likewise condemned, but was saved by Henry VIII's death. He had also been responsible for introducing as a royal bride his niece Catherine Howard, who fell from grace.

This is what moved the queen to action. Within a few months Elizabeth had in 1573 obtained a verdict in her favour, and a few days later granted the manors of Wotton and Symondshall to her favourite Leicester and his brother Ambrose. With Elizabeth it did not matter that they had both in 1553 been condemned with their father Northumberland and their brother Guildford for the attempt to enthrone Lady Jane Grey, but pardoned. Naturally Berkeley reacted; there followed thirty-six years of contention, as bitter as in any previous period, though less at the sword's point than by chicanery in the courts.

Before obtaining the grant, Leicester hoodwinked Berkeley with a great show of affection and regard. He used this intimacy to introduce a spy into Berkeley Castle to steal records that might be of use. Very shortly after getting the grant Leicester came to Wotton with a great train, smashed his way into Michaelwood Chase, then played a match of stoball on Wotton Hill which attracted multitudes of the local people, and after several days' stay departed. A year later both earls came with an even greater train.

The next move was that the earls managed, with due authority, to set up a Hundred of Wotton. It included the whole of Wotton Manor and Symondshall, Owlpen, Uley, Kingscote, Dursley, Cam, Cowley, Cromhall, and Arlingham: that is, about half the Domesday Hundred. This must have been the occasion for the "Survey of Wotton Manor taken 1st July 1573" which remains in the Berkeley muniments; of this survey John Smyth records that four of the jurymen resolutely refused to consent to an untrue presentment on one point, and were accordingly struck off the panel. One of these four was Robert Hale of Wotton,

grandfather of Sir Matthew: the firm rectitude for which Sir Matthew was famous has already been found in his father, and now appears also in his grandfather. Just what this untrue presentment was is not recorded.

The earls naturally appointed bailiffs and officers for collection of rents and administration, as Berkeley also probably did (at the expense of the unfortunate tenants), but they do not seem to have paid any more visits. Some of their records survive in the Fletcher Collection at the Birmingham Public Library. They left Wotton some rights in almshouses they established. In 1588 Leicester died, followed a year later by Warwick, who willed his rights to his widow. Leicester, too, left a widow who in 1590 sold her right for life in "half the manor of Wotton and Symondshale and Borough & Hundred of Wotton", with 300 messuages, and land in which Westridge Wood is specifically mentioned, and the advowson of the church. The price was 1,600 silver marks: the pair of purchasers have not been heard of before or since. The widow was Lettice Knollys, a cousin of Queen Elizabeth's as granddaughter of Anne Boleyn's sister, but "that She-Wolf" whom she hated most of any women. Before Leicester she had been married to Devereaux Earl of Essex and was mother of young Essex the Queen's favourite. After Leicester she married her former lover Christopher Blount, a contemporary of her son, young Essex, and as unstable but for her dominance. She was an untamed woman who would not have done Wotton any good.

Lawsuits were continued with full vigour, and administration of the "Usurped Hundred of Wotton", though there is no record of further violence unless the opposition was responsible for a poaching affray which is reported. It appears that one of the Daunt family of Owlpen, a Stone attorney-at-law, accompanied by eight others "all men of metal and good woodmen (I mean old notorious deer-stealers)" in John Smyth's words, came to Michaelwood at night, armed and with nets and dogs, and were detected by the Berkeleys' ranger. He called out a party of lusty friends, and there was a goodly battle in which one of the raiders was killed. Anne, Countess of Warwick, made out a great case

that the men were in part of the chase which was hers, but was forced by the contrary evidence to allow her case to be dismissed with costs.

The bitterness of litigation involved so many suits brought by either side that even the lawyer John Smyth found it too much to report them all. There was the usual suborning of witnesses: both sides resorted to abstracting and destroying documents, and the earls had tried methodically to collect all leases granted by the Berkeleys so that their name should not appear. John Smyth even prints a letter found in the Berkeley papers, in which Sir Thomas Throkmorton of Tortworth described how he had packed a jury.

At last, in 1606, Henry Berkeley decided to press his case as strongly as he could. An early result was that the usurped Hundred of Wotton with all the privilege it entailed was dissolved, and in 1609 a decision was given which restored to him all his estates, subject to the rents and annuities granted by his opponents, and payment to them of £8,333 6s. 8d. in instalments over two years or £7,320 cash down. The value of the estates was reckoned at £35,000. The final claimant, to whom the Lisle viscounty had also descended, was Robert, brother of Sir Philip Sydney. He was more reasonable than his predecessors, and the settlement was honoured, at last ending the dispute which had lasted in varying degrees of violence since 1417.

The burden of this payment was the heavier as Henry hardly tried to live within his means: a sportsman, as recorded earlier, ready to pay any price for a horse or to import a superlative hawk; a gambler with apparently some control of the fall of the dice. Only when in the ups and downs of the dispute he was more than ordinarily cut off from his revenues did he cut down his establishment for a time. His wife was of similar temper, so that "having in the first fower years after his marriage much over ranne his purse" he had for a time to board.

It is not even certain that this payment was the whole of his liabilities. When, in 1573, Queen Elizabeth had secured a judgement against him, and had granted Wotton and Symondshall

(valued at £251 3s. 4d. per annum) to the two Earls, Henry was found to have unjustly received £5,024 12s. 8d. of rents and other profits. Part of this was paid off; pardon was secured for the rest, though at what must have been nearly as great a cost. A similar valuation of unjustly received rents and profits from other estates made in 1585 amounted to £3,953 15s. 10d. It is not clear how far this was paid off or pardoned, or included in the final award.

To meet all these liabilities he sold outlying properties, and estates in other counties, for a total of £41,399 3s. 0d. as listed by John Smyth. He had raised £2,000 by sale of timber in Michaelwood Chase, which Margaret of Shrewsbury had already felled heavily; he had in 1561 been indebted to two of his principal officers for £2,000, and indemnified them by twenty-year leases of a number of the manors which he later sold; a further £700 he raised by way of a "benevolence" from all his tenants, said to have been paid willingly. This occupation of Wotton by the two Dudley brothers at least benefited the town charities, as reported later in this account.

Henry's ducal wife Katharine Howard, John Smyth's first mistress and his instructress in behaviour, excited his intense but not uncritical admiration, as appears in a lengthy account that is one of the most readable parts of his great book. It ends with the account of the high pomp of her funeral at Coventry, written for the husband who could not bring himself to be present. This funeral has a connection with Wotton, in that the procession was marshalled at the house of ex-mayor Sampson Hopkins, whose son of the same name later owned Wortley House. The Berkeley stewards seem to have been partial to *pompes funèbres*: a predecessor of John Smyth has left an account of the funeral of the alderman's daughter, Maurice V's countess. The kerchiefs on the heads of the lady mourners were not hemmed, to show that they were new. After refreshments to the mayor and corporation, "I thanke God, noe plate ne spones was lost yet there were twenty desyn spones."

Within a year of Katharine Howard's death, at the age of sixty-four, Henry married again. His wife survived him, and her

actions excited John Smyth's intense disapproval which he ex-
pressed freely and unequivocally, especially over what proved to
be the last major appearance of the Berkeleys in Wotton matters.
This was the sale of Wortley, in 1631, to Richard Poole, for
£1,500. John Smyth alleges that, in spite of his nearly insub-
ordinate protests, she made this sale against the interests of the
heir, her stepson, as one of a number of similarly disadvantageous
transactions, for the benefit of the next heir, his son, and also for
herself, and states the amount that she thus diverted as no less
than £11,000. Colour is given to these allegations by the fact that
Poole seventeen years later sold the same estate to Sir Matthew
Hale for £4,200: Sir Matthew accepted this price on a detailed
valuation by Poole. A full account of this appears in my history of
Wortley, and is summarised in a succeeding section on the Wort-
ley portion of Wotton manor.

Berkeley manor courts continued till 1884 for Wotton Borough,
and till 1887 for Wotton Foreign. The Castle archives have a
fairly complete set of court rolls from 1375 to the end. Only one
court roll is known to exist, among the Fletcher MSS., of what
must have been a Berkeley court, apparently of Wotton Borough
since only town business was brought up. It does not mention
the lord of the manor, but he must have been Thomas IV since the
date is 1416, a full year before Richard Beauchamp seized the lands
on Thomas IV's death. The steward mentioned, Eyston, is not
known. Then in 1543 and 1544 two courts were held by the well-
known Sir Anthony Kingston as chief steward for Henry VIII
who then held the title. This was for Wotton Foreign; the records
are in the Public Records Office. Another court for Wotton
Foreign, among the Fletcher MSS., was held in 1581 for Ambrose,
three stewards, Richard Bird, Earl of Leicester. It was held before
three stewards, Richard Bird, John Nuthall, and John Goodman,
which looks like being the full staff of the usurped Hundred
of Wotton. Only petty business was transacted at any of
these courts.

A point which emerges from intensive study of these happen-
ings is how little disasters of nation-wide occurrence have affected

this place. For the Black Death there is no direct local evidence, and not much for its effect in giving tenants more weight in dealing with the landowners. The Great Plague, which in London is said to have resulted in 68,000 deaths, in Wotton increased a previous steady annual burial rate of thirty-two on the average, only to sixty-four. I have sampled a few more parishes in the south of the county, and, for example, neighbouring Kingswood shows no appreciable increase, nor does Churcham, outside Gloucester; Newnham-on-Severn, a small seaport, shows a similar rise to Wotton's from seven to fifteen averaging ten, to fifteen to twenty-eight averaging twenty, but only in 1668–85. Wotton suffered far more severely in 1685 when the rate rose to no less than 160, from no known cause; Kingswood here shows a slight rise of about ten per cent; Churcham no rise at all; Newnham the prolonged rise noted: this must have been a local outbreak of smallpox or typhus. For real results an extended survey is needed, which would be outside my province.

Of civil commotions, we have seen that the Stephen–Matilda conflict seems to have passed by with no effect but the change of ownership. John is reported to have devastated the area and burnt Wotton Old Town, after having five years earlier at least seized the area. The Barons' Wars did not spread here; during the deposition and murder of Edward II there were two relatively small complaints of looting and damage, while most of the marching and campaigning followed the Severn valley. The Wars of the Roses too did not enter the area, but were replaced by the much longer struggle of the Berkeleys with the Beauchamps and Lisles, of which the effects have been described.

In the Marian persecutions, Bigland reports two victims recorded in Foxe's *Book of Martyrs*. In 1556 John Horne and a woman, two godly martyrs, were consumed by fire at "Wutton underhedge". This event is "mistaken through the default of those that made the certificate for Mr. Fox out of the registers of Gloucester or Worcester, for it cannot be proved that any such person suffered at Wotton aforesaid". So runs a statement recorded by one Mr. John Deighton not many years after; he was

not a Papist apologist, since he regretted having to correct Foxe whom he revered: he makes the rather improbable implication that there had been confusion with the case of Edward Horne, who was burnt at Newent two years later.

Another story of unmercifulness did not lead to the stake, but was hardly less cruel. William Dangerfield had fled from home for fear of persecution; hearing that his wife Joan was brought to bed of their tenth child, he returned to visit her and to see his children. His good neighbours carried him to prison, and he was brought before Bishop Brooks, who kept him so long under interrogation and fettered that his legs were almost fretted off. His wife too was cast into the common jail, with her fourteen-day babe; the thieves and murderers there, Catholic men, of course, would not even let her come near the fire, so that to warm clothes for the child she had to put them in her bosom. Bishop Brooks then began working on William: telling him that Joan had recanted, he persuaded him to do the same, and allowed him to join her in jail. There, finding how he had been deceived, he told her of his recantation, and this broke her heart. They parted, and on his way home he died, having been twelve weeks in prison. Joan was again brought before the bishop, but did not weaken, so that he sent her back to even more rigorous imprisonment. With the hardships her milk failed, and her child was taken from her, but too late and it died, soon followed by Joan. William's mother too, a woman of eighty, left at home all uncared for, also died. Foxe's account is said to have come from some of their neighbours: he does not know what became of the other nine children, but understands that they too were undone.

Brooks was Hooper's successor in the Gloucester see when the latter was burnt. He was one of Queen Mary's arch-persecutors, and the Pope's delegate who presided at Cranmer's formal trial at Oxford. Foxe reports three burnings in Bristol, but no more in Gloucestershire, in spite of Brooks's zeal.

The Wotton under Edge area was hardly touched by the Civil War. Some local writings mention minor incidents without

quoting any authority, which look like exaggerated oral tradition, though I have found some foundations in fact.

The only contemporary source is an account of "The Military Government of Gloucester", that is of operations during the siege of Gloucester and Colonel Massey's subsequent actions, by his domestic chaplain John Corbet. This rarely gives dates, so that it is hard to correlate his events with those of the general course of the war. When this was published in 1825 in *Bibliotheca Glouces-trensis* with a collection of contemporary tracts, documents and letters, the editor, John Washbourne jun., provided a Historical Introduction; this is well furnished with dates, but his descriptions cannot always be correlated with those of Corbet, as he was able to use other sources as well.

The five-weeks' siege of Parliamentarian Gloucester was ended on 4th September 1643: till then military movements in the county seem to have been confined to direct routes between specific targets, and the king frowned upon marauding, but after this operations were spread wider.

About late October 1643, the Royalist forces received the reinforcement of a brigade from Ireland, consisting of one thousand foot with a hundred horse and eight cannon. These landed at Bristol, and advanced to Thornbury and Wotton. On 20th December Captain Backhouse of the Gloucester garrison, with 200 horse, made a surprise attack upon the Wotton contingent in their quarters, but was beaten off without loss, having killed, wounded or captured a number of them. This is reflected in an entry in the parish register:

> "21st December, buried, Francis Smith a soldier and two souldiers more the same day."

A Royalist account of this little engagement, in *Mercurius Aulieus* of 2nd January 1643, is an interesting contrast to this account from the other side. Mentioning that a rumour has been put about that Colonel Massey has been lately at Wotton under Edge and brought home a great victory with many prisoners and four pieces of ordnance and divers arms, it sets

forth that on the previous 17th December Colonel Mynne went
there from Bristol to take up his quarters with his regiment, part
English and part lately out of Ireland; that the inhabitants ex-
pressed so much welcome that the weary soldiers took more than
was good for them. Colonel Massey had heard of the movement
and made a surprise attack, but co-ordination of two halves of
this failed, as did the surprise, with the result that they were
repulsed with the loss of four dead (but only three were buried)
and six prisoners: the only Royalist damage was a sergeant-major
shot in the arm.

A similar register entry three years later in 1646:

"26th December, buried, Primrose a souldiour"

nearly a year after organised Royalist resistance had ended,
cannot be correlated with any reported event, unless it was the
result of hospitality to a fugitive from the capture of Bristol and
Berkeley fifteen months before.

"Both parties established themselves in every eligible spot
where a castle or defensible house could be found. Wherever the
king's troops had placed a garrison, there or as near to it as
possible the governor (Massey) planted another." And there was
widespread pillaging. In this stage "the enemy (Royalists) was
imboldened to erect new governments at Tedbury and Wotton
Underedge": this is what local tradition wrongly reports as
Cromwell having made Wotton his headquarters for several
months. Massey captured Tetbury, but failing at Beverston Castle
retreated towards Wotton "where the enemy had placed a kind
of temporary garrison with a regiment of horse: they prepared
for the coming of our forces, drew up on a hill before the town
(presumably Symondshall) to face them, and at night retreated to
their garrison: where our men arrived somewhat late and found
the enemy all mounted, fell upon them and put them to flight, of
whom about six were slaine and twelve taken prisoner, the rest
escaping to Bristol." Massey then immediately marched back to
Gloucester.

A local tradition is reported that after the battle of Worcester

on 3rd September 1651 many of the fleeing Royalist troops passed this way; that the skeleton of a Highlander still clutching his claymore had been found in Lower Woods; and that quantities of arms of the period, some richly wrought, have been discovered in the thatch of old houses. A parish register entry of 1652 lends some support to the first assertion:

> "13th November, baptised, Jeremy, reputed son of Jeremy Bridges a souldier, by Jane Jones."

The other assertions lack even so much support, and thatched roofs are distinctly uncommon in the town. The local tradition that Elbury Hill, near Charfield, is a burial of soldiers killed in a Civil War skirmish, has no foundation: the hill is not artificial, and was mentioned in monastery deeds long before.

The only other Wotton incident of the war centres round Edward Massey. He was a soldier of fortune, who in the war fought for Parliament. Left in Gloucester as colonel commanding a garrison, when that city was threatened, he was the military mainspring of its defence during the five-week siege by the king in person, then of operations in the county, and then as a major-general in Fairfax's reduction of the West Country. When the first Civil War ended in 1646 he became Member of Parliament for Gloucester. As dissensions developed between sectarians and other elements, he was among the more moderate army leaders, and was appointed commander in chief of the London forces. He was among the "eleven members" denounced by the army extremists in 1647; he was impeached, fled abroad but returned, and was among those excluded from Parliament by Pride's Purge in 1648. He was again imprisoned, but escaped to Holland. There, after failing to find military employment in Denmark, he was one of the first to join the king, and gained his entire confidence. Washbourne gives a full account of his bold and leading part in the march south from the coronation at Scone in 1649: but at Worcester Massey was severely wounded and captured and was lodged in the Tower but again escaped. Charles II in exile in 1654–5 employed him to negotiate

with his friends in England, but saw no fresh prospect of success till after the death of Cromwell in 1658, when he gave Massey a commission to act in Gloucestershire. When he was preparing to attack the city, he was hiding for a night in a small house at Symondshall, where the Veels seem to have been distant relations: in the reign of Edward III the family had obtained the manor of Charfield by marriage of Sir Peter le Veel to Cicely daughter and heiress of Massey of that place. A troop of horse from Gloucester, detailed to capture him, surrounded the house as he was preparing to leave for Gloucester at dusk. To take him to a place of greater security he was placed upon a horse with a stout trooper behind him, two more riding on each side, and the rest of the force in front and rear. Passing down Nympsfield Hill in the stormy dark night, the horse stumbled with its double burden, and Massey escaped into the wood, and managed to elude the tipsy troopers. During the Royalist resurgence and Monck's march south, Massey was yet again arrested, but freed on parole. On the king's landing in 1660 he at once knighted Massey, and appointed him Governor of Gloucester. On the dissolution of the Rump Parliament, he had again taken his seat as Member for Gloucester and was re-elected at the subsequent election. Parliament voted him £1,000 with interest for his disbursements for the Western Association, and soon after £3,000 more for his services and other disbursements. He continued in parliament till his death some time in 1674-8.

In the Napoleonic wars there were two kinds of "Home Guard", yeomanry and infantry.

A 1st (Cheltenham) Troop of Gloucestershire Gentlemen and Yeomanry existed by March 1794. In 1796 troops were raised at Minchinhampton and Wotton, and when England found herself at war alone a year later five more troops were raised. At the peace of Amiens in March 1802 all except the Cheltenham troop were disbanded, but in May 1805 war was again declared. The Minute Book of the Gloucester Troop continues till October 1823. Most of the troops were disbanded in 1827, but there are records of services against Reform Bill riots in 1831.

Humphrey Austin received a royal commission as captain of the 4th (Wotton Underedge) Troop of Gloucestershire Yeomanry in January 1797. According to a return rendered in 1801 the establishment was of a captain, lieutenant, cornet, quartermaster, three sergeants and a trumpeter with thirty-eight rank and file, and forty-three horses. Dr. Taylor was enrolled as surgeon: vicar Tattersall was nominated as chaplain but apparently not appointed. They were enrolled for service anywhere in the county, but in reply to a specific enquiry in 1798 agreed to serve more widely in extreme necessity.

A return of equipment in 1800 for fifty men including officers was of fifty-two swords, fifty each pistols, cartridge boxes, helmets, jackets, bridles, pads and "crupiers"; also twelve carbines with bayonets, scabbards and rammers, with which the dismounted men were armed. To a request for more carbines the reply was that firelocks but not carbines were available. In September 1803 return of the twelve carbines "delivered to your corps last war if you do not continue the corps", was demanded.

In 1798 £3 per head per annum was allowed officially for clothing, and in 1801 £9 per head for forty-two men. Actual disbursements against this were claimed from a London agent, William Bownas, who also paid claims for allowances of sergeants and trumpeter, and feed of horses. Payments were also made by a local man T. Biddle (mayor 1797, occupation not known), from liberal local contributions, and a fund of "forfeits". Austin was at different times paid £500, and the rest £235 14s. 10d. The cost of an officer's uniform is shown as £22 10s. 0d.

In 1798 Biddle paid £33 for a troop dinner (plus £2 8s. 0d. for broken glass, which suggests a cheery evening). A year later, "Mr. Moore for what was left at dinner and wine and negus £7 3s. 0d.": and on 5th May 1800 there was a "supper when called out for a riot £2 15s. 0d." of which nothing is recorded. Humphrey Austin had also stood the troop a dinner at Mr. Moore's Crown Inn even before getting his commission.

There is no record whatever of martial activities. On the analogy of the Gloucester Troop there must have been drills and

inspections, for non-attendance at which "forfeits" were exacted, which by 1802 had accumulated to the amount of £61 17s. 0d.

There was also a company of Wotton Underedge and Wortley Infantry Volunteers under Captain Osborne Yeats, which in January 1804 separated from a (Dursley?) company under Captain Dyer. Their establishment was a captain, two lieutenants, an ensign, six sergeants, and 120 rank and file including six corporals and two drummers but only sixty muskets. Sergeants were due 1s. 6d. a day, corporals 1s. 2d. and others 1s., which seems to have meant a one-day inspection monthly. From 1805 they were allowed a drill sergeant apparently on 6d. a day. They drew no clothing allowance as none had been provided. In May 1805 they drew 1,200 ball ammunition and 2,600 blank and 240 flints: by the end of the year that had all been used up except eighty flints. Their monthly returns end in June 1807, when all withdrew on introduction of a new regulation for recruitment: but in 1808 George Austin, Humphrey's brother and partner was appointed lieutenant.

1. Volunteers' badge

There is no record of their dining. In April 1804 they served a month of voluntary duty at Bath, parading daily "if it was not wet": finally they marched home under the acclamations of the townsfolk, arriving soaked through and weary from the heavy state of the roads, finishing the twenty miles by two o'clock.

Most of the succeeding events which call for more than cursory mention are more appropriately dealt with in one or other of the succeeding sections: such is the extinction of the borough in 1886. Wotton then became, and still is, part of the Dursley Rural District. It was not a rotten borough with a seat in Parliament at the disposal of a magnate who could command the few eligible voters: it is part of one of the electoral districts of the county, whose boundaries are liable to occasional adjustment. Like every other city, town and village, it has duly played its part in the two

wars, as commemorated on its War Memorial. The town claims to have had the greatest number of enlistments for a town of its size during the First World War. During the last war it was able to watch with horror Bristol burning on several occasions, but suffered no more than some broken windows and slipped roof tiles when a German bomber jettisoned its bombs in a line: true, one of these blew a crater in a minor road, into which a respected resident drove his car in the black-out.

Wotton manor was defined by John Smyth as consisting of the six hamlets Nibley, Synwell, Wotton, Combe, Wortley and Bradley. After Wotton was made a borough, the rest, the manor of Wotton foreign to which Huntingford was also specified; Symondshall, which in Domesday was a separate *berewic* from Wotton came within the manor at some time, as a part of the Combe tithing. For fiscal purposes Synwell and Bradley were for some reason grouped together: I do not include Nibley in the table.

Bradley lies immediately west of the borough, and Huntingford detached to the west of that, separated from the body by former parts of Bradley which were sold about 1615 and transferred to Nibley. To the east of the borough comes Synwell: this and Bradley also embrace the borough on the north and south. Eastward again comes Combe, and beyond that on the upland comes Symondshall: south of Synwell lies Wortley.

Before proceeding to deal individually with the tithings, or "hamblets" composing the parish or manor, I present a few figures.

There was a *Nonae* tax in 1340, based on an ecclesiastical assessment of 1291: this amounted to £41 13s. 4d. for the sheaves, calves and lambs of the entire parish, abated by £17 3s. 4d. for the tax-free glebe, hay, the rector's "obligations" and the small tithes, leaving £24 10s. payable. Of this 13s. 8d. was due from the Abbot of Kingswood for his holdings.

In 1663 there was an assessment for paying and disbanding forces, and in 1689 one for Defence of the Realm: but records are incomplete as to detail.

COMPARISONS		WOTTON BOROUGH	SYNWELL AND BRADLEY	SYMONDSHALL AND COMBE	WORTLEY	HUNTINGFORD	TOTAL
Periodical "Purveyance", i.e. provision for the king's household. (The county assessment being £440)		8s.	15s.	20s.	15s.	5s.	63s.
The king's silver (tenths and fifteenths)	1415	£4 0s. 0½d.	£1 12s. 4d. £0 10s. 0d.	£1 4s. 0d. £2 0s. 0d.	£2 12s. 0d.	£0 10s. 0d.	£12 8s. 4½d.
Armada loan (subscribers)	1588	2	2	1	—	—	5
Men fit and able Subsidy men paying	1608	154 18 £8 18s. 0d.	70 7 £2 12s. 8d.	37 7 £3 4s. 0d.	43 6 £3 4s. 0d.	5 2 £0 14s. 8d.	309 40
Houses (Parsons MS.)	c. 1690	550	106	?	40	6	702+
The royal aid	1692	£42 16s. 0d.	£82 12s. 0d.	£72 4s. 0d.	£73 8s. 0d.	£26 6s. 0d.	£297 6s. 0d.
Poll tax	1694	£64 8s. 0d.	£23 4s. 0d.	£18 2s. 0d.	£9 11s. 0d.	£2 8s. 0d.	£117 13s. 0d.
Land tax	1694	£107 15s. 4d.	£143 16s. 0d.	£72 0s. 0d.	£39 3s. 0d.	£20 2s. 0d.	£382 16s. 4d.
Land tax at 3s.	1770	£74 8s. 3d.	£111 0s. 0d.	£54 3s. 0d.	£29 5s. 0d.	£14 17s. 6d.	£283 13s. 9d.
Families (Atkyns)	1712	400	?	?	4	7	
Tithes (in rate book)	1839	(£427 12s. 6d.)	£195 3s. 4d.	£179 13s. 4d.	£134 0s. 0d.	£33 13s. 4d.	£970 2s. 6d.
Health report population	1854	1,210	2,326	476	157	51	4,220

Some population figures of the parish:

1548	1,200[a]	1821	5,004	1891	3,276
1608	1,200[b]	1831	5,482[g]	1901	2,979[k]
1650	5,000[c]	1841	4,702[h]	1911	3,021
1712	3,500[d]	1851	4,224	1921	3,010[l]
1735	4,000[e]	1861	3,673	1931	3,121
1801	3,393[f]	1871	3,651[j]	1941	—
1811	3,800	1881	3,349	1951	3,509

a. A rough maximum from the 800 "houseling" (communicant) people of a Chantry certificate.
b. A similar maximum estimate from Smyth's 308 able-bodied men in *Men and Armour*.
c. Parliamentary Survey of Church Livings (inconsistent).
d. Atkyns's estimate.
e. Survey of Diocese.
 Subsequent figures are from national decennial censuses, which were omitted in 1941.
f. But Rudge gives 2,189, which is probably of town alone.
g. Bigland's 2,489 for 1831 is contradicted by the census.
h. The fall in numbers is ascribed to the failure of the cloth trade.
j. Of these 2,314 were in the town.
k. Figure is for the ecclesiastical parish; otherwise for the civil parish.
l. 2,990 is given for the ecclesiastical parish.

Parsons had about 1690 asserted 702 houses; Atkyns in 1712 says 840; Rudge in 1801 gives 638 inhabited houses. Rudge gives the total area as 4,390 acres; Bigland asserts 4,382 in 1831; the 1931 census says 4,950, but in 1951 only 4,683: the precise reasons for these small changes are not worth tracing.

2

The Borough

THE earliest origin of Wotton town can only be surmised. As shown elsewhere, the original main road from the east down the Old London Road, completely by-passed the town site. An abandoned King's Highway down the ridge which leads to Tor Hill and down Lisleway Hill, reaches the hill foot at Ragnall, turns to skirt the hill to Synwell, then crosses the valley and enters the earlier town site by Potters Pond below the church: this is marked "to Newark" on the 1763 borough map, and seems to have been the eastern approach to the town.

In locating the first settlement, water supply must be considered as a powerful factor. We have the church standing on a bluff (The Cloud) over the stream, with the manor house just east of it. While the church now shows nothing considered earlier than the thirteenth century, there is plenty of precedent for inferring greater antiquity for the site. The manor house, built by Berkeley soon after the reign of King John, is described as built "near the church, upon the place of the capital messuage where he (Berkeley) before his death often abode".

The manor house, with its curtilage as shown on a 1763 borough map, occupied the area east and partly south of the churchyard. The area west as far as the War Memorial was glebe. Between these The Cloud was "Waste", and that is where I place the first settlement, near the water supply. The only directions for expansion were down and perhaps across the stream; then up a gap in the bluff and round the glebe; and eventually and gradually into Old Town which the 1763 map shows to have extended almost to the later Long Street.

This settlement must already by A.D. 940 have been important enough to qualify as a *tun*, named "Wudetun" in the Anglo-Saxon charter of that date. In that charter none of the later constituent tithing-hamlets, such as Synwell, are mentioned. It is for the moment irrelevant that the church and the manor house still stand in Synwell.

Thomas I de Berkeley was deeply involved in the baronial resistance to King John, who in reprisal twice ravaged his estates: so the tradition that Old Town was burnt down at that time is more than likely. Being excluded from Berkeley Castle even into the time of Henry III, that lord made a second home in Wotton, built the manor house, and often lived there. His widow, Jone de Somery, secured her dower including Wotton even before release of the rest of the estates to her son. She resided principally there, and became known as "*domina de Wotton*".

In 1252 Jone obtained a royal grant to the holding of a weekly fair and yearly market with all the usual customs and liberties: from among the hamlets she selected Wotton as the place for these. Next year she made an agreement with the inhabitants, which amounted to constituting their hamlet a borough. The burgages were to be of a third of an acre, according to the usages of Tetbury; each burgess should have free pasture for a horse and a cow in the three fields of the manor after Michaelmas Day, paying twelve pence yearly. This act was formally confirmed by her son Maurice II for himself and his heirs. This act has hitherto been accepted as the foundation of the borough but now Dr. Finberg asserts an earlier foundation on the basis of a charter dealing with half a burgage in "Nocton", which Jeayes in his catalogue of the Berkeley muniments assigns to "temp. John". By another charter "temp. Hen. III" the former buyer sells the burgage "in Wotton", with several of the same witnesses. This dating, by handwriting, is doubtful: confirmation from knowledge of the parties and witnesses is made impossible because the same names were used for several generations, so the only hope of a decision on this point is from fresh access to the document by another expert in palaeography. Perhaps decisive enough is the

fact that John Smyth, with intimate knowledge of the muniments, asserts the accepted date and that Wotton citizens showed no knowledge of the earlier.

There is nothing to show when the boundaries of this borough were laid down, nor do they seem to have had any practical meaning beyond manorial duties and privileges. They exclude the whole Old Town area: the housing areas outside the borough are mostly of later origin, but what I judge to be the original settlement area, with the church and the manor house is also outside it and in Synwell. It looks as if the Berkeleys had retained their full control in the area that was already settled and built on, and limited their grant to undeveloped land.

The town, not limiting this term to the borough, is mainly a High Street running east and west, dropping gently eastward till it comes to the steep pitch down to the stream. Parallel with this on the north is Old Town (street) with two connecting cross streets, and the area between still partly blank; four cross streets also run out southward, one of them leading to The Chipping, again with more or less blank areas between them.

Nearly all the better houses are on High Street, and range from one of two low storeys with gables to the street, looking

2. Ropewalk entrance

quite mediaeval but for a recent coat of pebble dash done with marble chips and lines to imitate ashlar, to a five-storey Georgian reconstruction. Only very few of the early bow-fronted shop windows have been allowed to survive, and the principal street furniture is enamelled plaques advertising commodities. One old-established ironmonger still hangs out his sign, a kettle: and when the most striking house, of Elizabethan style, had recently to be divided for sub-letting as a shop, the shop window put in was perfectly acceptable.

On the side streets the houses and shops are mainly smaller, many of them better not examined. But the town shows quite a number of pleasant features such as doors and knockers and gables and a little oriel, while inside there are some good stairways and panelled rooms, and a few spiral stairs. Several houses have cellars of a mediaeval type.

The Hearth Tax Return of 1671 should have given valuable information: unfortunately the pages have been disarranged, mixing the tithings, and two pages are illegible.

The church is away at one side on rather lower ground and does not dominate the town. One of two dominating features is the Gothick Tabernacle built for Rowland Hill, and the other a factory building which has unfortunately been reroofed in corrugated iron after a recent fire.

The boundaries of the borough are marked on a 1763 "Map of the Borough of Wottonunderedge with environs" in Berkeley Estate Office: these are also recorded in a note by Vincent Perkins which does not state the source of information. John Smyth also records some points, which can be amplified by points in deeds of the market feoffees.

Smyth only describes the borough as of about sixty acres, containing High Street, Sow Lane, the Chepping or market place, Chepinge Lane, Bradley Street, Haw Street, Church Lane, Sym Lane, and (left incomplete). It is found not to include the Green Chipping. High Street is now called Long Street below the Tolsey, and The Steep where it drops to the stream. The only clue to Sow Lane is an 1871 reference to "Pig Park near Church

Street", which suggests that the communal styes lay in the open area of Old Town, and the lane was the access to this. Sym Lane ran for only some 100 yards from Long Street, before becoming a field path, which after another 100 yards turned sharp west till it reached Haw Street: the genuine first part has now been renamed Clarence Road, and the second part retains the old name, but with an added "n" to rhyme with hymn. One mention suggests the idea that it was Symonds Lane.

In the 1763 map the boundary excludes the Old Town, and the same is at least implied by some mentions by Smyth. Perkins's note, with comments based on the map, runs:

Beginning at and including The Kings Arms the boundary crosses Bradley Lane and the tongue of land opposite to the near side of Back Lane [now Gloucester Road] *to the top of the steep pitch: then down that and down the gutter of the north side of Bradley Street till it comes to the yard now occupied by Joel Witts* [now Mr. Hall's builder's yard]*: near the centre of this wall a large stone with a large B cut in the face* [no longer there now] *marks the exact position where it crosses the yard to a point nearly opposite the old pound in Back Lane* [there is still a set-back in the wall here], *and comes down the south side of the road to the back entrance of The Brands house: then follows the wall of the garden and that of the Rev. B. R. Perkins* [Berkeley House], *to the corner where a large beech stands: across the lawn to the opposite wall and so keeps the line of the wall along the close to the steps at the back of the factory building, and follows nearly with the wall that divides the stable yard from G. Dauncey's garden, then across the centre of Morley's garden out to Church Street where a stone stands in the pavement marking the spot* [this was a bad obstacle to pedestrians and has been removed. All this is, briefly, along the back of Long Street gardens till it reaches Church Street gardens, when it approaches Long Street more nearly, and comes out through a passage less than a yard wide between the first two houses of Church Street and crosses that] *then widening takes in all the hospital and Church Street round the road to the Grammar School*

and continues to a point just below the Waterloo Mill now occupied as a dwelling house by Richings. And from there in a straight line to Dyers Brook [The map boundary follows the E. side of Church Street to the end, passing an apparently displaced boundary stone some twenty yards short of it, marked on one face with B for Borough and on the other with S for Synwell: it then follows the S. side of the steep pitch at the head of Grammar School Lane and crosses to the E. side of it as soon as the houses opposite are reached: follows that E. side till it reaches a pair of houses occupied in 1763 by Mr. John Whittock, which the Terrier brackets as one item: it drops down to the brook just before and not below these, and follows the brook till it crosses the road preparatory to running up the S. side of the town.] *follows the brook to the Town Drain then up the drain as far as the top corner of the Crown Inn stables.* [The map boundary runs up the back of the gardens of Long Street with few exceptions, on a zigzag course which is most unlikely for the drain: on reaching the Rope Walk it turns out to embrace the whole property of the Crown Inn.] *Crossing in a diagonal line to Mrs. Bullock's house on the Chipping goes through her front door and along the wall separating her garden from Mr. G. Long's.* [On the map the two houses named, now the headmaster's house, were still two, with the boundary running between them. Most of the Green Chipping is thus outside the borough.] *Takes in the uppermost cottage in Haw Street where John Roach lives and turning sharp at the back of that skirts the gardens at the back of the houses in Haw Street coming close up to the cottage on Bradley Street of Cowles the blacksmith.* [The map boundary runs straight to Haw Street, makes a short step NE. along its E. side till it crosses to run behind the gardens on the opposite side: turns to run along the short gardens of Bradley Street till we come to longer ones, and then along these till it rounds a field to reach the Kings Arms.] *Passes right through the centre of the small garden at the back of Mrs. Bendale's house* [Cotswold House] *and continues about the same width till it comes up to the field at the top of Bradley Street takes round all that and concludes at the gardens and cottages as well as the Kings Arms.*

Perkins's account looks like the record of what some informant told him, not all quite accurate: for example the Town Drain is put in a position which almost precludes connections except for drainage from The Green Chipping, and on an unlikely zigzag line.

Exclusion of the Old Town accords with Smyth's definition of the "Borough or New Town": but it seems unlikely that it was not included in the borough administration. Since the Edbrooke field is defined as in Synwell, the fuller boundary would run along the backs of the gardens along Old Town (Street). The area of the Old Town between that street and Long Street is unexpectedly large.

Since the sites of the almshouses and of the grammar school are defined by the original deeds as in Synwell, it seems that Church Street was the original boundary with Synwell; how and when the area was extended to the 1763 boundary is unknown.

The original Chipping, now the Stony Chipping, seems to have proved inadequate, and the Green Chipping outside the above boundary was added. The houses round it formed part of the market endowment when that was created, but deeds show that this did not apply to those on its west, perhaps built later.

A borough having thus been founded, it was also constituted a manor under the name Wotton Borough or Marchant or *intrinseca* or *narinseca*, separate from the rest of the area under the name Wotton fforen or *extrinseca*. Then in 1327 the jury of the manor court was given leave to nominate three persons, one of whom the lord of the manor, acting by his steward, would select as mayor. The man selected was liable to a penalty of £10 if he refused to act: of the cases in which this penalty was exacted, the most notable was in 1639 when Richard Poole the nominee refused and was fined £10; thereupon the second nominee John Lee also refused and was fined £6 13s. 4d.; thereupon William Young, third nominee as the old mayor, tried to refuse but was overborne and had to serve a second term. In 1696 an appeal against the penalty as illegal was rejected by the Court of King's Bench. The mayoralty was not confined to the upper crust: the mayor of

1637, who died in office, was a shoemaker. In later years appointments were more select, and those of second rank considered worthy of honour were made only sergeant without subsequent promotion. All ex-mayors became aldermen, and with twelve other "fit and proper" burgesses constituted the Leet jury.

What the further duties of the court of aldermen, if any, were is uncertain before 1659. At the founding of the fair and markets an endowment had been provided for borough administration; no deed is extant, and the date is unknown. At first the endowment property was leased to individuals. The last of these was William Archard, valuable and valued assistant to John Smyth in the Berkeley stewardship, who later figured largely as steward of Wortley manor. In 1625 Archard obtained a renewal of his lease for a further ninety-nine years, for a £20 fine and 20s. annual rent. This renewal was not left to expire, for in 1659 a perpetual lease was granted to five leading burgesses for a £10 rent, on their buying out Archard's remaining interest for £400.

The properties at this stage were scheduled as the Stony Chipping and Market House, the Green Chipping of about one and a half acres, the houses and gardens around both these, the market stalls and booths, the stallage weights and measures, court and courts of piepowder, market tolls and profits. The houses to the west of the Green Chipping were built later. Under borough control there was also the Tolsey with adjacent property, which Anne, widow of Ambrose Earl of Warwick, had made over to trustees for the town.

In effect this created a body of market feoffees. For succession it was arranged that when deaths and other causes reduced the number to two, these should enfeoff five aldermen. Their duties were not defined, and in fact their accounts and reports of proceedings are headed "Feoffees and Aldermen". This arrangement continued till the supply of aldermen was cut off by the extinction of the borough in 1886. Then a body of town trustees was created to continue their functions, and now consists of nine members nominated by the parish council, with three more whom they co-opt. There was a degree of further amalgamation with the

charitable bequests which had at different times been made to some of the same burgesses on trust. At the very setting up of the feoffees they had taken £250 of the Perry bequest in order to pay off part of Archard's claim, on undertaking part of the objects of the bequest. All the rest of the trust bequests have been placed under a General Charities' Trust, which is now administered by four nominees of the parish council with seven more whom they co-opt.

When the endowment was made over to the mayor and the aldermen who were feoffees, their responsibilities were thus greatly increased, and were not differentiated in practice. When some of the same men were also the trustees of some of the charitable bequests, and especially when some of the charity funds were taken for legitimate civic use, the overlapping went a step further.

It appears that even in the manorial period the sergeant was responsible for collecting, accounting and paying in the rents of the lord of the manor in the borough: but it was the mayor who was held responsible, and John Smyth records that he had to hold a mayor responsible twice during his stewardship. The feoffees' accounts were drawn up by a clerk who was paid for this, and may have been a lawyer as he was also paid for drawing up deeds: in these there is not even mention of audit having been held till 1703, and even after that the auditors did not sign regularly. The "balance" seems to have been mainly arrears of rents, shown as "in the hands" of the persons concerned. In 1719 it was resolved that a feoffee should act as treasurer for a year, and that practice seems to have continued to the end.

The office of mayor was honorary, but one of the provisions of the Perry Trust undertaken for the £250 from it was an annual allowance of £1 for the audit dinner of the trust. In 1680 he was given an additional £3 "for his brawner" (a boar specially fed for the table), and in 1698 this allowance was increased to £5. This was an entertainment allowance rather than an honorarium, and the mayor may well have had to spend more, but from 1722 the feoffees seem to have allowed themselves increasingly good

beanos on various occasions. Thus in that year, in addition to the
£1 allowance and the £5 brawner, £1 1s. 7d. was paid for a din-
ner; in 1723 £3 10s. 0d. "at giving up the accounts" and £2 1s. 0d.
"at letting the market and several meetings"; in 1724 the dinner at
giving up the accounts was £4 6s. 0d.: and so on; for example in
1728 there were three dinners, for £5 13s. 4d., £2 4s. 4d., and
£1 2s. 4d., and in other years there were payments which look
like being similar, but without the allowance and brawner. In
1740 there was even £5 17s. 0d. for a ball and dinner; 1741 sees
a payment of £7 10s. 0d. to the mayor "for serving mayor"
without surviving record of any resolution by the feoffees for it,
and this is repeated till in 1750 the amount was increased to £10.
Some of those who received this increased amount were serving a
second time, but in 1755 £15 was paid for a second year of office.
The payments then became irregular in amount between these
extremes, till in 1788 it was unanimously resolved that the feoffees
and their treasurer should for the time being forgo their "salary
or stipend" allowed the mayor, because of the reduced state of the
revenues: the £1 allowance and the brawner were not resumed.
In 1796 bills for dinner reappear, amounting to as much as
£10 9s. 0d. in 1818, but stopping in 1819. Then in 1831 it was
resolved to pay a mayor £15 for any year after his first, but this
was paid only to the first two to qualify: the £1 allowance pro-
vided by the Perry bequest had lapsed. Most of these payments
were explicitly for entertainment when the feoffees (and aldermen)
met for business, and the rest do not seem to have been more than
an entertainment allowance.

The only official provision for an officer to help the mayor in
his duties was for a sergeant at arms, to be appointed by him on
taking office: his duties, apart from carrying the mace before the
mayor on ceremonial occasions, were to collect the rents, and to
pay the Berkeley chief rent of £10. The mayor himself seems to
have acted as treasurer, though an un-named accountant was paid
to keep the accounts and carry out the other work, including the
actual collection of rents for the sergeant: he was at first paid £1
per annum, but this was in 1709 increased to £2, and in 1863 to

£5, and in 1881 to six guineas. In 1719 the original accountant's writing showed a near collapse on his part, and it was at once resolved that in future a feoffee should be treasurer for a year at a time: these still employed collector-writers, who presumably got the allowance mentioned, to the end.

There arose other borough offices, presumably on the authority of the mayor, and honorary since the accounts show no payments of salary or even of expenses. There were three constables, to keep the peace and so on; two carnals to inspect the butchers' shambles and the meat on sale; two aletasters, needed as each inn brewed its own beer; a bread inspector. Others are servants rather than officers.

An instance of a mayor suffering unpleasantness from a rogue is revealed by the report of Thomas Carter being brought before the magistrates in 1663. He said he had come out of the Marches of Wales to serve a process on Robert Crew. When Nicholas Webb the mayor refused the help he demanded, he swore at him "God damn thee, thou lyest and thou art a rogue and a trayter", threatened to pistol him and presented a pistol at his breast. He was reported a common swearer who had lately been committed for swearing six oaths at one time.

The town crier, also called the bellman and later the beadle, may have existed earlier but is not mentioned before 1674. Most of the entries relating to this office are for his uniform, and their erratic incidence suggests that some of the incumbents were dressy individuals, and others more indifferent.

1607	for a bell & clothes for the crier	1	10	7
1682	for cloth triming and making the bellmans clothes	1	14	8
1685	cloth for the bellmans clothes	1	8	0
	for making the clothes and capp		10	0
	for the trimming of the clothes		?	
1717	for 3 yds cloth & hatt trimming and making bellman's clothes	1	14	6
1726	a coat for Abraham Walker the bellman		10	0
1728	a coate for yᵉ cryer	1	0	6
1729	a hatt for yᵉ cryer		5	0

1731	a coat for the bellman		6	0
1740	lace for cryer's hat		3	0
1743	the Bellman's Great Coate makeing			
	trimming & hatt	2	7	6
1746	for the cryers coat and hat	2	8	6
1753	Mr. Wallington for cloth for cryers coat	1	4	0
	Mr. Saml Vines for trimming for do.		10	0
	for hat and lace for do.		12	4
1755	coat for Edw. Cook with yellow cuffs	1	9	6
1764	makeing, trimming and cloth for cryer's			
	coat	2	2	6
1769	for the cryer's cloth and makeing			
	coat	1	19	6
1796	Mr. Vaughan for the cryers coat	2	5	0
1826	Mr. Coles bill for the cryers goldlaced			
	hat	2	10	0
	box for cryer's hat		2	6

In several years about 1761 the crier was paid 6d. for "pre-venting throwing at cocks". From 1829 Thos. Clark, the lessee of market tolls and apparently also crier, was paid £5 a year "for keeping vagrants out of the town". At a meeting in 1835, Clark being dead, one Mundy was elected town crier for a year and allotted the £5, and continued in office and paid the allowance, till in 1839 a special meeting was held to investigate a charge of misconduct against him, "the Beadle". Though the complainant did not appear to sustain the charge, Mundy was paid off and discharged at the half-year, and the office left unfilled.

Mr. Horace Wright in his *Memento* names a then scavenger. The appointment is said to have been used as a joke on some unfortunate butt: the office is never mentioned in the feoffees' records, the nearest being a payment in 1757 to Dan Cornwall for three years cleaning the streets. In 1849, following a resolution to repair the Tolsey pump for the purpose, a labourer was paid 4s. for working it to "cleanse the gutters in Long Street". In 1867 a resolution provided for watering the street during that summer for £5, and payment of that amount was made as a contribution towards the cost of doing so.

A special appointment was that of bailiff, for direct collection of the market tolls instead of farming them out. This was decided by resolution in 1871, but auction of the lease was resumed in 1874, only to change back to bailiff next year, till the end of the borough. The only recognisable bailiff is Rowland Lacey, who is known to have started life in the cloth trade and later became an auctioneer among other things. He received a commission on what he collected, but the amounts are grouped in general items and cannot be distinguished.

A curious appointment was that of "The Soldier". His duties are completely uncertain so are the reasons for the job, possibly a municipal liability to keep a trained man for the militia. The first mention occurs in 1683, of a trifling payment included in a miscellaneous item and one in the next year for his training. In 1685 he got a guinea from the constable as a months' pay, in addition to 5s. 2d. for six days' training and for mending the (unspecified) arms: in 1686 10s. 2d. was paid towards (not for) a new musket and sword and one day's pay. Then nothing till in 1689 he got 20d. as two days' pay, in 1690 four days' pay presumably at the same rate, in 1692 two days' pay, 1693 three days'; 1695 four days' pay and "towards a scabbard total 3/2d," 1696 two days 1s. 4d., 1697 the same, 1698 an uncertain amount, as also 1699, and two days' pay in 1700. He is not mentioned again, but it is possible that his trifling amounts were included in the constables' rate paid by the feoffees, or in a grouped item particularised only in "the other book".

Most of the detailed information in preceding and succeeding sections which deal with the corporation, comes from the valuable archives of the market feoffees. These were found when the local Historical Society secured the opening of a safe in a retiring room of the Town Hall, the key of which had long been lost: more of them were piled loose on top of the safe. These had been "found" by a former secretary of the society and placed in its library: now all have been deposited in the County Records Office under the reference D 553. They comprise:

1. A book of the *accounts* of the market feoffees from their founding in 1660 to 1752. Containing also *rent rolls* of 1715, 1717, 1731, *memoranda* of leases, bonds for loans, resolutions, and a proposal for augmenting the vicarage. The accounts are to a large extent based on a more detailed journal and on bills, which have not survived.
2. A book of the *accounts*, 1753–1878, with *minutes*, 1829–33, and 1849–52, and *rent rolls*, 1783, 1810, 1829.
3. A book of the *accounts*, 1878–90, and *minutes*, 1858–89.
4. Schedule of *leases* and some *rent* notes, 1668–1753.
5. *Rent roll* of market lands, 1871–88.
6. Sixteen deeds of periodical *feoffments* of market property, 1625–1739.
7. Nineteen *leaaes* and/or counterparts, 1764–1871.
8. Seven bundles: *leases* of market, etc., 1840–67; mayor's *report* to Mun. Corp. Commission 1877; others of less importance.
9. Four *deeds*, 1786–1864.
10. *Lease* by Lord Fitzharding of Jubilee Clump, 1888.
11. Act for altering rules of Leicester Hospital at Warwick, 1813.
12. Rules of Wotton under Edge Literary Institute.
13. Minutes of that Institute, 1848–90.

The income of the feoffees came almost entirely from leases of the market and its tolls and of houses, and fines for the granting or renewal of the leases which were irregular in incidence. Sales of trees or the materials of demolished properties and weighing charges did not amount to much. The income averaged about £40–50 from 1660 to 1700, £70–80 till 1775, then fell to £40–50 till about 1850, to the end it rose to £100–180. It looks as if the increases of about 1700 were due to ending some slackness in collecting the house rents; the cause of the relapse about 1775 is not apparent from the details given: about 1850 rents of some of the houses which had been improved and become important seem to have been graded up. It does not look as if the appointment of feoffees in turn as treasurers in 1719 had affected the collections.

There was drawn up in 1723

A SCHEDULE of the scales waites measures etc. belonging to the markett of Wotton and how in the hands of Charles Wallington

and to be delivered to the feoffees at the expiration of the lease of
5th December 1723. The market bell, the Cryer's bell; two large
beams and two pairs of scales; two half-hundered, one quarter
hundered, one ffouteen Pound waites of iron; one half hundered,
one quarter hundered, one ffourteen pound of lead; one brass seven
pound; one brass gallon measure, one bushel, one peck: 4 fformes
in the gate house.

The standard specification for what was let was: the market
house, profits of market, fairs with tolls & pickage or picking
money, stallage including ten butchers' stalls and eight more stalls
in Stony Chipping. After 1723 there was reserved "the room or
prison at upper end of market house, and liberty to keep a Court
Leet and Court Baron in market house once a year"; hay and
dung places and sawpit on Green Chipping were also reserved;
two fat hens or capons on 2nd February were an addition to the
money rents.

In 1702 and again in 1721 leases were granted to Edward
Ponting, carrier, of a messuage adjoining Upper Gate House in
Stony Chipping, three butchers' stalls and two chambers over
them in the inner row of shambles in Stoney Chipping, and the
place for refuse on Green Chipping. There is no indication of
abatement of market rent for these reservations. The chambers
over shambles-stalls are unexpected, when occasional repair bills
suggested that they were only ordinary stalls.

Rent of the market was at first the dominant receipt, but be-
came less important as the rent thus receivable fell and house
rents increased. At first seven-year leases were granted and often
allowed to run on: there is no indication how the lessees were
chosen.

		£
1660–86	Daniel Stoddard (Clothier)	14–25
1687–92	Robert Knee	14
1693–99	Giles Clarke and widow	24?
1699–02	Marmaduke Clarke	45?
1703–16	Chas. Wallington (Crown Inn?)	60
1717–30	Chas. Wallington (Card Maker)	52
1731–44	Anthony Barnes (Crown Inn?)	52
1745–51	Mr. Trotman	57

1752–58	Anthony Barnes (Inn Keeper)	52
1759–66	Cornelius Buckle	50
1767–71	John Fryer (Baker and Maltster)	42
1772–73	John Dimery	30
1774–84	John Dimery (often in arrear)	21
1785–89	John Dimery	20
1790–92	Thomas Jacobs	20
1793–94	Thomas Jacob, till he died	30
1795–12	Samuel Rose (Crown Inn)	25
1813–22	Samuel Rose	21

In 1706 Marmaduke Clarke was retrospectively allowed a £2 reduction "for loss he had in the market": in 1713 Wallington was allowed £10 for two bad years, £2 2s. in 1718, £1 in 1720, £5 in 1726, £2 in 1727, £2 in 1728, £2 in 1729: Anthony Barnes was allowed £5 in 1736 on account of smallpox. In 1743 a £5 rebate was again allowed for smallpox: in 1750 £2 2s. for a bad year and in 1752 £1 1s. 0d. for the same reason: in 1762 £8 for a bad year attributed to smallpox: in 1765 and 1767 £5 5s. 0d. each for bad years. It is possible that more of the "bad years" were due to smallpox. In 1866–7 £5 each for cattle plague.

From 1822 onward only one-year leases were granted, till 1850 on tenders presented at a meeting, then by auction at which bidding was encouraged by allowing 5s. for beer. Lessees were Thomas Clarke (the taker of the tolls) for thirteen years, Richard Roberts, Joseph Pepler, John Barlett four years, Joseph Witts of the Star Inn, W. J. Burford: the rents they paid show a clear tendency; £34, £55, £45, £56, £63, £30, £37, £25, £8, £16, £12, £20, £21, £12 15s., £15 10s., £12, £8 10s., £11 11s., £16 10s., £16, £10, £11 11s. In 1833 only £8 of the £20 bid was taken as the fair was quite suspended. From 1842 they were allowed £1 10s. off their tenders because the citizens had been given permission to hold a second (toll-free?) fair in March, which would affect the leased tolls.

From 1851 the leases were auctioned. Lessees were Joseph Whitfield, Edward Knight ten years, William George, G. H. Minett auctioneer, Samuel Riddiford, Cornelius Harris three years, Eusebius Portlock: rents were £15 5s., £25, £8 for only a

half-year, £15 15s., £15, £6 15s., for only a half-year, £18 5s., £16, £12 10s., £10, £13, £10 5s., £16 15s., £18, £10, £17, £10, £18. In 1869 the lease was granted to a Committee for Improving the Market, for £10 10s. a year: then, with an inter-ruption for one year in 1875 when John May got the lease for £11 5s., the mayor appointed a bailiff to collect the rents. What he paid in, after deducting his commission of £1 a year, and taxes and town-hall gas bill which amounted to more than half the gross amounts, varied between £5 and £11.

Obviously the feoffees were only enabled to fulfil their obliga-tions by the increase of rents of houses, for example up to £40 for what seems to be Chipping House also called Well House. After the opening of the railway at Charfield in 1844, establish-ment of a monthly market there in 1878 killed the Wotton market; fairs too had faded out, and receipts were practically only from town-hall lettings, plus letting of the Green Chipping for a yearly fun-fair which still continues.

It looks as if the market administration by bailiff and Improve-ment Committee gave rise to some dissatisfaction, for at a feoffees' meeting in 1871 a notice by "Cornelius Harris, secretary" was read out that in future a monthly market at moderate charges would be held in Pig Park near Church Street. It was decided to serve notice on Harris forbidding the market, and to take counsel's opinion on its legality: no more is known than that two years later the accounts show a charge for this opinion. Incidentally this shows that the pig-sties of the citizens were grouped in the area between Old Town (Street) and Long Street, and is the only clue to the Sow Lane mentioned by John Smyth. Harris was no mere trouble-maker or profiteer: he was principally instrumental in recovering the benefits of Chenies Hospital which had been lost sight of through the laxity of a vicar: and at his death in 1884 he left £1,300 for the poor of the town.

So much for the income side of the finances. On the expenses side the feoffees started with the £400 liability to William Archard. Towards paying this off they obtained £250 from the Hugh Perry Trust, undertaking the provision of payment of £12

a year for six lectures or sermons, as well as the £1 allowance to the mayor which has already been dealt with. There was also the £10 a year chief rent to Lord Berkeley: this was paid regularly till in 1891 the Town Trust, successors to the feoffees, redeemed it for a lump sum of £250. It is also on record that in 1671 Lord Berkeley refunded £5, half of it, "for the poor".

Till 1836 matters ran smoothly with an annual debit in accounts of £12 "for the lectures": but 1837 saw a first rumble of trouble ahead, when five and not six lecturers were named and paid individually. They included Benjamin Perkins the vicar since 1829, Cornwall the acting master of the grammar school, and three other ministers. In 1838 Perkins was paid for three of the six sermons, Cornwall for two, and two ministers had disappeared. Then from 1839 to 1846 no payments were made for eight years, and no explanation is on record: but in June 1847 the feoffees acted on some applications and ordered payment "of such sums as may be due", and accordingly £8 each was paid to Perkins, Cornwall, and four others, "to Michaelmas 1846". In 1848–9 again no payment was made, but in 1850 payment of £4 each was made to the same six, "to Michaelmas 1848": at the same time it was reported that no lectures had been preached since that date, and counsel's opinion was sought whether the lectures had "surceased". That opinion is not on record and the lecturers were at once asked to resume. Six months later, the first hint of the source of the trouble was a report at a meeting that Perkins the vicar refused to allow anyone to officiate unless he were approved and licensed by the bishop. The feoffees informed the appointed lecturers, and requested them to take the necessary steps. In 1851–4 no payments were made: next year Perkins got £8 out of the £12 provided, with Cornwall and another minister each getting £2: then, to the end of Perkins's incumbency in 1881, these three with an occasional addition claimed their allowances irregularly, but roughly got their dues, though these amounted to only about half the totals provided. The allowances were now calculated per annum and not per lecture, and called stipends.

The trouble obviously was that the feoffees had been appoint-
ing some nonconformist ministers. In the effort to evade the
vicar's prohibition permission was sought to allow lectures to be
read in the chapel of the Perry Almshouse: but a meeting of seven
trustees of this, including the vicar, refused this in 1859. Perkins
was succeeded by Canon Sewell in April 1881, and in July the
latter refused his pulpit to a preacher who had been regularly on
the panel since 1875. He further wrote to the Perry trustees in
May 1882 that he would not allow any lectures without his
written consent: and no more lectures were then paid for by the
feoffees.

These raised the matter again in 1884, referring to the existing
undesirable state of affairs, and the new vicar's expression of
opinion that the lectures were no longer necessary. As they
held funds in trust, they referred the matter to the Charity Com-
missioners as part of the whole problem of their impending dissolu-
tion, and suggested that the funds be used for the local elementary
schools. The Commission seem to have suggested that they
should rather be placed at the disposal of the vicar: the feoffees
totally rejected this suggestion. Their view was that the trust was
for the benefit of the town; that the appointment of lecturers
rested with the mayor; and that no preference was given to the
parish church. There was now a numerous body of noncon-
formists, and they refused to limit themselves to the church, or for
that matter to any sectarian body. The brief records of subsequent
exchanges do not show the reasons for the final decision, which
has resulted in the £12 being paid to the vicar. Probably the view
was that Hugh Perry had known only the church and so must
have meant that. The 1697 rent charge of £6 for the same purpose
is also paid to the vicar.

Archard's interest and capital and the other bondsmen had of
course to be paid. Honoraria to the mayor (sometimes stopped
when the finances were low), dinners at receiving the accounts,
rounds of drinks even at the signing of a single lease, were often
a quite appreciable part of the expenses.

Other smaller obligatory payments such as rates and taxes

begin to appear early: they are not easy to trace fully as descriptions vary, they may sometimes be entered to the names of the men paid or be included in miscellaneous entries: they are suitable for study by specialists, but would swell this account with too much petty detail and so are only briefly mentioned. They include royal aid, payments for church and poor, hearth money for the Tolsey, constables' rate, highways, and so on.

There were also certain royal occasions. For the proclamation of Charles II in 1660, 4s. 6d. was paid for a scaffold at The Cross, the trumpeters got 10s., 5 guineas to "James Bubb for wine drank" probably by the people, while the mayor drew 28s. 3d. more. For James II in 1685 £1 6s. was spent in proclaiming, there was a hogshead of beer for £1 12s. 6d. and the bellman got a new uniform. Neither William and Mary, nor Anne, nor George I received any organised acclaim. For George II £17 3s. 7d. was paid in 1727 for proclamation and "knots for the sherrif's men", and Ab. Walker got a pair of breeches for 3s. 6d. In 1735 63s. was paid for "ringing the bell on 28th October", an occasion for which I cannot account, unless it was for the election of that year. In 1743 two innkeepers were paid £2 5s. 6d. "at declaration of war" which occurred three and four years before; but the peace of 1748 which was acclaimed with so much joy elsewhere elicited no drinks here. On the next occasion war in 1755 was greeted with £9 5s., while peace in 1763 was ignored. On 5th November 1835 1s. was paid for "having fireworks cried down", though in 1758 6d. had been spent on a tar barrel for bonfire and 6d. on gunpowder for fireworks. In 1830, for the proclamation of William IV, the populace got £5 of beer, the ringers £1, the soldiers (3rd Dragoons) 11s. 6d., and the trumpeters and musicians 30s. For Queen Victoria's accession in 1837 the ringers were given £1, and £5 of beer was provided for the populace. In 1863 £6 was subscribed towards the rejoicings for the wedding of the Prince of Wales, and in 1872 £1 towards a tea on Thanksgiving Day, for his recovery from typhoid. By 1887 the borough had been extinguished; but the feoffees donated £6 towards the Jubilee rejoicings, and the Jubilee clock was installed at the Tolsey.

In modern times Mafeking night no doubt accounts for some of the untitled photos in the collection of the Historical Society. Peace after the First World War led to the building of the War Memorial at the bottom of the Old Town, and to a large panel in the town hall bearing the names of all who served. In World War II a battery of field artillery was billeted here, in addition to numbers of evacuees sent here from the poorer quarters of Birmingham, who, however, soon drifted back home. Harwich Grammar School came *en bloc*, shared accommodation with our own grammar school, and fitted in with our life very happily. After Dunkirk we received a number of the rescued troops, and they were visited by Queen Mary from Badminton: that house also saw a parade of the special constabulary before King George V. Our little victory parade on the conclusion of peace was joined by a contingent of U.S.A. troops quartered in the vicinity, with colours.

On a lower level, in 1671 Lord Berkeley was received with wine, beer and cakes costing £3 11s. 0d., towards which Edward Plomer, churchwarden, gave £1.

One of the largest sources of expense was the market house, later called town hall. A market house is mentioned in the original grant of 1659, but what it consisted of is not known. As early as 1678 and fourteen years before the initial debt was paid off, £34 18s. 7d. was paid for "building the market house for the corn market". Desks in it were provided in 1686 for £2. In 1698 it was decided to "go on" building a market house and take up loans for the purpose, and in that year £25 was spent on timber and on hauling it; and on "eight stone pillars", while next year £30 was spent on more timber and two more pillars, with £4 3s. 11d. for victuals and drink for the workmen. In 1700 loans of £370 were taken up, while Edward Smyth (probably eldest grandson of John Smyth of Nibley) donated a further £10. In that year £421 0s. 6d. was spent on labour and materials, while the workmen (and feoffees themselves) were stood £3 17s. 9d. on beer. In 1712, with £240 of the loans still owing, £1 17s. 6d. was spent on enclosing a room in the market house, and in 1717

£1 5s. 6d. was spent on making a timber "barr" in it and glazing the windows. The loans were cleared in 1720 when the old accountant was replaced and better control established. In 1729 a mere £13 was spent on unspecified work, and £4 on glazing windows, and in 1733 another £5 11s. 6d. for work, and in 1740 it was repainted. In 1826, during a period of borough prosperity when all loans had long been paid off, £161 19s. 4½d. was spent on repairs, and £88 8s. 6d. plus £6 4s. 0d. carriage on enclosing the ground-floor arcades with iron railings and gates. In 1850 there were again repairs, and it was "necessary to build a brick wall to support Market House" at a cost of £4. In 1855 a heating stove was provided for £7 1s. 11d. In 1866 it cost £34 13s. 10d. to alter the gates and iron railing "for accommodation of great markets".

A serious state of affairs was revealed in 1870, when the Jury of the Court Leet, which included the individual feoffees, "presented" the dangerous state of the town hall and demanded immediate attention. An architect was present at the meeting of feoffees, and exhibited plans for restoration which would cost £600–700: in detail, £550 for restoration and repairs and enlarging the building, £50 for enclosing the market with windows and doors, and £100 for warming apparatus, gas fixtures, and seats. Finance was also considered: it was decided to carry out work up to £600, and to raise a restoration fund; to contribute £120 from the market funds, and to raise a further £300 on the security of market properties, but this last decision was shortly after rescinded. The feoffees' accounts show only that the £120 was duly contributed: but the restoration fund was separately administered, and its records are not available, so it is also not known just what repairing and enlarging amounted to. Unfortunately this restoration left the building looking less attractive than before, especially by omitting the dormer windows in the roof. A petty item at this time is that in December 1872 6s. was paid for "cleaning Town Hall after snow storm".

Further work was undertaken by the feoffees in 1884 during the gradual extinction of the borough. In addition to spending £33 0s. 6d. on general repairs, including much-needed ventilation,

and £7 5s. 3d. on a carpet, £200 0s. 3d. was spent on enclosing the ground floor and dividing it into rooms, and providing a lavatory and gas heating (which had been left over in 1870): this was paid for from credit balance, with £150 from the sale of investments.

The Town Trust to whom the feoffees then handed over only effected maintenance and repairs, until a recent War Memorial scheme. It was in 1947 decided to build a Community Centre, and its estimated cost of £15,000 was set as the target for the fund to be raised: in three years only £2,000 had been raised, and with it the Well House on the Green Chipping with its grounds had been bought, for adaptation and extension. But the initial impetus was exhausted, and it was then realised that the project could not be carried out: so the Well House was sold, and the funds available, £2,467, were devoted to improving the town hall.

The only information about the accommodation in and use of the market house is in some leases of the market in which it was included. These are no more than that a number of the leases reserve "liberty to keep a Court Leet and Court Baron in the Market House once a year." Since the ground level was open arcading, this must be the first-floor hall. Also reserved in 1767 only was the "room or prison at upper end of Market House". Butchers' shambles were on the further side of the Stony Chipping, in front of the Star Inn, and the stocks stood on that side till they were placed under the market house when it was railed in in 1826. There was then also a large fishmonger's stall at the back of the Swan Inn, under what later became a billiard room.

The mayor and his brethren already possessed the Tolsey. According to Atkyns and Bigland this was in 1595 granted to the town by Anne Countess of Warwick, widow of Earl Ambrose, and was for the poor aged and impotent. In 1617 it was passed by surviving trustees, headed by Stanton the vicar, to fresh trustees headed by the mayor Nicholas Heskins, as Charles's (Sherman's) house, and later became the new Tolsey House. By subsequent feoffments it became in effect part of the market property, for the keeping of the market courts.

From deeds it appears that the ground floor was the court

room, with a little room "within" at the upper end, and a buttery "within" that: there were two chambers over this, one of which is now let to the Historical Society for its library. In the loft over these was the town clock, and over this a turret: underneath was a cellar and adjoining Blind House or common prison. Hearth money was paid for the Tolsey.

The clock in the loft was only the driving mechanism: the time is now shown on a very characteristic Jubilee clock projecting into High Street. Though a new clock was provided in 1683 for £42 3s. 0d. and a man was regularly employed to wind and care for it, there was frequent trouble: at that time there was a dial, in some way and somewhere set on a post, which seems to have lasted till the Jubilee; it was out of doors, for in 1802 and 1887 it was stopped by snow. In 1876 a Bristol man had to be called in to see if it could be made to keep correct time, but apparently

3. Tolsey turret

nothing more was needed than one of the periodical petty bills for cleaning and repairs, 13s. 6d. Again in 1878 another Bristol firm was consulted, and estimated £18 10s. 0d. which was duly paid.

The turret carried the clock dial, and the bell, which had to be recast in 1666: in 1707 £10 11s. 6d. was spent on repairs, adding the cupola, and putting the copper dragon vane on top of it, which, with the dial, had to be regilded in 1737, and was altered in some way in 1740; but £3 more of work was needed in

1780. In 1859 the cupola was reported unsafe, and apparently a new dragon had to be provided.

The cellar is cut in solid rock; one side has a recess about 6 feet square with a Tudor arch and signs of a stout well-secured door, and was apparently a prison cell. Bills for work on the Blind House are infrequent and small, and may well have been for this cell: only in 1822 was there a £12 bill. On the other hand "the New Tolsey Blindhouse or Common Prison" was in 1734 given out on lease to a maltster Edw. Bearpacker for £10 per annum. Mention has been heard of a record, which cannot now be traced, of a prisoner being committed to the Blind House in 1832.

The cellar is reached by a good stone spiral stair: this is continued upward: as far as the first floor it is of the common type in which the wood blocks of the steps are mortised into a central newel post. The upper part is more interesting, being of the less common older type in which, as in a stone staircase, the wooden blocks support each other at the centre without a newel post. There is an old outer door, heavy "two-ply" oak heavily nailed.

When a shop-front was recently put into the adjacent house in Market Street, it was found that the upper floors used to project and the level brick façade was a later modification. At the dates first mentioned for the Tolsey, this was described as the house of the Daunts of Uley.

As the Tolsey was owned before the borough was made over, the courts held in it must have been those of Piepowder, with the later manorial courts in the market house after that was built in 1678. Having been held by the market feoffees, as is shown by numerous transactions throughout their period, it should have passed to their successors the Town Trust: actually it is held by the General Charities Trust, though there seems to be a curious provision that the Jubilee clock on it and its works under the turret do belong to the Town Trust. As neither body can afford the cost of radical repairs needed by this ancient building, accentuated by the roof strains due to the heavy clock works under the turret, the parish council is being moved to take over.

Access to the two market places was not unrestricted. In 1662

the cost of two gate-posts and a gate, and two stone stiles, is included in a general item. These seem to be for the three entrances on the further side of the Green Chipping which still exist, one open for vehicles and two restricted by posts. In 1666 a new "leaping stock at the end of the Tolsey" was provided: and in 1718 9s. was paid for "pitching before the Tolsay staikes" which are probably the same thing. The passage between Stony and Green Chippings used to be a mere horseway, and was crossed by a passage at first-floor level from the Crown Inn. In 1826 the latter was removed at the same time as the market house was railed in, and the passage widened by 4½ feet by cutting back the inn, all at a cost of £52. At the other end of the Stony Chipping the 1763 Survey shows Market Street similarly constricted by a "projecting building on each side". A payment in 1685 for "raising the gate-house", and one in 1726 for negotiating taking it down, though without identifiable payment for doing so, seem to refer to clearing this constriction.

The early deeds of the Tolsey from 1617 give its position as "in the high street next to the high cross". The site has nothing like room for an erection that one would picture as a High Cross, and it looks as if that were only a name for the important road junction, though it is only a T junction and not a cross-roads. In 1660 one of the first acts of the new feoffees was to pay a mere 7s. 4d. for "making an upper cross": as further a scaffold was erected at "the cross" for proclaiming Charles II, the site may well have been the Cheese Cross which existed on the market-place, under some form of roof, for mending and tiling which 10s. 10d. was paid at the same time. In fact in 1687 £2 1s. 6d. was paid for roofing work in mending the Cheese House, to which the market bell had in 1674 been removed from the Tolsey turret at a cost of £4 7s. 6d. The confusion in these items cannot be cleared.

The only other mention of a cross is in a scheme, the best report of which is given by John Smyth in 1639. He records that as recently as 1630 water had been brought underground from Edbrooke field to the market cross at the charges of Sir Richard Venn and his son-in-law Hugh Perry: and that at the cross a

conduit had been erected with an inscription to that effect. Rudder, reporting this in 1779, adds that by then the conduit was entirely destroyed. The explanation is undoubtedly that leaks in what then must have been a stone-slab culvert would waste all the flow that could be passed by the gradient available, even if the goal were the Tolsey and not the market place. The idea had been initiated in the 1572 will of Thomas Gowre, but nothing was done then.

In fact in 1667 a mere £2 16s. 6d. was paid for "finishing" a "new" well at the Tolsey, with no record of other payments: moreover this payment covered an "arch and table" over it and leaf gold for gilding.

Trouble began when in 1789 the well was fitted with a pump which cost £7 0s. 6d. plus some £4 for fitting it; in 1804 repairs cost 15s., and in 1805 a further £2 2s. 0d., in 1818 no less than £10 18s. 0d. In 1834 £15 was spent on "putting up" a (new?) pump, but in 1850 £8 was needed for repairs when it was needed for flushing gutters. The feoffees got tired of the frequent trouble, and in 1865 commissioned "Mr. Parker" to repair the pump by fitting a new head, brass cylinder, and suction pipe, as well as keeping it in repair for three years for no more charge: only in December 1868 was he paid £10 2s. 8d. for doing this in 1866, after deducting £2 2s. 1d. in consideration of cancelling the rest of the agreement. In 1882 the mayor suggested removing the pump, but a meeting decided for repairs under the supervision of mayor and clerk. In 1903 the well was condemned as impure, was filled in, and the footpath paved over it.

There was similar trouble with pumps fitted in feoffees' wells at the Swan and Star inns; the well on the Green Chipping in front of Well House only needed new ropes and buckets at intervals.

One public service performed by the feoffees was the provision of fire precautions. In 1676 £1 10s. 1d. was paid for ladders and buckets and for hanging them up. In 1708, without any previous mention of buying a fire engine, the pipe of one was mended, and an engine house provided for £8 10s. with 7s. of beer for the

workmen, and some more ladders were provided. In 1729 there seems to have been a more serious fire, for 24s. was paid to the men that helped to quench it, with a further 1s. 7d. for beer for them. In 1732 some fire crooks were bought, and there were several bills for work and materials for "building", perhaps repairing the engine house. It looks as if there had been some epidemic of fires for the market house was insured, a caretaker appointed for the engine, a series of petty repairs to the engine done, more buckets bought, a man paid for "playing the engine twice", an engine tub provided, and 10s. 8d. spent for "torches at the fire in the market" in 1760. In 1837 we hear of two engines, for the repair of which and the engine house £5 12s. 6d. was spent, and then a caretaker for the fire engine alone was appointed for £5 per annum: in spite of this, in 1846 it cost £5 5s. 3d. to provide new pipes to replace what had been stolen. That seems to have led to terminating this arrangement, for then nothing more was paid till from 1854 (Police) Sergeant Watts was paid only expenses, and in 1859 was presented with £3 3s. 0d. for his "great care of and attention to the fire engines", which was repeated in 1870.

In 1870 the engine house was reported decayed and unsafe, and it was resolved to pull it down and build accommodation under the town hall. In 1887 the feoffees and the town trustees who were in process of replacing them resolved to buy a new "improved manual fire engine" at a cost of about £118, in commemoration of the Queen's Jubilee: the several fire offices doing business here were to be asked to contribute, failing which they would be charged a guinea for use of the engine at any fire in which they were interested. The new engine was bought for £120, towards which £13 3s. had been given by the insurance companies, and £100 of investments realised: a further £16 was spent on "repairs" and accessories. The old engine, said to date from 1761, just after the market fire, was offered for sale: an offer of £4 for it was refused, a reserve price of £7 decided, and £17 was received from the former bidder. Mr. George Dauncey plumber offered to organise a voluntary fire brigade and act as

6

captain: that was agreed and he was given £8 a year for this and for care of the engine. Subsequent steps may be shown by other records which I have not seen; in World War II the volunteer brigade served in Civil Defence, has since been nationalised, and prides itself on good service.

Attempts to bring water from the little flow of Edbrooke, which is now led into a horse trough opposite the churchyard, proved as inept and more troublesome than the Venn-Perry conduit.

There was a drinking fountain opposite the War Memorial: the date on it, 1741 or 91, has been defaced by clumsy drilling for a cock, and has quite recently been walled in. There is no mention of it until 1855 when £25 9s. 8d. was spent on "a conduit etc at bottom of Old Town".

This cannot have been satisfactory, for in 1866 an estimate of £140 was obtained for improvements in connection with the water at Rymers Row. Expenditure of £100 was approved if the balance were contributed otherwise. In 1867 it was resolved to remove the tap "at Worlock's house" there, and lay the necessary pipes, and £9 2s. 8d. was spent. Later, in 1868 the actual cost of the bigger work was reported as £145 8s. 4d. (and an item of £5 8s. 4d.), and reference made to an understanding under which £15 for a pump had been paid in addition to the £100 specified: the owner of the land said to have benefited by the improvement was invited to contribute, gave £10, and the feoffees paid off the balance of £35 8s., plus £12 18s. 3d. "balance of a/c for Old Town pump".

All this too must have proved unsatisfactory, for the mayor reported having employed a man to bore for water in the well in the Old Town, "now empty", but without success after forty feet of boring: but at the next meeting "a good supply was reported". (I have myself found that stratum quite unreliable at Wortley, though the well might fill to ground level at times.) Then in 1870 the pump was put out of action by someone dropping stones in it, and we are not told what action was taken. In 1871 a report led to inspection by the mayor, when clearance of the conduit

and putting an iron trough at the spring was ordered for £6; but £10 had to be paid when the work was done.

Trouble of another kind began with a solicitor's letter in 1877 complaining of dampness and damage in Culverhay from stoppage of the Rymer's Row pipe. A committee, after inspection, replied that the cause was that the ground outside was well above floor level inside, and was kept wet by discharge from a rain spout which was not led away. This was after £2 12s. 6d. and £5 5s. had been spent in 1875 and £7 7s. 6d. in 1877. Then, after six years of peace, the complaint arose again in 1883, again alleging stoppage of the pipe: clearance had been done four times in the interval at small cost, but now clearing and relaying of the whole conduit, and clearing of the filter at the source were ordered, and were carried out for £4 8s. 3d. That brings us to the end of the feoffees' records.

There is no record or even mention of the Courts Leet regularly held annually to choose a mayor: but the Minutes record a summons in 1872 by the Berkeley steward, to a court on the 10th October in the town hall. Their ritual is known.

A precept was issued to the sergeant at mace to summon all inhabitants and residents, copyholders and leaseholders, and all others owing suit or service, to appear personally. The court being opened by the bailiff, the jury were empanelled and sworn: then the steward gave the retiring mayor a form of presentment on which the jury were to enter their nominees for the coming mayoralty, and any grievances: he then swore the constable to enquire into the offences committed in his year: the constable then handed the steward the roll, the crier called on all to answer their names, and the steward called the roll, fining absentees 6s. 8d. He next swore the foreman to enquire without fear or bias, and then the rest four at a time.

The first business was to confirm that decisions of the last court had been carried out. The jury were charged to present any nuisance committed, encroachments on highways, any dunghills or other obstructions by which cattle might find their way to trespass, any eavesdroppers, barrators or mischief-makers, riots or

unlawful assemblies, unlicensed alehouses, good order in licensed alehouses, gaming houses and bawdy or lewd places, any failure by vendors to supply wholesome bread meat and drink, and a few other matters.

The court then adjourned, and the mayor and aldermen in procession behind the mace retired to the luncheon room and filled up the form, then let the steward know they were ready, and in procession returned to the court. The mayor was selected from the nominees as already specified, and sworn, followed by the sergeant and other officers. Last came consideration of presentments of offences, grievances and disputes. The crier then announced the close of the court, the mayor and aldermen took formal leave of the steward and invited him to a dinner that evening, and the mayor was escorted in procession to his house.

The last record of a Court Leet of the borough is a summons, issued by the constables in pursuance of a precept of the Berkeley Steward, to a court to be held in the town hall on 24th October 1884.

Civic pomp was enhanced by robes. In 1746 (though it put the town in the red) £48 13s. was spent on sixty-nine yards of purple cloth, 9s. on lace, 2s. 3d. on silk, 16s. 10d. on ermine (for the mayor?) and 30s. on making six cloaks. In 1767 two more cloaks cost £6 9s. There do not seem to have been any other charges to market funds on this account, though there may have been bills unrecognisable when only the name of payee is given.

Official attendance at church was another occasion for processions. The mayor's seat was furnished with a wrought iron mace rest dated 1696 when Jonah Okes was mayor (page 177): mended in 1739 for 1s. 6d. and gilded for 2s., this was not only removed in the reseating of the church in 1882 by Canon Sewell, but allowed to disappear. In 1739 there was also expenditure on seats for the aldermen, £3 13s. 9d. for boards, £1 9s. 7d. for locks, hinges and nails, £3 3s. 7d. for carpentering; also £4 7s. 6d. for green cloth and £1 4s. for lining the seats with this: they were relined in 1784, with £9 13s. 6d. for cloth and £2 18s. 6d. for labour. The aldermen were also provided with prayer books, at a cost of

£4 5s. in 1739, four folio books cost £3 in 1754, and in 1784 £1 12s. was paid for binding.

The mace used in these ceremonials still exists, the fifth of a series. It is not known whether there was an earlier Berkeley mace, but John Smyth mentions one with the Lisle arms, dating according to him from the time of Henry VI, but dated by Vincent Perkins (without specifying his source) from 1327. If Perkins's date is right, it would refer to a Berkeley mace given by Thomas III when he took in hand the ordering of his estates after the disturbances of Edward II's reign: the Lisle arms could not have arisen before at earliest Beauchamp's death in 1439, which was in Henry VI's reign: they may have been imposed on the earlier Berkeley mace, or a new one substituted. This was sold and a new Berkeley mace substituted in 1559. That again was defaced in 1573, and a third mace substituted with the arms of Warwick and Leicester, to whom Queen Elizabeth had then granted the estates. In 1610, when the estates were at last again awarded to Berkeley, this was banished and a fourth mace with the arms of Henry Berkeley substituted. In 1747 this was for some reason sent to Berkeley Castle in exchange for the fifth and present mace.

4. Mace head

The head of this mace, of silver-gilt, is in the form of a loving-cup, and has embossed round it the Berkeley arms, the Rose of England, the Thistle of Scotland, the Lily of France and the Harp of Ireland. The cover of the cup is a royal crown of England, a circlet with alternate *crosses pattées* and *fleurs de lys* and two arches

surmounted by orb and cross, with the royal arms of George II embossed on the cap. Round the basal knob is engraved in Italian hand

Ex dono praehon. Augusti Com. de Berkeley pro usu
Majoris Burgi sui de Wotton, A.D. 1747.

The hall mark is of London 1746–7, but the maker's mark is illegible. A mayor on election had to drain the cup in toast to his colleagues.

On the dissolution of the borough in 1886 this mace was conveyed to Berkeley by the mayor and his brethren, and handed to Lord Fitzharding for custody with an illuminated address: that lord gave them a luncheon, with speeches and toasts from the cup, and he undertook to have the mace on show in the castle. At a subsequent date he apologised that it was not on show because Sir George Jenkinson as executor had locked it in the strong room, and was away. When the castle was closed to the public, the mace was returned to the town, where it was placed in a glass case in an unguarded room of the town hall, but when objects disappeared from a showcase there, including the silver trowel with which the foundation stone of the Tyndale monument at Nibley had been laid, it was removed to safer storage in the bank.

The corporation also supported the church with money, apart from the poor and the church rates. In 1710 it wrote to Christ Church offering to pay the vicar £10 a year if the college would do the same: the college refused, so this project failed. But in 1711 Gregory, the popular vicar, 1708–38, was apparently promised £100, of which £15 was paid then: in 1724 £65 was noted as still owing, and in subsequent years up to 1739 £110 was paid him, making £125 in all. These seem to be the only such direct payments: but in 1756 £21 was contributed towards recasting the eight bells, and for some periods the ringers were given small annual payments at the feast of SS. Simon and Jude.

Among the citizens, lawyers were prominent, of whom a number became mayors. They were often employed by the corpora-

tion, and some of the payments look liberal. In 1662 "Mr. Smyth of Nibley", son or grandson of the historian, was paid £2 for "counsell for the case of the market", an unspecified question. The historian's grandson Edward, a barrister, received £1 19s. 6d. in 1679 and another payment in 1693; and it may well have been he who subscribed £10 in 1700 toward building the market house. In 1695 Mr. John Rouse was paid £10 "for law", and next year £25 for "charges in a suit of law": he was also Steward of Lord Berkeley's Court. In 1709 John Okes received £4 3s. for "suing an ejectment against a tenant", and in 1724 "in consideration of his necessitous circumstances" was paid a liberal £15 for drawing some deeds: he may have been related to Jonah Okes, mercer, an ex-mayor. He was succeeded by William Scott, later twice mayor, who in 1730 was paid £7 10s. for "making the new enfeoffment being very long writing". For the next feoffment in 1749 John Scott was paid £8 3s. 6d. without remark, and for the next succeeding enfeoffment Mr. Whittock, not otherwise known, received £7 8s. Thomas Perry, a solicitor and mayor in 1788 and 1803, was paid £9 11s. in 1790 for unspecified work. John Dyer, mayor 1827 and of a mayoral family, and James Perrin, three years mayor 1859–61, were solicitors, but there is no record of their being employed or paid. 1872 saw a payment of £8 2s. 3d. to the late Mr. Anthony Adey's estate for law charges: he had been mayor in 1841, and about 1850–56 had founded the firm which still serves Wotton. He had been joined by his son-in-law Turner, and by 1873 by Osborne Dauncey, reputed a sporting character. Of a Wotton clothier family which had been in partnership with Wallingtons, he had started as articled clerk in 1859, to Richard Bracey of Wotton, who has not appeared in these records: he was mayor for three years 1875–77, and it was he who drew up the borough's memorandum for presentation to the commissioners. He died in 1882, but his name was for a time retained in the firm. Also in that year the firm was joined by Mr. Chanter, and some six years later by Mr. Goldingham, a keen antiquarian but of doubtful accuracy. Then in the 1890's Chanter died and the firm was joined by Mr. Lloyd who had by 1915

been succeeded by Mr. Chaffers. Finally, after he too had died, the firm was joined in 1927 by Mr. A. H. Jotcham, who was the sole partner after Mr. Goldingham retired and died, and has recently been joined by his son Paul.

A year after the posthumous payment to Anthony Adey, £4 7s. 4d. was paid for counsel's opinion on Harris's attempt to establish a rival market. In 1851 counsel's opinion on the matter of the vicar refusing to admit lecturers appointed by the feoffees cost £2 12s. 10d.

The next lawyer after Adey was W. Horace Wright, mayor for three years 1871–3, greatly respected, and trusted to the extent that he was given *carte blanche* to conduct several negotiations for only out-of-pocket expenses; he was also compiler of the "Memento". No payments to him even of expenses are recorded, and it is then sad to find a Minute and a Debit recording that he had absconded during his third year, a bankrupt and owing £57 7s. 10d. He does not seem to have falsified the accounts, but just dipped his hand into the till. In the next year £5 0s. 5d., a dividend of 1s. 9d. in the £, was recovered from his estate in bankruptcy. In 1886 £18 7s., including a counsel's fee of £7 17s., was paid in the matter of winding up the feoffees' responsibilities, including the lectureships.

The above payment in 1886 was made to Messrs. Blake and Henley. Osborne Dauncey, who had in the interim drawn up the memorandum on the threatened suppression, and may have done other legal work, was not paid anything. Blake was mayor for the final four and a half years, and was accorded cordial thanks, with regret that he was changing his residence. Adey's son-in-law and partner Turner in 1887 applied for the post of clerk, but Blake and Henley were appointed to represent the feoffees before the dissolution commissioners: this is the first and only mention of a clerk, and there is nothing to show who the person was who drew an annual fee from the beginning for making out the accounts. After Blake's departure, Henley's relations with the feoffees were not happy. When in 1887 he submitted a bill of £15 4s. for charges, they were "greatly dissatisfied", and offered £8 8s.,

which was duly paid. Again in 1890 his bill of £16 13s. 7d. was
queried and £13 10s. 7d. was offered and paid.

The medical profession hardly makes any public appearance.
In 1756 Mr. Huntridge, surgeon, inserted an advertisement that
"he is fitting up his small-pox house at Tiley, 1½ miles from the
town" (probably the Pest House at World's End, under the
Warren House), "for the reception of patients to be inoculated,
on most moderate terms"; he speaks of having practised this art
for sixteen years, having inoculated 446 last spring of whom only
four died, his first casualties. Only a fortnight later notice was
given, signed by vicar, mayor, churchwardens and overseers, but
no doctor, that smallpox was completely discharged from the
town and parish. The alleged clearance is disproved by rebates
of market rents granted later: in 1762 a lessee since only 1759 was
allowed £8 off his rent for bad markets on account of smallpox;
and in 1767 and again in 1768 rebates of 5 guineas were allowed,
though without giving the reason. Then we know only of William
Hill, surgeon, of the Well House, mayor 1826 and 1846, who gave
important evidence in the sanitary enquiry of 1854 dealt with
below; and Adam Adams, surgeon, mayor 1830, who was medical
officer of part of the Dursley Union and also gave important
evidence. The list of mayors also makes mere mentions of J.
Cooper 1767, David Taylor 1820, and Benjamin Simmons 1869.
Later doctors I refrain from listing.

Nowadays it is hard to realise how elementary ideas on health
and sanitation were till within living memory. When a movement
for improvement at last began, the state of things and the public
indifference is hardly credible.

The first record of any sanitary measure is a payment in 1739
for repairing the "necessary house" in the Chipping, of building
which there is no record. In 1756 £2 3s. 5d. was paid for "cleans-
ing" it, the only occasion recorded: what is omitted may be
concealed by abstracting from an original detailed record which
has not survived, or be in bills of which only the names of payees
or of materials used are given. Occasional payments are recorded
for clearing dung at a Chipping wall. In 1860 (there was no flow-

ing water supply in the town till 1894, or sewerage till 1913) the most important residence, Chipping House, occupied by Dr. Hill, was given a water closet costing £18 4s., and his rent was increased by 30s. In 1881 £18 14s. 9d. was paid for erecting a urinal near the town hall, a service not extended in the town till about 1935, and for making an earth closet at the Star Inn. In 1881 the grammar school was given permission to build itself an earth closet, paying an "acknowledgement rent" of 2s. 6d. a year. Other privies and drains are mentioned but details are not clear. The perambulation of boundaries mentions a drain from the Chipping along the edge of the built-up area, and there is once mention of a subsidiary drain apparently to discharge into it.

At last something began to be set in train by a preliminary public enquiry and report by an inspector of the General Board of Health in 1854. It was not till 1871 that the matter came before the corporation, when all that was recorded was that "owing to the great expense and opposition, it was considered impracticable to improve drainage at the present". Then in 1875 the Medical Officer of Health to the Dursley Rural Sanitary Authority submitted a report. So in 1880, as a result of a specific complaint, £3 was allowed for dealing with defective drainage of the Crown Inn (now called Criterion), and £7 11s. for the foul state of its well. Not till 1886, after extinction of the borough, did the matter come up again, on an application from a parochial committee for a contribution toward the cost of finding the best mode of obtaining a water supply: the reply was that this was solely a rate-payers' matter, and the "feoffees and Town Trust" enquired the probable cost of such a survey. On that being given, they deferred reply till the cost of supply had been estimated, and some progress made. The question was not raised again so far as my records show.

The 1854 report recorded that wells were the principal source of water supply, many too deep for pumps and usable only by rope and bucket, and all liable to fail in dry weather. Dyers' Brook was too much contaminated by mills and dye-house; as to springs, the supply to the bottom of Old Town had been dismantled, and there were now only several little springs. As to

drainage, there were a few covered drains in the lower parts of the town, made by churchwardens or road authorities, intended for surface water, but used for house drainage and refuse of the most offensive description. As to privies, many houses were wholly without, and many had only the use of one among several, and they were such as generally to contaminate the water. The vicar stated "to this deficiency I attribute the filthy state of the ways and footpaths". Unhealthiness and even stench were so bad that in summer he could not open the front windows of his Berkeley house. Opposition was massive and vocal. The stinks were denied; but principally the objection was to the expense, which it was said could not be faced when the population had grown less and property values had seriously decreased; and figures were quoted on these points. Dr. Adams stated "a vast number of the privies empty themselves into the open channels in the streets". Other nuisances recorded include slaughterhouses draining into the open channels, often with blood flowing from them: swine, accumulations of dung, and so on. Cholera did not come in 1832, but made havoc in 1849, almost exclusively in the lower parts of the town. The place was not unhealthy since about a quarter of the burials were of people over seventy and many above ninety. The churchyard was in 1873 reported by the vicar Tattersall to be hopelessly confused and a rubbish tip: the graves so shallow that if horses got in ——: he had done what was possible to put this in order. Perkins had discouraged burials within the church, allowing only very few, encased in lead; his successor Sewell (1881–1903) stopped them and is said to have filled in the vaults with rubble, personally and with a few friends, quietly by night: and he concreted the floor. The Tabernacle and the Baptist chapel in Ropewalk had small grounds, not overstrained; the Wesleyan chapel, then in Haw Street, had no ground, and used to have its few burials in the chapel. Old Town Meeting House had not used its ground itself for decades, and in thirty years perhaps twenty burials had been within the building, not in lead. There was also Mr. Perrin's private ground, on the site of the earlier Baptist chapel next to the grammar school, lost sight of and only

found when a new outbuilding was erected for the school, when the vault contained only the remains of two children.

The 1875 report did a little towards bringing the statistics which the inspector had collected twenty years before up to date, but concentrated more on preliminary ideas about measures to be taken. The state of sanitary affairs was very much what it had been then. These descriptions and what they entailed are borne out from a different point of view by a statement given me by an old inmate of the Almshouses, of conditions about 1890, but mostly too unsavoury to reproduce; a striking point is the total lack of fastidiousness necessary in dipping water from a stream which carried floating sewage. A drainage system would have been useless without a water supply that would allow of flushing the sewers, and effluent could not just be discharged into Dyers' Brook, so that some kind of purification plant was essential. Referring to what he claimed to be doing successfully on his own premises at Gloucester, the inspector strongly advised the abolition of cess-pools, and the adoption of dry closets, under proper supervision, and organised conservancy for those who had not the means for clearance and disposal themselves.

In the light of these descriptions one would expect there to have been frequent and considerable outbreaks of water-borne disease. However, William Veele of Symondshall moved Quarter Sessions to disallow the cost of inoculation out of the rates; it was disallowed and the churchwardens and overseers of the poor who were responsible were surcharged £28 3s. 6½d. Not till 1894 was a limited water supply brought in largely on the persistence of Canon Sewell, but was not given to business premises. This was from the unreliable Fuller's Earth geological horizon on Rushmire Hill. In the first quarter of 1896 the supply was a mere 70,000 gallons a day, and in the second quarter only 52,000 gallons. Only in 1910 were the Tyley Bottom springs tapped and pumped to a high-level reservoir. Even this is at times unsatisfactory in the higher parts of the town, and improvements are still in progress. Not till 1913 was a sewerage and drainage system completed, with purification plant below Hack Mill: this too is now being extended.

Under the conditions described, the wonder is that typhoid was not endemic.

Of other public amenities, a local gas company had started supplies in 1839 and the first telephones were installed in 1906; electric current came in 1929, for domestic purposes only.

The first appearance of banking in the town is that Goodson Vines, mayor in 1780, 1799 and 1813, is known to have been a banker; but of his activities as such nothing is known. In 1796 he was also Treasurer. He lived in the Well House on the Green Chipping, later known as Chipping House, and seems to have played a considerable part in converting it from its primitive original during his long lease. The start of that lease is not known, but in 1786 he received a ninety-nine-year lease from Lord Berkeley of premises behind it; he was still there when he sublet some of these in 1802 (and a pew in church) to Eliza Austin for twenty-three years at £30 per annum: this rent suggests that the Well House may have been included. There is no direct indication of his having gone, and the house was still attributed to him; but from 1852 there were other tenants. The mayors of 1709, 1736, 1738, 1745, 1758 were named Thomas Vines; the man in 1745 was designated clothier. In 1744 and 1755 the mayors were Samuel Vines, and in 1776 John. The first name of Goodson obviously derives from another family, and appears in the prenomina of several other prominent families by inter-marriage.

In 1834 the National Provincial Bank began to open branches in the provinces, the first being at Gloucester on the 1st January of that year. Following a meeting at Wotton which promised strong support, the bank's fourth branch was opened there on the 10th June. Lestrange Southgate Austin, who can be described as a financier and may have done some banking locally, was appointed a local director. The premises in which the branch opened are not known; in 1851 the bank moved into its present premises at the top of High Street, leasing them from the Grammar School, and in 1930 purchased them.

The other bank in Wotton has a history of successive amalgamations. In 1803 the Dursley solicitor Mr. Vizard had

established a private bank there, of which Anthony Adey, the Wotton solicitor, had been one of the directors. In 1836 the County of Gloucester Bank was formed, and bought the Vizard bank. In 1863 this bank established a Wotton branch in Killarny House, now a tobacco and sweet shop a little above the post office; in 1877 it bought its present premises from the Cheltenham Original Brewery Company, and in 1897 Lloyds Bank absorbed it. The history of these premises, at first "three burgates under one roof", granted by Lord Berkeley to Walter Osborne in 1611, is fully related in describing these grants. Soon converted into the New Inn, it had in the long interim become more of a wine business called the Vine Inn when the bank bought it.

In this period there was also a local savings or penny bank. The feoffees in 1855 began investing surplus funds in it (as well as in buying Consols), and by 1883 were £312 8s. 11d. in credit. Having in 1884 withdrawn £150 towards the cost of making the new rooms under the town hall, and in 1887 £100 towards the cost of the new fire engine, they in 1890 withdrew the balance of £141 16s. 7d. on the closing of the bank, and placed it in current account with the National Provincial Bank which still carries their account. It is also on record that in 1866 the savings bank was located in Orchard Street and managed by William Guise Foxwell, and in 1871 by Vincent Perkins.

Existence of a flourishing "Wotton Underedge Twenty Pounds Annuity Society" is shown only by a single surviving printed account for the year 1819–20. It then had a capital invested in £9,617 7s. 10d. of Navy 5 per cents, the interest on which added £476 to the premia and made a total income of £1,550. It paid the £20 annuity to fifty-five widows and a few part-years, absorbing £1,162: £281 went in super-annuation or sick benefits to men members: Mr. Taylor received a retaining fee of £31 10s. as surgeon, there was a guinea for a chaplain, and Walter Miles had £8 15s. salary as clerk. "Dinners, liquor, tobacco and waiters" cost £54 15s. Beneficiaries came from a wide area, as far even as Cheltenham. Povey of Wotton, otherwise not heard of, was the printer of the account.

In 1872 Mr. W. Horace Wright, the then mayor, published his *Memento* based on borough records. This contained a very brief history of the borough, a translation of Henry II's 1252 charter granting the market, from the town copy since lost, the indenture by which Lord Berkeley in 1659 granted the market endowment to the town, items of interest in the accounts, and a list of mayors and sergeants. To the last, previous owners of my copy and myself have added the subsequent and some earlier mayors, and have noted the professions of a number of them. The list of mayors (and of later sergeants) is printed here, with notes on some who do not call for other mention.

MAYORS OF WOTTON UNDER EDGE

pre 1570	Robert Dawes	1651	Jonah Okes, mercer
1508	Robert Plomer	1652	John Smith
1558	Robert Biddle	1653	Nathaniel Derrett
1578	Richard Crewe, clothier	1654	John Saunders
1582	John Birton	1655	Samuel Daw
1589	William Trotman	1656/7	Robert Gayner, died, then Thomas Burton and Jonah Okes
1594	John Briton, clothier		
1595	John Byrton		
1600	Hugh Venn of Synwell	1658	William Shepheard
1602	William Venne	1659	Richard Hyett (2nd term)
1605	Richard Webb	1660	Francis Jobbins
1617	Nicholas Heskins, clothier	1661	Thomas Winston
1618	Robert Smith	1662	Thomas Dawe
1619	Robert Scott	1663	Nicholas Webbe
1620	Robert Smith	1664	Nicholas Heskins, clothier
1624	Henry Venn	1665	Jonah Okes, mercer
1625	Henry Venn	1666	Robert Dawe, clothier
pre 1630	Robert Dawes	1667	John Smyth
1630	Henry Nelme	1668	Nathaniel Derrett
1637	John Smith, shoemaker	1669	William Sheppard
1638	William Young, felt-maker	1670	Richard Hiett
		1671	Richard Tiler
1642	William Young	1672	Thomas Winstone
1647	Thomas Dawes	1673	Francis Jobbins
1648	Nicholas Webb	1674	Thomas Dawes of Bradley
1649	Nicholas Heskins, clothier	1675	William Osborne
1650	Thomas Burton	1676	Nicholas Heskins, clothier

Mayors of Wotton under Edge—*continued*

1677	Christopher Jordan	1713	Thomas Lockier
1678	Jonah Okes, mercer	1714	Jonathan Nelmes
1679	Daniel Stoddard, clothier	1715	Thomas Jobbins
1680	Robert Dawes	1716	John Trotman, clothier
1681	Francis Jobbins	1717	Jonah Okes, mercer
1682	Thomas Dawes	1718	John Austin, clothier
1683	John Arrowsmyth	1719	Philip Dauncey
1684	Richard Tiler	1720	William White (Wight?)
1685	John Biddle	1721	Thomas Winstone
1686	Thomas Winstone	1722	John Saunders
1687	Edward Nicholas	1723	John Saunders
1688	William Chandler	1724	Charles Wallington, card-maker
1689	Edward Wallington, mercer	1725	Charles Wallington, card-maker
1690	John Smyth	1726	William Wathen
1691	William Osborne, wool man	1727	John Richards
1692	Christopher Jordan	1728	Edward Bearpacker, malt-ster
1693	Richard Meades	1729	Edw. Bearpacker, maltster
1694	Jonathan Nelmes	1730	John Wallington, clothier
1695	John Barnes	1731	Thomas Bayly
1696	Richard Hickes	1732	Henry Winchcombe
1697	Jonah Okes, mercer	1733	Richard Winstone, clothier
1698	Richard Osborne, Monks Mill	1734	Humphry Mayo, gold-smith
1699	William Wallington	1735	Stephen Hunt, maltster
1700	Thomas Scott	1736	Thomas Vines
1701	Edmond Rowles	1737	Edward Wallington
1702	John Austin, clothier	1738	Thomas Vines
1703	Richard Colwell	1739	Edward Colwell
1704	Thomas Winstone	1740	Philip Dauncey
1705	Edward Nicholas, clothier	1741	William Scott, solicitor
1706	Edward Wallington, mercer	1742	Thomas Austin, clothier
1707	Samuel Goodson, clothier	1743	Richard ffryer, baker and maltster
1708	Richard Nicholas	1744	Samuel Vines
1709	Thomas Vines	1745	Thomas Vines, clothier
1710	Hastings Walter	1746	Philip Dauncey, jnr.
1711	Jonathan Nelmes	1747	Isaac Austin, clothier
1712	Edward Wallington, mercer		

Mayors of Wotton under Edge—*continued*

1748	Edward Bearpacker	1787	John Dauncey
1749	Joel Cam	1788	Thomas Perry, solicitor
1750	W. Townsend	1789	D. Taylor
1751	Thomas Bayley, clothier	1790	J. Cooper
1752	Henry Winchcombe	1791	H. W. Dyer
1753	Philip Dauncey	1792	S. G. Dauncey
1754	William Scott	1793	Samuel Dyer
1755	Thomas Austin, clothier	1794	Samuel Dyer
1756	Richard Fryer	1795	Isaac Austin
1757	Samuel Vines	1796	William Townsend
1758	Thomas Vines	1797	Thomas Biddle
1759	C. Dyer, clothier	1798	Richard Evans
1760	J. Dyer	1799	Goodson Vines, banker
1761	J. Holbrow	1800	H. Austin
1762	J. Holbrow	1801	Joseph Bence, bookseller
1763	William Cambridge	1802	Thomas Foxwell
1764	Edward Bayley	1803	Thomas Perry, solicitor
1765	J. Dauncey	1804	
1766	Thomas Austin, jnr.	1805	
1767	J. Cooper, surgeon	1806	H. W. Dyer
1768	J. Hunt	1807	George Austin, esquire
1769	J. Barnes	1808	George Austin
1770	Samson Carey	1809	Richard Nelmes, esquire
1771	Anthony Austin	1810	S. G. Dauncey, clothier
1772	John Hodgson	1811	Samuel Dyer, clothier
1773	John Powle	1812	Edward Austin
1774	Mr. Austin	1813	Goodson Vines, banker
1775	Samuel Vines	1814	W. L. Nash
1776	John Vines	1815	Thomas le Chevalier, brewer
1777	William Townsend		
1778	Mathew Biddle, ob. 1781	1816	Anthony Austin
1779	Cornelius Buckle, innkeeper	1817	L. S. Austin
		1818	
1780	Goodson Vines, banker	1819	
1781	Martin Evans	1820	David Taylor, surgeon
1782	Charles Dyer	1821	John Cooper
1783		1822	John Cooper
1784	Humphrey Austin, clothier	1823	H. W. Dyer
		1824	William Moore Adey, major
1785	Joseph Bence, bookseller		
1786	Edward Bayley	1825	G. G. Dauncey

7

Mayors of Wotton under Edge—*continued*

1826 William Hill, surgeon	1856 Richard Wallington
1827 John Dyer, solicitor	1857 Thomas Robins
1828 William Leman, esquire	1858 James Perrin, solicitor
1829 Samuel Dyer, esquire	1859 James Perrin
1830 Adam Adams, surgeon	1860 James Perrin
1831 Carey H. Metivier, gent.	1861 Edward Pinnell, carpenter
1832 Carey H. Metivier	1862 John Richings, butcher
1833 J. B. Harris (Burland)	1863 Thomas Plomer, iron-
1834 J. B. Harris, esquire	monger
1835 William Moore Adey	1864 John Blizard, butcher
1836 Daniel Lloyd, bank man-	1865 John Wellins, clothier
ager	1866 John Wellings
1837 William Hill, surgeon	1867 Wm. Guise Foxwell, ac-
1838 W. H. Wallington, inn-	countant
keeper and wine merch-	1868 Wm. Guise Foxwell
ant	1869 Benjamin Simmons, doc-
1839 John Jortin, esquire	tor
1840 John Jortin	1870 Eusebius Foxwell, chemist
1841 Anthony Adey, solicitor	1871 Wm. Horace Wright,
1842 William Dyer, gentleman	solicitor
1843 Edward Cooper, esquire	1872 Wm. Horace Wright
1844 Samuel Long, clothier	1873 Wm. and Henry Foxwell
1845 Samuel Long, clothier	1874 Henry Foxwell, clothier
1846 William James Hill, sur-	1875 Osborne Dauncey,
geon	solicitor
1847 William White, wool dyer	1876 Osborne Dauncey
1848 L. S. Austin, esquire	1877 Osborne Dauncey
1849 L. S. Austin (J. Biddle)	1878 V. R. Perkins, wool-dyer
1850 Abraham Vaughan, tailor	1879 George Ricketts, draper
1851 Abraham Vaughan	1880 Clement M. Harris, sur-
1852 James Flack, gent.	geon
1853 James Flack	1881 Clement M. Harris
1854 Richard Wallington, gent.	1882–1886 Fred. J. Blake,
1855 Richard Wallington	solicitor

SERGEANTS WHO DID NOT BECOME MAYORS

1660 Samuel Gainy	1666 Thomas Crewe
1661 Richard Arrowsmyth	1667 John Smyth the smyth
1662 Richard Hiett	1670 Richard Bubbe, publican
1663 William Workman	1671 Samuel Pontinge

Sergeants who did not become Mayors—*continued*

1672	William Damsell	1827	Wm. Woodward
1679	Thomas Okes	1829	John Foxwell
1681	John Hopkins	1830	Henry Williams
1682	Richard Birton	1831	Edward Plomer
1683	John Denny	1832	George Lord, apothecary
1690	Richard Tanley	1833	Thomas Cary
1695	Henry Phillips	1834	Thos. Woolwright
1698	Nathaniel Saunders	1835	James Morley, cheese-monger
1700	William ffortune		
1701	Nathaniel Hieron	1836	John Harmer, draper
1704	Giles Austin	1837	William Strong, draper
1711	William Wight	1838	James Dutton, draper
1712	William Everest	1839	Adolphus Howell, chemist
1716	John Wallington	1840	John Wiles, innkeeper
1718	Thomas Wallington	1841	Thomas Harmer, draper
1719	John Colwell	1842	William White, dyer
1721	Edmond Colwell	1843	Wm. Poole, shoemaker
1722	Anthony Deyer	1844	Edward Watts, saddler
1723	A. L. Tiler	1845	Geo. Hobbs Minett, auctioneer
1724	William Clarck		
1725	Joseph Cook	1846	Llewellen Fowler, carpenter
1726	Edward Luten		
1738	John Carpenden	1847	John Carey, innkeeper
1739	J. Bearpacker	1848	George Weeks
1745	Mr. Vesey	1850	James Oliver, confectioner
1748	Gabriel Barnes	1853	George Godsell, tailor
1749	Mr. Wallis	1854	W. Wiles
1750	Timothy Wallington	1856	Thomas Duffett, glazier
1751	Samuel Hadnot	1858	Hugh Keene, draper
1754	John Woolworth	1859	Robert Whitfield, carpenter
1769	Mr. Tilton		
1777	Mr. Naish	1860	Absolom Perrett Allen, butcher
1778	John Witts		
1781	George Sheppard	1861	Robert Oliver, pastrycook
1793	John Cook	1862	Eusebius Portlock, chemist
1797	Thomas Cook	1863	John Spencer, draper
1798	Charles Cook	1864	John Jotcham, decorator
1811	Joseph Palser	1865	Joseph Witts, coal merchant
1812	Samuel Hamblin		
1820	Thomas Neal	1866	George Ricketty, draper
1826	Richard Bailey	1868	Samuel Holloway

Sergeants who did not become Mayors—*continued*

1869	John Bartlett, fishmonger	1877	Walter Brain, innkeeper
1870	Jos. Osborn, innkeeper	1879	Maurice Richings, florist
1871	Richard Presley, stationer	1880	Llew. Tilley, confectioner
1872	Rowland Lacey, tax-col-	1881	Dav. Brown, watchmaker
	lector	1882	John Jotcham, decorator
1873	George Minett, auctioneer	1884	Chas. Ford, grocer
1874	Wm. Hewett, ironmonger	1885	Geo. Ricketts, jnr., draper
1875	Geo. Thomas, carpenter		

N.B. The year of office began at the previous Michaelmas. While many of the gaps are on account of promotions, more are due to lack of mention in records.

Leland remarks of Wotton that it was well occupied with clothiers: this became a distinct understatement as the trade developed, for a good number of them receive mention in this account, and are only a fraction of those mentioned in various records who are not worth mentioning here.

Bigland asserts that Flemish weavers came to Wotton early in the reign of Edward III. Though Kingswood Abbey had acquired three mills by 1220, which cannot have been all for corn grinding, there is no specific mention of cloth work at any of them till shortly before the Dissolution.

Sixty years after Leland more detail is thrown on this point by a military census of "all the able and sufficient men in body fit for his Majesty's service in the wars", compiled in 1608 by John Smyth for his master Lord Berkeley who was Lord Lieutenant of the county. This gives the occupation of each man, and that information is abstracted in the following table.

This shows that the number in the cloth trade was no less than twice that even in agriculture, almost half the whole community: and this in spite of the fact that I have included in the latter all labourers, all doubtful servants and gentlemen, including a "gent" (bailiff?) and four men "servants to the Lady Berkeley of Bradley".

A number of the yeomen working the land of Synwell seem to have lived in the Borough: also clothiers operating the mills on

1608	Borough	Synwell and Bradley	Combe	Wortley	Hunting-ford	Total
Yeomen and husbandmen	15	5	13	10	2	45
Servants and labourers	6	16	3	2	1	28
Total in agriculture	21	21	16	12	3	73
Clothiers	18	2	—	3	—	23
Weavers	35	28	17	12	—	92
Fullers	7	3	—	7	2	19
Shearmen, dyers, etc.	5	—	—	—	—	5
Mercers	4	—	—	—	—	4
Total in cloth trade	69	33	17	22	2	143
Trades and shops	64	16	4	8	—	92
Total	154	70	37	42	5	308

Tyley stream. The number and distribution of fullers are unexpected. Tradesmen in clothing are only two shearmen, one cardmaker and a sleymaker.

Trades and shops serving the community include no less than twenty-one shoemakers and fourteen tailors, and five glovers; five butchers, two bakers in one shop, four vintners or innkeepers, one chandler, a barber and an apothecary; six smiths, seven carpenters, four masons, a glazier, a tyler and a hooper: six millers, three tanners (in the tanyard), and five carriers. This gives a fair view of the composition of the community at the time.

Rudge gives an account of the processes of cloth manufacture about 1801 which shows little advance from that of a poem of 1641. Parters sorted the wool, scouriers scoured it, and it was then oiled on a tin floor. It was dyed ("medley" cloth was made of dyed wool), stock carded, knee carded more finely, then spun on the wheel. Weavers set up the warp, and wove with an assistant when using a broad-loom. The brayer cleaned the cloth of oil, and the burler from burrs and bits. After felting by the fuller with fuller's earth it was hung on tenters or racks to dry. Rowers

drew out loose threads and raised the nap with teasles, shearmen cropped the pile, and drawers hid faults by drawing loose threads together.

Much was obviously home work. The first application of power was the fulling mill, introduced about 1485 to supersede "walking". About 1470 Wiltshire, Gloucestershire and Somerset are said to have produced a third of the woollen cloth made in England, compared with East Anglia's quarter and Yorkshire's eighth, thanks to the Cotswold streams: the intensity of work in our area will appear when I come to deal with individual mills.

Not till about 1767 was there another advance, the "jenny" which coupled several spinning discs, at first worked by hand. This must have been preceded by the scribbling machine which loosened the fibres of the raw wool, after which fluted rollers parted it into slivers. "Billeys" lengthened these and twisted them into coarse threads, which were wound on cones. The jennies untwisted these and twisted them in the opposite direction into finer tighter threads which were again wound on cones. At some date the setting up of these threads on to warps ready for the weavers was also started in the mills. Spinning machinery was in use in Yorkshire by 1787, but not in this county till later. The decay of the industry locally is ascribed partly to the slowness in adopting machinery; not only was there opposition from the operatives, but instead of ploughing back profits the clothiers invested in land and became squires.

In weaving, fly shuttles were patented in 1733, but only reached the county in 1793. Weavers held protest meetings at the prospect of seeing their home work killed by factories, and were then allowed to buy such shuttles, but did not adopt them for years. About 1628 gig-mills were introduced, to supersede hand teaselling of cloth: the saving of labour was so great that the weavers naturally resented them violently, so violently that a proclamation of 1633 forbade them; but the march of progress could not be checked. Power looms were in use in the north by 1822: but while 1,842 of them existed in Yorkshire and Lancashire by 1835, there were then still only four in this county. By that time the

local industry was fully in decline. A shearing machine had been invented by Lewis of Brimscombe in 1825, and also led to the introduction of the lawn mower.

Ever since business-men clothiers began to enter the field at first filled by weavers, and master weavers employing a few looms, there have been periodical labour troubles. The causes have been aggravated by scarcities, wars, and political measures which interfered with the staple trade: but I must not diverge into these, beyond noting the local fact that in 1272 the Abbot of Kingswood paid £60 to help the merchants whose woollens had been arrested in Flanders.

After a regulating statute in 1563, and in 1603 an Act empowering Justices to fix minimum rates of pay, foreign restrictions on imports led to a severe depression in 1619: workers petitioned the Privy Council, largely blaming the clothiers, who retorted. This led to an Order in Council in 1622, calling upon justices to require clothiers to keep their people in employment: "those who have gained in profitable times must be content to lose for the public good till the decay of trade be remedied". The financial backing which Benedict Webb secured for an experiment with rape oil about 1628 shows confidence in the future of the industry: but the Act of 1666, repeated in 1678 and again in 1680, ordering burial in woollens, shows that prosperity had not yet come.

Prosperity did however dawn in some degree about 1690. The system of wage regulation, revived in 1728, fell into disuse, and another period of poor trade led to a weavers' petition, which secured re-enactment of the Elizabethan statute in 1756. Clothiers had begun to organise their side of the case about 1750, but were taken by surprise: their evasions of the Act were helped by the Justices' refusing an order against weavers, and these embarked on a strike which lasted six weeks, and troops had to be brought in to deal with them.

The two sides were brought together: weavers demanded the 1728 rates; clothiers proposed a quarterly assessment board composed of eleven clothiers chosen by the weavers. Discussion was ended by the mob breaking in, dragging back the clothiers

as they tried to escape through the windows, and forcing them to concede the 1728 rates, which the Justices then confirmed. Peace then reigned till approach to Parliament about 1800 got the whole scheme annulled.

In 1792 there were riots in Uley. Within a few years stagnation began to loom, which clothiers tried to meet by forced reduction of payments, but the mid-nineteenth century ended in the death of the industry: this can be seen in my more detailed account of the Wortley mills.

In November 1825 there were serious riots at Wotton, in which the principal target was Messrs. Neale whose mills were two vanished buildings adjoining Britannia Mills; Mr. Plomer was also attacked. For several days the weavers held long mass meetings, terrorised dissenting weavers, attacked their houses, seized work they were doing and burnt it publicly. They then marched on the Neale mill which had been armed with some muskets, and there was some firing in which twenty-one men, all outsiders, were injured. Before the magistrates reached the spot the mob had dispersed, but the injured men were taken: three of them were sentenced to two years each, and twelve more to shorter sentences. The men who had fired were also brought up immediately and bailed. The court sat till 8 p.m.; immediately after, the mob attacked Mr. Neale's house, smashed all the windows, and went on to the factory but were checked by the special constables. A troop of the 12th Lancers reached Wotton a few days later, and the North Somerset Yeomanry were held ready at Bristol: but the riot had subsided, and many weavers had left for fear of punishment.

A few miscellaneous points may be mentioned from Sir William Marling's account of the industry and other sources. In 1615 half the cloth of Wiltshire, Gloucestershire and Somerset had been accounted for by the yarn of poor people who bought small parcels of wool from chapmen and returned the yarn weekly. In 1727 spinning was still reckoned a cottage industry. Home weaving is said to have gone out about 1830, when weaving sheds were set up near mills; but as late as 1863 a lot of speciality cottage

weaving was still reported on doeskins, venetians, and kersey-mere. In 1839 hand loom weavers were in misery on an average wage of 6s. 10½d., compared with shop weavers on 11s. 9d., and power loom men on 14s. to 20s. according to the nature of the job. Rudge had said of his time that men and women earned one to two guineas a week, and children of six years could earn eighteen pence. The local family names Clutterbuck, Hague, Malpass, Marmont are attributed to the coming of Flemish weavers in the time of Edward III.

Rudder in 1770 says there were seven to eight master clothiers, and that the trade was already on the down grade. There were actually numbers more of smaller clothiers. Bigland asserts of 1831 that there were thirteen clothing mills, which employed 778 families compared with the mere sixty-eight in agriculture. The 1854 Health Report asserts only three mills in the parish, employ-ing about 200 hands, the number that Rudge asserts to be em-ployed in 1801 by Austin's New Mills alone. That report further says the trade had been at its best about 1813 with fifteen to twenty mills, and the decline about 1825: but the dyeing business was as good or better than ever, employing 300–400 hands in Mr. Long's mills alone.

A circular from an unnamed manufacturer in Trowbridge in 1798, to Messrs. Austin, gives his estimate per "cloth".

	£	s.	d.
Wool, 60 lb. @ 4s. 2d.	12	10	0
dying	1	10	0
scribbling and carding	1	4	7
spinning		14	6
weaving, 40 yd. @ 15d.	2	11	0
dressing	2	15	1
various	1	0	3
overheads on a trade of			
6 cloths per week	3	13	7
Total	£25	19	0
Sale at London price			
29½ yds @ 16s. 6d.	24	6	6
Loss per cloth	1	12	6

So the shrinkage in fulling was from 40 to 29½ yards in length: that in width does not appear here. Filed with this are some MS. cost figures, probably Austin's, not drawn in ways that make them comparable but amounting to about the same. In these the cost of two kinds of wool is quoted as 4s. 10d. and 5s. 9d.: these stop at the preparation of "abb" or warp thread of two qualities.

The annual fair from 25th September, instituted in 1252, naturally had the usual sweet stalls and earlier forms of coconut shies: it is likely to be the end of one of these that is marked by an entry in the accounts of the market feoffees in 1761: "By paid the crier to prevent throwing at cocks 6d." The trade of the fair is likely to have been conducted largely at the inns: but there were also market stalls. After the foundation of the Bluecoat School in 1715, Fair Sunday was also made a popular event for the annual examination. In a packed church, often with also a crowd in the churchyard, the head boys in their new uniforms were ranged along the front of the organ gallery, while the vicar questioned them from the reading desk on their faith and duty. The choir was augmented, and the organist was supported by a band of violins and kettle drums. A stranger preached the sermon for the 10s. fee provided by the 1722 bequest of Richard Osborne. A collection was taken for the school and generally produced from £25 to £30. The service always ended with the Hallelujah Chorus.

Vincent Perkins (born 1830) in his unpublished MS. history (from which I get the previous item) quotes from "an old church book of 1494" of which nothing is now known, the profits from Whitsun Church Ales of £8 to as much as £36: these were given to the poor. They seem to have ended in 1560. "Church House" was commonly a parish room where the ale was brewed: but here it is remote from the church, and nothing is known of the actual brewing. Perkins also records the pancake bell which used on Shrove Tuesday at five minutes to twelve to strike pan, on, pan, on, pan, on. This was done till 1881.

He also records recollections of May Walking in his youth, that is a few years before 1850. Everyone went into the woods at

about five, returning about seven, to get young beech boughs to decorate the town and the shops before breakfast. In fact it was unlucky to fail to do this, and any boy or girl who had no beech leaf to wear was "scoffed with an epithet that I cannot remember, but which implied slug-a-beds not entitled to join in games". He and his brothers used to implore their mother to let them sit up the night before so that they could be among the first to start.

Whitsun offered plenty of what used to be considered amusement. On Whit-Monday a fair was held in the Cockshoot Ride of the woods on Westridge, with shows and stalls presided over by a master-weaver Abbott, who lived at the weighbridge in Bear Street and was a celebrated character. It was after dark and after the arrival of some wagons of beer that the "fun" started. Rough-and-tumble games soon led to an annual battle between Wotton and Nibley, for which loyal citizens would come from far to support their sides; this did not satisfy their robust feelings, and on Tuesday they would go on to Ley Hill for a similar orgy of violence. Wednesday saw even a third revel for the breaking up of the Benefit Club at Nibley, after which the Wotton men would be escorted home in triumph by their friends. This seems to have lasted until about the mid-nineteenth century.

A rival attraction was prize-fighting in a ring, by Hack Mill, with the sheep-walks between it and Brown's Piece a natural grandstand. Perkins, who alone mentions this, says it attracted patrons and pugilists from various parts of the county, and that stakes ruled high, apart from the wagers.

An advertisement in Farley's *Bristol Journal* on 7th May 1774 runs: "To be played for at Back Sword at Wotton in Whitsun Week, 8 guineas the first day by nine men a side, and 12 guineas the second day by eleven men a side. Each couple to play till one of their heads be broken. The side which gets the odd head to have the prize. No padding allowed." I have seen no other record of pugilism.

It may be a tamed later version of the earlier Cockshoot Fair that Perkins records as a stroll to Nibley Knoll after service on

Good Friday, the young people to play games, and their elders to patronise the stalls of ginger beer and hot cross buns.

Also less robust was the Cherry Fair held on the last Sunday of June, in a large cherry orchard in Synwell just beyond the green. By evening the revels used to become fairly cheerful. They were resumed on the next Sunday in the orchards about the Chipping; what is now the playing field beyond Sym Lane for long kept its name of Cherry Orchard. Between the Chipping and William Watt's Ropewalk, now converted into Orchard Street, was Watt's Orchard. In the angle of Sym Lane was Osborne's Orchard; the position of Wellington's Cherry Orchard is uncertain. This fair dwindled till it died in 1846.

Perkins has a long description of the Christmas celebrations, including all the traditional events (except the Victorian importation of the Christmas Tree), with larger gatherings and family parties than modern conditions encourage. The most interesting item is an evening round of a troupe generally of five, in home-made costumes of old shirts or night shirts with stars of coloured paper tacked all over. Father Christmas had a long white beard and a long farmer's stick and of course was bowed with age; Saint George was the tallest, and the doctor the smallest. This was clearly a traditional survival of something like the Marshfield Mummers. Perkins also gives the libretto:

> In come I old Father Christmas, Christmas or Christmas not:
> I hope old Father Christmas will never be forgot.
> Roast beef, plum pudding, mince pies, no-one likes them better
> than I.
> A room, a room, a room my friends, give us a room to rhyme:
> We've come to show activity upon this Christmas time.
> And if you don't believe now what I say
> Enter the brave Saint George and clear the way.

> *Enter Saint George.*
> In come I Saint George the valiant knight,
> With my trusty sword prepared to fight.
> I fought the dragon, brought him to the slaughter,
> And for this won the King of Egypt's daughter.
> What man so brave will dare to stand

Before me with my sword in hand:
Soon would I cut him up as small as flies,
And send him to Jamaica for to make mince pies.

Turkish knight advances.
Here come I a Turkish knight
With my good sword prepared to fight:
I'll fight Saint George, a man of courage bold,
And if his blood is hot I'll quickly make it cold.

Saint George replies.
If thou art a Turkish knight,
Draw out thy sword and with me fight.

They fight; the Turkish knight falls and then Saint George exclaims
Ladies and gentlemen, see what I've done;
I've cut down the Turk like the evening sun.
Is there any doctor in the land that can be found
Who can cure the Turkish knight of his deadly wound?

In comes a little Italian doctor.
I can cure.
What cans't thou cure?
I can cure the itch, the stitch, also the rheumatic gout,
Pains within and pains without.
I'll take an old woman of ninety-nine
And wrap her up in a bundle with turpentine.
I've a bottle in my pocket called hokum pokum alicampane,
Which quickly will affect the brain.
So I'll touch his eyes and nose and mouth and chin,
And say "Rise up dead man and fight him once again."

The dead man being touched in this way rises up ready for another encounter.

Other occasions were naturally seized upon for celebrations. One such was the opening of the Bristol and Gloucester Railway in 1844. On 2nd July a public meeting convened by Mr. Samuel Long the mayor resolved that the mayor and corporation, followed by such people as chose to accompany them, should go in procession to Charfield Station, and present an address on the advantages it was hoped might result to the town.

After several days of considerable rain, people were aroused early on the morning of Saturday the 6th to a fine day, by a royal

salute of twenty-one guns. At ten o'clock they assembled in the Chipping, and the mayor and corporation, in a train of carriages attended by horsemen and footmen and preceded by a band, marched to the station, where the "assembled thousands" took their stand. The train was due at eleven, but did not arrive till one: no doubt the time-table had failed to allow enough time for all the speechifying at all the earlier stations. However, "the enlivening strains of the band and the wit and pleasantry of the people passed the time agreeably". The gentlemen celebrated the occasion by a dinner at the Swan Hotel; some of the tradesmen dined at the Falcon, while the townspeople had tickets given them for bread and beer. It was a high holiday, and the procession was very orderly and respectable. "One circumstance gave me much pain and regret, drunkenness, the besetting sin of Englishmen on all festive occasions". Thus Henry Ratcliffe Lacey of the Tabernacle in his diary.

Lacey's diary also has some account of the mild Chartist agitation of 1839. He, with his brother Rowland (whom we meet in other connections) made themselves prominent, but their brother Newton had to keep quieter, being master of the British School. There was a large meeting on the Chipping, addressed by Henry Vincent, a noted national leader then out on bail, who was very soon gaoled at Monmouth over a great riot of the Newport miners. At half past five one Saturday morning brother Rowland came to tell Henry that Mr. Cogswell and two others were waiting for him downstairs, and he had a warrant served on him for attending an unlawful meeting. After telling his mother he was going for a walk, he persuaded Mr. Cogswell to go on and he would follow. A little down Nibley road a fly was waiting and took them to Dursley for examination. Friends had brought bail, and it was accepted; at assizes on the Wednesday they succeeded in getting postponement till the Spring Assizes. The prosecution wanted them to come to terms, and their friends persuaded them to plead guilty and enter into recognizances to keep the peace for two years. Nothing more happened.

Much more serious were the riots in 1826, which have been

described, when there had to be a mass enrolment of special constables.

While the market accounts had not been debited with any of the cost of the procession to see the railway opened, and there is no item connected with the Chartist affair, in 1826–7 no less than seventeen levies of the poor rate were called for in place of the usual four to six.

Another event of which there is surprisingly no sign in the accounts, while Perkins luckily leaves us some record, was a scarcity in 1795–6. At a public meeting convened by vicar Tattersall, a number of prominent citizens pledged themselves in a written resolution to cut down their consumption of wheat by a third, by using less bread, or of lower extraction, and by cutting out pastry. The mayoral dinner was unaffected in cost.

Again in 1841–2 there was scarcity: for this vicar Perkins collected £340 which was distributed in bread and coal. Vincent Perkins gives a full list with amounts, of the forty-eight tradesmen who were paid for supplies, which naturally contains many familiar names. For this there was a distinct rise in the poor rates.

The railway, passing Wotton two miles away, clear of the hills, was too late to be of any use to the dying cloth trade when it was opened in 1844. Till recently a local garage ran a bus to Charfield Station, at first horse-drawn, and motorised quite early: this has now ceased, and passengers depend on the timing of buses from Bristol. For goods, businesses are within range of the railway lorry service from Dursley, and have their own vans and lorries.

The principal roads out of Wotton are three. The London road, running out of the bottom of Old Town, past the church and up Rushmires Hill, has forks for Dursley and for Stroud about the parish boundary, and runs on to Tetbury. This road was only constructed about 1840 as far as its junction with the Old London Road at the top of Rushmires Hill, where a toll-gate lodge stood until a few decades ago. Before that, traffic must have faced the steep ascent of Lisleway Hill, and pursued a course as far as the old road, apparently with the Dursley connection in

mind. Rudder (1779) remarks that there is "little travelling through the Town by road, except of people of the neighbourhood and such as are connected with it by trade". Bigland remarks that trade traffic was by pack-horse. This now neglected road appears in manorial records as a field connection, but was sometimes called a king's highway. This naming is supported by the way in which for part of its course it and its verges run between stone field walls. The resumed part of the Old London Road has a Roman look, and is labelled accordingly on Ordnance Survey maps, though not on those devoted to the Roman road system. The Stroud road now has a service of the Bristol Omnibus and Tramways Company.

Areas to the north are served by a road starting westward out of the opposite end of Old Town, which also carries a bus service to Gloucester, visiting Dursley on the way. Till about 1825 traffic for the south-east also left the town by this road. Not far beyond the point at which the Old London Road met this, a minor road to Bradley Green carried this traffic.

Better lines in this direction were blocked by Haw Park till it was disparked. Not till about 1825 was Haw Street, running south out of the town, extended as a direct road to Charfield, with the only surviving tollgate lodge (plate 17) where it picks up the old Bradley Road. This immediately throws off a branch to Kingswood, constructed in the same period. A regular bus service between Bristol and Gloucester, visiting Kingswood, runs on the Charfield road; a less frequent one between Bristol and Stroud runs by the Kingswood road and through Sodbury.

Three paths lead across the Green Chipping to gaps between the houses on the south side of it. Two of these led to paths between the orchards, marked "to Kingswood" on the 1763 map; one of them is still shown on the 1830 copper-plate of the Ordnance Survey one-inch maps: it is not known how these and any possible predecessors gave access to Kingwood without trespassing in Haw Park.

A secondary road continues eastward out of Long Street and The Steep, and joins one running along the foot of the lower

Oolite scarp as the way to Wortley, Alderley, Badminton and Chippenham, crossing the Bath–Stroud main road on the way. This was improved at points in the turnpike era, had a toll-gate lodge where the sunk track down Tor Hill crosses it, and got a bridge in place of the old bridge at Monks Mill. In manorial times there seems only to have been a path from Wotton direct to Wortley, and a "road" from Wortley to Kingswood as well as the present Nind Lane.

Directories give patchy information of the existence of carriers, who must have been quite numerous in pre-railway times. After an unsuccessful venture in 1807 with a coach between Stroud and London, which failed within a year and lost some £6,000, a second venture in 1817 added a small coach to Wotton. More successful was the Dart coach between Stroud and Bristol through Wotton, which was able to allow five hours for business in Bristol. This ran for more than thirty years, and latterly carried the mails in both directions. One of the last to be mentioned is Le Chevalier in 1820, brewer and London carrier, living in Lisle House; he was mayor in 1815, and died in the Rose and Crown "on the Cloud wall" but otherwise unknown. Later, two Bristol carriers in 1871 were Stephen Derrett and Henry Gabb, one of whom may have run the Bristol coaches which started from the Star Inn. There was also a Cirencester coach, running from the Vine Inn, which continued long after all others had ended. James Derrett had a posting house at the Pack-horse Inn, premises from which the only present carrier runs to Bristol. In 1871 E. Cook was the Stroud carrier who also ran a bus (succeeded in 1873 by C. Hale). Walter Brain ran a service to Charfield, and there was also John Bletchley, a general railway carrier, succeeded in 1872 by William Tapscott, who was by 1877 also a coal merchant, a business which survived till his son died in it a few years ago.

Occupations give us a longer and much more varied list than in 1608. The directories hardly descend to recording the few farmers who have consolidated the holdings of all the yeomen, and their labourers not at all. In the cloth trade, all the employers

8

are listed as "gents" without mention of their occupation, and again the employees are beneath notice. Including the clothiers and often the brewers, lawyers, doctors and clergy, there is a good list of "gents". Officials have begun to appear, as well as the honorary officers of societies with objects: a supervisor for the Inland Revenue division of Berkeley, and one for the Wotton district; a clerk to the magistrates, Osborne Dauncey; a clerk to the highway board, W. H. Wright, followed by William Guise Foxwell, with Joseph Cook the drainage engineer as surveyor; W. G. Foxwell also in charge of the stamp office, and of the savings bank, which for a time became the penny bank with Vincent Perkins in (probably honorary) charge; a registrar for births and deaths, while marriages were registered independently by R. Presley the bookseller; Eusebius Foxwell in charge of the post office in Haw Street, and of course a sergeant in the police station.

There was a choice of clothing shops: seven tailors and drapers, including one who also conducted funerals, one whose wife made ladies' mantles, and already in 1866 the shop which carries the name of Mr. Fred Holloway who retired not many years ago, with another of an earlier Fred in the Tolsey, who was also auctioneer and appraiser. Ladies had the choice of the wife of one of the drapers, who made straw bonnets; the fancy and wools shop of Miss Foxwell who was succeeded by Mrs. Hewett, and she in turn by the Misses Tait, who produced a little book of sketches of Wotton; and a lady who offered to sew for young ladies. There were also three bootmakers and an umbrella-maker.

Of chemists, it looks as if Mr. Hancock had the present shop opposite the Tolsey, and Eusebius Portlock combined it with groceries in the Long Street shop managed by his grandson until quite recently: they united their businesses, but only for a few years. There were four other grocers, one of whom was also a sauce manufacturer, and one shop, not a chemist, was "agent for Pectoral Balsam" and also a herbalist.

In metals there were two smiths and a locksmith. One of them was the Hugh Palser who is mentioned in Synwell, succeeded by

John Vines followed by George Vines; the other was the widow of an ironmonger, brazier and tinsmith who was also auctioneer and appraiser; and there was a gas-fitter who mended umbrellas and set razors. Jellyman was the last shoeing smith, but finished about 1945: Bob Andrews had had to stop shoeing a few years earlier, but blew his forge for general work until about 1952. Wathen, the last tinsmith, died about 1945 and has no successor.

In woodwork and the like there were eight businesses combining carpentry, joinery, cabinet-making and wheelwrightry; one an "upholder", which may have been funeral director; two were carriage or coach builders and one a coach painter.

Others were a cooper, a saddler, a watchmaker and a blacking maker.

Wotton used to boast two pawnbrokers. I have not listed butchers, bakers and small shops.

Through the importance of the cloth trade of the area, and the wool production in its Cotswold hinterland, Wotton early achieved a certain importance in the postal system. Already in Stuart times direct routes radiating from London had been established, but with irregular services, and letters between towns not on the same route had to travel *via* London, paying the 3*d.* postage for each leg of the journey. Among these routes Bristol became of importance on account of West Country activity during the Spanish troubles, and for communication with Ireland. A first cross-route was established in 1696, between Bristol and Exeter. The success of this led to others, Bristol–Chester via Chepstow in 1700, and Bristol–Birmingham via Gloucester. Wotton had a branch post-boy mail from the London–Gloucester route.

Devon clothiers could then communicate with their Cotswold sources of wool supply only via London, and agitated for communication between Bristol and Wotton to save time. This would have cost only £30 a year and was recommended by the Post Office but was not accepted. It may have been only after 1772, when a private mailcoach to Gloucester began to compete

with the postal service, that communication between Wotton
and that route was established. At any rate, when the London–
Bristol mail was robbed near Maidenhead in 1781, a bag for
Wotton was among those stolen.

In 1793 the system of penny post for local letters was intro-
duced in Bristol, and the area for that rate extended to Wotton,
which was thus still a terminal point.

Before the introduction of "adhesive labels" called stamps in
1840, postal towns were given hand-stamps for franking the
letters handed in: Wotton was a little unusual
in that its name needed three lines. After the
introduction of the labels the offices were issued
with brass hand-stamps for cancelling, in the
form of a Maltese cross, and letters thus cancelled
have become collectors' pieces. Large towns had
their own identifiable types; smaller towns which
were issued with a standard type had their own
ways of making them identifiable: Wotton filed lines across its
stamp in two directions. The post office was formerly in Haw
Street, and in 1881 employed one town, one suburban, and five
rural messengers.

5. Postmark

Sir Francis Hyett wrote of early printers "if the claims to
establishment of the first printing press in our country are to be
decided on secondary evidence, the honour must be awarded to
the little town of Wotton under Edge. According to Archdeacon
Cotton, John Excell carried on the business of a printer here in
1704: but no work of his is known in existence. But there is 'A
Portion of the Psalms selected from the Rev. James Merrick's
new version for the use of the church at Wandsworth', printed at
Wotton under Edge by Richard Dyke, 1780". A single job
printed by Povey in 1820 is known. Presley began an almanac
and added a directory to it in 1866: in 1881 he published an
eight-page *Wotton under Edge Chronicle & Advertiser*, but six
of the pages were supplied from outside. Dr. Joan Evans has
traced three ballads printed in Wotton, "the Purton Stoke
Murderer" by Watkins, "the Wiltshire Labourer" of about

1760, and "the Poor Tradesman's Lamentation": printer not known.

A few minor activities are of a certain interest. In 1672 the tokens, of which issue had been permitted because of the shortage of small change, were called in at a cost of £4 10s. 10d., and 9s. 4d. realised by their sale as brass. Detailed descriptions of five, including private ones, are given me from one of the full lists:

222	Obv	THIS FARTHING WILL BE OWNED	in Wotton Vnder Edge
	Rev	BY THE MAIOR AND ALDERMEN	(a woolpack) 1669
223	Obv	WM BROWN HIS FARTHING	IN WOTTON VNDER EDGE
	Rev	BY THE MAIOR AND ALDERMEN	(a woolpack) 1669
224	Obv	LAZARUS KEMPP IN	The Apothecaries Arms
	Rev	WOOTTEN VNDER HED	K/LM
225	Obv	AT THE MAREMAID IN	(a mermaid)
	Rev	WOTTON VNDEREGE	S/IM
226	Obv	DANIELL STODDARD IN	(a fleece) S/DS
		WOTTON VNDRIDGE	HIS HALFPENY

Glos. Notes and Queries quoting from *Numismata Glocestriansia* omits the Brown token, but adds more briefly

151	Edward Wallington—mercer in Wootton
162	Wottonunderedge—at the Maidenhead

No. 222 is obviously a specimen of the official tokens which were redeemed: 223 seems to be the same, only "Wm. Brown" is completely unknown: in *N. and Q.* both these are dated 1659. Lazarus Kemp's will of 1664–5 shows that he kept a shop, so that, and not an inn, was the "Arms". Stoddard is described as a clothier in his 1660–86 leases of the market, his only appearance in records. Wallington does not appear in the first list quoted because his token was attributed to another Wotton: but my records clearly show that he belonged here. The Maidenhead is queried as a misreading of a very worn Mermaid token: but it

seems to have been a symbol of the Mercers' Guild: and a token is known of William Whittaker, a mercer of Watford in Herts, showing a half-length crowned woman in a shield.

In January 1939 1*s*. 6*d*. was paid for digging up the ice at the well. A mysterious item in 1740 is "expenses at Carthagena". In 1872, and in that year only, a guinea was paid for excise duty for armorial bearings: there is no record of a grant from the College of Arms. In that year 2*s*. was paid as well for "removing cannon" presumably a Crimea trophy no longer appreciated. At the celebration of peace in the Crimea, this had been fired several times from Wotton Hill.

3

Houses and Families

AMONG a series of grants by Lord Berkeley in 1610–11, towards raising the large sum payable to Sir Robert Sydney on restoration of the ancestral estates, were burgages in Wotton granted to seven men, Walter Osborne, William Venn, John Stanton, Thomas Perry, Thomas Adams, Robert Dawe and Robert Smyth. Some of the grants are not identifiable, but the others lead to information on the old properties and on some persons who have not appeared in borough records.

The first mention of a Wotton inn comes in the grant to Thomas Adams of a "messuage or common inne in the High Street in Wotton, then the sign of the goate, nowe (1639) of the White Lion". The grant also included Friendless Acre at the edge of the Edbrooke open field.

As we enter by the archway in the blatant modern red-brick façade of the White Lion, the old buildings survive, including what is now a skittle alley and the Lodge of the Royal Antediluvian Order of Buffaloes and the yard from which the White Lion motor coaches operate. Petty Sessions used to be held here. We then emerge at the top of Old Town. Adams, of whom no more is known, sold to Francis Brache a girdler of London, of whom too no more is known than that he also had a house in Bradley Street. The latter sold to Richard Poole, who has appeared when he was fined £10 for refusing to serve as mayor in 1639.

The sign used to have three little tuns and a bunch of grapes hanging from it, but these fell into the road and were smashed.

Poole's grandfather, another Richard, "lynnendraper" of London and apparently of ordinary status, had retired to Long Newnton near Tetbury and had begun to acquire property there. The father had risen in the world, married a daughter of the lord of the manor, an Estcourt, and added a near-by manor. Richard, a younger son, had left to make his way in life, and seen the prospects in Wotton better than in Tetbury. Here his life and activities seem to have been confined to Wortley, and they are dealt with in the account of that tithing.

Another grantee of several properties was Walter Osborne, son of the founder of what was to be one of the most important local families, though they have not come into the limelight before. One of the properties was "three burgages under one roof in High Street", and identification is simple and certain because the description recurs in the title deeds of the present Lloyds Bank, which quote the original Berkeley grant. Walter's great-grandson Richard the elder, 1660–1722, rebuilt the property as the New Inn, and left it charged with an annuity of 50s. to clothe two poor boys of the Bluecoat School, plus 10s. for the minister to preach a sermon at the annual public examination: this charge was compounded by the family in 1797 for £80. The back premises still show signs of the brewhouse of the inn, and the cellar contains the stone racks for beer barrels. The deeds purport to show a series of sales beginning in the year of the grant, but I think my information mistakes some leases for sales, and has even put the wrong date to the first of them. In any case it passed through several hands not otherwise known, until it was held by William Hunt Wallington, wine and spirit merchant, mayor 1838. In 1863 he leased it to Joseph Osborne, farmer, of Evercreech in Somerset, not related to the original grantees, and later sold it to him. Joseph, now a wine merchant, occupied it as the Vine Inn, when it was also the meeting place of the Freemasons. It was also the starting place for the Cirencester coach, which is said to have continued for long after all the others had been taken off the road. It seems to have been sold to, or been a tied house of, the Cheltenham Original Brewery, for it was from this brewery that it was in

1877 bought by the County of Gloucester Banking Company, who had since 1863 had their branch elsewhere in Wotton; then in 1897 this bank was amalgamated with Lloyds Bank.

The other property granted to Walter Osborne was a burgage house with orchard garden and barn adjoining, position not specified except that it too was in the Borough. The position is shown by the fact that when his successor in 1730 rebuilt the house, he bought a further one and a half acres behind it, bounded east and south by Sym Lane and west by William Watt's Rope-walk which has since been extinguished by the construction of Orchard Street. It lay among specified orchards which account for the name, and the southernmost patch was in 1763 still marked as Osborne's Orchard. The house lay just inside the borough boundary, and behind Church House, at the corner of Sym Lane and the adjacent house. It was still in Osborne hands in 1763 and 1847, but its later devolution is uncertain, and it has now been demolished.

The house on the corner of Sym Lane opposite to Church House was in 1763 also Osborne property; this is shown by a deed to have been bought after the 1611 grant: it is now a fish saloon.

To identification of the burgage granted to Robert Dawe there is only one clue. In 1692 Giles Clark of Wotton, shoemaker, exchanged with the feoffees his lease of his dwelling-house for that of the market house; and his house is described as on High Street, adjoining that of William Osborne on the west and that of Thomas Dawes on the east. The Osborne house referred to cannot be either their older home now the fish saloon, or the isolated single burgage, and so must be the "three burgages" now Lloyds Bank: so the Dawes burgage was the second to the east of that, part of what was till recently Lewton's Garage.

The family of Dawes, Dawe or Daw made quite frequent appearances in Wotton for about two centuries, and contributed largely to its charities; a satisfactory solution of identifications and relationships is impossible, but they are dealt with in Bradley, where they belonged.

John Stanton, another grantee, was vicar at the time, a noted

Puritan, chosen for that reason to be tutor to the future Sir
Matthew Hale. His grant was the site of the ancient manor house,
itself a mere ruin, with some cottages and a little land.

There is no record or mention of the "capital messuage" at
which even the Berkeleys of the earlier house are likely to have
lodged when touring their manors, till Thomas I during his
tenure 1220–43, is reported as erecting a manor house on its
former site and often living there. Then, as recorded earlier in this
account, his widow Jone made it her principal residence. It also
gained importance by the creation of the borough in 1252. The
only sign of the general damage done in the disturbances which
led to the deposition and murder of Edward II was that in 1351
Thomas III had to spend £100 on repairing the manor house, and
similar amounts in other years. Next there arose the conflict with
Richard Beauchamp, Earl of Warwick, who in 1426 obtained
legal possession of Wotton. Continuance of the quarrel after his
death led to James Berkeley attacking the manor house, and
methodically damaging it to the extent of 4,000 marks according
to Beauchamp's daughter Margaret of Shrewsbury. The house
was again repaired and occupied by young de Lisle till, in 1470,
after the Battle of Nibley Green, it was again sacked and pillaged
by William Berkeley. There is no record of the extent to which
William used the house. Wotton was not among the estates which
William made over to Edward IV's younger son, which reverted
to him when Richard III was killed at Bosworth, but it was among
those he made over to Henry VII, which again reverted to him
on the death of Edward VI. Early in the last period William's
wrong-headed and disloyal widow Lady Ann dismantled the
hall of the mansion, to use the timber and lead for roofing the
great kitchen at Berkeley in preparation for Henry VII's visit
there in 1494–5, leaving only the ruin and piles of rubbish which
Leland saw some forty years later; these were what John Stanton
was granted in 1611. Twelve years later his son sold it to Robert
Webbe, who was living in it in 1639, so that it must have been
rebuilt. "Lisle House" as it now stands does not suggest this period
and age; in fact the present windows and porch and details give it

a Victorian appearance. In the garden a dwarf wall holding up a terrace is said to be a relic of the Lisle house, and there are said to be cellars and dungeons under the lawn. At the edge of the lawn a twenty-foot high retaining wall holds it up above the plain and site of the mill-pond of the former Cloud Mill.

Investigation of the 1611 grant to William Venn leads to two sets of title deeds going right back to this grant.

Minor items in the grant include a house in Haw Street of 10s. per annum, which might be the present police station, as that was in 1763 owned by Mr. Bearpacker, who certainly bought the main property in 1741. There also is mention of a house of 10s. 1d. in High Street near Sym Lane, which is unidentifiable. There is also an acre of land in The Middle, which is marked as Venn's Acre in that common field on the tithe map of 1847, while the name has recently been appropriated for a small building estate on the adjacent plough strip. There is also an acre of land in Mare Haven, variously rendered in later records as Merry Haven, Moore (probably Meere) Haven, Mary Heaven, and now Merlin Haven. This acre is named as Bemmerley in a later deed of the series, found on the tithe map as the plough strip along the slope lying below the strip Mary Heaven on the top: the name in the form Bennerley has been taken for the easternmost of the detached modern houses constituting the present Merlin Haven.

The main body of the grant, of £3 18s. per annum, was of "a toft, messuage, and tenement, barn and outhouses, Court Meadow of twenty acres in Synwell divided into three closes, and two acres in Edbrooke": this is found to comprise practically the whole area bounded by Old Town Street, Culverhay, Adey's Lane, and the path running up by the Tabernacle. I judge that the toft and messuage are the original of the present Edbrooke House, and the barn and outhouses what have by successive steps become Under-the-Hill House.

The original William Venn of Wotton, clothier and mayor in 1602, appears in John Smyth's military census of 1608, "Men and Armour", as a clothier, in the age class "about 20" which is sometimes a very loose estimate, a strapping fellow classed as fit

to be a pikeman, owning his own musket, and affluent enough
to be a subsidy man. He is likely to have been a son of Hugh

6. Venn arms

Venn, noted in the 1608 military census as
"unable in body", but possessing two corslets
and two calyvers for the general armoury. He
may also have been the husband of Walter
Osborne's sister Edith. His name attaches to
what was later known as Strange's Mill, which
has now disappeared. In 1617 he died, leaving
his wife Mary in occupation, though the title
had passed to his brother John, of Wotton,
yeoman. The latter that year for £111 sold to Richard, of Lon-
don, haberdasher, who must be the Sir Richard who in 1630
with his son-in-law Hugh Perry brought Edbrooke water to the
Market Cross. In 1667 the widow of James of London, merchant,
sold for £220 to Thomas of Wotton, merchant, whose interesting
will of 1682 will follow. A deed of 1720 seems to be an under-
taking by which in 1720 Thomas of Synwell, yeoman, sold for
£400 to Thomas Rous of Synwell. The name Rous recurs, in
1731 in a Thomas of Monmouth, esq., and James of Wotton,
gent. In 1741 Thomas of London, merchant, son of the above
Thomas, sold to Edward Bearpacker the elder of Wotton,
maltster, who has appeared as the lessee of the Blindhouse
under the Tolsey. Also see the story of the
Old Rectory (The Court).

This Edward died in 1742, devising the
property to his son John, a clothier, charge-
able with £10 per annum for his son Edward:
but John too died within a year, leaving
"Venn's House" to his minor son Edward:
and in 1759 his widow Sara released the
property. In that year young Edward borrowed

7. Bearpacker arms

£600 on a mortgage of property which included "the site of the
Little House now lately fallen down, and the old barn, cowhouse,
and the three Court Meadows"; and in 1770 Edward, now a
clothier, borrowed a further £800.

Edward dying in 1803, the property passed to two daughters, one of whom, Anne (died 1837) founded the Bearpacker Alms-houses standing on the property. It passed in the family to Thomas Harmer Sheppard who is shown as owner in the tithe statement; on his death in 1860 it passed to his daughters.

There is then a gap in the deeds, as next it is the mother of Anthony Adey the solicitor who in 1867 passed to him Under-the-Hill House with grounds, and some more property not part of the original grant. Only in 1873 does a deed show that the surviving Sheppard daughter sold to Mrs. Adey Edbrooke House, the land, and The Court House and the factory described subsequently, which also were not part of the original grant though adjoining. Anthony's son the eccentric Moore Adey sold Edbrooke House to Major Beaver in 1926, and the estate and upper house to its present owner in 1927. The Adey family is fully dealt with in the account of Combe tithing, where they were prominent earlier.

The deeds do not clear up the occupation of the houses by the owners, and give no clue to their ages. Only the £600 mortgage in 1759 suggests a rebuilding then of "the Little House now lately fallen down", whichever that was; and the £800 mortgage in 1770 more rebuilding of the other. From the houses themselves I incline to the opinion that it was the upper house that was rebuilt first, and perhaps extended when the lower house was also made larger.

Both these houses have extensive back premises, which are older than the fronts. Edbrooke has a spiral stair of the newel-post type while the upper house had only a straight stair, now demolished. The front part of the upper house has been added in two stages, and that of Edbrooke House is somewhat later. In both cases the apparent dates are not really inconsistent with the dates of the mortgages. The upper house has a roof turret with a bell dated 1726. I am inclined to surmise that the "messuage" of the grant was Edbrooke, in the town area; and that the barn was what was later developed into the upper house, "Under-the-Hill".

After the original William Venn the only Venn mayor was a

Henry in 1625, who does not appear in any of the documents.
There is mention of a Hugh who seems to be father of the original
William. The Thomas who in 1720 sold to Rous was son ⟨
Thomas of the 1682 will, who was son of Arthur of North Nib.
presumably descended from a William of North Nibley, broth
of the John who had succeeded his brother the original William .
1618. Some of them are described as "Venne alias ffenne", but
with no more obvious significance than that the spelling may ha⟨
been a fashion started in London.

In 1885 Mrs. Adey completed her ownership by buying the
quit rent from Lord Fitzharding. Having also in 1878 obtain
from him water-rights in the Edbrooke spring for supply to h
house, the upper house, she in 1882 granted water-rights to Christ
Church for the use of the vicarage and the rectory.

The story of the 1611 grantee Thomas Perry is more appropri-
ate in the account of the almshouses bearing his name: his burgage
has not been identified. Of the last grantee Robert Smyth and
his burgage nothing is known, except that he is likely to be the
mayor of 1618 and again of 1620.

Coming to properties not mentioned in 1611, The Court stands
at the Old Town end of what was formerly glebe adjoining the
churchyard: it was the Old Rectory till a purchaser changed the
name, to avoid the annoyance of receiving frequent letters on
parish business. It was from this house that Berkeley followers
assaulted Lady Warwick with missiles and abuse on her entering
the town.

The façade (Plate 3) seen from the street across a lawn is late
Palladian, and has been pronounced one of the best examples of
good architecture in the town. Enquiry resulted in finding a stone
tablet within the building, with "J. Rous 1727": that there has
been an extension is also shown by the fact that a pump standing
over a well is now within the building.

A John Rous *gent* 1648–1709 is recorded on a plain grave slab
in the church: he cannot have built the 1727 extension. The only
other John known is a leading local lawyer who in 1695–6 was
paid ample fees by the feoffees: he may have built the extension.

But the date is rather early for the style of the facade, which also speaks of greater opulence.

The Christ Church archivist Mr. E. G. W. Bill has found for me that in December 1771 an early descendant, George Rouse, wrote to the college apparently seeking a reduction of rent, as the house had not yielded an average £3 over the past twenty-seven years; he asserts that it had been built by his grandfather "at great expense": as the house had existed for centuries, this can only apply to extensions. Mr. Bill surmises that the grandfather was a Thomas who died in 1729, leaving his Wotton estates to his son John then aged twenty, who released them to his younger brother Thomas then aged eighteen. Leases were granted in 1754 and 1762 to Thomas the younger (there was yet another Thomas 1677–1737, a lawyer, of whom a memorial exists in the church); neither the latter nor brother John is otherwise mentioned.

Thomas the younger 1710–71 is the subject of the longest epitaph in the church. The Latin of this is untranslatable, but other information makes interpretation possible. *E vicino ortus* suggests "born next door"; *rerum Indicarum Orientalium scientissimus*, and *in Directionem*

8. Rous arms

plus quam bis-decies successive electus fuit, and again *ter etiam in Cathedram ipsam vocatus* do not imply high oriental scholarship and a professorial chair, but expertise in Indian affairs, twenty years' service on the Court of Directors of the East India Company, and election as its chairman. Of the twenty years' service I find no record, and only one of election to the chair, though a highly critical one.

Affairs in Bengal were in a deplorable condition: apart from political difficulties with the Nawabs, the Company's officers were guilty of the most shameless abuses and corruption. In February 1764 the news reaching London so much alarmed the Court of Proprietors that they brought pressure to bear on the Court of Directors. These, though equally divided between the pro- and anti-Clive factions, elected Clive's chief partisan

Rous to the chair, and sent Clive back as Governor of Bengal and commander-in-chief. His directive was to work with the Bengal council if possible: failing that he was empowered to form a committee of four named men with himself in the chair, to take over all the functions of government. Though Clive's hands had not been clean in the past, he at once began to attack the abuses, and to secure administrative instead of merely trading powers. This was a first step towards what became the Indian Empire, with its Indian Civil Service: and it was Rous of Wotton under Edge who gave him the opportunity to do so.

So, while the lawyer John probably extended the house in 1727, it is likely that the nabob Thomas later built the façade.

Opposite Edbrooke House, what is now the Tower Café has a fine little panelled room. A number of carved stones have been built into the exterior of the back premises, at least one of which came from Kingswood Abbey: this is a corbel with a shield showing the arms of the Pyrton family, *a chevron ermine between three leopards' faces:* the abbot forty years before Dissolution was Thomas Pyrton. The history of the house is blank, except that it was recently the workshop of George Bennett, whose family had for generations been estate carpenters, wheelwrights, undertakers, at Wortley, till he moved into town.

A little above Edbrooke House is The Court House, wrongly reputed to have been a royal court because of some reliefs in what used to be the single large room occupying the whole of the first floor: in fact the scale of the symbols suggests that the building was originally a plain hall, divided only later into storeys.

At one end a panel shows a mermaid *"natant guardant"*, the badge of the Berkeley family. This device is seen on the "mermaid collar" on the brass of Thomas IV Berkeley in the church, reputed to be a mark of his admiralty. He was made admiral of the fleet in the suppression of the Glendower rising, with commission to keep an amply manned and considerable fleet at sea for much of the year. In an action off Milford Haven he came up with a French fleet sent to help the rebel, burnt fifteen and took fourteen more

of them: in a subsequent action he took fourteen ships of another fleet carrying the Seneschal of France on the same mission.

Actually the mermaids appear first on the seal of this lord's great-great-grandfather, Thomas II, substituted for the flying serpents previously used as supporters: he had no naval appointment or service. The great-grandfather reverted to the serpents. The grandfather, Thomas III displayed a fine pair of mermaids: he was described as "a most able sea captain", and took part in the battle of Sluys under the king. The father did not use mer-

9. Court-house escutcheon

maids, but Thomas IV had them as supporters as well as on his collar. His son followed his example, but his grandson the flamboyant William used a more complicated display of heraldry by marriages. So this evidence from John Smyth does not decide whether it was a special honour or a hereditary family badge.

The corresponding panel at the other end of the room shows what is popularly described as royal arms and accounts for the name of the house. Though blurred with many coats of paint and whitewash which cannot be cleaned off for fear of damage, the lion and unicorn are there as supporters: but the lion is not

9

guardant, and his mane and crown are not distinguishable: both creatures are *rampant* in the ancient upright style. There is no shield or garter-with-motto between them, but on the field a thistle plant is depicted, mainly one big flowering stem, rising out of a small rose bush with a single bloom. Over the flower, an object which is not recognisable as the royal helm *affrontee* with bars: this is surmounted with three toy balloons for mantling, topped by something more like a crest-wreath than a crown and lion. The whole looks like a bucolic effort to follow a very amateur description.

This has no relation to Berkeley, and must be a mark of fealty and thanks for restoring their estates. The thistle was James's badge for Scotland: after his succession it was dimidiated with the rose of England, and this is suggested by the small rose bush.

On the under-side of one of the beams crossing the room is a fleur-de-lis at each end. The other beam has what can only be described as an incredibly bad version of the Tudor rose: quatre- instead of cinque-foil, with the petals deeply serrated. The local significance of neither of these can be explained.

I surmise that this was the court of the manor of Wotton Foreign (the borough being governed by its own corporation): that the Dudley-Lisles substituted their arms here as on the town mace, and that the Berkeleys restored their marks in 1609.

There is no clue to the presumably earlier date of the building, and the last manor court was held on 17th November, 1887, at the White Hart Inn in North Nibley: there is no evidence of courts being held here.

In the 1763 survey this house and the next above it were one item owned by Robert Crewe. The latter house is of two instead of one span, with three storeys and a usable roof space. The walls are carried two feet above top-floor level to gain height; as tie-beams would have been in the way, the thrust of the rafters is carried to the ceiling beams by little frames at their feet. So the house is naturally reputed to have been a weaving floor; but that is corrected by the description of Robert Crewe on his tomb as a gold- and silver-wire drawer.

These two houses appear later as added to the properties of the 1611 Venn grant, and in 1873 were sold by the then owner Miss Sheppard to Mrs. Adey.

Among the next higher houses was a must-mill, sold in 1755 as no longer a mill but a dwelling house: this has not been definitely identified.

At the top of Old Town the name The Brands has been applied to a relatively modern house, which lies just outside the Old Town boundary; the name had however been used earlier for that area. The house was built on the site of one of three houses in different parts tenanted by Mr. Huntridge, the surgeon who organised the 1756 inoculations against smallpox. It has two curved walls and a small detached outbuilding which look old. On the opposite corner of Bear Street stood an extensive building; in 1763 it was owned by Henry Winchcombe, mayor in 1732 and 1752, and was populated by five males and ten females. Though he is not known for a clothier, this is likely since he was buried in the same tomb as Jonathan Witchell who is described on it as a clothier. It is likely, too, that this was the workshop in Bear Lane, in 1838 offered for sale with its machines and stock of teazles with the Dye-House or Strange's Mill in Pound Ground.

The British School now occupying the site, built in 1843-4, is to some an interesting example both of "late Gothick" and of a stage in English primary education: others would call it just plain Welsh Bethesda.

The only other point of note up Gloucester Road, then called Back Lane, is the set-back in the road wall in front of the former brick-workings, marking the site of a former town pound. The brickworks were started in 1815 by Le Chevalier the brewer: a photograph showing the pug-mill and the extrusion machine I judge to be quite a century later. Another pound is shown by the naming "Pounds Ground" of a quarter-acre scrap on the edge of the untithed blank area in the 1763 survey, above the Britannia Mill: here the last smithy of the town has recently ceased work.

The whole extensive police station premises at the other end of Bear Street—an admirable bit of official architecture—was

then owned by Edward Bearpacker, the clothier son of the maltster of the same name: it had a population of only four and so was not a workshop. Between this and the Royal Oak Inn was a house with a markedly narrow deep front, and a population of no less than nine males and seventeen females, suggesting a workshop: but nothing is known of Lord Berkeley's tenant of it, Mr. Colwell, even from his tomb. Facing the police station across

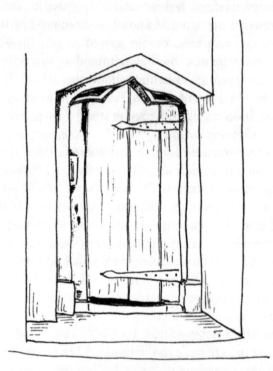

10. Tudor doorway

Bradley Street, a house has a wooden door lintel cut to a curious early Tudor arch with cusps. In a builder's yard a little higher, Pitman established his own school when the Tabernacle committee dismissed him; the house alongside has a good late seventeenth century oak staircase. Higher up Bradley Street are two Georgian houses of no special interest.

At the top of High Street (Plate 5) the premises of the National

Provincial Bank deserve recognition as one of the finest houses in the town. The house is of three storeys crowned by a parapet; it has a three-window frontage, those of the ground- and first-floors of Venetian type, the jambs and lintels with ornamental mouldings and little capitals. Inside, an entrance passage between the two front rooms leads to a staircase hall. The staircase, ordinary at first sight, has square balusters of finer section than usual with fluted edges, and the stair has a gracious rise. Cornices and plasterwork are good but not specially noteworthy. The house was the property of the grammar school: the present appearance must be due to an affluent and cultured tenant of the later eighteenth century, but there is no clue to him in the deeds deposited in the Record Office. All that is known is that the bank leased it in 1851, moving in from a near-by house, and bought it in the early 1930's.

Turning into Market Street at the Tolsey, which has been described, the houses which are now numbered 13 and 14 were in 1763 one premises owned by Susanna Wallington: communicating doors are still there though blocked. The roof plan is a little intriguing. A ridge parallel to the street runs the whole length, and in the northern half is still untouched, though there may have been dormers before it was relaid with clay tiles: in the other half two gables run out as far as the front wall; beyond them a smaller gable projects a little as if that had been the entrance. Time and regard for the occupants have prevented my poking about enough to trace the original arrangement inside. The house contained a spiral stair of the newel type, continued down into the cellar in stone: and there is a well in the cellar. The ground floor is likely to have had shop fronts as attractive as one still existing next door to the Rope Walk, but these have been modernised, and recently abolished. Above this the façade is made interesting by a small oriel of Venetian type in No. 13, and a tiny plain oriel in No. 14.

On the Green Chipping, Well House may at one time have been in the same class with the Bank. It seems to have been shaped from an ordinary building by the banker Goodson Vines as tenant: before his time there was mention of a wool loft over,

indicating a working clothier, who might with difficulty be identified from feoffees' records. It was let by the market feoffees to Goodson Vinesby 1786, when Berkeley let him some adjoining premises "behind his house near the Green Chipping". He was still there when in 1802 he sublet to Eliza Austin some of these premises (and a pew in church) for twenty-three years at £30 per annum, a rent which suggests that Well House was

11. House in Market Street

included. He must have gone by May 1851 when the feoffees advertised the house "late Vines" in *The Times*: in 1852 it was described as void when they got an estimate of £111 17s. for dilapidations, and in March they got a new tenant, Dr. W. J. Hill, surgeon and apothecary, who gave evidence of the cholera epidemic of 1854. They undertook to give him a water supply, and to cover the well, though that was reopened in 1865. In 1859

their minutes refer to a surgery lately added to the house, and allow £18 4s. for making a w.c. In 1853 they also bought "Mrs. Harris's fixtures in Chipping House late Vines": she would hardly have installed fixtures worth considering for quite a short tenancy, so Vines must have gone some time before that.

In 1871 the house was let to one William Stonor Hunt for seven years at £32 per annum, still described as "formerly Goodson Vines". Now, after years of occupation by evacuees, it has become drab, and it remains to be seen if the building firm who now occupy it can restore it. Not many years ago it was bought to form the nucleus of a Community Centre as a War Memorial: but enthusiasm did not last long enough to raise more than a fraction of the sum needed to carry out a rather ambitious scheme, and it was sold: the money was then used for improvements at the town hall.

On the farther side of the Chipping, one in the row of smaller houses has a good shell porch, like the one to be seen on the old almshouse in Culverhay facing the church, now the Bluecoat School.

Continuing down Long Street, as High Street below the Tolsey has long been named, and passing the mouth of the Ropewalk (page 56) with an unspoilt shop front beside it, the eye is caught by the unspoilt Jacobean front of Berkeley House (Plate 4); unspoilt even by the introduction of a small shop front in part of the façade, added with such taste that it would be meticulous to object. The appearance is what would be expected and need not be described. I doubt if there is any justification for the name: it probably arises from the description in the sale catalogue of 1922 as "at one time the property of the Berkeley family, and was formerly the Burgage House of the town". There is no record or tradition of connection with the Berkeleys more than with any other houses all of which they originally owned: the term "Burgage House" with capitals is meaningless.

The above description was probably by Vincent Perkins, whose accuracy can be judged by the fact that he once noted "my house" in pencil on an old deed concerning the Osborne

house lower down the street: Vincent, described as a wool dyer and met with in the Britannia Mill, was occupying the house in succession to his father Benjamin the vicar, while the vicarage was given up to the curate. The purchaser of "Berkeley House" was a speculator who rifled the house and sold off anything he could; I surmise that he seized on this description, and coined the name Berkeley House, to make it sound more interesting when he wanted to sell it.

The most interesting feature in the house was a room (Plate 12), bought by the Victoria and Albert Museum in 1924, and erected complete in the museum. The panelling is of pine wood painted green, furnished above dado level with the original set of paper hangings painted in the Chinese style with flowers, birds and trees. The cornices are also painted in the Chinese style: an 18th century brass and iron grate was recovered, but the Dutch tiles were not. The chimneypiece and surround with applied plaster decoration were also recovered. This is considered to date from about 1740, or perhaps 1760. This paper is in fine condition: the only two other examples known in the county, at Painswick House and at Hardwick Court, though believed of later date, are faded by the light in south-facing rooms. A very fine oak-panelled room of earlier date was sold to a museum in the United States. The house has a timber spiral staircase of the newel post type, continuing down into the cellar in stone.

The 1763 survey shows that the house was then owned by Humphrey Mayo. Tombs show a William Mayo, a goldsmith who died in 1740 aged thirty; and a daughter of the Wortley family of Osborne 1674–1726, who had married a Humphrey, also a goldsmith and mayor in 1734, who can be pronounced the originator of the fine Chinese room.

The house has only quite recently lost a fine lead cistern (Plate 13a) which stood in its courtyard: the Victoria and Albert Museum considered this as early seventeenth century, though the pattern was at least fifty years earlier. The only known similar cistern is at St. Fagan's Castle and is dated 1629. The house also contains a stone votive tablet (Plate 13b) depicting three *genii*

loci: found by the roadside, probably in the Chestles area at the north-east end of the parish, it was brought to Vincent Perkins.

The house next door has a date-stone of 1748, with the initials

$\begin{array}{cc} & W \\ S & E \end{array}$ of the sisters Susanna and Elizabeth Wallington.

Susanna's interesting house in Market Street has been described. This house was in the 1763 survey divided into two, in the separate ownership of the two sisters. The family was of long standing in the town, following a variety of occupations. While there is not enough information to establish all the family connections, their appearances are worth recording.

The first to appear is Edward Wallington in John Smyth's military census of 1608, living in Synwell, a tanner, affluent enough to be assessed as a subsidy man, and having two servants, possessing a corslet furnished, of age about forty, and physically in the best class fit to serve as a pike-man, but untrained. The census does not list any others but an old weaver and a shoemaker, who may or may not have been related. Edward was borne to his grave in 1616 by six grandsons, who are likely to have been employed outside the county as they do not figure in the census; Edward's memorial describes him as merchant.

The same memorial records a son, also Edward, 1646–1728, a mercer, married in 1669 to Susanna Okes 1651–1725; he issued some trade tokens which were recalled in 1672. An Edward was Sergeant in 1699, and the same recurs as mayor in 1706 and 1712, and in 1736 which was paid for as a repetition: these cannot all have been the same. There was also a Katherine, a widow, who in 1611 held property on both sides of Venn's land in Court Orchard, who cannot be placed.

One Edward Wallington bought Rack Close in Combe and probably operated the Scouring House by it. He had a son Richard 1676–1746, a mercer, who built the house on the close, and was married to a Mary 1669–1736. This Richard had a son John, who died 1761, a clothier whose daughter Susanna in 1759 married Charles Adey and got Rack Close as her dower: and this John in a partnership with Philip Dauncey which was

dissolved in 1758, took a lease of Venn's Mill, alias Strange's, in 1749.

Charles Wallington was a card-maker (for use in carding wool, not for games), was Sergeant in 1706 and then mayor in 1724–5: in 1703 he advanced £50 on loan towards the building of the Market House. He secured the lease of market tolls in 1702, and renewals till becoming treasurer in 1731, but had several times to be given rebates for "bad markets". He was lessee of the Crown Inn. In 1721 the feoffees paid him £1 1s. 6d. presumably for refreshments at the sealing of renewal of his lease, and in other years paid for a room or for dinners held there. Next on this lease "for lives" was his son John, followed by John's children Samuel, Elizabeth, Susanna: John followed Charles in the inn, and may have been followed by Samuel when he died in 1744 aged fifty-eight: Susanna and Elizabeth must have been the owners of the houses described, as well as one on the unidentified "Red Lion Close" which was let in 1723 together with a pew-right in the church.

Others of the name were William, Sergeant 1689 and mayor 1699 and lessee of the Tolsey 1699–1700; Thomas, Sergeant 1718; Timothy, Sergeant 1750; Ann, a house-owner; Richard of Yate, clerk, party to the Wallington-Adey marriage settlement of 1759. The name then does not appear further till in 1810 to 1817 another Charles was paid for rooms or dinners without naming his inn: he must have been a good host as the charges ranged from £4 to £8, and in the last year he got £20, perhaps for several years. Then William Hunt Wallington, mayor 1838, inn-holder and wine merchant, bought the Osborne "three burgages", converted into The Vine Inn and sold to Joseph Osborne (unrelated to the original family) in 1863. In this period there was also a Richard, mayor for three successive years 1854–6, described as a gent, which may account for his having neglected his duty to audit the accounts.

There was also a Wallington family in Dursley, which there attained rather higher status than the Wotton family. A pedigree which has been drawn for them derives them from Charles of

Malmesbury, gent, 1674–1752, said to be son of the above Edward and Susanna.

Just above the end of Sym Lane, what is now the office of our solicitor and is reputed formerly to have been a Berkeley love-nest, has some good ornamentation and plaster work of about 1790 inside. A little lower, "Carlton House", now used as an overflow for the grammar school, is esteemed enough to have been the subject of protest when the post office proposed to rebuild it. It has a pleasant parlour, some good Jacobean detail and a dog-leg stairway with barley-sugar banisters tucked away in the back part. Just east of the brook at Potter's Pond, "Moore Hall" looks promising outside. In Miss Tait's booklet it is described as having an oak balustraded stair, and a panelled room with an oil-painted panel over the high mantelshelf. These lasted until after the last war, but the room is now a workshop.

Wotton was and is well provided with inns. Licensing records are too recent to be of use, and the principal information is from directories and some personal notes.

The White Lion has already been dealt with, as the subject of the first recorded mention of any inn, in 1610.

With the beginning of feoffees' records we hear of the Star and the Crown, both on the market place and parts of the market endowment. The Star used to be an important house, from which the Bristol coaches ran: the inn's custom naturally benefited by the proximity of the market. The building between the present inn and the passage to the Green Chipping seems originally to have been part of the inn. The lessees are often named, but none seem worth mentioning. Examples of the rent are £3 2s. in 1753 and £17 in 1852.

The Crown was more important. The feoffees often held their meetings there, as evidenced by bills for refreshments or dinner: some of the early lessees were given the leases of the market and fair. In 1826 the passage to the Green Chipping was widened four and a half feet by cutting back the inn, and a former passage at first floor level connecting it to the Star removed. Cellars under it, now blocked off, are also said to connect with those of the Star,

and are reputed to have staples for chaining prisoners. The inn had assembly rooms where concerts and dances were held; these have now become the local cinema, and the rest of the building accommodates the Conservative Club. It was still licensed in 1911.

The Swan, almost on the market place, was not part of the market endowment, though an extension was built on to market property and paid rent. This inn, too, had a covered bridge to the house opposite it on Market Street, demolished about 1750, and shared the patronage of the feoffees. All the inns did their own brewing (hence the need for an ale-taster); on one occasion there is specific mention of the Swan's brewhouse and reservoir, and its well, in 1822 "lately built".

Leases of 1712 and 1751 mention a Bear Inn of which there is no actual record, which seems to have been between the market place and Haw Street. In 1758 it is recorded as "formerly". There is also mention of a Red Lion which seems to have adjoined it; also a house "formerly called The Angel" in 1821, by the passage into Green Chipping from Market Place, which may not have been an inn.

Oldest as a house, if not as an inn, is The Ram at the bottom of the Cloud area: this is reputed to have lodged the workmen who built the church, but of that there is neither proof nor disproof. It does not figure in a solitary list of licensed victuallers of 1755. Having been church property "from time immemorial", the property is dealt with among the charities.

For the rest we have only records, not complete, beginning in 1842, apart from a Victuallers' list of 1755, which lists only ten inns out of a possible total of thirty-eight. In Bradley Street, the Kings Arms is listed in 1842 and has just ceased to be. The Rising Sun is not heard of before 1881 and disappeared a few years back, as also the Washington Head which disappeared in 1911 and now has a builder's yard behind its arched entrance. The Dun Cow, up the hill and now a farm-house, appears only in a note recorded by an unknown informant not very long ago.

In Haw Street the Pack Horse stood opposite Packhorse Lane,

which now leads to the garages of the local Bristol carrier: with a swinging sign, grey on one side and on the other brown with a pack saddle, it existed in 1755, in 1871 was a posting house, and is last recorded in 1896. The Royal Oak seems earlier to have been on the site of the police station. It is described as facing down Long Street: it has now moved two doors south. It,

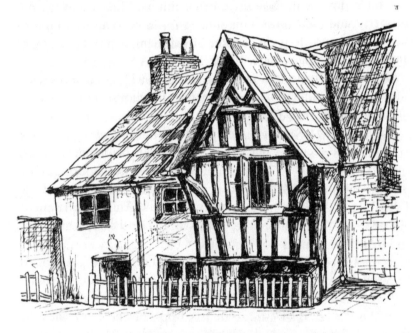

12. Ram Inn

too, existed in 1755, and is still open. On the opposite corner, in Bear Street, was the Grocer's Arms, of which there is no record but the list.

In High and Long Streets, there was opposite the White Lion the Greyhound with a sign grey on one side and black-and-white on the other, and railed steps running sideways to a landing in front of the door. A little lower was the Black Horse, with the sign of a prancing steed on one side and an ordinary horse on the other.

Again, on the north side was The Vine, starting place of the Cirencester coaches, dealt with as the Osborne "three burgages"

and now Lloyds Bank: it is not mentioned in any of the lists of inns. There was also a Bakers Arms on High Street, existing from a few years before 1881 and closed in 1911: there is no indication of its location.

Continuing down the Steep, facing up this at the bottom, is the Shearman's Arms, listed in 1755 and still in action. A photograph of 1880 in the bar shows that this building was then the local Co-operative Stores: at that time the inn was on the opposite corner, where the bracket on which its sign hung is still to be seen. This may earlier have been The Crosskeys. A little above this was the Glaziers Arms, and opposite it the Green Dragon, still showing the trap-door in the pavement where the barrels were lowered into the cellar, closed in 1911. At the top of the Steep on the corner of Church Street, stands The Falcon, not recorded in 1755 but still active, one of the larger inns, which had a conspicuous sign on the corner visible from all directions: the house bears a placque with date 1659. Then beyond the almshouses stood the Jolly Reaper, shown in the sign with his sickle and quaffing a tankard: this had a short life, 1881–1911. On the further corner an inn whose name is not recorded, which may conceivably have been the Crosskeys, since the lane from this corner swinging round below the grammar school, now wrongly renamed School Road, is shown as Crosskeys Lane in the 1763 survey of the borough. "On the Cloud Wall", more or less opposite the Ram, was the Rose and Crown, of which there is no record, and only a mention that Mr. Chevalier the brewer (mayor 1815) died there. Crossing into Combe Road, a little above the church there stand the Salutation and the Apple Tree, of which nothing is known beyond that both existed in 1881 and the one still survives while the other has just been closed. Also on that road a Brewers Arms is shown in an 1861 list of licensed premises and was one of those closed in 1911. Shown only in a 1755 list of licensed victuallers without indication of location were the Ship and the Dun Horse. That list also gives the Fox at the corner of Sym Lane: none of these three are otherwise mentioned. The Lamb stood on the same lane at the lower entrance to the Chipping.

Crossing into Wortley Road in extension of the Steep, first at the top of Mitre Pitch stood the Mitre, known in 1861 but closed in 1911: on the opposite side of the road the Earl Grey, not known before 1881 but still open. At the Locombe Well corner the Fountain still shows its name painted in tar on the back, but does not appear on any list. Out in Wortley there was the Star, not in any list: I recovered its swinging sign which is now in the local museum, with the nice wrought-iron scroll showing a barley head from its gallows, and in the ledger of the local carpenter I found the 1838 entry of the charge of £2 10s. for making the sign and gallows.

Back on Synwell Green stands the Full Moon, existing in 1861 and still open: further in Combe the White Hart, of the same age but closed in 1920: townward, in Pounds Ground, the Cottage Inn is recorded from 1889 to 1896. At the other end of the parish, in Huntingford, stands the Rose, recorded in 1881 and still open, though Presley's local directory omits it after 1896.

Also scattered about the place were "little places called tiddly-winks where a glass of beer could be got on the sly", perhaps the ten off-licences recorded in 1861. So people had no need to go thirsty.

These inns used to do their own brewing: but the second half of the nineteenth century saw the rise of "common brewers" and brewing companies, who later bought up inns and tied them to selling only their beer. The Guinness Brewery at the Combe Lakes will be described. 1871 sees the first mention of the Bourne-stream Brewery of Henry and Absolom Perrett, who lived respectively in the house which they bought from Austins in 1877, having leased it from 1846, and at the neighbouring Beaconsfield which Absolom began to build in 1873. In 1869 David Perrett, common brewer and maltster, had died leaving an estate sworn worth not less than £10,000: then in 1871 Eliza, widow, also died. At the same time there was a Jesse, common brewer and wine and spirit merchant, unconnected with the brewery. In 1875 Messrs. Arnold of Wickwar secured the lease of the Crown Inn.

Before this the 1842 directory lists Carpenter as a brewer at the foot of Long Street, a George Playne as the Wotton Brewery: but nothing is known of these.

The Berkeley grant to Walter Osborne has been mentioned. The Osborne family appears first as a prosperous and influential burgess family in the middle of the sixteenth century. They then moved to Wortley and raised its mill there to the highest level in the county, bought land and entered the ranks of the county gentry, and faded out only when the local cloth trade collapsed after the Napoleonic wars.

William Osborne, the first to appear, is seen in his 1584 will as sheep farmer and not clothier. He was on friendly terms with George Huntley, from whom he held his farm of Burnells Place in Leighterton and Boxwell; also with Thomas Throkmorton of Tortworth whom he named overseer of his will of 1584, leaving him his "best silver salt with the cover doubly guilt". His second-best salt of silver went to his eldest son John, principal legatee, who also got the rights of his farm, with the stock including 300 of his best sheep, but there is no mention of the general flock; also his own bedstead which was furnished with a flock- and a feather-bed, a pair of blankets, two coverlets, two pairs of holland sheets, two pillows, and curtains "of saye redd and greene". Money bequests were trifling except one for £100 to an unmarried daughter; the 40s. to a kinswoman-maid was sardonically increased by the 30s. debt which her mother owed him. A young god- and grand-son was given sheep to make his flock up to ten, which rather suggests an annual present of a lamb, as we might give a savings certificate. It transpires that the wainscot in the house and portals and glass were not at that time regarded as parts of the house, but were bequeathable. William had a good wardrobe: he mentions three of his best gowns, a "satten doublet and best puke coat", as well as "best frize coat, medle hose and best hat" given to a servant.

The 1605 will of his widow Agnes completes the picture. As well as four silver goblets of which William had disposed, there were a dozen best silver spoons and four more are mentioned, only

a trifle of money, some specified crocks and pans; and unspecified pewter and clothes. William was able to sign, but Agnes had to make her mark. Their son was the Walter who received the Berkeley grant of property mentioned above: their daughter Edith married Hugh Venn who has appeared in this account.

Walter's grandson William was still a "Lanarius" according to his memorial and twice mayor before 1620: he had displayed arms, and for this was called to account by the Heralds in 1682 and forced to "disclaim as no gent". Richard of the next generation was the first to expand into the cloth trade: a mark of his rise in prosperity is that his unmarried daughter was given £1,100, with other bequests also bigger than William's. He moved to Wortley, and the family story is continued in the account of that hamlet.

13. Osborne arms

The 1692 will of the grandmother of Samuel Yeats, who married the daughter-heiress in whom the Osborne name ended, included

	£	s.	d.
Wearing apparel and money in the house	20	0	0
Debts due	546	13	0
Furniture including 3 beds in cockloft	19	10	0
Books of all sorts		15	6
Two silver cups		12	0
Brass and pewter of all sorts	3	10	0
Cheese in the house	1	0	0
Wood coal lumber and misc.	3	0	0
Total estate	595	0	6

The Yeatses were a Quaker family of dyers at Woodchester. The debts which account for nearly the whole of the estate are in line with the "stock of money in many hands" of her husband's will. Their amount shows that the dyehouse must have been quite a big business, and the owners might have been expected to have more personal possessions. Samuel in his time brought £4,000 into marriage settlement.

10

In 1682 the owner of Edbrooke House was Thomas Venne alias ffenne gent and merchant of Wotton, and made his will, the bequests in which constitute a most useful inventory. Specification of the house is not very full: there was a hall, a kitchen, a best and a "forestreet" chamber, while Thomas had another chamber, and "Anne Johnson now living with me" who got £5 and her bed must have had a room.

The hall contained a "Shipp", a side cupboard and a cupboard. In the best chamber was a great bedstead, two more beds with curtains and "vallons" and one arras coverlet and one "least" quilt, two carpets, and irons, dogs, a fire shovel and tongs, showing that it had a fireplace. In the forestreet chamber were a bedstead and two beds with their furniture, a best chest, a press and a standing (broad) box, containing linen. Thomas's chamber in addition to his own bedstead contained a side cupboard and a broad box. In the kitchen only the screen, an iron jack, and the "drane" in the chimney are specified. Two chairs and four joint stools embroidered are specified, and the house also contained tables, boards, benches, forms and "all other standards".

Of fabrics there were linen and napkins not catalogued, another carpet, a (table?) cloth, two turkey cushions, a second-best rug, six holland pillowbeers and one East India and one calico, a calico board cloth, a pair calico and a pair best holland sheets and one marked M : P, a diaper table cloth and a diaper towel.

Utensils specified: brass, one great and two small pans; one old pot with hangels and one new and one great pot; one chafing dish, one skimmer, one kettle, one ladle, one warming pan, three candlesticks: pewter, a set marked H : H, two best platters, nine pieces and "all my other pewter": silver, only uncatalogued tankards: three spits, the biggest flagon.

Personal articles, searge suit and coat, cloak and shirt, grey coat and all other wearing apparel: carbine and sword, saddle and bridle and a pair of "busgins". One gold ring with diamond stone, one crystal seal, one golden signet marked T: F, one golden ring called the Escreatoure.

Books, his bible marked T: V and another bible, a book of

Dr. Maye's works, one of Dr. Adams's and one of Dr. Hall's, a book called *Summum Bonum*, the *Book of Good Conscience*, and one called *John Quirke, Witt's Common Wealth*, the *History of the World* (presumably Raleigh's), two statute books, "and all my small books".

No wife is mentioned, so she must have died earlier; nor any sons, and the property, including "land under Conygre Hill", is left to a kinsman Thomas, son of Arthur of North Nibley. His sole executor is Walter Osborne, a younger son of the contemporary grantee, who is given a silver jug.

Another Wortley man was William Shrewsbury: his 1663 inventory contains.

	£	s.	d.
His interest in an estate chattel	80		
400 sheep @ £6 the score, 10 kine @ £3 10s., 3 heifers @ 50s., 3 yearlings @ 20s., 6 oxen @ £11 the yoke, 7 bullocks @ £4, 2 mares @ £4 10s., 4 pigs @ 15s.	240	10	
2 wains and all instruments of husbandry	10		
Timber boards	4		
50 bushels of wheat @ 4s. 6d., 20 of maslen @ 4s, 50 of barley @ 2s. 6d., 30 of peas @ 2s. 6d., 40 of oats @ 1s. 8d.	28	16	8
20 acres of wheat @ 40s., 20 of barley @ 30s., 10 of peas @ 30s., 18 of oats @ 20s.	103		
Beds and bedclothes, curtains, carpets and half-dozen cushions	15		
Sheets, pillowbeeres, tablecloths and napkins	9		
Bedstead, chests, coffers and trunks	3	10	
Tables, forms, stools, chairs, and one cupboard	2		
Brass of all sorts	5		
Pewter	2		
Irons and pots, etc.		15	
Wooden vessels	1	10	
Bonds, Giles Lockier £20, John & Hugh Taylor £65, John Smith £10, John & Richard Taylor £14, John Taylor £39, Richard Hugh & John Taylor £20	166		
Total estate	£669	4	0

Shrewsbury was a yeoman, and £472 of the above total was accounted for by his farm. This "estate chattel" was the lease of a farm at £120 rent. The core of the holding had in the 1546 chantry inventory been the Knappe House and a virgate, but not held by the Shrewsbury family. All the chantry property passed to Sir Gabriel Lowe, and when he conveyed it to Sir Matthew Hale in 1649 in an exchange of lands, Shrewsbury was holding land of "clear yearly value" £13, rented at 16s.: in 1660 he was assessed as worth £15 per annum and paid 6s. poll-tax. In his 1648 lease from Lowe, Shrewsbury had been described as a clothier, but otherwise was always yeoman. Knappe House I have identified as what stood in a mass of brambles just across the stream from Wortley House garden, where the back was dug into a steep slope: it was of the size of an ordinary yeoman's house. The holding contained a garden and two orchards, and about thirty-five acres in small scattered units: these Shrewsbury in 1652 gave up in exchange for a compact unit about his house.

The only other clothier to mention is Thomas Gowre of Wotton, whose inventory has not survived and whose will of 1572 does not illuminate much. He gave his children £850 and six silver spoons, and held some leases of land including one in Haw Park. The most interesting point is that he left £20 towards bringing a conduit to the Market Cross provided that it be done within three years, a project which was only carried out sixty years after by Venn and Perry.

Another farmer accounts for the 1663 inventory of John Nelme of Bradley, a family mentioned in the account of that manor. The inventory is useful also in listing the rooms in the house, probably Canoncourt Farm.

The hall contained a table-board with forms and stools, and two carpets, value £1 10s.: the (adjoining?) buttery contained the pewter-ware worth 2 guineas, six dozen trenchers, and six barrels, worth 8s.: then "whitehouse" with a salting stool, etc., 15s. In the kitchen only the brass worth £3 2s. is mentioned. Presumably over this, the best chamber had a high bedstead with

"tike" bed, etc., and a french bedstead, and linen, £4 10s.: also
11 yards of medley cloth £3 6s. A chamber over the kitchen had a
standing bedstead with appurtenances. Apparently over the best
chamber, a wool loft contained a warping bar and "skarme",
two turns, two hurdles, etcetera. Over the other chamber there
was a loft, and a cheese loft containing 400 of cheese of all
sorts worth £2. In barn and outhouses were a pack saddle and
hacking saddle and husbandry tools 5s.; in the grounds, ten
milch kine, three yearlings, one horse, four pigs, £40: three
acres of standing corn £6. Wearing apparel £3. Total estate
£78 9s. 8d.

A good half of the estate being in the farm, John seems to have
been a small farmer, perhaps with some interest in cloth, and
relatively fair house effects. The house an ordinary yeoman's
house, perhaps half of what Canonscourt is now.

A bigger estate is the 1685 inventory of Thomas Winston the
younger, mercer (dealer in textiles especially silks). Of the
£1,376 13s. 4d. estate no less than £781 6s. 8d. was the value of
"goods of all sorts, mercery, linen, drapery, silk wares, grocery,
in shop and house": £416 8s. 8d. was the total of debts owed him:
the balance £178 18s. was enough for a good establishment.
Starting with the kitchen containing a brass furnace and brewing
vessels £3 10s., there is a "cellar backward", and a closet with
table board and frame and two chairs 10s., and about five dozen
glass bottles 10s., apparently the business room; in an upper loft
a beam and scales, and timber; then the buttery, contents £11 9s.
The hall contained a table-board and frame, a livery table, one
settle and four chairs, £2 10s.: next a parlour with small table-
board and frame, two joined stools, six leather chairs, and fire
irons, £3: underneath, a fore-street cellar with twelve barrels
and two horses £2. Next a dining-room with long table board and
frame, thirteen leather chairs, six round chairs wrought, and chest
of drawers £5 7s. 6d.: also one long carpet, two window curtains,
fire irons, one large picture and ten smaller, one large and six
small parcel salts £4 17s. A parlour chamber, a new chamber and
a hall chamber probably formed a first floor and contained

bedsteads and bedding, cushions and turkey-work cushions, etc. In upper lofts were more beds. A vessel of vinegar 10s. is listed, forty-eight ounces of silver plate £12, a bay nag £4, and 300 lead weights.

This Thomas is not recorded in civic affairs in spite of his affluence, but his son Thomas II was thrice mayor, twice even during his father's life: and Thomas III was mayor twice. A Richard was mayor in 1733 and was a clothier. I find nothing else to record about the Winstons except dates and names of wives on their memorials, and the family makes no further appearance.

Another mercer, Christopher Willis, has a 1663 inventory, but not well preserved. Of the £177 estate £87 was debts and £42 apparel: no detail of house, a pity, as all the rest of the estates are small.

Giles Godsell had an estate of £28, of which £3 was the value of a broad loom in shop, showing him to be a weaver. His house contained shop, hall, buttery, two chambers and cockloft. The best chamber was crowded with a french and a truckle bedstead with flock beds and so on, a joined and a painted chair, chest, little coffer, and side cupboard, £3 13s.: the other chamber had only three stools and two old coffers, and things. There was a low bedstead and old flock bed in the cockloft, with a beam and scales and an old beating hurdle. In the hall are listed a table board and frame and pots and pans: in the buttery seven barrels, some old trendles, and other lumber. The biggest item is chattel lease of four acres of wood, £12.

William Workman 1664 left an estate of £58 10s., of which £30 was "chattel lease of a certain messuage". Occupation not stated, and neither house nor household goods "of all kinds" are detailed.

John Street, 1633, was a tailor with an estate of £21 10s. 4d., of which £8 was in debts. In the shop there were only tools 13s. 4d., and no cloth, perhaps suggesting that customers brought their own cloth to be made up. He had only a canvas flock bed, pewter worth 25s. and brass vessels worth 33s. 4d.

Nicholas Fowler, 1667, skinner, owned £23: but his inventory is badly written and ragged, so it is possible to distinguish only that his house contained kitchen, brewhouse, hall, buttery, chamber with two bedsteads: and he had two hogs.

The 1587 estate of Thomas Ellmes, currier, amounted to £19 8s. 10d. of which no less than £10 was his apparel, and he had a good stock of house linen. Vicar Stanton was one of the valuers, as also in some of the other inventories. In the shop were shoes, boots, and laste: in the hall a "chripet", eight cushions and three little chairs; in the parlour, a feather- and a flock-bed with appurtenances but no mention of bedstead, seven pairs of sheets, tureen (*sic?*), canvas, and lockram, five table cloths and a dozen napkins, and the only chamber pot that has been mentioned. In the parlour within the hall, a truckle bedstead, three flock beds with appurtenances, an old cupboard and coffer. In the chamber within the parlour an old bedstead and flock bed with appurtenances. In the kitchen a good outfit. In the cellar "treen (wooden) old ware 2s. 2d.". In the buttery thirty-six pieces of pewter 40 lb., 16s. 8d. More cellars with old stuff, and in the backside a load of wood.

Thomas Humfrey in 1587 left £13 3s. 4d., with no details of interest: his house had hall, buttery, and chamber.

One innholder is represented by the 1784 inventory of Wiles of Wotton Underedge. His inn is not named, nor had it estate value as freehold or lease-chattel. Accommodation was little parlour, ban [*sic?* bar?], back kitchen, brewhouse, kitchen: further, room over the parlour had two oak bedsteads which, with their bedding were worth £10 7s., and was well furnished and even contained fourteen books. Room over the passage had an oak bedstead with bedding of £3 4s., and beyond that only a small table. Little room over the passage, had a cheap bed and eight chamber-pots; room over back kitchen, room over brewhouse, garrett, each had a cheap bed and no furniture: "Room over the kitching" had three tables and six cheap chairs, and the linen.

The big item was contents of the cellar

	£	s.	d.
29 hogsheads & vessels	35	1	9
3310 gallons of beer	165	10	0
9 gallons of British brandy	2	5	0
2 gallons of British shrub		5	0
2 gallons of Jamaica rum		18	0
3 gallons of French brandy	1	13	0
3 gallons of compounds		12	0
there were also cash in house and book debts	96	3	7
leaving for the value of effects including beds	59	0	5
the total estate being	£361	9	9

The executor paid off £179 2s. 9d. which was owed; and £10 a year for five ensuing years for board of deceased's mother Ann Gabb, and 1s. a week for Betty Godsell to attend her for her last two years.

"Shrub" is the Anglo-Indian version of the Persian *sharab* or wine: "compounds" I cannot interpret. The prices, 1½d. per pint of beer, and 1s. 10d. per bottle of French brandy, and others, are refreshing.

A refinement absent even from most later wills is the mention in the 1506 will of Richard Motton of "six silver spoons with maidens heads". The 1547 will of Geoffrey Bruten mentions "three silver spoons with a gems spoon".

By far the most valuable inventory is that of Jonathan Witchell, clothier of Wotton, in 1701–2, amounting to £3,066 11s. 10d. taken two weeks after his death. He has a tomb in the churchyard showing that he was born in 1639, and that his wife Mary had died in 1678. His house and a shop and his mill seem to have been close together at Combe: there is nothing by which the mill can be identified, but it was probably Venn's alias Strange's. At none of the other mills were the premises big enough for the enterprise shown by the inventory.

The will adds a few points. In 1681 he had married the widow

Mary Adey, settled £250 on her which had not all been paid over by his death. A daughter Mary, married to Richard Wallington, got £200: Sarah wife of Thomas Tudgey got £150: Ann Webb got only a "brode peece of gold": unmarried Elizabeth got £500: they also got some goods. Son Jonathan was residuary legatee and sole executor. Thomas of Charfield, who appears below, was brother and an overseer of the will. In addition to the inventory there was a little land, Lord Meadows in Ham, and something in Clinger.

Of the £3,066 estate the biggest items were

	£	s.	d.
"Money in the house and bad debts by bond"	15	10	3
Due in good debts in London	475	8	6
"Bank bills and Exchequer bills due from the factory to balance the last account"	459	8	0
Cloth at London and dressed in house and at mill and in shop	1,046	0	0
Wool in the warping (weaving) loft and list and wool, with 2 spooling turns, a warping bar and "scarme"	66	5	0
Looms and coloured wool and yarn	146	0	0
Chains and spinning and wool at dyehouse	20	0	0
Goods at the house at Combe and colouring stuff there	13	0	0
The shop, tools, racks, teazles, remnants etc. and serge, the horse and hay	23	0	0
Wood etc., and oil in the looms and packing, scales weights and hurdles	30	2	6
In the Parlour, 26 cane chairs, 2 cases knives, fire irons etc.	4	10	0
Parlour chamber, standing bedstead with feather-bed and blankets, 10 cane chairs, looking glass, fire irons	13	10	0
Hall chamber, flock bed and blankets, etc.	2	0	0
Another chamber, bedstead, 2 beds, looking glass	3	5	0
Little chamber, bedstead and bed, two desks	2	0	0
Warping loft, feather bed etc.	3	10	0
Hall, 6 Turkey chairs, side-board, 2 joint stools, 1 joint chair	2	0	0
Kitchen (usual pots & pans), 6 chairs, fowling piece	4	0	0

	£	s.	d.
All the books: and in the brewhouse 18 pewter dishes, 24 pewter plates, 4 pewter flagons, 4 pewter cups, 1 pewter tankard	?		
In the cellar, malt mill, 7 drinking barrels, bacon and cheese, 1 silver tankard and 6 silver spoons	12	0	0
Linen of all sorts	9	17	0
Wearing apparel	12	0	0
"all other things"	6	0	0
Total	£3,066	11	10

Thus, of this total £2,694 14s. 3d. was in the business, leaving only £371 17s. 7d. for private goods. Only £12 for wearing apparel is most modest. Putting the little silver ware in the cellar may have been for safety. I cannot explain the "scarme" here and in the Nelmes inventory.

He seems to have been almost a "foreigner" to Wotton: the only other occurrences of the name there are the 1684 will of William senior, the 1695 will of Jane; a tomb of Mary widow, 1627–1707, daughter of Robert Crew, perhaps an aunt of the gold- and silver-wire drawer of the Court House; and two simple headstones. The 1763 survey shows an Eliza Witchell as Berkeley's tenant of three properties at the top of Bear Street.

But there were Witchells in the cloth trade in adjoining villages. *Men and Armour* in 1608 lists three weavers in Alderley, where also in 1668 Thomas senior left a will, and in 1670 Robert a broad-weaver aged thirty was getting married. There are wills of Witchells in Charfield from 1663 to 1757; Nicholas a clothier of Kingswood had a marriage licence in 1677, and a second in 1691; Thomas of "Charvill", clothier aged twenty-eight, in 1668 obtained a licence to marry Elizabeth Ithell, whose name is borne by one of the mills I describe; and in 1695 he obtained another licence. Thomas had done well, for in 1698 he made a purchase, which, added to a former purchase by a George Witchell, put him in possession of all south and east Kingswood as a manor;

and he built the former manor house on the first site of the Abbey, while he held this till 1757.

I have not traced the inter-relationships of the above.

A number of worthy citizens have been mentioned where they come into the story: Wotton has also produced a criminal whom local legend speaks of as a highwayman: actually he does not deserve even the false glamour of that description.

Will Crewe was born at Wotton in November 1749. When he was fourteen his father died and left him in the care of his mother. After three years of discontented service as apprentice, he opened his professional career by stealing three half-guineas from his sister's money-box: with this he bought a horse, but sold it to get something he wanted worse. He pilfered and cheated, and when things began to get hot enlisted as a marine, was there again caught stealing, but let off prosecution on promising his sergeant to be a good boy. He married a maid-servant for the sake of her £20 savings, spent that, and deserted her. He broke into his grandfather's house three times in two weeks, stole 8 cwt. of cheeses, and "borrowed" his horse to take them away. When a heavy grating was put on the window, Will used a rake to pull the cheeses nearer and then cut them into pieces that would pass through. Being returned to his unit he was given 300 lashes, and deserted again to return to his old life. He had several times been brought before a magistrate at Thornbury, but was acquitted when the victims soft-pedalled their evidence against him or even spoke for him. At thirty-one he lapsed into piety, but did not long remain devout: in fact he soon stole a silver chalice, and rifled the poor-box.

His end ensued from selling a pair of stolen pistols. The buyer was alerted when Will refused an offered drink and bolted, and got frightened of being involved: he gave chase, and caught Will in spite of being threatened with a dung fork. The case was remitted from Salisbury to Gloucester, where he was condemned. On 21st April 1786, when he was thirty-seven, two carts containing ten convicts were driven under the gallows, and after a pause for pious dying speeches driven on. The show was attended by a

large crowd, and there seem to have been as many groans of sympathy as shouts of satisfaction. When he was cut down, his friends were allowed to take the body for burial. The public attitude is also suggested by the fact that two editions of his life, *The Progress of Vice*, were published in the year of his execution.

4

The Church and the Chapels

WHILE nothing in the fabric of the parish church of St. Mary the Virgin is considered older than the thirteenth century, the foundation is certainly more ancient, apart from my surmise of the origin of the town: but the word "church" in records is not precise. When it refers to the building or fabric that is likely to be clear: it may however refer to the patronage (advowson, right of presentation) or the rectory (endowment, sources of income), or to the actual incumbency. I take first the rights, then incumbents, then the fabric.

RECTORIA

The earliest state is recorded by John Smyth from Walter Map, that as part of the royal manor of Berkeley it was in the grant of Berkeley nunnery; that Earl Godwin secured their property and brought about the destruction of the nunnery by organising a mass seduction and disgrace of the nuns. This story has been exploded as "another of Map's amusing fictions": there were no nuns at Berkeley, only an abbey destroyed by the Danes in 910, when the property reverted to the Crown.

No chaplain is mentioned in Domesday. As a member of the manor the church was held from the Crown by the earlier house of Berkeley; they, however, were dispossessed by Henry II even before he actually succeeded to the throne, and the property was subsequently granted to Robert Fitzharding. Even earlier than this, at the consecration and dedication of his abbey of St. Augustine at Bristol in 1148, Robert had been in a position to

endow it with property including the "church and advowson" of Wotton, subject to paying the vicar twenty marks per annum. Shortly after, the abbot presented to the churches, including Wotton, Robert's son Henry, a priest and later Bishop of Exeter: it is likely that he did no more than enjoy the endowment, with a vicar Gerinus, who appears as "persona ecclesiae de Wotton" in witnessing a deed of 1154. A similar situation seems to have occurred in 1321 when James Berkeley was presented by his father Thomas II, apparently on the day of his death 23rd July. He resigned in the course of preferment, and his nephew Eudo who was then presented may well have served, as he died (at Bradley) in 1329 when de Lacy was presented. James was consecrated Bishop of Exeter in 1326 at the demand of Queen Isabel, with the intense disapproval of the Pope who wanted gift of the appointment himself. The abbot of Reading disputed possession of this advowson before the pope in 1167, but the king secured his acquiescence for an annuity of fifty marks.

There is an element of doubt whether the grant to the abbey included the endowment and tithes: the incumbent who was duly presented in 1172 had to pay the abbot three marks per annum and is referred to in a deed of twenty or more years later as "sometime rector of Wotton" (and father of the lady who is one of the parties): the incumbent of 1274 is twice referred to as vicar.

Property in the church reverted to the Berkeleys certainly before 1322, but there is uncertainty about how and when. Miss Tait asserts that the abbot granted the advowson to the Berkeleys in 1307, but she gives no authority. Perkins, too, asserts two (untraced) deeds to this effect. It is a fact that in 1311 the abbot moved the bishop for assent to his appropriating the church, and that this was licensed for a fee of fifty marks. The incumbent who had been regularly presented in 1301 later acquired higher office, and it was the Pope who in 1316 "regularised" his position; the next year, on his having succeeded to a bishopric, it was the Pope who granted the "void rectory" to a foreign cardinal.

The presentation of 1322 was made by Edward II, the Berkeley properties being "in his hands" on Berkeley's having come into

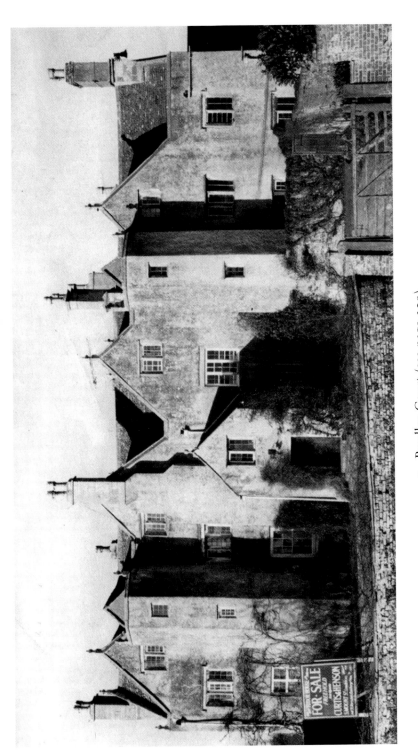

1. Bradley Court (see page 309)

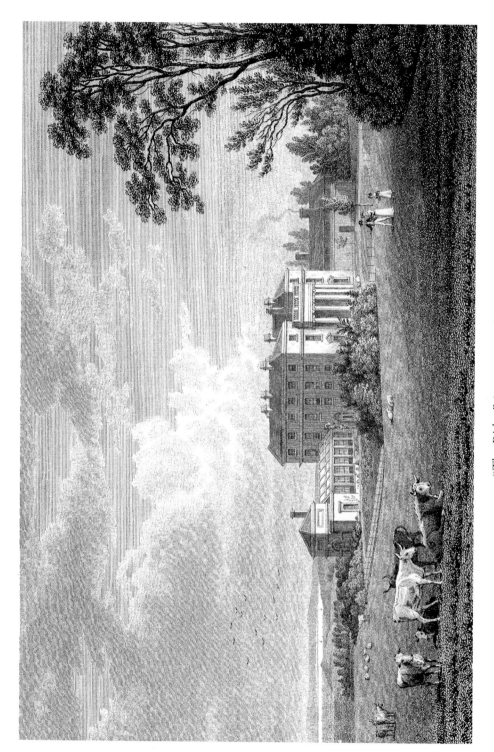

2. "The Ridge" (see page 326)
(From Brewer's Delineations)

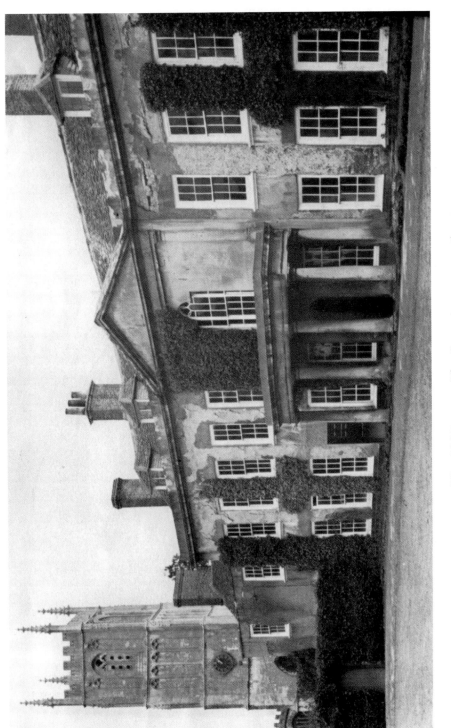

3. The Old Rectory, The Court (see page 126)

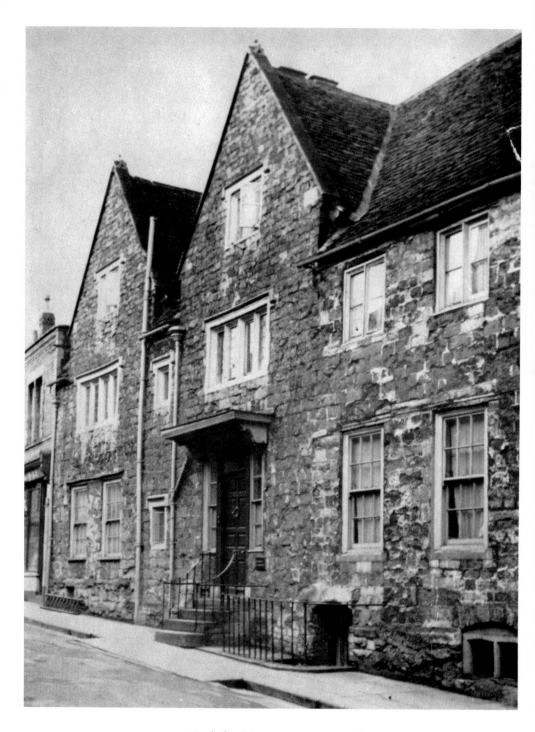

4. Berkeley House (see page 125)

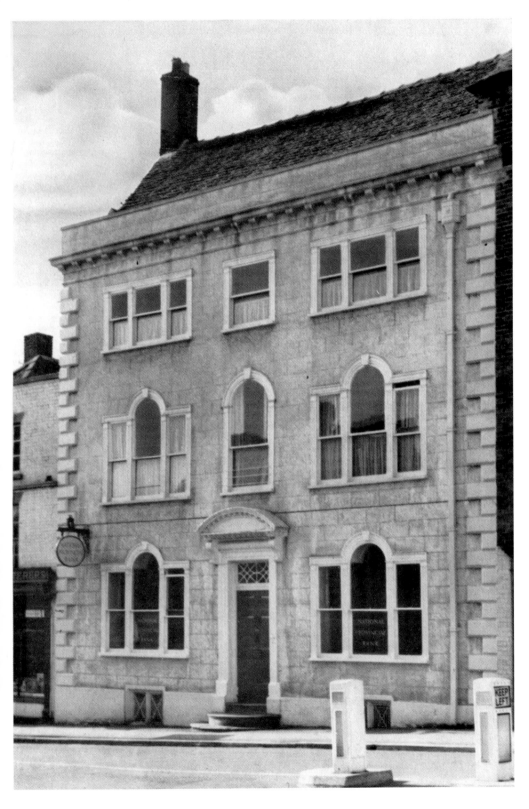

5. National Provincial Bank (see page 132)

6. Austin's New Mills (see page 291)

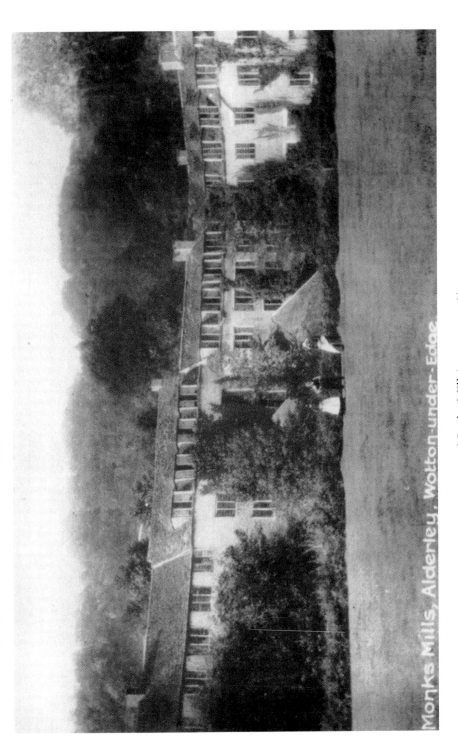

7. Monks Mill (see page 278)

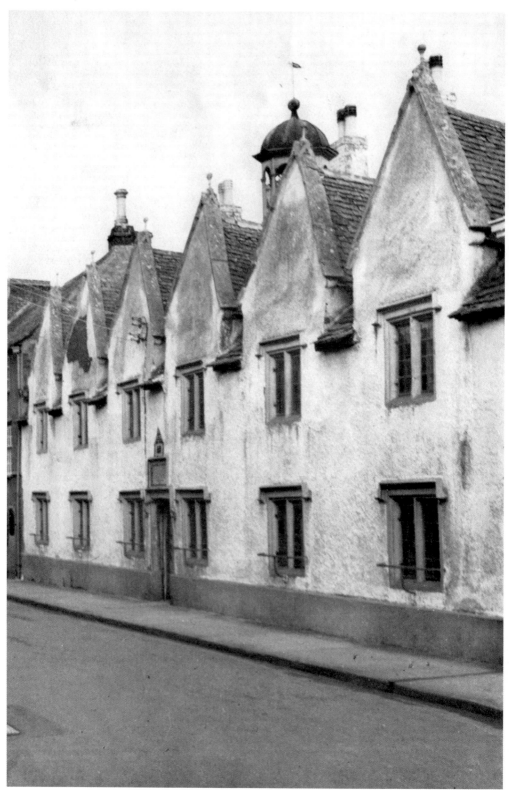

8. Perry Almshouses (see page 212)

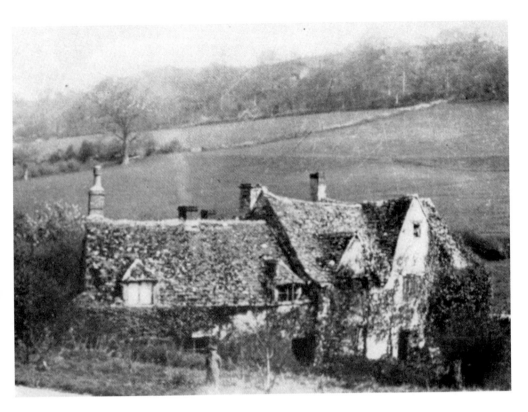

9. "Purnell's", Wortley (see page 268)

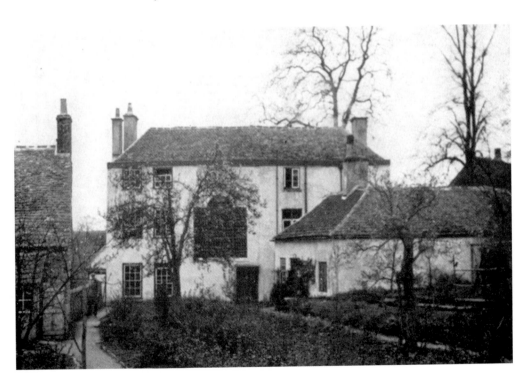

10. Wortley House, back (see page 269)

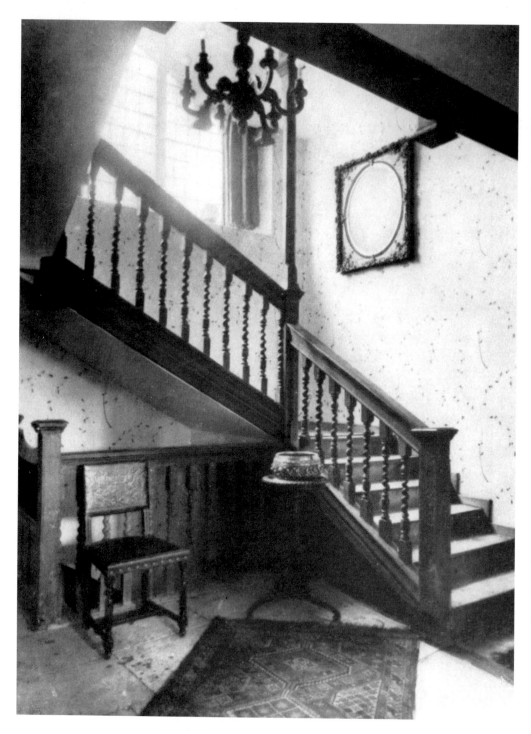

11. Wortley House, stairway (see page 274)

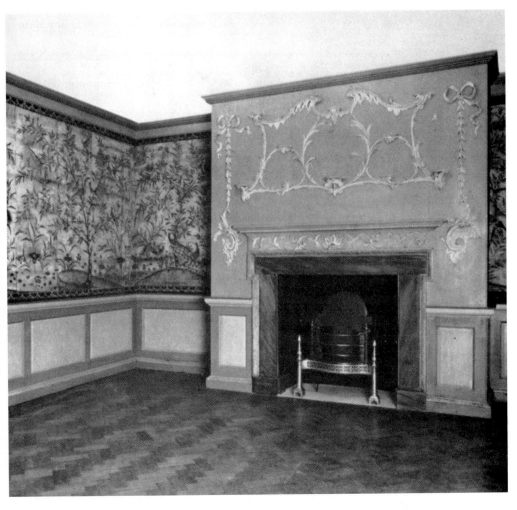

12. Room from Berkeley House (see page 136)

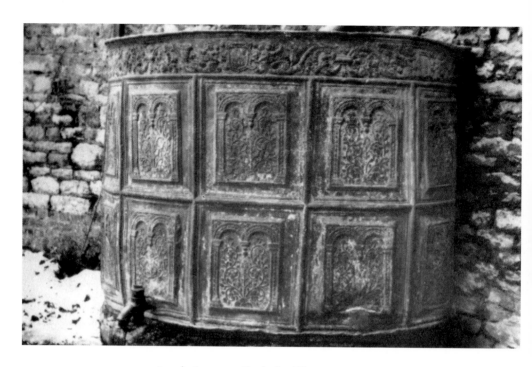

13a. Lead cistern at Berkeley House (see page 136)

13b. Genii loci in Berkeley House (see page 136)

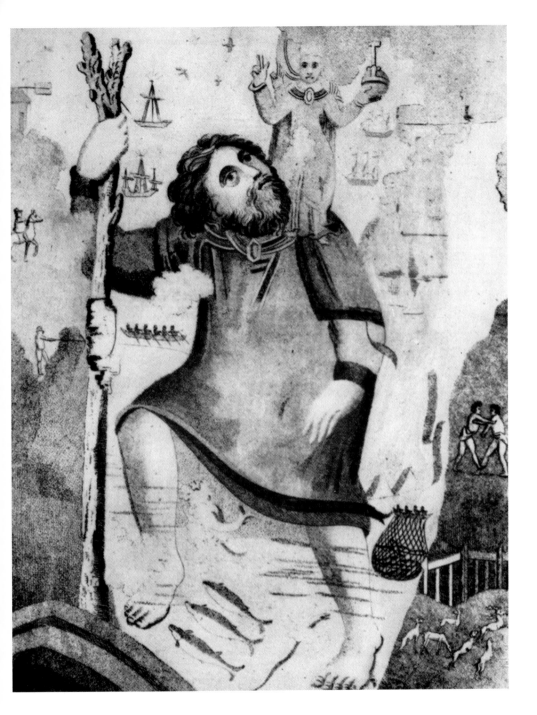

14. The St. Chrispoher mural (see page 187)
(From Fosbrooke's History)

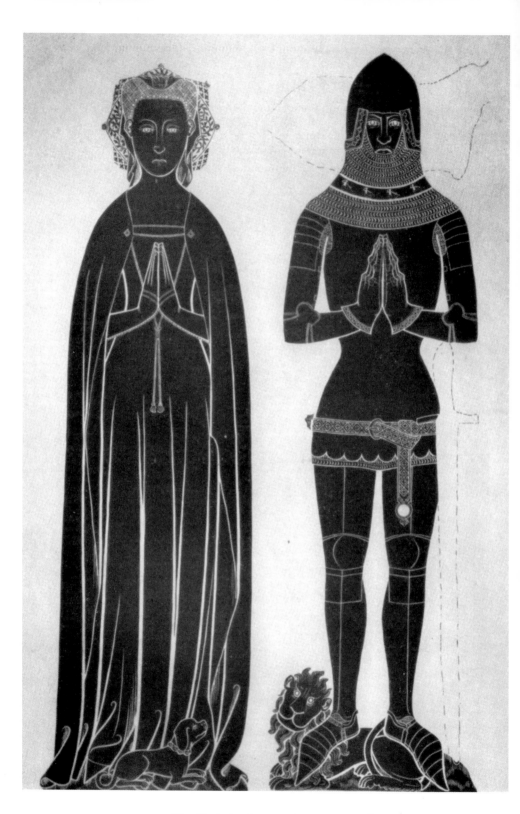

15. The Berkeley brasses (see page 194)

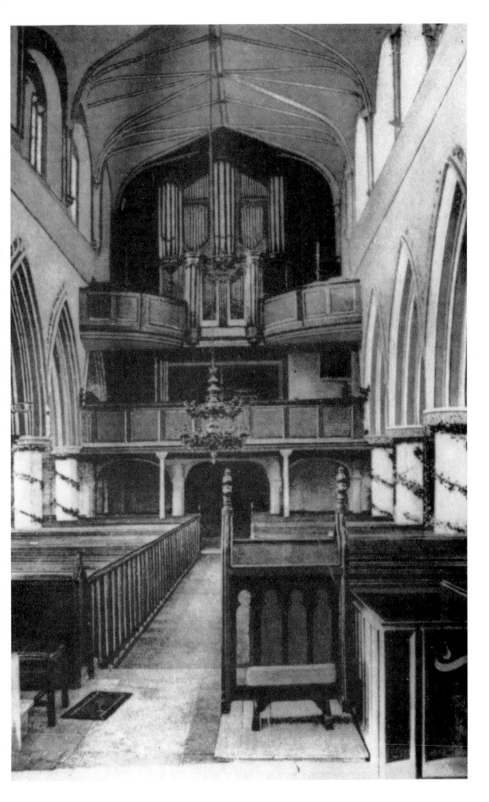

16. Old west-end gallery of the church (see page 174)

17. Round House toll-gate lodge (see page 112)

open opposition. In 1326 and 1368 there is specific mention of Berkeley holding the advowson.

The incumbent of 1375, William Seward, had trouble with an interloper Wells, which was finally settled in Seward's favour by the King in Parliament; then a presentation was made by the Archbishop, and it was he who pronounced on another complaint by Seward. All these men, and their successors, till Berkeley granted the property to Tewkesbury Abbey in 1504, are specifically referred to as rectors.

In 1491, on the death of William Lord Berkeley, the property passed to the Crown, but was recovered by his successor Maurice V in 1504: the latter immediately granted it to Tewkesbury Abbey. The Crown had no vacancy to fill, but no doubt enjoyed the revenues. The Abbey granted first a lease to the vicar for twenty-five years, then in 1521 a thirty-year lease to Hollester and Matston subject to stipends. On the Dissolution and Surrender of the Abbey in 1540 the property again passed to the Crown, and in 1547 was granted to Christ Church, Oxford. On expiry of the Matston lease in 1562, the college divided what related to Nibley and to Wotton, and leased the latter to Robert Biddle (mayor in 1558) who exercised patronage in 1566 and 1578. In 1577 Christ Church had to assert its rights in some unrecorded matter. The College still holds the property, subject now of course to what has been changed by the Tithe Act of 1935.

There is no record of any effect on the church of the dispute with Beauchamp and his successors in claim.

Figures occur which give or suggest the value of the *rectoria* and of the *vicaria* at different dates. The 1291 Taxatio of Pope Nicholas IV gives £35 6s. 8d., of which £5 13s. 4d. was paid the vicar. A 1340 Exchequer Inquest of Nonae (a civil tax said to be based on the ecclesiastical assessment of 1291) assesses the parish on sheaves of corn, calves, and lambs, at £41 13s. 4d. gross: of this £17 3s. 4d. is deductible on account of glebe, hay, the rector's oblations and small tithes, leaving £24 10s. net: and of this 13s. 8d. is payable by the Abbot of Kingswood. The 1504 conveyance to Tewkesbury specifies the allowance to be given the

vicar as £13 6s. 8d. Perkins asserts that the vicar in that year
obtained from the patrons an increase to £35 plus his house, but I
can find no confirmation of this large increase. He also names a
vicar, John Ackson, who is not on record, and there was no
vacancy he might have filled. The abbey did let the rights to the
vicar for their first twenty-five years for £33 per annum, and in
1531 let it to Matston and Hollester for thirty years at the same
rate plus £13 6s. 8d. to the vicar, and the pay of a chaplain at
Nibley and of a deacon at each of the two places. John Smyth,
writing in 1628, is bitter that the abbey "found means to incor-
porate the same and appropriate it to the feeding of themselves",
and that the £13 6s. 8d. "scarce suffices for the bread of those that
serve the altars". He also estimates that the value of this
£13 6s. 8d., paid in fruits and not in cash, had by then risen to
£40. *Valor Ecclesiasticus* in 1535 estimates the value of this
rectoria among the abbey possessions as £55 11s. 2d., and it was
allowed to deduct £19 17s. 10d. for taxation purposes as paid to
the vicar, while the vicar is allowed 7s. off: but a bigger difference
is that a revision of 1550 taxes the vicar on only £13 10s. A
parliamentary survey of 1650 estimates the living as worth
£25 6s. 8d.

In 1839 L. S. Austin, who held a long lease from Christ
Church, was assessed for £542 9s. 8d. in the outer parts as well
as glebe, without mention of the £427 in the Borough shown by
the 1847 Tithe Apportionment: the apparent omission is not
understood.

Christ Church sold the rectorial glebe in 1876: the vicar was
not among the purchasers. The college had granted the leases of
The Court which stands on this glebe: it is not understood how
the vicar came to be the vendor when the house was sold early in
this century.

First Fruits paid by the vicars were the £19 12s. 6d. in 1542,
£13 10s. in 1549, £14 10s. in 1623, £13 10s. in 1641, and £12 3s.
in 1662: the variations after the first are not explained.

In 1710 the market feoffees moved Christ Church to augment
the stipend of the popular vicar Gregory by £10, undertaking to

contribute an equal amount themselves. The proposal was not accepted, but I have reported payments which they made him unilaterally, apparently towards a total of £100 promised him. Also in 1724 Queen Anne's Bounty donated £200 and a Coulston Benefaction £100. Again in 1927 Christ Church donated £200, the diocesan board of finance £100, parishioners £400, and the Ecclesiastical Commissioners £700, totalling £1,400 which was invested, and is described as completing the augmentation of the benefice.

The vicar was also able to enjoy one or more of the six £2 lectureships under the will of Hugh Venn. In 1837 the vicar began to object to nominations of Free Churchmen as lecturers, and now the £12 is simply paid to him, as well as another bequest of £6.

What land the endowment of the church originally included is not known. The 1763 survey of the borough shows none, nor does the 1839 assessment to poor rate over the whole parish, while the 1847 tithe map leaves blank what the impropriators were interested in, the whole triangle west of the church. The only known fact is that there were three cottages and a plot of land in Wortley, which Hale of Alderley bought in 1876.

Rectorial tithes amounted to £969 12s. 6d. in 1839. Lestrange Southgate Austin had bought a long lease of these, but for an unknown reason his assessment to poor rate does not include the £427 2s. 10d. of them from the borough. These of course did not benefit the church. There was also rectorial glebe of fifty acres.

Of lesser tithes there is no account or statement. The only records of which I know for the purpose amount to less than the above fifty acres of rectorial glebe, and I do not know if there was any vicarial. It is now all sold.

The church also held a little property given for the fabric. One item was Church House, at the corner of Sym Lane, dealt with in Chapter 5. The house, much modified, still shows slight traces of mediaeval work.

Another property held for fabric repairs is listed as "the house of Edward Wallington in Sim Lane": the 1763 survey shows this

as well as Church House as "Church Lands". This seems to have been the vanished freestanding Osborne house behind the houses lining Long Street, though the marking on the map is not quite clear.

Yet another property was "a tenement by the Horsepool in Synwell", said to have been church property for repairs "since time immemorial". This includes what became the Tan Yard, which the 1763 survey lists as "Hospitall Lands", that is of the almshouses; the Ram Inn, and the land on which in 1763 stood the workhouse, later an infant school and now the mortuary. It was vested by the trust deed of 1767 in the general charities trustees, who are said to have paid the rent over to the church-wardens to apply for repairs, but their accounts which would have shown this are not extant. It was sold in 1825.

Incumbents

An official list of incumbents is displayed in the church: the list that follows contains some revisions. Some of the men have already been commented on sufficiently.

William "clericus de Hesl" is likely to be the same as William Clarke, and, having a daughter was presumably married: his stipend was three marks. Simon in 1274 received licence to obtain consecration of an altar of the Holy Spirit; when in 1289 the bishop committed the church to R. de Vienne, canon of West-bury, on account of the illness and old age of the vicar, and when in 1293 de Chyreton was given custody and inducted, this seems to imply that Simon still held nominal charge. It was Orleton who was regularised by the Pope on achieving higher office, and whose rectory was disposed of also by the Pope on his receiving a see.

Richard of Wotton was presented by Edward II, Berkeley lands being "in his hands" for disaffection. He asked to be buried in the centre of the chancel, the place of honour. From his name and this honour he has been reputed the founder of the church, but it was actually dedicated much earlier by the bishop in 1283.

His burial place was covered by a great ledger stone 7 feet 6 inches by 2 feet 11 inches, removed in one of the church improvements and now relaid under the tower. Round the edge there ran an invocation and epitaph recording that he was born in the town. At the foot a small figure of a praying priest under a canopy with slender shafts "speaks" an invocation to the Virgin seated within a large floriated cross at the top. All this was in separate brass Lombardic letters which have long been removed, but the cavities are legible enough. As he died in 1329 this would have been forty

RICHARD OF WOTTON. 1320. (MATRIX) 7.6 x 2.11.

14. Ledger stone

years earlier than the earliest surviving brass in the county and sixty years earlier than the Berkeley brass here: a serious loss for the sake of a few penny-worth of metal.

The troubles experienced by William Seward have been briefly referred to. Duly instituted in 1375 during a vacancy in the see and forty-five years after the death of the last recorded incumbent, he was in 1386 faced with the presentation of John Dautre by King Richard II, on a (false) allegation that Thomas Berkeley was dead. His petitions were rejected by the church and by the King's Bench: only on the succession of Henry IV in 1399 was he able to obtain a decision by the King in Parliament, annulling Dautre's appointment and restoring him. More chicanery over Dautre's appointment was revealed at this hearing:

Seward (alias Cheddre) had been appointed to "Wotton under Hegge"; Dautre to "Wotton Undyrheg", purporting to be a different place. No explanation is forthcoming of how the archbishop in 1402 came to collate and institute John Charleton and issue a mandate for his induction. Next, in 1404 Seward complained to the archbishop that William Forster, clerk, was taking his tithes and fruits. The archbishop issued an inhibition pending a suit on the matter, but the record goes no further. Six months after the inhibition yet another man, John Welle, was ratified as parson of Wotton: within a month the archbishop appointed a commission to hear the suit between Seward and Welle. Again there is no record of the suit, and all that is known is that in 1410 Welle "Archdeacon of Salop and Rector of Wotton" was dead.

The next gap may have been up to sixty years. When the next man, Harneham, resigned and was awarded a pension determined by an inquisition of no less than ten clerics including his own "parish priest" and the master of the grammar school, and ten laymen, he was immediately succeeded by Looge, who at the end of thirty-five years' incumbency asked to be buried at the north end of the high altar, and made bequests of about £4 and three cows. His will is useful as it was witnessed by a mayor earlier than any recorded elsewhere. The John Ackson whom Perkins asserts as vicar in 1504, during Looge's incumbency, and as having secured an impossibly liberal increase of stipend, is subject of some error which I cannot correct.

"Sir" John Andrews, described as curate but likely to have been vicar, was more advanced towards Puritanism than his congregation, and they charged that in his preaching he described as "folyshe lewd and beggarly ceremonies" what was not yet abrogated by the king; that he refused to hear confessions and give absolution; that he described the "antemps *Salve Regina* and *Et Tuam sub Protectionem* as idolatry and superstition", and that he had admitted an unlicensed preacher, the vicar of Malmesbury, to preach. He was suspended.

Merryman was the first to have to compound for first fruits in 1542. His incumbency was troubled otherwise than by grant of

the advowson to Christ Church near the end of it. In 1543 he complained to the bishop that the Coldwell family were calling him "naughty knave priest": next year he cited Bedyll for not paying tithes on a water-mill of rent £6, and Coldwell on a tuck-mill of £4. Bedle can hardly have been the lessee of the tithes from Christ Church; "Sir" Robert Coldwell, headmaster of the grammar school, is not likely to have been the other defendant, though he was in 1552, when nearly sixty, cited for incontinency and condemned *in absentia* to suspension from entering the church. It may have been another, William Coldwell, an attorney, though he had been executor of Robert Looge's will. Merryman was presented by the churchwardens in 1548 for not distributing the fortieth part of his benefice, and for not keeping a sufficient curate; but a 1547 record lists his curate "Sir" Thomas Stelle-horne: he was old, and a year later died and was buried at Kensington, so may finally have been a pluralist-absentee. This is implied by the complaint of 1548 based on Thomas Cromwell's first injunctions of 1536, which applied only to non-residents.

The first Act of Uniformity was passed in 1549 and Burnell, who was presented in that year, had to swear to renounce the Bishop of Rome, and to give a bond for £100: he lasted for five years, and was then deprived. One can speculate that the congregation still sympathised with "idolatry and superstition" and did not give him away, till an informer or a visitation blew the gaff. According to John Smyth, Lord Berkeley "shortly after his restitution to Wotton in the time of Queen Mary", presented one Knight who was duly inducted. This is bad evidence as the two events are fifty years apart, though the assertion is supported by a deed in the Berkeley muniments. Actually it was the grammar school to which Robert Knight was appointed and which he served: his compounding for first fruits "of the school" is recorded. But he was on the official list of vicars.

On Burnell's deprivation ap Gryffyth was presented, on the same oath, and a bond of only 100 marks: he died or perhaps resigned in 1566. It is uncertain if Adams, who was then presented in June of that year, actually served, for Mower was presented

only six weeks later, who was followed by Pilsworth only a year later, who had to cede in 1578 for having accepted the Osleworth rectory without a dispensation.

Staunton was a noted Puritan, and as such appointed tutor to the four-and-a-half-year-old orphan (Sir) Matthew Hale, by his Puritan uncle and guardian Anthony Kingscote. He was the buyer of the ruin and site of the Manor House.

Nothing is known of the next four men on the list: two of them may not even have served, but there is not sufficient ground for omitting them. Richard Kent the next was reputed a scholar, and was given a last line in Greek in his epitaph. He was among the sixty-six signatories in the county to a Covenant against the Errors Heresies and Blasphemies of the time in 1648: the wording of this Solemn League and Covenant is not forthright, but seems intended as anti-Popery. He died of fever in 1650.

Among the next men Bowden was deprived for noncon-formity on "Black St. Bartholomew's Day", with 1,800 others, and Nant quite shortly resigned for unrecorded reasons. Pye died and Stephens resigned. After him Bigland interposes Samuel Hieron without reference and in fact he was only curate. Bowden's deprivation and perhaps Nant's resignation would have been effects of the Act of Uniformity of 1662. Stephens, then a young man (for in 1683 at the age of thirty-three he was licensed by the bishop to marry Susanna Eyre, a maiden aged seventeen) was required to take an oath in accordance not only with that Act, but also with the articles of religion of 1562 and three articles in Canon 36. His resignation for unrecorded reasons when he was only thirty-seven may have been a personal protest against the coming Act of Toleration of 1688.

Allway, appointed on oaths similar to Stephens's, died in office; then Stockman had to subscribe to oaths of allegiance, supremacy, simony, canonical obedience, and continual residence. Gregory's popularity has been recorded in the financial help that he received: when he died in 1738 the vicarage was sequestered to the churchwardens till Taswell's appointment. Gregory had before this incumbency had an interesting four-year spell as naval

chaplain. He was in *Torbay* of Admiral Rooke's fleet, which broke the nine-foot boom at Vigo and was then set on fire by a fire-ship which blew up under her bows. Most of her crew were blown or jumped overboard, but the rest, with Gregory among them, managed to subdue the fire: in this they were helped by a cloud of the snuff with which the fire-ship had been laden, blown into the air by the explosion. What brought the incident into local records was that the widow of Gregory's son, a minor canon of Durham, gave the chapter library a set of ten pictures of Apostles (in return for a gift of forty-two guineas) which seem to have originated in Gregory's chaplaincy, and enquiries for "the other two" of the set of pictures were made at Wotton.

For twenty of Taswell's thirty-seven years' incumbency he held Almondsbury vicarage as well, under a dispensation from the bishop; this was stated to be worth £20 nominally but £60 actually; Wotton which was worth £13 10s. nominally being worth £100 actually. In 1756 Taswell headed the signatures to a public notice that smallpox was "entirely discharged" from the town, but items in the feoffees' accounts show that this was optimistic. 1756 also shows the payment of 21 guineas by the feoffees towards recasting the peal of eight bells by Rudhall. What Taswell is principally kept in mind by is his memorial, the most ornate in the church, which will be described in due course.

Tattersall made a greater impact, by alterations which are the first of which we have details in the faculty for them. While in 1714 under Gregory and again in 1766 under Taswell, there had been minor measures providing "faculty" seats, there was now greater demand for such, and for a general improvement of seating; beyond that provision had to be made for installing the fine historic organ that Tattersall had seized the opportunity of acquiring, and of giving it a fitting setting. What was done is described in more detail when we come to deal with the church itself. Tattersall is mentioned by Fosbrooke as setting to music Merrick's psalms "as a substitute for Sternhold and Hopkins' collection, made by them with the pious intention (but in vain)

of superseding the indecent songs sung by the courtiers of King Edward VI".

The incumbency unfortunately ended unhappily. Tattersall opposed the actual proposals for the improvements, but unsuccessfully. He appealed to the Court of Arches, and then to the High Court, but was each time unsuccessful: so he ceded. This does not mean that he relinquished office: in 1816 he made a long representation asserting enmity and insults by the wealthier

15. Canon Sewell and the waterworks

parishioners while he was loved by the masses; that Cornwall, the master of the grammar school, was officiating on £60 allowed by him and the £80 salary of the school. In 1822 he nominated a curate at £90, and did not die till 1829. A posthumous verdict comes in the 1850 report of the Charity Commissioners, that "not having been resident in Wotton for some years, he neglected to exercise the control vested him" as trustee.

Benjamin Perkins's activities appear in his attitude to some of the lecturers under the Hugh Perry will, in the account of the

grammar school, and that of his changes in the church: his tolerant treatment of Pitman's most ill-advised protest is much in his favour. He is believed to have been the first to leave the vicarage to his curate and to live himself in Berkeley House.

Sewell went further than Perkins in objecting to lecturers, and did more radical work on the church. While Perkins had almost prohibited burials within the church, Sewell is said to have filled in the burial vaults himself with helpers. He made himself unpopular by his successful advocacy of drainage and water-supply, to which ratepayers objected: he was accordingly caricatured with his big spade beard, and lampooned in unpublishable rhymes. Of the rest it need only be recorded that Hodson left on preferment to the suffraganship of Tewkesbury.

INCUMBENTS OF WOTTON UNDEREDGE

1150 c.	Henry Fitzrobert presented: died 1188.
1154	Gerinus *persona ecclesiae* occurs.
1172?	William Clark presented: possibly identical with:
1193?	William *clericus de Hesle* presented: certainly recorded in 1189.
1274	Simon, became ill and old.
1289	committed to R. de Vienne.
1293	William de Chyreton inducted in custody.
1301–17	Adam of Orleton presented: preferred.
1322–9	Richard of Wotton, died in office.
1329	Peter de Lacy.
1356	Ivo de Clynton of Northfleet by exchange with de Lacy.
1375	William Seward instituted, and restored 1399.
1387	John Dautre presented, but annulled 1398.
1402	John Charleton collated as rector.
1405–10	John Welle ratified; died.
? –1473	John Harneham, resigned on pension.
1473–1508	Robert Looge admitted: died.
1508–9	William Kent admitted: died.
1509	William Fryth admitted: still occurs 1521.
?	Richard Gounde.
1531	Robert Hale on death of Richard Gounde and again 1538.
1540	John Andrews in office.

1542–9	John Merryman admitted; died 1547.
1549–54	Maurice Burnell presented; deprived 1554.
1554–66	Phillip ap Gryffyth presented; died or resigned.
1566	Henry Adams presented 15th June.
1566	John Mower presented 2nd August.
1567–78	Augustin Pilsworth presented; superseded.
1578–1622	John Staunton presented; died 1622.
1626	John Lane succeeded.
1626?	John Singleton occurs.
? –1632	Thomas Osborne occurs.
1633–41	Thomas Ackson instituted; died.
1641	Thomas Heywood instituted.
1641–50	Richard Kent presented; died.
1653–62	Joseph Bowden occurs; deprived.
1662	John Nant presented 10th October.
1662–75	Moore Pye admitted 19th November; died.
1675–87	William Stephens instituted; ceded.
1687–1704	Samuel Allway instituted; died.
1704–7	Thomas Stockman presented.
1707–38	Edward Gregory presented; died.
1738–75	William Taswell succeeds. died.
1775–79	William James instituted; ceded.
1778–1829	William Dechair Tattersall instituted; ceded 1813; died 1829.
1829–81	Benjamin R. Perkins.
1881–1903	Henry Sewell.
1903–6	Lionel Everard Mackinder.
1907–23	Frederick John Greenham.
1923–34	Austin John Hodson; preferred.
1934–	James Donald Buckley.

CURATES

There are some definite records of the employment of curates, and some others can be surmised: I here include the chaplains serving chantries while these existed. These sometimes include the master of the grammar school, which ranked as a chantry so much that it was nearly suppressed at the Dissolution.

A document refers to one Peter de Wotton, chaplain in 1341. The William Forster, clerk, whom Seward cited in 1404 for taking his tithes and fruits is likely to have been a curate, pre-

suming on his office under the cloak of one of the interlopers. In 1473 Walter Stratton is described as parish chaplain when appointed to the inquisition for fixing Harneham's pension. In 1506 "Sir" William de la Warre, parish priest, witnessed the will of Richard Motton. He appears again in the 1509 will of Robert Ellyce as "my confessor", with a bequest of "my best sword and my second pair of beads with silver gauds". The subsidy roll of 1513 taxes at 6s. 8d. each four chaplains, William Smith, Robert Horle, Thomas Elston, and Robert Coldwell: the last was master of the grammar school; the rest are more than the known number of chantry priests at any other time, and are likely to have included or perhaps shared curacy.

1531 affords the first indisputable evidence, in the provision for a deacon in the Matston lease of the *rectoria*. In a 1538 tax-book Robert Heron was curate, and John Breston and Thomas ap Howell "stipendiaries" (in addition to Coldwell in the school). In a survey of charities in 1547 "Sir" Thomas Stellehorne is noted as curate to the vicar Merryman, and "Sir" John Middleton as chantry priest. The Samuel Hieron listed by Bigland as succeeding Stephens in 1687 was actually licensed (as a curate) to preach in 1683: in 1695 Henry Brookes and Nicholas Baker were similarly licensed after making the prescribed declarations on oath, but are not otherwise heard of. The parish registers for the period 1696–1703 have the entries signed by William Deighton, and for 1703–7 by William Bromfield, both describing themselves as "Minister": the latter was in 1704 licensed to serve the cure, but the former is not thus recorded.

Matthew Hale, a direct descendant of Sir Matthew, and later Bishop of Adelaide, began his career as a curate to Perkins in 1838 for a year. Of the latter's incumbency it is also known that he left the vicarage to his curate. It is also remembered that Hodson did without a curate for part of his time, to save money needed for work.

Vincent Perkins has compiled a list of churchwardens: this will not be printed here, but can be seen with the copy of this book deposited in County Records.

BRIEFS

During Gregory's incumbency the church was faced with some calamity grave enough for them to secure a brief for collections in other churches: the response of three has been noted. Warrington in Lancashire raised 11s. 4d. on 16th April 1732, a very good amount compared with their other collections; Stanton St. John, Oxfordshire, raised 2s. 1½d. on 21st May, also a very good amount relatively. It is likely to have been in very prompt response to the same appeal that East Budleigh in Devonshire on the previous 28th July collected 8d., a small sum but good for the parish which lists hundreds of briefs in the years 1669–1816, and got nothing for an appeal from Slimbridge, Gloucestershire, in the last year. In none of these is the cause stated. Nor has mention of any other briefs for Wotton, or of briefs collected there, been found.

FABRIC

The church is of nave with chancel, north and south aisles, all three about 24 feet wide and 90 feet long, with the chancel extended about 12 feet by a sanctuary. The north aisle has an excrescence, traditionally part of the passage to a vanished detached chapel, surviving after alterations as a chapel of St. Catherine. The south aisle is entered by a porch, to which a priest's chamber over was added in 1659, when the porch was rebuilt. The arcades and all this up to sill level of the aisle windows are considered to be of the thirteenth century: this accords well with the recorded date of consecration by the bishop in 1283. As the building will have taken years, and the south arcade looks noticeably earlier than the north, one can even suggest that the building was due to Jone de Somery *domina de Wotton* who lived till 1274. Her husband Thomas I Berkeley had earlier rebuilt the manor house "near the church", but of that church there is no sign: it may conceivably have perished in the legendary conflagration of King John's reign.

The south arcade of alternate round and octangular shafts with

plain capitals, and the north arcade with more elaborate deeply undercut floral capitals, have survived. The first two stages of the tower at the west end of the nave were added in the fourteenth century, and the other stages in the sixteenth century. The first roofs, shown by drip courses at the ends, were three equal steep pitches which must have been stone-tiled.

A first reconstruction is ascribed to the fifteenth century. This included enlargement of the aisle windows all round, and probably construction of a three-light window over the former chancel arch. A drip course shows new roofs with higher springing levels but a lower crest, which were later found to be lead-covered: the object may have been to allow of making a clerestory, but the nave springing level would allow for only about half the height of the present clerestory windows. The chancel roof and walls were not raised with those of the nave. A blocked doorway inside the aisle just east of the porch traditionally led to an exterior chapel dedicated to St. Nicholas, which was probably destroyed at this time to make room for an aisle window.

Next, the roof of the "middle aisle" was found to be unsafe as the ends of the beams had rotted. This is said to have been shortly before 1800, but it is significant that authority for a brief was obtained in 1731, the response to which by several distant parishes is on record. A new roof was built, presumably the present higher one roofed with slates, allowing for the present higher clerestory windows which look as if the old tracery had been re-used on higher mullions. The old lead was sold and paid part of the cost.

Vincent Perkins in his "Notes" ascribes this to shortly before 1800: he names the architect and the pargeter, so that he must have been quoting from documents, but his sources cannot be checked, and his facts may relate to the insertion of a ceiling under the roof which was done about that time. Then in 1804 Samuel Yeats suggested ceiling the aisles to match the nave, and gave £300 towards the cost. Tattersall at this time also did other radical work, relating to fittings rather than fabric.

A minor measure, one of interior repair, had also to be carried

out in 1790: the opening between the old chancel and the south aisle had been spanned by a beam, supported by a pillar which had decayed: this was replaced by an arch as on the north.

Next, under pressure for increased accommodation, Benjamin Perkins in 1838 included the chancel in the nave. This involved demolishing the chancel arch, removing the screens round the chancel, extending the arcades by two bays, raising the roof and walls uniform with the nave, making new clerestory windows in the extension, and a window over the new chancel wall. He also did a lot of work on interior and fittings according to his aesthetic ideas, not affecting the fabric proper. He has recorded how poor the work of inserting the window over the old chancel arch had been: he seems to have had little experience of old masonry work and expected too much, and his description really means random rubble laid in mud-mortar of local sandy soil.

Though Perkins's successor Sewell, among other measures, reversed Perkins's extension of the nave by converting it into a choir, there have been no more radical alterations of the fabric, only of the furniture and fittings, and successive measures of repair of the external stonework which had been allowed to decay seriously.

GALLERY

The most spectacular internal alteration was of the west end. In 1626 Lord Berkeley had given materials and built a gallery across the tower arch. In the late eighteenth century Tattersall greatly extended this "old singing gallery" over most of the first bay of the nave. This had a panelled front with the Berkeley arms in the centre (now preserved in the vestry), and the rest blacked to form a benefactions table. It was approached by a "grand open stair" in the south aisle. A little later an upper gallery was added, the centre containing the fine historic organ which Tattersall bought in 1800, with a balcony bay for singers on each side: it is not known what if any provision there was before that for accompanying the singing. (Plate 16.) There is no record of the cost of this and Tattersall's other work, only a list of subscribers

who include Tattersall himself, and Elizabeth Osborne of Monks Mill, who died in 1797.

The next measure had unhappy results. In 1812 there was an application for a faculty to build a gallery of faculty pews with two ranges of sitting places behind them, at the west end of the north aisle. In spite of Tattersall's opposition this was granted and his protest over-ruled. An appeal to the Court of Arches was referred back with the obvious result, and his appeal to the High Court rejected.

The result was that Tattersall "ceded" and retired to his other living in Westbourne in Sussex, though he did not relinquish control, as recorded in the account of his incumbency. It had been necessary to negotiate with the owners of faculty pews in the galleries. The main difficulty seems to have been with the "singers", a select coterie led by Edward Bearpacker, who claimed a right of veto over new admissions. This new gallery was not actually built until 1815.

The grammar school too had its gallery, built by the school in 1728, just east of the Catherine chapel, reached by steps along the wall from the east.

SEATING

The seating situation on the floor is obscure. Gregory's popularity is likely to have attracted people, but for forty years after his time there is no sign of new provision even for the gentry, when Tattersall began to extend the galleries. Fifty years later Perkins began to do something for the community: in fact, there is mention of "kneeling space" for the Bluecoat school which was only founded in 1715, and this suggests reservation of a section of the standing room for them.

As early as 1692 the deed of sale of Bradley Court reserves "the little seat and joint use of the great seat", and in 1712 the buyer Thomas Dawes obtained a faculty for a further seat in the south aisle. In 1714 appropriation of several personal seats to the houses of their owners was approved. In 1723 Elizabeth Wallington included a pew in church in the lease she gave of a house: in 1766

four men of station were allowed to build pews 8 by 4 feet at the west end of the south aisle: and Tattersall allowed twelve more pews to be built in the nave. The great pew for the mayor and aldermen, with lesser seats for the inferior officers, stood just inside the chancel arch on the north side and carried the mace rest: it was matched on the south by the rectory pew, also with servants' seats. Then in about 1780 the extension of the galleries was begun by Tattersall.

A plan printed by Vincent Perkins in his "Notes", made certainly after 1780 and apparently made when his father's proposals of 1838 were being considered, shows what seems to have been this state: mostly box pews with seats on three sides, some of them "faculty" and some of them seats claimed by prescription. Men and women were separated on opposite sides, and Vincent Perkins could still see where hat-pegs for the men had been plugged into the pillars. Some pews were less roomy, but there was only one block of single-sided pews, where the organ now stands in the south aisle; many more people could have been seated, and there were even open spaces in the aisles.

Perkins's measures of 1838, nine years after he had taken office, were principally to increase seating and were radical. Primarily, the nave was to be extended to include the chancel, which involved removing screens surrounding it, demolishing the chancel arch and wall above it and rebuilding these at the mouth of the sanctuary, raising the chancel walls to agree with those of the nave, inserting windows in them (of perpendicular style) and a window in the new east end wall, extending the arcades by two bays: the mortuary occupying the east end of the north aisle and the grammar school gallery were abolished and the boys given seats "on each side of the altar": all faculty seats on the floor were abolished by negotiation, except four at the west end of the south aisle, and four between the Catherine chapel and north door. The former chancel had to be re-roofed and ceiled to match the nave. The whole was then reseated to better effect, and thrown open "to the poor".

The cost, as also of Perkins's subsequent aesthetic efforts,

was covered by voluntary subscriptions, to which Christ Church
contributed £100: and the town trustees gave £60 for thirty
seats for their tenants. Perkins reported with pride that all this
work was carried out in July to Septem-
ber 1839 without interrupting services,
and with the congregation sitting "bare-
headed in the open air".

Perkins designed and personally
supervised the execution of an ornate
stone font, which was in 1840 placed in
the mouth of the Catherine chapel: this
involved building the present vestry in
the angle between sanctuary and north
aisle. The old plain octagonal font is said
to have been given to Leighterton, but
that is uncertain. Perkins also provided
a similar but extremely massive pulpit-
like lectern, which was placed against the
north side of the new chancel arch in
1850, and a similar pulpit which was
shortly built a little further out on the
south side.

This involved destroying Tattersall's
three-decker pulpit with sounding-board
above and clerk's desk below. The old
oak pews disappeared, probably into
bonfires, as also the mayor's mace rest
and the royal arms from over the chancel
arch. An Early English doorway of the
south porch is said to have been de-
molished.

Some work on the south aisle roof is
shown by a plumber's foot-print mark

16. Mace rest

"R. Keynton 1872"; and the uniformity of the roof suggests
that the whole was relaid.

Perkins's successor, Canon Sewell, almost at once on coming

12

into office initiated alterations which can be described as more ruthless than Perkins's. Popular support was prompt: in April 1881 he was inducted: in December Mr. Waller, the Gloucester architect, presented his report: after examination of the church and an analysis of its history, he made recommendations to effect what Sewell wanted, and roughly estimated the probable cost at £2,500 to £3,000.

In October 1885 Sewell reported completion of the work on nave and chancel, and published a list of the £1,729 collected, which included £400 from Christ Church, £250 from the Warneford trustees, and some other considerable amounts. The work done included the total removal of Tattersall's galleries and the moving of the organ to the east end of the south aisle, exposing the tower arch and west window to view; the reclamation of the former chancel as a choir, with removal of Perkins's massive stone lectern and pulpit to the present positions, and probably their replacement by the present light wrought-iron forms. All wall monuments in the choir were removed and placed over the south door. The seating was again totally revised, and the whole floor laid with a bed of concrete. While Perkins had restricted burial within the church, Sewell totally forbade it, and is said to have filled in the old vaults himself with helpers. In fact, he effected some debatable "restorations", some undoubted improvements of decency and convenience, partly no doubt made possible by a decrease in church attendance, and some outright vandalism, like the ruthless destruction of the Christopher mural painting over the south door. It is also regrettable that in lifting the most valuable gravestone of Richard de Wotton for the concreting, this was broken into three pieces.

At the same time Sewell appealed for a further £1,500 for the work on aisles and tower. There is no account of the raising of this fund, nor of what was done; but Waller's report had mentioned cleaning and repair of the interior stonework and plastering, repair or renewal of stonework of windows, a formal mention of repair of outside stonework, and the provision of drainage along the foot of walls. Heating was also installed. A

reredos was made, reputedly of old oak from the house of Mr. Hooper Organ by the Ropewalk. It makes an error in elementary scholarship: one of four church worthies depicted is Gerinus, the first recorded vicar: though the name is probably a latinisation of Gereint it is here spelt with a C; and as the only mention of him is among the witnesses to an early deed, in the ablative case, he is labelled *Cerino*.

OUTSIDE REPAIRS

Attention to outside repairs must have been perfunctory, for in 1902 Waller's successor, Wood of Gloucester, submitted a most alarming report. In fact the only record of attention at any time is that something was done in 1798 and in 1822 (*temp*. Tattersall) the vestry agreed to an expenditure of £50 on repairing the tower pinnacles and battlements, and a month later a further £25 for taking down and rebuilding the north-west and south-west pinnacles as beyond repair.

Wood reported the tower to be in so dangerous a condition that it needed taking down to cornice level and rebuilding. The cost of such repair he estimated at up to £600. The damage was largely due to the use of iron cramps, and iron stayrods for the pinnacles, which had rusted and split the stone. At the same time Taylors of Loughborough were called in to report on the bells and their gearing. The immediate results were that Wood raised the figure for probable total cost to £1,010, and the bells were silenced after a muffled peal for Queen Victoria's death.

In 1903 Canon Sewell reported successful completion of the work and published a list of subscriptions totalling £1,154, which must have been additional to the £1,500 asked for in 1885. The Warneford trustees (their secretary was named Sewell) gave £100, and an appreciable amount in sums down to 3s. was obtained by collectors with cards. In 1908 it was reported in vestry that the windows in the north aisle and their decayed mullions had been repaired.

In 1925 the vestry received an architect's report from Sidney Barnsley on the condition of the fabric. The patrons undertook

the repairs to the outside of the chancel estimated to cost £50: the church appealed for £1,000 for repairs to roofs, spouting, and heating, itemised as £260 for the exterior, £280 for interior improvements, £325 for a new heating apparatus and £145 for a furnace chamber for it. In digging for this last under the north aisle the tombs were discovered of Hugh Venn, 1620, the benefactor, and of John Barnes, 1693. It was decided to raise the money by an appeal rather than by bazaars and jumble sales: to that end Hodson, the vicar, sat in church all day to receive gifts, and was given no less than £1,275 by 796 persons. The work was completed for £1,070. In 1927 the bell frames were overhauled and repainted. In 1933 electric light was installed.

In 1929 Gimson of Devizes reported leakages in the whole main roof, through loose slates and gaps, wetting the internal plaster ceiling: nothing less than relaying the whole slating would suffice, and he recommended compo instead of iron nails, and for greater safety an undercloak of felt. Gimson had not been able to examine the roof timbers as there was no access. There is no record of what was actually done.

Gimson also reported local leaks in the aisle roofs, called attention to the leading of the clerestory windows where a few mullions needed replacement, while pointing would suffice for most, and pointing all round the exterior. He also recommended guttering round the feet of walls, as Waller had recommended in 1885. The only record of the raising of funds is a letter from the Warneford trustees granting £50 towards the estimated £300, of which £200 had been for the main roof.

It looks as if the recommendations about clerestory windows had been optimistic and had been ignored, for only a year later a younger Waller, Colonel Waller till recently the diocesan architect, reported widespread splitting of the stonework by the iron tiebars, and recommended their replacement with Delta metal. The leading, too, still needed attention: also the east window of the north aisle. Waller also recommended that the font, which had in 1885 been moved from the Catherine chapel to a position under the tower, was badly placed and should be moved

to just inside the south door; also that the Richard de Wotton stone, which had stood against the wall of the north aisle since Sewell took it up, be laid in the middle of the tower chamber when the font was moved: these two last measures have now been carried out, thirty years later.

In 1955 it was reported at vestry that the whole church, excluding the roof, had been thoroughly treated against the death-watch beetle. Unfortunately it is the roof timbers that are most exposed to that risk. Some small items of expenditure, including one of £131 17s. 3d. next year, probably relate to this. In 1957 the south side of the sanctuary was reroofed for £237 5s. 9d., apparently by the vestry and not the patrons. Last year the present vicar spent £951 19s. 6d., mostly on redecorating the interior. In spite of all the above, a few days ago there was a pool of rain-water on the floor from a severe leak over the north arcade.

The Porch

The porch, ascribed to the thirteenth century like the body of the church, has a priest's chamber (wrongly called a "parvise") over it. The statues which occupied the two niches flanking the typical window have gone. A stone dated 1658 with church-wardens' initials R.D and R.W. marks a rebuilding: there is a sundial over the window, the undated gift of a Biddle. The porch has the old stone benches along the sides. The chamber has a squint, now blocked by one of the monuments moved there: it contains a library of 300 early theological and other works.

The porch used to be fitted with a pair of wrought-iron gates, which Sewell abolished: they were of sufficient interest for the later Major Beaver, then of Edbrooke House, to rescue them and place them in the care of a prominent Long Street shopkeeper. When I heard of them seventy years later, the family who still kept the shop knew nothing of them. Vincent Perkins asserts that an Early English doorway was at some time removed from the porch and also that a statue of the Virgin used to stand over the inner doorway, but had decayed and disappeared long before.

CHANTRY CHAPELS

Early historians mention chantries of St. Mary (Our Lady Service), St. Catherine, St. Nicholas, and Holy Cross. Parsons further mentions one of All Souls, of which nothing further is known. That of the Holy Cross is likely to be a misunderstanding of the licence granted to the Crutched Friars in 1349, dealt with in my account of schools below; that of St. Nicholas is, traditionally, one that existed just east of the south porch as shown by a blocked doorway in the aisle, presumed demolished in the fifteenth century to make room for a window. Our Lady Service cannot be identified but is likely to have been at the east end of one of the aisles, where piscinas survive. It is said to have been founded and endowed by persons unknown, to keep a priest singing for their souls and to aid the curate: but later the 110s. 8d. was found insufficient, and the parishioners used it for the curate. At the Suppression, Sir John Thynne of Longleat and Lawrence Hyde applied for a grant: the property included the "small chamber called the priest's chamber in Wotton", and the rest is described as "small cottages in tenure of poor men and ruinous", in the hope of getting it cheap. The Thynne grant included the Lampelands, given by an unknown donor "to keep a lamp burning before the altar": it consisted of land in Wortley worth 17s., including a meadow with the quaint name of Ymphay: this income had been diverted to a yearly distribution to poor people.

The Catherine chapel is the best known. There is a tradition that what still exists was a passage to a detached and vanished chapel, which Hodson records on a plan as a building 18 by 36 feet adjoining the square end of the chapel as first recorded: his authority for this reconstruction is not known. In 1780 the square end was reconstructed as an apse, and the chapel used as a vestry. In 1840 the font was moved to a position in the entrance practically blocking it, so that the present vestry in the angle between sanctuary and north aisle had to be built. In digging foundations for the font very broken tiles were found with St. Catherine's

wheel, showing that the dedication was old. Others with Berkeley arms suggested Katherine Lady Berkeley, and to some extent justified the fact that the saint is here generally spelt with a K. The entrance arch seems then to have been found unsafe and was lined with a supporting arch. In 1885 the font was removed to the tower chamber, and the floor was lowered to that of the aisle. In 1928 the plaster ceiling had fallen and was replaced by an oak roof; the arch supporting the entrance was also found unsafe, and the entrance was opened to its present full width and re-arched. An altar and reredos were placed against the north end, and the piscina moved from its former position serving a vanished altar at the east. An aumbry for Reservation of the Sacrament was made, but to be used only for carrying Communion to the sick. All this work, costing some £600, was an anonymous gift, but was known to be due to Sir Stanley and Lady Tubbs. It was consecrated by Bishop Headlam in December of that year. Then a candelabrum was presented in memory of Charles Wells, long a churchwarden, and the British Legion presented a Book of the Fallen. The chapel is now used for the Daily Offices.

The name of the foundress of the grammar school being spelt with a K, the same usage has been followed fairly generally for this chapel too. There is mention also of a Berkeley chapel in the church. The possibility that it was this is supported by the fact that in one of the diggings of the floor, broken tiles with the Berkeley arms (as well as some with the Catherine wheel) were found. It may be supported by the absence of any endowment, and the fact that the foundation deed of the grammar school ordained that the (clerical) master should sing masses "in the church". It has also been suggested that the east end of the south aisle was the Berkeley chapel, on the strength of a blocked door-way in the angle between that aisle and the sanctuary, which would have afforded convenient access from their Manor House: this is not impossible, for attendance at services as distinct from the chantry singing of masses. A suggestion that it used to stand in the angle between that aisle and the sanctuary and has disap-peared seems to stem from no more than the existence of a

"leppers' squint" in the south wall of the sanctuary, and is not considered likely.

There was also a chantry-chapel, outside and independent of the church, in Wortley; this is described in the chapter on that hamlet.

That there was a private chantry-chapel in the Manor House is shown by the original statutes of the grammar school: they provide that the priest-master shall celebrate in it during residence of any of the family, for the souls of all the family, without any stipend beyond that as master, and otherwise in the parish church. I have also in the appropriate place recorded the licence in 1275 to Elias de Combe to build an oratory in his house at Combe, subject to the church.

The chaplains of these chantries are not distinguished from the curates whom I have listed, only "Sir" John Middleton being specified as a chantry priest. Suppression records show that at the time the Wortley incumbency was held by John Collins, about forty years old and parson of Littleton (upon Severn) and Oldstone (Olveston) besides. In 1548 the churchwardens and others, in the hope of getting the endowment at the impending Suppression, petitioned that he did nothing for the three pounds odd that he drew in the name of a chantry: but the Wortley men testified that services had been held till recently, and the petitioners were disappointed.

CHURCHYARD

The churchyard was, at some date after 1763, extended by taking in a strip about 20 yards wide between its east boundary and the lane leading to the Manor House, which contained a house and garden belonging to Lord Berkeley, occupier unknown. The pair of buildings at the main road end of this lane, shown by the 1763 map, may have been the "Keep Gate" of the manor house.

A sanitary inspection of the town in 1854 revealed an incredible and long-standing state of affairs in the churchyard. The vicar produced a note of 1783 in the parish books by Tattersall: "more

like a dunghill or tip for rubbish and filth . . . the graves so shallow that if horses got in they often broke the coffins". A neat plan in the register at that date shows that he tidied it up. In 1854 Perkins reported that it was still extremely overcrowded and in a disgraceful condition: before his time, "often no more than 20 inches of soil was left above coffins, but now it is rarely less than 3 feet."

In 1910 the then owner of the Manor House objected to the sanitary state, the house being at a lower level, and an inspector advised against further burials in the south-east and nearest part of the yard. In 1913 an Order in Council stopped burials in the old part of the yard, though brick graves could be opened if more than 50 feet from the house. It was not till July 1921 that the church portion of the new cemetery was consecrated by the bishop.

LESSER FEATURES

Of lesser features, there is just inside the north door a piscina-like recess, but at floor level: the only suggestion for its use is Vincent Perkins's surmise that it may have been for pilgrims to wash their feet at entry. There are piscinas to the right of the main altar, and of the surmised altars in both aisles and in the Catherine chapel. To the left of the main altar a stone bracket may be a credence, but its workman-ship and perhaps its nor-thern position suggest that it is not old. The "lepers' squint" in the sanctuary

17. "Foot-bath"?

has been referred to. No signs of a rood loft or of access to it have survived Perkins's destruction of the chancel arch.

The ceiling has a full outfit of floral roof bosses, large on the main and smaller on the subsidiary crossings. In the area affected

18. Roof bosses

by removal of the old chancel arch there are three pictorial bosses: over the chancel rail, one popularly named "the Great Tithes swallowing the Lesser" but correctly "the Devil chewing Judas",

19. Hood stop

a not uncommon subject: to the east is one that looks like a goose brooding, and to the west one that looks like a swan alighting.

There are some quite nice corbels, but only of hackneyed subjects, and in the main only of later reconstructions. There is an interesting hood stop over the vestry door, "the silent wife", thoroughly gagged.

No consecration crosses are visible inside or out.

The survey of mass-dials in the county describes a good well-cut dial on a corner angle stone of the west side of the porch, with nine long rays and a deep style hole: a late dial, and as it is 10 feet from the ground it must have been a sun- and not a mass-dial.

Mural Paintings

Few will disagree with those who severely blame Sewell for destroying the large mural painting of St. Christopher over the south door, to accommodate the monuments which he removed from the chancel (Plate 14.) A plate in Fosbrooke's history of 1807 shows it, already a little damaged by scaling of the plaster. It has the traditional windmill, and apparently two mermaids, while the hermit's cell seems to be represented by the platform on to which the saint is stepping. Perkins at first said this had been on the west end wall, and that was the general tradition. The gallery would have prevented Fosbrooke from seeing it there, and later Perkins recognised that it had been over the south door, as I found independently. The traditional position is facing the main entrance, to catch the eye of travellers entering and give them safe journey: the "foot-bath" inside the north door makes a slight suggestion that that was used as the entrance, but at Beverston too this subject was in the same position, and there is no north door at all there.

What was held to support the tradition of the west end position is a faint shadow on the north-west corner, where painting on the plaster which has been scaled off penetrated to the stone: but this is recognisable as a figure of Death with staff and dart. This was an Elizabethan subject, often used with texts in Gothic letters to cover the earlier "popish and idolatrous" paintings: it was often balanced by a Time on the south-west corner, but this does not occur here.

The Organ

Of fittings, there is nothing to add to what has been said about pulpits, reading desks, reredos and fonts. Tattersall's great extensions of galleries at the west end have been described. The organ that they incorporated came from St. Martin's-in-the-Fields: King George I had accepted office as churchwarden, but got tired of it after only three months, and gave £1,500 for the organ as a solace. The contract went to Christopher Schrider, son-in-law

and best workman and successor to the famous Father Smith, and this was one of his first and best works. The original specification is said to be in the cope chest under the organ case. It was described as in the cathedral style, with a separate choir organ in front; and to contain twenty-two stops, three manuals, and pedals. The diapasons were considered Schrider's best work.

Of the King's gift of £1,500, £1,300 was paid for building it, while the rest went in fees and gifts, and the inevitable dinner. Following neglect, the churchwardens in 1799 considered alternative proposals from William Gray: one to repair and enlarge the organ for 350 guineas, the other to build a new one for 600 guineas and allow 100 guineas for the old one. In the hope of getting a better price for it the churchwardens advertised, and it was bought by Tattersall for £200 got by voluntary contributions. It was set up in the gallery, still with the choir organ in a separate case behind the organist. Not long after, the vestry was unfortunately persuaded to dispose of several stops on the plea that the organ was too large, among them a very fine bassoon and vox humana.

Slight additions were also made, until in 1822 Sewell pulled down the whole of the galleries and rebuilt the organ at its present position at the east end of the south aisle. More additions and alterations were made, with yet more in 1899 and 1906 at a cost of £300. In 1937 more extensive work had become necessary, and under Hodson £1,000 was spent on preservation, including the old pipework, a new console and improvements including pneumatic action. At the move the choir organ had been placed clear of the console, in the middle of the works: during the later work by Percy Daniell of Clevedon it was found that the pipes of some sets had at some time been scattered, and this was put right. An electric blower has now been fitted. I found a bundle of several tiny pipes in the safe over the porch.

THE BELLS

The mishaps with the bells have been referred to, as also their casting or recasting by Rudhall of Gloucester in 1756: they were

eight in number, ranging from the 3 feet 10½ inches of the tenor down to the 2 feet 3½ inches of the treble, weights not recorded: they bear inscriptions of the usual kind.

The 1902 report had been that all the gearing from wheels to clappers was so worn and dilapidated that ringing was quite unsafe. The wooden frame had been made too light in the first instance, had later been cut away to clear the swing of the bells, and had also decayed. So a frame of steel girders was submitted, and placed five feet lower. At Longborough two bells were recast, one having cracked in transit and the treble to bring it into tune.

20. Rudhall bell-mark

The bells chimed the tune "Hanover" ("Ye servants of God") every three hours of daylight, certainly up to 1897, though one note could only be rung a semitone out. Taylors quoted £80 for a new bell to correct this, and their estimate included fitting the chime hammers to the new frame: but the chime was abandoned.

The mechanism has just again been found badly in need of attention, and the bells have again been to Loughborough: the cost of £441, which includes putting the bells on ball bearings, was quickly raised by the energy of a warden who is also captain of the tower. Chiming has also been restored in the form of the Westminster chimes at the quarters, and striking the hours: this is not disturbingly loud.

GLASS

The stained glass in some of the windows is all modern and undistinguished. Fosbrooke records that earlier the arms of Berkeleys, Lisles and Teys, and of the kings of Denmark to whom Abbot Newland (erroneously) traced back the Berkeley pedigree, had been placed in "the South window": but that and any other old glass has long since disappeared.

CHANDELIER

In the aisle hangs a fine brass chandelier presented by William Moore in 1763: it has two tiers, each with twelve arms and an

ornamented stem. It is still fitted with candles which are lighted only for festivals. In 1926 it was declared unsafe and was taken down, and left till two years later an estimate of £14 10s. was obtained from a London firm for reconditioning and rehanging it. The only pity is that, as hung, it is inconvenient for regular cleaning and polishing, so that its full effect is lost. William Moore moved to Abingdon, and is said in 1770 to have presented a similar chandelier which hangs there, of whose actual origin there is no record: but it is not a fascimile, being plainer and having only ten branches in each of the two tiers.

Plate

The church plate goes back to 1591, when parishes were ordered to provide chalices sufficient for all communicants and not only the priest. It would seem that orderly care for them was neglected, for only in 1907, a new archdeacon visited shortly after the induction of Greenham, and "suggested" an inventory: then it was necessary to get from Canon Sewell, who had retired four years earlier, an order of release on the bank in which the plate was deposited in his name. It is worth mentioning that when, a few years ago, I was collecting the data for a catalogue of church records in the county, I found few parishes with inventories.

The plate consists of:

An Elizabethan chalice and paten-cover, well preserved, date 1591, weight 12 oz. 6 dwt.

A chalice and paten, copies of the above, originally silver-gilt, date 1679, weight 13 oz. 4 dwt.

A credence paten by the same maker, date letters obliterated, given 1686, inscribed in dotted letters "The gift of Mrs. Sarah Winston"; diameters 10 inches and 4 inches, weight 15 oz. 9 dwt.

Another credence paten; ornamental rim, the sacred monogram with rays in centre; inscribed "the gift of Mrs. Ann Moore 1765"; diameters 9¾ inches and 3¾ inches, weight 20 oz. 1 dwt.

A credence paten, similar to Mrs. Winston's given by vicar Perkins five years before his retirement and on his eightieth birthday, inscribed accordingly, date-mark, size and weight not given.

A 9 in. high chalice with large paten; on foot a *cross patee* in a circle, repeated on the paten; given by Osborne Dauncey in 1881.

Facsimiles of the last made in 1896 from two alms dishes, recording these as *"ex dono Osborne* (Richard Osborne the younger, of Wortley House in 1748 gave two silver collection plates) *et Biddle"* (gift not recorded).

Two tankard flagons with rather sloping sides, large handles and flat tops, inscribed "The gift of Sir Richard Fenn, Knight and Alderman of the City of London, deceased anno 1639", and his arms, *crest a dragon's head erased azure; quarterly 1 and 4 argent on a fess within a bordure engrailed azure three escallops of the first (Fenn); 2 and 3 three battleaxes;* height 11½ inches, diameters 4½ and 7½ inches, weights of each 49 oz. 4 dwt.

REGISTERS

Entries have not been copied into the parish registers back to 1538, the date of Thomas Cromwell's introduction of registration; nor even to 1558, the alternative given by the 1598 order for new parchment registers; but only to 1571. Apart from my own examination, they have been thoroughly scrutinised by Vincent Perkins who, with his daughter Edith, transcribed them for the Hockaday Abstracts at Gloucester, supplying missing entries which were in the diocesan transcripts. He also gave the church a transcript register of the first volume which runs to 1659, and of the second volume (which runs to 1747) down to 1715. The original earlier paper registers have not survived.

The period 1585–99, covered by the incumbency of the puritan John Staunton 1578–1622, is blank but for some baptismal entries in the last year. The period 1653–58, when registration was transferred from the church incumbents to elected civil "Registers" is defective; the batches of entries are scattered and mixed, rather illiterate, and the headings often wrong. When in 1753 "Lord Hardwick's Act" ordered the recording of marriages in special books, with more particulars, directed to checking elopements without parental consent, the entries were made only on loose sheets which have been inserted in the register. The churchwardens seem to have provided the new registers of printed forms

only in 1769. Specification that burials had been in woollen, as demanded by Acts of 1666 and 1668, seems to have been observed.

At times the register seems to have been kept by the clerk: thus till 1653 the writing does not seem to change. There is a change of hand at 1661–2, which may be due to the Restoration and a change of incumbency, but there are also signs of some supervision: thus there are several blank pages at 1674–5, crossed and endorsed later,

"Would not bear ink, Wm. Stephens 7–2–1679" (1680), the vicar, with a still later endorsement,

"Stupid and false, Wm. T. 1747"

which supports a certain arrogance in Taswell, of which something in his entries had given me a vague impression. An endorsement

"the end of the register by Henry Brookes minister 1694",

who was not vicar, seems to mark the end of a curacy, but the writing does not change until 1695–6, when there was no change of vicar, and the register continues to 1747. Then William Deighton, minister but not vicar, signs yearly from 1697 to 1704; and Bromfield, also not vicar, continues signing yearly till 1708, while the same writing continues. The annual signing is then continued by the vicar Gregory, who counts the annual entries but is not writing them.

A note against a baptismal entry in 1634 of Peter, son of Margaret Seborne, suggests that vicar Ackson was of a kindly and tolerant disposition:

"an innocent who could never reveile the father of the child, through ignorance and not wilfulness".

This is matched by a baptismal entry of vicar Gregory's in 1710, with what lay behind it:

"Charity Hay, a girl found in ye Feild."

In 1929–30 the vicar was faced with a problem in registration. He had in 1926 married M—— P—— to W—— H—— C——: she later notified the vicar that his real name was B——, and

he had said he was afraid his family would find out and stop the marriage: he had left her after only about a year. After consulting Goldingham, the solicitor, the vicar advised that a note be entered in the register, and that the wife should use both names.

VESTRY RECORDS

Wotton has practically nothing of the other records that one expects to find in the parish chest. Of vestry minutes there is only one book for the period 1822–43: but at some time within the last thirty years I have myself made a note about the year 1804 from a previous book which is not now to be found. Vincent Perkins, on being appointed churchwarden in 1907, started a book and continued it till he retired in 1909: it was continued by his successors till Hodson became vicar, when the latter continued it as a series of notes, not minutes, till 1928, after which he only inserted relevant press cuttings. It was then discontinued by his successor, but survives in private hands. Now a new warden has started a fresh book in 1955.

There are no books of churchwardens' accounts. Atkyns and the Parsons MS. quote from the "church book" that in 1494 the church ale yielded 36s. for repairs; Fosbrooke attributes to John Smyth a number of quotations (which I cannot trace) from the churchwardens' accounts 1449–1509: receipts included these church ales, from outlawries, gifts to light and so on: expenses were mostly for repairs, but included keeping the clock and blowing the organ.

The chest also includes a few miscellaneous books such as the accounts of the Hugh Perry almshouses, 1663–1704, the Sunday school cash-book, 1813–1850, the minutes and the ledger of the Bearpacker almshouses from 1837 to the present day, a collection of faculties, and routine church (service, etc.) books. Records of the overseers of the poor should also be in the chest, but seem to have been handed over to the guardians after these were instituted in 1834; but the book of their accounts, 1695–1757, remained in the hands of the general charities trustees, who were also able to

13

buy for 4 guineas the book of assessment to poor rate for 1839; both these last are now in County Records. A number of the apprenticeship indentures initiated by the overseers are in various private hands.

MONUMENTS

Of monuments in the church the best known is the table (Plate 15) tomb with brasses of Thomas IV Berkeley and his wife Margaret. Some facts about him have been mentioned in describing the badges in the Court House. John Smyth gives an extensive account of him; of shorter accounts a good one appears in the *Notes and Queries* article on the brass. His most weighty act was probably in connection with the deposition of King Richard II, when he was chosen as the baron among the representatives to announce the deposition. Margaret was daughter of Gerard Warren Lord de Lisle, which accounts for the arms of Lisle, and Tyes (her mother's) which Fosbrooke records as formerly in a church window here. The marriage was arranged when she was only seven, and it was agreed that she should remain with her family for four years: but the father, Maurice IV Berkeley became so ill as the long-term result of his wounds at Poitiers that they were married then, he being only fifteen. She died in 1392 aged about thirty, and Thomas remained so constant that he never married again. When he too died in 1417 he was buried here and her remains were translated here.

They had no son and heir, only one daughter, Elizabeth, who married Richard Beauchamp, Earl of Warwick: this, and the fact that Thomas left no will of estates, opened the way to the disastrous dispute of nearly two hundred years between the Berkeleys and the successors in title of Beauchamp.

The tomb used to stand in the middle of the north aisle just west of the Catherine chapel: it was moved to its present position at the east end of that aisle, formerly partitioned off as a mortuary, in the course of Sewell's alterations.

The brasses, in the absence of inscriptions which were already missing in John Smyth's time, are dated to the time of the Lady

Margaret's death. There is only one earlier brass in the county, and apparently only two more before Thomas's death. Their beauty, and the detail in which the costumes and armour are portrayed, very fully described in the *Notes and Queries* article, make them of extreme interest apart from their age: but the description is too long to quote here, and my illustration must suffice. In addition to the inscription, the *heaume* under his head, his sword and dagger, and perhaps his shield, have disappeared. The brass must have been made in the same workshop as that of Lady (Isabel) Russell at Durham, for the little dog with its collar of bells is identical, but in reverse.

Even earlier is the grave-stone of Richard de Wotton, a vicar who died in 1320: if the surviving ledger stone had not been unforgivably robbed of all the brass insets, it would have been an extreme rarity, especially as devoted to an ecclesiastic.

The wall monuments have been examined by Mr. James Irvine with a view to tracing their authorship; he has placed his notes in my hands for dealing with that aspect. Of these the most noted is that of vicar Taswell who died in 1775: there is nothing to add to what has already been written about him. The monument is signed "Giuseppe Marcelli, sculptore Romano". Even by widespread enquiries Mr. Irvine has not been able to find any trace of him: as the monument is of a type of which many examples can be seen in the Campo Santo of any Italian city, he is likely to have been a monumental mason, such as have their workyards at the gates of many cemeteries. The tradition is that this was being shipped somewhere, was taken by a privateer, and was bought by the Taswell family who, no doubt, considered it elegant and fitting. The monument was erected on the south wall at the east end of the chancel where it can be seen in the photograph of Benjamin Perkins's cherished pulpit printed in Vincent Perkins's "Notes". When Sewell cleared the chancel, he moved it to its present position over the south porch, to the detriment of the St. Christopher mural painting. The subject shows a figure commonly described as Hymen, holding an inverted torch and pensively leaning against a pyramid with an urn on it. I made the obvious correction

of Hymen to Thanatos, and this has received an unexpected esoteric amplification. Edgar Wind in *Pagan Mysteries in the Renaissance*, discussing the philosophies of the neo-Platonists, describes them going so far as to equate Thanatos with the *Funeral Eros*: "Slumbering there he stands, holding his torch downward, crossing his legs": this precisely describes the figure.

There is no more statuary in the church, only memorial slabs with some decoration. They begin about 1650, though one commemorates two earlier deaths: they then become quite frequent. Among the very earliest is one to "Deare Kent" the vicar, at the west end of the north aisle, whose scholarship is given the tribute of a final line of his epitaph in Greek. The most noted sculptor represented is Sir Henry Cheere (1703–81), a pupil of Scheemakers and patron of Roubiliac, who was responsible for many monuments in Westminster Abbey. Cheere has not actually signed it, but Mrs. Esdaile attributes to him a monument by the vestry door, which Mr. Rupert Gunnis more cautiously describes as "good Bristol or Bath work". It has been moved to its present position from the chancel by Sewell. The subject, Mrs. Mary Blagden, 1686–1761, had married into a junior branch of the Nind family: she was daughter of the first Daniel Adey of Combe. Another monument, also unsigned but attributed to Cheere's Bristol school, is that of Mrs. Ann Moore of Sinwell, 1690–1765, a family interrelated with the Adeys: this tablet, now also by the vestry door, is unaccountably not recorded by Bigland. Another of the same origin is that of Robert Webb, of about 1660, with a coat of arms, and a long Latin epitaph, mostly about the 40s. per annum charity charged on the Grange Farm in Kingswood which he left by will: this too has been moved from the chancel to a position behind the organ. Another is signed by F. Curtis of Bristol, of whom only three other signed monuments are known. This stood in the chancel and has been moved to the south-west corner of the north aisle. It commemorates Thomas Rous, 1677–1737, and his wife Jane, 1671–1740, while that of his son stood near it with the family arms and a long Latin eulogy: my account of the Old Rectory shows his importance for India.

Another Bristol work is the monument of John Nelmes, 1681–1742, last of the name to hold Bradley Court, and his wife Elizabeth, 1688–1713, and daughter Elizabeth, 1710–78, erected by the daughter Mary Smart who succeeded to the property. This is signed by T. Paty of Bristol: he was one of a family of statuaries and was responsible for the carvings on the Bristol Royal Exchange, and of monuments in the Redland chapel.

A more noted statuary was Sir Robert Taylor, 1714–88: son of a stone mason and pupil of Sir Henry Cheere, he was responsible for a number of monuments in Westminster Abbey. He also worked as an architect, with the Stone Buildings of Lincoln's Inn and some additions to the Bank of England among his works. These are likely to have contributed more to the £180,000 he was able to leave at death, from which the Taylorian Institute at Oxford was founded. He signed the monument to Richard Osborne (the younger) of Wortley, 1688–1749, and his wife Sarah (Blagden) 1691–1743, which stands at the south-west corner of the north aisle, to which it was removed by Sewell from the chantry.

A monument which Mrs. Esdaile attributes to Taylor, while Mr. Gunnis again says "good Bristol or Bath work", is that of William Adey of Combe, 1698–1765. He was a younger son of the first Daniel Adey, of whose activities nothing is on record. This stands above the children's corner in the north aisle and does not seem to have been moved.

The monument of the first Daniel Adey of Combe himself, 1666–1752, and of his eldest son Daniel of Synwell, 1696–1763, who carried on the direct line, is signed by Taylor and is one of those moved to above the south door. The monument of the two young brothers Richard, 1686–1712 and Robert Dawes 1699–1711, of Bradley is by the vestry door: this monument, with a very long inscription, records also Thomas and his widow Lydia. It is signed by Giles Dance, brother of the more noted George the elder, architect of the Mansion House, who built Guy's Hospital among other works: no other monument signed by him is known.

A later monument, which Mr. Irvine did not include, is that of

Dr. David Taylor of this town, standing behind the organ, by E. H. Bailey, R.A., who was the designer of the Nelson Column.

FREE CHURCHES

Old Town Meeting House

The first free church in Wotton is the Old Town Meeting House, built in 1701–3: it is Congregational, though occasionally described as Presbyterian. It was initiated by a "Society of godly professors in this town", believed to stem from the ejectment of ministers from the Church in 1662. A diocesan survey of 1735 gives the "Presbyterian" community as 300 families: but a 1750 report says only 70. It must have been a blow when in the period 1771–83 the more affluent members of the congregation drew off to found the Tabernacle, nonetheless about 1800 the Meeting House was greatly improved, and side galleries were added, giving a seating accommodation of 300. The chancel was also added then. About 1898 a garden plot and disused mill behind the Meeting House were bought and converted to house a Sunday school, which had till then been held in an upper floor room: towards this Richard Bailey of Back Lane had left £25 in 1893. The bicentenary in 1903 saw a restoration and renovation: the side galleries were removed, tall lancet windows in the street frontage replaced former ordinary small windows on two levels, and the east window was built: the estimated cost of this work was £275. Joseph Woodward, who was appointed master of the grammar school in 1640–41, but had left it by 1647, is believed to have been one of the "godly professors". A large proportion of the ministers bore Welsh names: David Thomas from Pembrokeshire served for thirty-eight years from 1823 till his death: a Mr. Langdon resigned the ministry in 1784 to engage in the clothing trade. The most notable minister was the Rev. James Hardyman who served for sixty-one years from 1880 till his death in office in 1941 at the age of eighty-nine. The chapel is now served by visiting preachers. It had a burial ground, but this is said to have been disused after about 1800: however, the above Rev. David Thomas reported

that there had been some twenty burials within the building during his incumbency.

Baptists

Next in time, a Baptist chapel was founded about 1717 in a house adjoining the playground of the grammar school. When that school rebuilt a science wing on the site, a burial vault was found containing the coffins of two children, but they were re-buried before I was able to note particulars. In 1859 this was listed as Mr. Perrin's Burial Ground. The present chapel in Rope Walk was built in 1818 and had a burial ground which is one of those listed in 1859, with adjoining school rooms with seating for 500. This also is now only served by visiting preachers. In a survey of the diocese in 1735 the Anabaptist community is reported as fifty families: a report of 1750 records them as only ten families.

Wesleyans

It is not known when the Wesleyan community was first established here. In 1805 they built a chapel in a yard above Haw Street. The present red-brick chapel, with seating for 300, and benches, and its school off Bradley Street, are of 1896. This too is now served by a circuit minister.

The Tabernacle

Most notable is the Tabernacle (Congregational) built in 1783 for Rowland Hill, and radically rebuilt in 1850 by the generosity of two local gentlemen: its name board claims foundation in 1771, the year of Hill's first visit to Wotton. The first building was little more than a version of the common box-chapel style; the rebuilding is "Gothick", good of its kind and impressive within, but a prominent and rather incongruous object in the general view of the town. It has seating for 800, and in its heyday in the 1880's benches had to be provided in the aisles. It still has its own minister, now a lady. It has a Sunday school to match.

Rowland Hill is one of the few celebrated Wotton men, though he was not of local origin and did not confine his activities to the place.

Born in 1744, the sixth son of Sir Rowland Hill, Bart., he was greatly influenced by his elder brother Richard, who was in 1768 expelled from St. Edmund's Hall, Oxford, for his Calvinism, and subsequently engaged in controversy with Wesley. Rowland first experienced religious sentiments while at school at Eton; from there he proceeded in 1764 as pensioner to St. John's College, Cambridge, where he graduated with honours in 1769 and took his M.A. in 1772. While at Cambridge he preached in surrounding villages, and got insulted. He paid his first visit to Wotton in 1771, preaching in the market place, and making a great impression by his simple but forcible and vivid style. After six bishops had refused to ordain him, the Bishop of Bath and Wells made him deacon in 1773 and gave him a curacy, but the Archbishop of York refused him priest's orders.

He seems to have alternated the work of his Somerset curacy with visits to Wotton, where he preached in the surrounding villages. A manse was built for him and he founded a row of almshouses for ten aged women, which have been rebuilt, as well as a Sunday school which was added at the rebuilding. He built Dudley Mill to provide an income for his poor, and acquired a plot in Combe with some cottages for the same purpose. He spent the summers in Wotton, and the winters at the Surrey chapel which was built for him in London in 1783. He worked to the end, dying in 1833 aged eighty-eight. He left a permanent library for his successors in his house, and there was a little museum of relics of him: but these were sold by auction in the town.

An incident shows his Christian charity. Preaching at the funeral of one who had been his servant for more than twenty years, whom many present would testify to have been sober, honest, industrious, and religious, he revealed that he had once been a highway robber and had stopped Hill: asked what had brought him to this, he said he had been a coachman, but lost his place and could not get a character. Hill had taken him into his service, with the result they had seen.

Hill's attitude was tinged with Puritanism, as is shown by a "play-bill" drafted by him and printed by Presley of Wotton, which he stuck up close to the play-bill of the day at Richmond in June 1774, "to divert the minds of the gay and dissipated from the vain amusements of the Theatre and to fix the attention on the awful circumstances which shall usher in and succeed the great and terrible day of the Lord". He also published an open letter to vicar Tattersall, opposing an application for a licence for a stage performance locally. Otherwise he was broad-minded, for he was an advocate of vaccination.

One of his successors, Richard Knill, was no less zealous and was considered by some to be as powerful a preacher as Hill. Born in 1787 in a Devon family and village "in a state of moral and spiritual darkness", he found religion at an early age. He enlisted, to his mother's despair, in the hope of getting into the band as he was too much drawn to music, but was soon bought out. In the new contacts he had then made, he experienced religion, and entered upon Sunday school and missionising work, but began to feel a greater call to the foreign mission field. At twenty-five he began regular study to that end, with more home mission work, and after ordination, four years later, sailed for India in 1816. Two years of a trying climate in the Madras Presidency with nothing of modern amenities to soften it, and lack of even elementary care for his health, broke him down. Two years of the voyage and work at home set him up enough to be offered and accept a missionary post in Russia, upon which he entered in 1820. At first he worked in St. Petersburg under Imperial patronage, and even friendship, though not approved by the Orthodox Church. There he went through a devastation of that low-lying city by a tidal wave. In 1828 he passed on for a period to Finland, with St. Petersburg, during which there was a bad epidemic of Asiatic cholera. In 1833 he was recalled to England to tour appealing for mission funds, and did not go abroad again. In 1841 he wrote of having laboured in twenty-five counties and in Ireland. Visiting Wotton on this work, again in very feeble health, he was pressed to preach again: and then to become the

minister, which he undertook in 1842. He began to work up a very large and live community in the villages, though constantly over-taxing his powers. By 1847 he felt that he had carried out his mission in Wotton and accepted a pastorate in Chester as a new field: there, apart from working up a congregation and community, he had at the start to pay off a debt of his church and provide amenities: during these repairs he took the unprecedented step of using the theatre for his preaching. When in 1855 he greatly enlarged the area over which he travelled preaching, that was too much: he gradually declined, and in January 1857 died.

Synwell Chapel

The Tabernacle has several charities. An offshoot of the Tabernacle was the Union Sunday School started on Synwell Green in 1863 by William Woodward, a retired tailor, who left the Tabernacle no less than £10,000. This has become the Oliver Memorial Chapel, commemorating a modern Wottonian whose life deserves remembrance as much as any of those who only bequeathed what they could not take with them into the grave.

Born in 1870, Harry Oliver was one of three children of a cloth factor working for 12s. a week in Nind Mill. Leaving Bear Street primary school at twelve and a half, he was apprenticed to a bootmaker till, at eighteen years, he secured employment as a part-time postman. At twenty-five years he became a full-time postman and continued in that occupation till his retirement at the age of sixty-five: he was employed on the Osleworth–Boxwell–Leighterton round.

At eighteen he began to help in the Union School, and at twenty found himself left with entire responsibility for it. Making a success of this, he started a Sunday evening service for older folk, bought a plot of ground out of his own pocket, and on it built a little chapel 40 feet by 20 feet with material from the abandoned Leighterton Aerodrome: this lasted till 1949, when it was rebuilt in his memory.

His work in school and chapel led him to become the leader

of the community, which then displayed an initiative which contrasted with the passivity of the borough. For example, while the borough had long "demanded" a playing field for the children, and that "they" should do something about it, the smaller and less affluent community of Synwell bought a field, laid out a football pitch, installed swings and so on for the children, bought a large army hut and adapted and erected this as a pavilion. Oliver's annual holiday was devoted to a mission among the hop-pickers in Worcestershire. His social services were recognised in 1920 by his appointment as a J.P., the first wage-earner from outside the ranks of the gentry to be thus honoured in the district.

Typical of him was his garden at the bungalow which he built near Locombe Well, at the back of the house and the workshop in which he spent his spare time on boot-repairing. It was planted with fruit trees, under them, fruit bushes and vegetables, with his beehives dotted about among them. In fact the bees were his principal hobby, and it was he who introduced me to the "art and mystery". He was always ready for the sport of taking the swarms reported to him, and in the season regularly called me out, on his bicycle festooned with skeps ready for the catch. "Driving" the bees of old-fashioned beekeepers who only wanted to take the honey was another joint activity in which I learnt much.

His widow has a link with a past age. As grand-daughter of the tollgate keeper at the Ham Green gate on the Bath–Stroud road, she took the toll of the last horse and cart to pay toll at this gate. The chapel is still full of life, served by Oliver's lieutenant, Ralph Reynolds, J.P.

Others

There is no record of a Unitarian community at Wotton: in fact when Isaac Pitman was denounced and expelled from the Tabernacle in 1837–8 he turned to the Church of England, for as member of a vestry meeting he was among the signatories to the application for a faculty in 1838.

John Biddle, one of the most eminent writers among the Socinians, was born at Wotton in 1615, and was educated at the

free school there. He showed such promise that George Lord Berkeley allowed him an exhibition of £10 a year. Before even leaving school he had translated Virgil's Bucolics and two Satires of Juvenal. At thirteen he proceeded to Magdalen Hall at Oxford. In 1641 he was appointed master of the Free School in Gloucester, S. Mary le Crypt, and was at first much esteemed, but in the time of the Commonwealth suffered various persecutions and imprisonments for unorthodox opinions on the Trinity. During one of those confinements he was employed by the London printer Roger Daniel to correct the impression of the Greek Septuagint Bible that he was about to publish. Biddle was freed by the General Act of Oblivion in 1651, but in 1655 he was banished for life to the Scillies by Cromwell, allowed 100 crowns a year for subsistence, and in 1658 again liberated. At the Restoration he was fined £100 and condemned to prison till this should be paid; confinement ruined his health and he died in 1662 aged forty-seven.

Though there have been Quakers at Wotton, no meeting was ever set up there: they had to go to Nailsworth Meeting, except that there was a small meeting at Dursley in the seventeenth century. But more important was that in 1725 a Circular Regional Yearly Meeting was held here, a regional convention of the western counties, for worship and propaganda. These ceased about 1770.

The upper room of the Market House was engaged: the mayor was paid 3 guineas for this, and 25s. for putting up seats and lime-washing it, with 5s. more for "writings and charges". Additional accommodation was engaged at John Wallington's Crown Inn. Both these premises were licensed for the purpose by the Court of Quarter Sessions.

On the Saturday, visiting or "Ministering" Friends arrived and were welcomed at the Crown by local Friends: on Sunday morning there was a more or less private meeting at the Crown for worship, and in the afternoon a public meeting in the Market House: early on Monday morning, a meeting of ministers and elders, to which the public seem to have been admitted, as they

were asked not to "interrupt": and in the afternoon a public meeting for propaganda: then on Tuesday visitors departed. There is no disclosure of the numbers or identities of local Friends.

Freemasonry was for a long time unstable in Wotton. A first start came when the (Bristol) Lodge of Jehosophat, warranted there in 1773 and moved to Shirehampton in 1794, in 1779 removed to the Swan Inn in Wotton: but this died out and was erased in 1809. The Wotton Lodge of Sympathy was in 1821 founded at the Star Inn, but in 1832 was also erased.

1861 saw the warranting and consecrating of a new Lodge of Sympathy at the Vine Inn by ten brethren including Lord Fitzharding, who were shortly joined by ten more: the place of meeting was changed to the White Lion, the Swan, and the Old Town schoolroom. For a short period in the 1870's the Lodge was again in danger of losing its warrant, but survived and is now very active.

In 1937 the foundation stone of its own Temple in Venn's Acre was laid, and this was consecrated a year later. During the war the dining room and car park were requisitioned by the Army. A random bomb fell near by, shaking the fabric severely and shaking the roof: subsequent repairs cost about £2,000.

The Lodge has just celebrated the centenary of its foundation in 1861, ignoring the earlier abortive efforts. The Centenary Warrant was presented by the Provincial Grand Master for Gloucestershire, who attended the formal meeting with his Grand Lodge officers and took the chair.

A feature of which members are proud is a pair of pillars of the Temple, discovered when some Bristol buildings on College Green were demolished in 1928, and presented by St. Andrew's Lodge, Avonmouth.

Of smaller congregations, the Particular Baptists existed in Synwell Lane 1877–81, and the Plymouth Brethren in Bradley Street 1877–8. In 1882 the Salvation Army "opened fire" and "spoilt the Sabbath" with a brass band: it established itself at its "Barracks" in Old Town 1886–8, and for some time rented the Britannia Mill,

of which they let part to the Britannia Lodge of Oddfellows, whose existence in 1871 is recorded. The Church Army held services in the Parish Room in 1911. The Roman Catholic Church has recently taken the former Liberal Club, and is served from Woodchester Priory.

Some Free-church Meeting Houses were early licensed by Quarter Sessions.

1689 Thos. Crew's house in Sinwell and Bradley, of Protestant Dissenters.
1697 Stephen Hunt's house of Protestant Dissenters.
1701 A new erected house of Presbyterians (the date is that of the Old Town Meeting House).
1709? Sampson Carey's house of Quakers.
1710 Wm. Slade's house at Nind of Presbyterians.
1710 Joseph Mundy's house at Wortley of Presbyterians.
1725 Town Hall licensed for Quakers (for the Regional Yearly meeting reported above).

There were also for a time some episcopal licences for dissenting houses.

1764 Dwelling house of Richard Dauncies, weaver, licensed for meetings of Congregationalists.
1767 Dwelling house of Michael James licensed for meetings of Protestant Dissenters.
1771 House, The Acre, near Bear Lane licensed for meetings of Independents (likely to be the origin of the Tabernacle).
1804 Dwelling house of John Dyer licensed for meetings of Protestant Dissenters.
1815 Dwelling house of Samuel Holloway at Combe licensed with Stephen Hopkins as minister.
1818 Dwelling of Daniel Cooke, gigman, near Huntingford Mill licensed.
1819 Licence for meeting of Protestant Dissenters in a field, Merry Haven.

5

Charities and Schools

WOTTON is so well provided with charities that a cynic once divided the population into recipients of doles of shillings or clothes or bread, and patrons who allocated these doles.

Early gifts and bequests were sometimes in landed property with direction that the proceeds be used for the purpose specified. Sometimes they were in money: this might be directed to be spent on carrying out a specific scheme: or the direction might be that it be invested in property; sometimes they were in the form of rent charges on specific property.

These gifts and bequests were placed in the hands of trustees to discharge the obligations: these might be the executors or relatives of the testator. Generally the mayor would a few years later obtain legal transfer of the trust to himself and some prominent citizens: often the mayor and citizens would be original trustees.

In 1767 an indenture provided for superseding all these by a single body of appointed trustees, with provision for periodical filling of vacancies by death or otherwise, to make the trusts self-perpetuating. On one such occasion in 1875 the name "Trustees of the Wotton under Edge General Charities" first appears.

A country-wide enquiry concerning charities was instituted. In 1826 commissioners spent eleven days in Wotton investigating, and their findings were published in 1829. This report lists and details the various charities, and the disposal of the funds down to the contemporary position: it leaves the charities still individually accounted and administered.

In 1884 the commissioners framed a consolidation scheme, a second in 1925, and yet another in 1959: these do not extend to the charities for which the Church authorities or those of the Tabernacle are responsible. A local statement was published in 1891, bringing the facts of the 1829 report up to date and giving the accounts of the local consolidated fund for the year.

One effect of these successive moves was that in 1853 income and expenditure were each £540-odd and some £450 was carried over annually. In 1891 £457 of the total revenue was still in rents and rent-charges, and £247 in interest from funds, making a total of £704. The most recent scheme has brought in all charities as general charities: those for almshouses and those for poor are accounted separately, though some which might have belonged to the second class are included in the first; it also includes some mixed bequests of which parts are payable to Church or Bluecoat school. The almshouses account includes the only property still held, the Tolsey block which yields £217 9s. in rents, and £14 3s. of perpetual rent-charges, and £636 0s. 4d. of interest from funds, a total of £867 12s. 4d. The poor account gets £19 of rent-charges and £31 5s. 8d. of interest, a total of £50 5s. 8d., making a grand total of £917 18s.

For trustees, four are appointed by the parish council for four years, and seven co-opted for seven years. Capital is vested in the official Trustees for Charitable Funds.

Not included in this, apart from Church, Bluecoat school and free churches, are the original Berkeley grants to the market feoffees, for town purposes. These are now administered by a town trust of nine members nominated by the parish council for five years, and three co-opted for five years. In 1956 this had an income of £638, of which £307 came from town hall hirings, £94 from rents of properties still not sold, and £179 from interest in funds; expenditure was £734, which entails a call on capital: this is over and above what can be charged to rates, of which the parish council calls for a total of about £1,300.

Of gifts and bequests, apparently the oldest is the Tanyard, on the bank of the stream below The Cloud, first mentioned in

1520 as a "tenement opposite the Swynewelle", owned "time out of mind" for repair of the church fabric. On this stands the very old Ram Inn, sold to the brewers in 1905, also a building which was the local workhouse, was then used as an infant school in the years about 1870, and is now a mortuary. This, and the rest of the site, now used as a car park, has been sold to the rural district council; interest from investment of the prices realised is paid by the general trustees to the vicar for fabric repairs.

Another property, Church House, on a corner of Long Street and Sym Lane, is also said to stem "from time immemorial": its probable origin is shown by a deed of 1476, by which John Cantlowe of Bristol (of whom nothing is known) conveyed to James Wolworth (likely to have been the mayor then) and other citizens, his messuage on "hie street" with Sym Lane to the east and a house owned by Berkeleys on the west. In 1557 a feoffment conveys the same to the mayor and others. Another in 1603 which passes it to another set of feoffees, names the adjacent house as of Anne, Countess of Warwick, while behind it lies a close of Walter Osborne, which has appeared elsewhere in this account. Then a deed of 1648, conveying it to vicar Richard Kent and others, confirms surmise by naming it Church House, and specifies that it was for the benefit of the inhabitants. In 1826 it was managed by the general trustees, and the £8 rent was so inadequate that surrender of the lease and re-letting were agreed to; in 1891 the rent was £25. It has now been sold, and the interest on funds yields £24 10s. which the general trustees receive for the almshouses.

The only other surviving ancient property is the Tolsey, which has been described when dealing with the borough. The town enjoyed two other benefactions of the Dudley family. In 1571 Robert, Earl of Leicester, while in possession of the Berkeley estates, took over the buildings of an earlier dissolved guild at Warwick to form a hospital for twelve Brethren who had been maimed or wounded in the wars of the realm, who were allowed £80 each as well as the privileges of the house. They were to be from Warwickshire or Gloucestershire, the latter county being

14

allotted two, to be nominated in turn from Arlingham and from Wotton, by the vicars. Arlingham seems to have dropped out now, but when I visited the hospital recently it was a Brother from Wotton who showed me round. The Brethren had a walking-out uniform of gowns of blue cloth, with on the left sleeve a silver badge with the Bear and Ragged Staff: one of these was stolen about a century ago and cost 5 guineas to replace: the rest are original with the names of the first Brother and date 1571 on the back. The quarters of a Brother contained bed- and sitting-rooms and a pantry, and there was a common kitchen with attendant cook and housekeeper: the hospital also contains a fine chapel, and the old Guild Hall up steps from the quadrangle.

The other benefaction was the hospital at Chenies in Buckinghamshire, founded by Ann, Countess of Warwick, in 1596, allotting two places in it to Wotton; the date over the iron gates is 1603. The hospital is a fine Elizabethan brick building, with six quarters for local people in the frontage, and a wing of two quarters at each end, of which one wing was for Wotton: the quarters each had substantial outbuildings and a garden, and the allowance was 2s. 6d. a week and a ½ cwt of wood. At some time Wotton folk found the allowance, with living so far from home, unattractive, and it was arranged for Chenies to send them 3s. 6d. allowances to Wotton: this was lost sight of by the laxity of a vicar till Mr. Cornelius Harris traced it and unsuccessfully tried to recover the allowances. However, this was effected in 1887, and the vicar still receives and distributes the allowances to one man and one woman. Wotton also obtained a sum of £750: this is alternatively explained as accumulated arrears, and as a share in the sale of the hospital: it is too much for either of these alone and is probably the two combined. The property is now a farm. For the original endowment Countess Ann had charged property at Cam and Hinton with £30 a year.

The most considerable charity is the Church Street almshouses, originating in the Hugh Perry hospital. Hugh Perry, born in Wotton, was a merchant and mercer of London, where he became alderman and was sheriff in 1632. Dying in 1634, he was given

a goodly monument in St. Bartholomews by the Exchange, which was destroyed in the Great Fire. He must have been a very wealthy man, for his widow and executrix married Lord Newburgh, two of his daughters married peers and the other two county knights. The almshouse archives, now in Shire Hall, include a writ of attachment of 1646 of the person of Katherine Lady Newburgh.

The youngest daughter Mary, born in London and brought up under the loving care of Lord Newburgh, at the age of fifteen married Henry Noel, second son of Viscount Campden. Shortly after their house at Chipping Campden was besieged by Parliament, and she assisted the defence, even melting lead for bullets. But they had to surrender, the house was plundered and they were imprisoned. She fell sick of smallpox, which led to a late miscarriage; the husband too became infected and soon died. Thus she had been maid, wife, widow, and childless mother, all within a year. After three years she married Sir William Fermor, who died in 1661, leaving her to bring up a numerous young family: she too died in 1670. Her son Sir William was created Baron Leominster in 1692 and died in 1711: his son was created Earl of Pontefract in 1721, but the line died out and the titles became extinct in 1867.

Hugh Perry's will of 1630 left £300 to the mayor and aldermen of Wotton to erect an almshouse with gardens for six poor men and six poor women near the church: and £250 more, to yield £12 a year to be distributed to the inmates, plus £1 for an annual dinner for choosing the inmates.

One thousand pounds more was left to the mayor of Gloucester, partly for the benefit of that city: but a codicil of 1633 made the Mercers' Company the trustees, and gave the whole benefit to Wotton. The capital was to be lent to young clothiers at 5 per cent. Of the £50 interest, £8 was to be used to apparel the inmates, with £5 for fuel for them and 20s. each in cash; £8 was for an usher to teach writing and ciphering in the free school, and to read service daily in the almshouse; the balance was for lectures and the annual dinner of which we have heard in dealing with the borough.

On an application by the mayor to Chancery in 1640, it appeared that the Mercers' Company had refused the £1,000 trust, and it was accordingly entrusted to Sir Robert Poyntz and (Sir) Matthew Hale and three others, who in 1647 invested in land. The Newburghs were ordered to pay over the £250, and this with the duty of providing lectures and the annual dinner was made over to the corporation, as related in dealing with that body. The Newburghs in 1637 spent £85 on buying Harsfeld Court as a site, and the balance of the £300 on building the almshouses and installing inmates.

Harsfeld Court was named after Thomas Harsfeld of North Nibley who held it in 1584, comprising ten messuages, six tofts, four gardens and orchards, worth £44. A few adjoining tenements had been bought and made over to the mayor in 1637. The endowments were added to on a number of subsequent occasions, as related below.

The Perry hospital proper is the range of high-gabled buildings on Church Street (Plate 8). The six quarters below divided by the entrance passage, and the six above, face the courtyard behind, with a timber gallery running along them. The plaster of the façade has now just been scaled off revealing the original masonry, rather small undressed rubble stones partly coursed, fortunately unspoilt by later insertions. Under competent advice this has been pointed with correct mortar, with joints wiped and not lined or struck. The chapel in the middle of the courtyard is believed to have been built at the same time out of Perry's £300. On the opposite side is the Dawes hospital of six quarters, and closing the south end of the courtyard the general hospital of twelve quarters, while the north end is closed by the blank walls of private houses. Behind the Dawes hospital lies a lawn where the former gardens of the inmates were, at the top of a cliff overhanging the building and playground of the grammar school; at the north end of the lawn a cottage has at some time been built for the matron.

The Dawes hospital originates from a bequest by Thomas Dawes in 1712 of land at Bournestream "for the benefit of the poor". Up to 1719 the yield of £20 10s. of this was applied to the

Bluecoat school; in the next year citizens obtained control from Dawes' descendants, and decided to build this hospital. The land was sold in 1919 for £1,935.

As to the General hospital, shortly before 17th October 1714 a joint meeting of Perry and of Dawes' trustees resolved to pull down almshouses of unknown age and origin in Culverhay, in order to build what became the Bluecoat school on the site, and to substitute this General hospital. The properties which endowed the old almshouses were appropriated for support of the school.

Surviving records throw hardly any light on life in the hospitals. In the years about 1800 there were discreditable happenings. There was such reluctance among Dawes pensioners to live in that in 1779 the trustees posted a notice which had so little effect that when vicar Benjamin Perkins was made almoner in 1837 he reported that three out of the six persons were absentees: Eliza Baker was a midwife, and residence would interfere with her engagements; Susannah Wherrett had never lived in because there were no facilities for her occupation as the best tripe-dresser in the town; Ann Lacey had never even seen her quarters, because she would die if she gave up her nice house and garden at Wortley, and besides her son who was a respectable business man objected.

In 1879 there was some scandal over a "house of ill fame near the King's Arms", and in 1881 a woman almshouse inmate was specifically mentioned. In 1877 measures had to be taken against drunkards in the hospitals. Incidents of other kinds occurred; in 1873 the nurse was allowed 5s. a week extra to attend a woman whose "leg had rotted off", her husband being blind and helpless. In 1864 Nurse Hill died in the almshouses aged 104. In 1876 earth closets were provided, there having been only privies before that.

As a result of the consolidation schemes, the inmates of all three hospitals have been treated alike. On the introduction of National Assistance the Charity Commissioners agreed to reducing the inmates' cash and "apparel" allowances in 1950, and stopping them in 1954. Only fuel is continued, and about two-thirds of their individual bills for electricity.

About 1910 the earth closets were replaced by an annexe behind the Dawes hospital, two quarters of which had to be appropriated for access to it: this contained a range of w.c.s and two wash-rooms. In 1952–4 part of a comprehensive scheme of improvements involved reducing the original thirty quarters to twenty-two, providing eight bathrooms with w.c.s in place of the old annexe which was taken down. Further, while before that each quarter had only electric light and a tap and sink in the gallery, they were now given electric cookers and water heaters. The whole quarters were redecorated, including the replacement of the old fireplaces with modern appliances. The scheme, not easy to carry out in these ancient structures, gives the inmates up-to-date amenities, and completely preserves the character of the buildings.

In the following list of bequests, the income of all is paid into the almshouse charities account of the general charities unless otherwise noted, and is applied to them except to the degrees noted.

Ancient Tanyard, related above, only collected and paid in for church fabric. Income now £5 4s. 2d.

1476 Church House, related above, now sold. Income now £24 10s.

1571 Rights in Warwick Hospital, as related. No receipts, and nominations made by vicar.

1596 Rights in Chenies hospital, as related. The allowances for pensioners remitted to and paid out by vicar; the £30 rent-charge on land here is paid only to Chenies.

1595 The Tolsey property as related in "Borough" chapter, yielding £217 9s. in rents to almshouses.

1578 Robert Hale, grandfather of Sir Matthew, left a 20s. rent-charge in North Nibley for "the poorest inhabitants"; it is paid into almshouses account.

1588 Joan Gower left property in Bradley Street "for the poor": yielded 70s. rent till sold: proceeds with some amalgamation now yield £9 12s. 4d. in funds to almshouses. She is likely to have been the widow of Thomas Gower, a wealthy Wotton clothier with a big family, who in 1572 left small sums for distribution. He is more notable for

having earmarked £20 towards bringing water to the Market Cross if done within three years, sixty years before the Venns had and carried out the same idea.

1602 Hugh Venn of Synwell left his house in Dursley for the almsfolk. Rent then 30s.: proceeds of sale now producing £7 18s. 2d. in funds.

1620 An amalgamation was made of three recent bequests. Elizabeth Lady Berkeley of Bradley (who split the old Bradley manor) left £20 for the poor. Margaret Mallowes in 1614 left £100 for the same, John Birton, twice mayor, left £10 for the same. All was invested in land near (old) Bushford Bridge yielding £20 rent: now £24 5s. 8d. from funds for almshouses.

1627 A rent-charge of 40s. on land at Rockhampton in 1569 by Margaret Hale, confirmed in 1578 by Thomas Webb, superseded by gift of the land, "for the poor": when sold later, the proceeds were joined to those from sale of adjoining Hill lands of the Sir Jonathan Dawes 1674 bequest for several purposes, and Richard Hale's 1650 bequest for the poor, and given to the almshouses account.

1630 Hugh Perry's bequests detailed above. In addition to the almshouses themselves there is £171 12s. 8d. interest from funds. The concern of the bequests with apprenticing, the Bluecoat school, and "Lectures" is dealt with below.

1636 (Sir) Matthew Hale cleared an entail which had barred the gift by his father Robert, to the poor, of land in Rangeworthy. This was greatly improved by exchanges at the time of the Enclosures in 1811, becoming a farm which let for £115. The land has been sold and the proceeds yield £70 4s. 6d. in funds to almshouses.

1650 Richard Hale (Sir Matthew's elder uncle) for £55 sold land in Rockhampton "for the poor": this too has been amalgamated with the Sir Jonathan Dawes bequest.

1662 Robert Webb charged his Grange Farm in Ringswood with £15 p.a. for a weekly dole of bread to twenty-four poor people, and an annual shilling to forty "poor housekeepers". This is paid by the owner to the poor account.

1674 Sir Jonathan Dawes about this date left £1,000 "for the poor" and for binding apprentices, to be invested in land worth £50 p.a. A farm of £40 was bought: with contiguous land of the 1627 and 1650 gifts this was letting for £125 10s. in 1826, though in the boom of 1812 it had

fetched £196. In 1878 it was sold to Mr. Jenner Fust, and produces £150 7s. 8d. in funds for the almshouses account.

1693 William Hyett merchant of London, nephew of Sir Jonathan, left £60 "for the poor": his brother Robert added £40 to this, and himself gave £500 more. £10 of the income was to be used to pay a master to teach twenty-four poor children and provide them with "horning books" and primers and testaments: 10s. more was for a mayor's audit dinner, and the rest was for setting up young men who had passed Sir Jonathan's apprenticeships. With this bequest land at Huntingford was bought, which in 1826 comprised a farm let at £60: the Midland Railway bought the strip needed for their line, and the proceeds earn £2 3s. 8d. in funds: the rest of the land was in 1891 rented for £90. The land has since been sold, and the proceeds yield £42 3s. 8d. in Consols held for the original Hugh Perry charity in the almshouses account.

1697 Richard Meade, alderman, gave two rent-charges of £6 each on land in North Nibley: one of these was to augment the £12 p.a. Perry lecturerships and is paid direct to the vicar; the other was for half-crowns for the poor, was distributed by the general trustees as the Candlemas half-crowns, and is still paid by the tenant to the poor account. Distribution is now combined with the Harris charities below.

1712 The Dawes bequest of land at Bournestream has been reported above. The Dawes range of the hospital seems to have been built from income, after its being used till 1719 to support the Bluecoat school. In 1919 the land was sold for £1,935: augmented by accumulation of income and sales of timber, it now amounts to £2,969 of funds, yielding £94 6s. 4d. in the almshouses account.

1721 William Bailey gave £20 for the poor and £20 for the charity school: these were lost before 1826, it is said by the insolvency of the person to whom they had been lent.

1725 Mary Blagden left £20 to provide bread for the almsfolk, and £10 for the charity school. The former used to provide an annual packet of mixed bread and cakes, and has now become £40 in Consols which yield £1 per annum to the almshouses account. The latter is part of the capital of the Bluecoat school managers.

1743 is the date of first mention of a rent charge of £10 on Fortunes Farm in North Nibley, left by Sir Richard Venn

for the poor: the mention then occurs regularly in "the Mayor's account books", and what seems to be the same had been appearing in "the parish books", as disclosed by the 1826 enquiry. These are not the books of the market feoffees, and seem to be some lost records. The charge is still paid, into the almshouses account. Sir Richard may be the man who in 1630, with his son-in-law Hugh Perry, brought in water.

1763 Robert Purnell gave £100 to the charity school, which is an item in the managers' endowment fund. He also gave £550 to provide bread for such poor as have not received alms. This has never appeared in general charities, and was as late as 1944 distributed by the vicar and wardens as nine quartern and ten half-quartern loaves. It has now been consolidated with the Olney and the Harris charities in the vicar's hands.

1773 Sarah Winchcombe left £40 to supplement allowances in the "Old Hospital", and £30 to the charity school. The former is now £64 of Consols yielding £1 12s. in almshouses account; the latter is an item in the school endowment.

1788 Thomas Clissold, for forty years master of the grammar school, left £300 for the different parts of the hospital; this is now £1,200 of Consols, yielding £30 per annum in the almshouses account.

1826 Thomas Perry of Wotton left £1,000 to increase the allowances of the twelve poor people in the Perry hospital. In the form of £1,200 Consols it yields £30 per annum in the almshouses account.

1872 Cecilia Lewton Taylor and Esther Cooper created a trust for the clothing club of which I find no mention except in the 1954 scheme of the commissioners. It then figured as £209 of Consols yielding £5 4s. 8d in the poor account. I have seen nothing else about the clothing club.

1892 John Spencer created a similar trust to which the same remarks apply, now represented by £93 of Consols yielding £2 6s. 4d. in the poor account. These two last cannot have been applied fully and regularly, since the poor account also receive £3 14s. 8d. from the investment of what amounts to twelve and a half years of their income. The almshouse charities also have a £4 13s. 8d. income from invested accumulations.

1904 By will proved in that year Henry Foxwell, a former
 treasurer to the general trustees, left a sum now repre-
 sented by £481 Consols yielding £12 0s. 8d. in the alms-
 houses account, to provide nursing in the almshouses,
 though nurses had been mentioned earlier: in fact in 1869
 Nurse Hill had died in the almshouses aged 104. The
 income was paid to the District Nursing Association for
 the services of the district nurse. After introduction of the
 National Health scheme, the charity commissioners
 allowed it to be used towards the pay of the matron.
 Foxwell left another sum now represented by £511 yield-
 ing £12 15s. 8d. in the almshouses account, for the
 almsfolk.

1884 Cornelius Harris, cabinet maker, who in 1871 proposed to set
 up an independent market because of obvious public dis-
 satisfaction with the conduct of the feoffees' market, and
 who was instrumental in reviving the Chenies benefits
 which a vicar had let slip, left £1,300 of Consols. The
 original scheme provided that £5 be distributed annually
 by his trustees to 100 poor persons in "Cornelius Harris
 shillings"; a further £10 was to be paid by them for the
 vicar, wardens, and overseers to distribute at their dis-
 cretion; the balance was to be divided equally between the
 Tabernacle, the Baptist, the Wesleyan, the Old Town
 Presbyterian and the Synwell chapels, for distribution in
 their congregations.

 The bankruptcy of the trustees lost more than half the
 capital, and in 1908 a new scheme was drawn up for the
 £611 1s. 9d. recovered. £200 Consols was made over to
 the General trustees for distribution in shillings on 1st
 January, and figures in the poor account: since 1952 this
 charity has been combined with the Meades charity above
 and the two other Harris charities below, and distributed
 at the discretion of the trustees in forty-five to fifty gifts of
 10s. to 20s. The share of the church is dealt with below:
 those of the chapels were lost in the bankruptcy.

1885 William Harris, tinplate worker, left an unstated sum with
 specific directions for application of £30 of the income,
 and directions for a further £80 which the estate proved
 insufficient to provide, so that I need not detail this. £10
 per annum was for distribution by general trustees in two
 payments of St. Valentine's or Harris shillings to 100 poor

persons: this is provided by the transfer to them in poor account of £400 Consols: distribution has followed the same course as the Cornelius Harris bequest. The £5 and £15 for the vicar to distribute are dealt with below.

1886 Martha Harris, spinster, left £1,169 2s. 11d. of New Consols. Her trustees were to distribute £5 annually in "Martha Harris Shillings" to 100 poor people: the rest of the income was to be divided equally between the Tabernacle, the Baptist, the Wesleyan and the Old Town chapels for similar distribution.

At some date between 1886 and 1952 the general trustees have been given possession of £200 of Consols yielding £5, which has been dealt with as above: the rest, which is not quite clear, is dealt with below with Tabernacle benefits.

1937 Mr. William Grimes, late of Melbourne, is said on a brass plate in the Town Hall to have given £60 for the poor: there is no record of this, but I have been able to trace the facts. Coming home on retirement, he gave £A100 to two friends, to apply for the good of the place as they saw fit: they eventually devoted it to buying the equipment for the playing field.

The overall position of the general trustees then was, in 1853 income and expenditure were each £540 odd, while one £8 rent was written off, "tenant very poor"; and some £450 was being carried over annually. For 1891 a schedule of property shows £704 total income, of which £457 came from rents and rent-charges and £247 from funds. Actual accounts for that year show the £8 15s. of the Tanyard collected and duly paid to the vicar; but the £31 14s. rents of Bluecoat school properties, though collected, were not paid over at any rate in that year: nor was the £8 of Perry bequest for a master, nor the £10 of the Hyett bequest, also for a master. So the £80 grant made to the school was largely what was owed to it; and when it had been only £60 up to 1881 or so was only £10 over it. Of the expenditure, £527 went on allowances and expenses of the almshouses, and only £6 in help to outside poor, while £20 held for them is not scheduled and does not seem even to have been collected in that year.

The apprenticeship benefits provided in bequests seem to have

been used very little, the Hugh Perry and the Sir Jonathan Dawes apparently not at all. The Hyett provision was said to be used accordingly, and probably accounts for the indentures of Bluecoat boys, some of which still exist in many hands. Under the present administration at least a separate account is kept of them, and they are used as intended, including provision of clothing and tools.

I have omitted mention of smaller gifts not intended for investment on trust.

The Bluecoat school, before it became a Board school, was largely but not entirely dependent on general charities for funds.

The managers had received and invested (now in the hands of the Official Trustee) the £10 bequeathed by Mary Blagden in 1725, the £100 given by Robert Furnell in 1763, the £30 given by Sarah Winchcombe in 1773; also the 1798 commutation for £80 of the 1722 rent charge on his New Inn, given by Richard Osborne the elder to clothe two poor boys and to pay the minister 10s. for a sermon at the annual examination. They also seem to have received, though they did not list, the £50 given by Thomas Blagdon in 1737, the £100 given by Richard Osborne the younger in 1748, and the £100 given by Edward Bearpacker in 1769.

The Official Trustee has just intimated that he holds £513 1s. 6d. of 2½ per cent Consols for the school, unclaimed: this may be the part of the 1693 Hyett bequest which was for the master and for "horning books".

There are also the rents of the properties adjoining the school with which the old almshouses had been endowed: these have now been sold, and the proceeds yield £31 14s., which is not paid the school directly: also the £8 part of the 1630 Hugh Perry bequest for "an usher to teach writing and ciphering in the free school" (and read service in the almshouse): perhaps also the above part of the Hyett bequest. These may be considered covered by the £60 annual grant the general trustees made the school, increased to £80 by or in 1881. William Bailey's bequest of £20 in 1721 has been lost, as stated.

The school also received annual government grants, and finally became a primary school under the Gloucestershire Education Committee. The managers are now responsible only for maintenance and insurance of the building, and occasional benefits not normally provided from local authority funds.

The church is independent of the Charities Trustees, except for receiving from them the rents of the Tan Yard which they collect. The vicar benefits personally by the £12 of Perry lecturerships paid him by the town trust, and the £6 Meade rent-charge of 1697 in augmentation of them paid him direct by the tenant. The organist benefits by the proceeds of Humphrey Austin's gift of £200 in 1800, when the organ was installed.

Charities in the vicar's hands include nomination to the two brotherhoods in the Warwick hospital, and dispensing the money he receives in lieu of two places in the Chenies hospital. The part of the Purnell bequest of 1763 which provided bread for "such poor as have not received alms" is seen in a 1944 distribution by the vicar and wardens, of nine quartern and ten half-quartern loaves. By a consolidation scheme of 1954 this has been amalgamated with the Olney and the two Harris charities, forming a single distribution of sums of 15s. or 20s. A bequest in 1839 by Lt.-Col. Olney of Cheltenham, of £300 to provide coal and blankets for poor persons at Christmas, was invested in the name of the vicar and wardens. In 1944 the vicar with two Free Church men, representing the parish council, distributed 10s. vouchers for drapery and clothing to twenty-five persons: this has now been amalgamated as stated above. For the £10 of Cornelius Harris Shillings allotted in 1884 to the vicar, £400 was put in his hands by the 1908 scheme after half the original capital had been lost by a bankruptcy. In 1944 the vicar, with the two wardens and four Parish Council representatives, distributed £10 in eighty half-crowns. Now this is amalgamated. The £5 share of the William Harris charity of 1885 was in 1944 similarly distributed in fifty florins, and has also been amalgamated. The church has no share in the Martha Harris charity.

The vicar also has control of the Bearpacker hospital near the

Culverhay. This originated in a bequest in 1837 by Miss Ann Bearpacker of the site which carried ten tenements, and £3,000, for ten poor infirm members of the Church of England, who were to receive 3s. a week after attending morning service on Tuesdays. She also made specific provision for life for Samuel Snell, a dissenter not eligible for admission, of 2s. a week. Part of the endowment was consumed in building the present quarters in agreeable Victorian Gothick in place of the ancient tenements, but in 1875 it was augmented by a £250 bequest from Miss Bearpacker's niece, Mary Hannah Sheppard. A parish council meeting in 1894 asserted a claim to a right to appoint trustees to this and the Harris charities, which was denied by the vicar; but it has been seen that in 1944 they shared in distributing the latter.

Rowland Hill built a row of almshouses for ten aged women. These have long been superseded by a new set beside the Tabernacle. The much more attractive old houses still stand, in the Edbrooke valley 150 yards beyond the Tabernacle, the Streamsfield cottages, which yield £52 rent of which £30 goes in rates and repairs. Any of the new houses not needed for almsfolk are let.

The Tabernacle has received a number of bequests. After more than half a century in which the trustees have disposed of the income, the finances have been placed in official hands. Some of the trusts had been placed in the hands of Hackney College, formerly the Village Itinerary Society and now New College of London University, whose accounts are not available, so a fully clear account is not possible.

It has been mentioned that Rowland Hill built Dudley Mill for cloth, and bought a little group of cottages which cannot now be identified since sale for the support of his poor. The trustees were Hackney College, who must also have received some other trusts, and who make annual "grants" for Tabernacle purposes. In the trust, income amounted to £20, and was to be distributed in sums of 7s. 6d., 10s. 15s. The mill cannot have furnished any contribution for long, and now few even know of its existence.

In 1868 the Tabernacle received a bequest of £10,127 6s. 7d., the largest bequest to any public body in Wotton. The testator

was "William Woodward gent", the "retired tailor" who started the Synwell Sunday School in 1863. The capital was half in funds, and a quarter each in railway stock and in land. The will directed that £16 was to be used towards the salary of the master of the British School; £25 for clothing fourteen boys of that school; pensions of 10s. a week for eight poor people attending one or other of the free churches, and 8s. a week for eight more: this accounts for only £88 of the total income, which must originally have been more than twice that figure. Vincent Perkins notes that when he saw the will, a part had long been lost which made some provision for the Synwell school, but that is not enough to fill the gap.

At the turn of the century the trust was reorganised as two schemes by the Charity Commissioners, with a combined capital of £12,000 of funds, income £303, but separate accounts. One scheme was "Eleemosinary", to provide 6s. a week for eight Nonconformist (but not Roman Catholic) poor, but was enough for four times that. The other scheme was educational; this paid £10 12s. 8d. to the school treasurer: £25 was intended for clothing ten poor boys of the school, but only £20 6s. 8d. was available for this. This is only half the income, and nothing is said of the rest. Now the only identifiable receipt is £49 rent of three cottages adjoining the Synwell chapel in the accountant's provisional summary, which may be the £55–£60 of "Woodward Trust" of accounts for a few years earlier.

Other bequests are small, have nothing of interest, and have more or less disappeared in a series of funds for different purposes of Endowment No. 1 and so on: but one small one has kept its individuality. This is the 1871 bequest by Richard Lacey, originally of Wortley, first in the cloth trade in Stroud for experience, and finally a valuer and collector of tolls for the market feoffees; also the "respectable business man" who objected to his mother going into the almshouses. This was £300 to provide coals and clothing for the poor of Wortley irrespective of creed. 1944 was a typical year, when vouchers were distributed to thirteen couples and one individual. Payments must have been withheld

in some years, for in 1959 a middle-aged widow and a spinster in employment each got £5 of coal, more than the income.

There were also the shares of the Tabernacle and other free churches in the 1886 Martha Harris bequest. In 1904 each of these four received £5 1s. for distribution: in 1907 £24 0s. 4d. was handed to the Tabernacle Minister for division with the others. The 1944 distribution is shown by a statement of six lists: for the Tabernacle, A. Long as secretary submitted a list of nineteen recipients for Old Town Congregational church; Mr. Leyshon the minister submitted a list of nineteen; for the Baptists the minister's list was of eighteen, and for the Wesleyans a trustee listed twenty. But there were two more lists of twenty-three and twenty-five, signed respectively by Robert Excell (a Baptist) and Fred. Holloway (Tabernacle) as trustees. Mr. Holloway tells me that he acted on this occasion only, he believes as nominee of the parish council: that he collected six bags containing £5 each from the National Provincial Bank and passed them on for distribution. The Official Trustees for Charities hold the capital and remit annually. The present procedure is that each of the four chapels prepares a list of eighteen recipients which are co-ordinated and scrutinised in a meeting with two parish council referees, on which they each receive £9 for distribution.

All the above, with the Streamsfield rents, and the £62 rent of the Manse with some fields as a farm, form a backbone endowment of the Tabernacle for expenses and for charities: but this is only the backbone, and they raise considerably more by jumble sales and such, and from gifts.

EDUCATION

The endowment by Katherine Lady Berkeley of the Wotton under Edge Grammar School in 1384 has hitherto been accepted as the date of foundation of the school, among the earliest in the country, only two years younger than Winchester and considerably older than Eton: but there is evidence of earlier activity. The endowment deed's instructions include "newly build a school-

house", which implies superseding existing accommodation. Mr. Irvine Gray finds in the bailiff's account for the manor of Hurst in 1291–2, nearly a century earlier, "amount delivered to the master of the scholars of Wotton according to agrement 48s by tally": and the earliest account roll of the borough in 1292–1323 mentions rent of the school house in Wotton Borough.

There was also an effort, though it proved abortive, between these dates. In 1349 the Friars of the Holy Cross obtained royal licence to buy and hold a habitation and lands in Wotton of £10 yearly value, for the celebration of Divine Service and maintenance of free schools in the town. Atkyns, on the authority of Dugdale, definitely asserts that such a house was founded. Vincent Perkins has asserted in an unpublished note that the house stood two doors below his residence in Berkeley House, (where there was and is a draper's shop) still visible a few years before he wrote about 1890. It is recorded in Knowles's and Hadcock's *Mediaeval Religious Houses*, with qualifications partly based on my information. It is also shown on the O.S. map of Monastic Britain, which is based on data supplied a little earlier by Mr. Hadcock.

It is more than likely that this project was an offshoot of the friary at Oxford, where these Crutched Friars had obtained a precisely similar licence in 1342. They had established themselves there in spite of intense opposition headed by the Bishop of Lincoln, and in 1349 were forbidden to use their chapel for services: so they may even have planned total removal to Wotton, outside the Lincoln diocese. In fact Mr. Hadcock has a recollection of a reference connecting the two places: unfortunately his own records, and a duplicate set deposited in the O.S. office, were both destroyed by bombing in the last war.

The diocesan registers of Worcester have no mention of any attempt to set up this house, or of opposing it. There is no record of any purchase or lease of land to the friars by Berkeley, and no one else could have provided the 270 acres or so needed. There is no sign of the remains which Perkins said he had seen or heard of, nor is there any tradition on the subject. In fact it is all but certain that nothing came of the project.

15

Coming now to the grammar school, Mr. Hornsby, the recent headmaster, has for years been working at a full history of it in the light of documents not before available. It would be improper for me to duplicate his researches. The *Victoria County History* has a very thorough account, though written nearly sixty years ago: and from the endowment point of view, the 17th Report of the Charity Commissioners' report of an enquiry in 1826 is even fuller. I can also add a few points which have come under my eye elsewhere.

The Lady Katherine was daughter of Sir John Clyvedon, married Sir Peter le Veel of Charfield, and after his death became the second wife of Thomas III Lord Berkeley in 1347, he being great-great-grandson of the builder of the manor house and the foundress of the borough. She had wide estates, from her father, from her first husband, and from her Berkeley husband. From these she endowed a number of charities as well as the grammar school, and left her cherished and only surviving son enough to put the Berkeley of Beverstone line, which he founded, in a status which for some time rivalled that of the senior line.

On 16th June 1384 a royal licence with dispensation from the Statute of Mortmain was for a fine of £20 granted to her two agents, to endow a free grammar school. On 1st July her grandson Thomas IV granted her a confirmatory licence in similar terms, specifying the lands for the endowment: this is preserved among the Fletcher MSS. at Birmingham. On 20th October Lady Katherine executed the endowment deed, instructing the two chaplains her agents to build a new school house, and to acquire and dispose of the specified property for the purposes specified.

The property conveyed consisted of the school house (already existing) with two acres, and seventeen messuages in Wotton; twelve messuages including a mill, 166 acres, and about £1 of rents including a bunch of cloves, in Nibley, Stancombe, and Woodmancote. The value of the endowment is variously stated at amounts of about £17.

The objects, specified principally in accompanying Statutes, were to "build" a new school house, and provide for the mainten-

ance of a master and two "poor" scholars in the art of grammar, and informing of all scholars coming for that study without taking any fees. The master was to be a priest, who should in addition to his school duties celebrate in the Lady Chapel of the manor house while any of the family were in residence, and otherwise in the parish church. His appointment was reserved to the Berkeley line, or in default to the lord of the manor or, if he were a minor, then to the abbot of St. Augustine's, Bristol: presentation to and institution by the Bishop of Worcester. Management of the property was placed solely in the master's hands, and he was to take the balance after providing the scholars with all necessities except clothing. Contrary to general belief about such early schools, holidays were specified: eighteen days at Christmas, fourteen days at Easter, eight days at Whitsun, and six weeks in August–September.

The scholars were not ordinarily to be under ten years old at admission; they were to attend for six years; they were not to be set to services or tasks: they could be removed for misconduct or refusal to submit to chastisement, on proof before the patron or his steward. The master too was removable by the patron after three warnings. If he resigned through age or cause not his fault, his successor was to pay him a pension of five marks. The specification "poor scholars" meant no more than children of a class that did not customarily employ private tutors: sons of prosperous burgesses were freely admitted as foundation scholars.

The limitation of the mastership to priests led later to difficulties with men who proved unsuitable or even bad. The inclusion of chantry service in the master's duties very nearly led to the suppression of the school in the period of Dissolution: in fact that was the first difficulty encountered. Though it had been classed as a free school in the Valor Ecclesiasticus, Edward VI's chantry commissioners classed it as a chantry, even in their final report, until this entry was crossed out and superseded. But this did not save the school from informers on alleged "concealments". John Smyth implies that this was the motive behind defamations against which he had to defend the interests of the school in

protracted and intricate suits: but an opposite view is that Smyth
was really the villain in the piece. The truth will remain uncertain
till Mr. Hornsby produces his results.

The *Victoria County History* writes of a first attack on the
school about 1559 by "ould Moore", but I can find no other
mention of this. In 1589 Richard Moore of Bristol and Robert
Crokey of London moved the Lord Chancellor for delivery of the
lease of Warrens Court in Nibley, by Grace Thomas, to some
"substantial and indifferent friend": this was the Nibley part of
the endowment. Grace was the daughter and heiress of William
Thomas, to whom the master Coldwell had in 1535 granted an
eighty-eight-year lease at only 48*s.* By 1592 Grace had married
John Drew, and the case was transferred to them. John died, and

21. Smyth arms

in 1597 John Smyth married Grace (the
Victoria County History wrongly gives this
date as 1578). Smyth also at some date for
£200 bought out a lease granted by Queen
Elizabeth in 1589, which conflicted with
Grace's rights, now his. Still other persons
come upon the scene by a transaction shown
by Foot of a Fine of 1591, when Henry
Duponte for £40 bought, from a man not
otherwise mentioned, the advowson of the school. The actions of
this Duponte or Duporte family were distinctly dubious; in 1592
John Duport as master, with Thomas and John Duport two poor
scholars, leased all the school property to James Duport for
ninety-nine years, for 40*s.* rent plus cost of repairs of the school
house; and also the further reversion of the lease: that is, they
swallowed not only the property but also the posts it was intended
to support. Duport did not even carry out the duties, but em-
ployed a deputy, Stanton, who was allowed use of one chamber
and the usual schoolroom, which were reserved from the lease.
It is perhaps relevant that the puritan John Stanton was vicar
1578–1622. Because John Smyth in 1604 bought the lease from
James for £100, and in 1608 the reversion for £300, the *Victoria
County History* suggests that all this had been arranged by Smyth.

In 1609 John Duport resigned the mastership; Thomas and the younger John must have ended their schooling some ten years before, and no more is heard of that family.

The above John, a notorious pluralist (d. 1617) was also a notable Greek and Latin scholar: he was Master of Jesus College Cambridge, four times Vice Chancellor, and one of the translators of the 1611 Bible.

Meanwhile the Crokey matter was far from having been disposed of. The former Robert had been succeeded by Benjamin, gent. and merchant of Bristol City. In 1615 he laid a complaint against Smyth, who three months later laid a counter-complaint and in 1618 the cases came before the Star Chamber. Richard Moore appeared and was perhaps one of the associated defendants.

One issue was the alleged defamation of Smyth. Crokey brought numerous charges of "foule and impious practices" to obtain control of the school property: anything Smyth did had this ulterior concealed motive; any other happening was prompted by Smyth to the same end; "she Grace Drew being very old, sick in her bed and likely to die, and Smyth being a very young man of little value or estate, married the said Grace in her bed, two women holding her up during the ceremony". In fact Smyth was thirty and had at marriage been for ten years steward of the Hundred and Liberty of Berkeley: and Grace was well enough to survive another twelve years till 1609, though there were no children of the marriage. It is plain that, whatever basis there was in fact for the allegations, Crokey had become obsessed, and let himself go: so it is not surprising that at last in 1631 the Star Chamber found against him. He fled to Ireland and on returning was arrested at Bristol, and was committed to the Fleet prison at Smyth's instance; he continued petitioning Parliament at any rate up to 1647, though with no known success.

The other issue, the more real and important one, was the validity and honesty of Smyth's title to the property: this was confused by the entry of other attackers. Thus in 1601 Moore brought a suit of which nothing more is known. In 1616 Edward Bishop, of Gloucester, brought a bill of complaint against Smyth:

this led to a finding that the lands were "concealed", the school really being a chantry: and in December 1617 Smyth obtained a fresh royal grant of them in fee farm, a better title than before. The opposition alleged that these moves had been instigated by Smyth as part of his tortuous campaign, to the end thus achieved. The case continued, with more fresh interventions, and an enquiry into the endowments by the Archbishop and the Bishops of London and of Winchester.

So in 1623 (the date 1603 given in the *Victoria County History* seems to be an error) the Court of Common Pleas found that the school was a school and not a chantry; that the property consisted of thirty-one houses and 162½ acres at a rent of £21 4s. 6d. though the true value was £121 17s. 2d. more; that all leases should be surrendered to the Crown for regrant and reform of the school. In view of his expenditure and long possession, Smyth should get a new lease at one-third of the value, £47, of which £26 13s. 4d. was to be paid to the master and £4 to each of the five scholars, to which their number was increased. If and when the income allowed, the foundation scholars should be further increased. The master and these scholars should be a body corporate with perpetual succession. The admission age for scholars was definitely fixed as above ten, and the leaving age as eighteen. The master was allowed to charge scholars up to 6d. a quarter for teaching. The Crown assumed the powers of visitor; the mayor was substituted for the abbot as second reversionary patron; the master should be "religious, discreet, and learned" but need not be a priest, must reside, and masses were abandoned.

In 1632 Smyth obtained transfer of the patronage from Lord Berkeley to himself. After his death in 1640 his son John in 1647 obtained a fresh lease of the Nibley lands from the master, who also covenanted under a penalty of £500 to resign if he should refuse to renew the lease further. This is distinctly worse than anything his father is proved to have done, but it provoked no immediate reaction. When reaction did begin eighty years later, it took the form of a demand to fit the school for better service

to the community, rather than personal efforts to control the property. This master, Byrton, enjoyed a long incumbency.

It was George Smyth, grandson of the younger John, who brought matters to the breaking point. On the appointment of a new and more resolute master, Samuel Bennett, in 1706, he exacted a bond similar to Byrton's, and a fresh lease not only at a reduced rent of £32 10s. but without fine at entry. The result was that in 1710 Bennett, backed by Richard Osborne of Wortley and John Austin on behalf of the inhabitants, filed a bill to set aside the leases of all the school lands, which they said were worth no less than £350 a year. When the case was heard, George was said, during a vacancy in the mastership in 1703, to have broken into the school muniments and abstracted documents. The judgement, delivered in 1718, was that George should deliver up the lease and the bond, but that he was still entitled to a lease of Warren's Court at the one-third value, though he should pay full value for the other lands. On appeal this judgement was confirmed in 1723 and George was further ordered to pay a sum of £4,225 to the school: on a revaluation this was reduced to £940.

A scheme for further reforms was in preparation and was ordered by the court in 1725. This raised George's rent to £60, the master's stipend to £40, and raised the number of foundation scholars from seven to ten. It called for the rebuilding of the school, which was effected next year for £450 out of George's £940. The buildings remain, sadly battered and modified by the requirements of subsequent generations. Much more important, it took the management of the property out of the hands of the master and scholars, and prescribed a body of seven trustees with the mayor and vicar ex-officio. In spite of the opposition of Lord Berkeley as direct descendant of the foundress, the nomination of the master was confirmed to George, and of the scholars alternately to him and the trustees. Any surplus income, to which proceeds of sales of timber and such like were later added, should be applied to the purchase of land.

In 1798 the successor-in-title of the Smyths sold his Nibley rights and the school patronage to John Jortin. He had also

arrived at an arrangement which was sanctioned by an Act of 1799, by which the school's 166 acres lying dispersedly among undoubted Smyth lands were exchanged for Starvall Farm: the latter, though only 134 acres, was of the same annual value as the former, £107.

In 1801, the total income of the school having risen to about £400, the master's salary was raised to £80 and the exhibitions to £30 (compared with the £5 given when first authorised, and one of £55 granted in 1833): and in 1824 the master was given an additional gratuity of £20.

In 1826 Lord Brougham's Charity Commissioners came to attend to this charity. They found the total income from the above Nibley farm, risen from the

	£	s.	d.
former £107 to	136	0	0
from a 40-acre farm in Charfield, bought with part of George Smyth's 1723 payment, though it had in 1817 been let by auction at £37	24	0	0
from twenty-one houses in Wotton and one in Newport, reserved rents plus average of fines	81	17	6
from £3,850 in the 3½ per cents	134	15	0
Total £376	12	6	

	£	s.	d.
While expenditure of that year was			
to master, salary plus bonus	100	0	0
to six foundation scholars	60	0	0
to exhibitions	nil		
to caps and gowns for the boys, about	15	0	0
to the clerk, land-tax and insurance, chief rent	8	16	4
to repairs, average	30	0	0
£213	16	4	

leaving a surplus income of £162 16s. 2d., while the treasurer had a balance of £305 8s. 9d. in hand.

The Commissioners made no criticism of the finance or the schooling: while Cornwall, the master, was eighty-one and infirm, his son the Rev. George Cornwall was performing the actual duties satisfactorily. In addition to the ten foundation scholars

fourteen more boys were being educated free. At the representation of some leading citizens that many of the boys had insufficient elementary teaching, and that some were sons of "low parents", the trustees had decided to institute an examination before admission.

The period of apparent peace lasted for some fifty years. On occurrence in 1839 of the first vacancy in the mastership after his institution as vicar in 1829, Benjamin Perkins secured appointment as master from the patron Jortin. There is, regrettably, no doubt that he used his position as master, and chairman of the trustees, and vicar, for the advantage of his family.

Three months after Perkins's nomination as master, his eldest son Vincent was appointed as one of four probationary scholars, a new class created by the trustees in 1856 for free education without grant. A year later in 1840 he was appointed a foundation scholar though under ten, and the next son George was appointed a probationary though under eight, the trustees specifying that these young appointments should not constitute a precedent. In 1848 Vincent was given a £50 Exhibition at Oxford: of the three other sons admitted on the foundation according to the *Victoria County History*, the only record in the trustees' minute book is of Charles getting a £40 Exhibition at Oxford in 1855.

Public action began with a vestry meeting on 8th July 1853, which appointed a committee to enquire into the town charities. This committee considered the grammar school first and drew up a memorial to the trustees, which a second vestry meeting on 5th August approved. The trustees rejected this, and on 17th January 1854 "postponed" a parallel memorial from the mayor and aldermen. A public meeting on 28th February 1854 heard and discussed a report of the situation, and decided to ask the trustees to reconsider the matter: in the event of refusal to place the matter before the Charity Commissioners. These proceedings are most informative: but information on points that were not common knowledge had been refused the committee, and they went to the limit in trying to avoid personalities or any statement which could possibly give offence. The appointment of all these Perkins boys

is not mentioned, nor is there any mention of dissatisfaction with Benjamin's conduct of the school though that is obviously felt. I also have a MS. statement drawn up by or for Benjamin in his defence, undated, but apparently a reply to what transpired at the meeting and to a subsequent visit by an inspector.

The market feoffees later, in 1885, gave £10 towards the costs of the committee in all these efforts.

There was dissatisfaction that the vicar and chairman of trustees should be master: without any personal reflection, it was not desirable that Mr. R. H. B. Hale, who had recently bought the patronage, should be a trustee (and treasurer). Of the others of the seven trustees prescribed in 1725, one more was Mr. Hale's son, while two others, Edward Austin and Carey Metivier, had long left the district and had taken no part.

The master's salary, which had in 1826 been reported as £100, was understood to have been raised from £120 to £150 in 1836 to cover his educating the probationary scholars, and was now to be £180. It was alleged that a guinea was charged on election to the foundation, by whom received and for what purpose being unknown: that £12 per annum was charged for preparatory teaching (the probationers?), and that £50 salary allowed for an under-master was increased to £75 by taking £2 10s. out of the £6 payable to each foundation scholar. To this last the Perkins note makes confusing reply. He refers to an order or decree of 1831, not mentioned elsewhere, which allowed deductions for what had been spent on these scholars: that by agreement with the parents "some years ago" the assistant's salary should be thus made up: that the £6 allowance had been sufficient to find the boys in books, and in "almost every case" there had been a balance payable to the boy on leaving. Each boy paid a further 10s. per annum for stationery and the cost of fires and cleaning the room. An entrance fee of 10s. had been paid by foundationers from time immemorial, which his predecessor had spent on requisites for the school, and 1s. to each foundationer "who was also required to give a supper to his schoolfellows on pain of personal ill-treatment".

The committee, though lacking official information, believed the school income to be more than £540, and the expenditure about £360. Perkins noted the disposable income as nearer £400, and that the reduced value of house property in Wotton must be remembered. With that they were providing for ten foundationers only (and the committee did not mention the fourteen free scholars): they compared this with the Bluecoat school which for £152 14s. 11d. educated and clothed thirty boys and provided them with stationery and educated sixty-five more for 2d. a week.

Commenting also that the £116 8s. 7d. cost of repairs to property in the previous year left room for improvement by better management and timely attention, they suggested that funds would permit widening the curriculum to include mathematical and commercial subjects; that even now thirty boys could be taken: that caps and gowns, introduced at the instance of more substantial citizens, could be discontinued at a saving of £15 per annum; that the salary of the master should be £250, and of the assistant £100 with residence in the school and liberty to educate a limited number of private pupils (as fitting for the wider abilities and responsibility). Perkins claimed that the education he gave included scripture and doctrine according to the Church of England; grammar, composition and translation in Latin, Greek, French and English; ancient and modern history; outlines of astronomy, geology, chemistry, natural science, physical and political geography, Euclid, algebra, trigonometry, arithmetic; and in two instances elements of fortification. Encyclopaedic! The assistant took writing, reading, dictation, arithmetic, Euclid, English history, catechism and bible history, Latin and Greek, for the junior boys. Perkins also pointed to the success at Oxford of boys from his school in competition with boys from Eton and Westminster.

A year later the matter was referred to the Charity Commissioners, resulting in the inspection to which Perkins refers, though there is no other mention of it. This led to a scheme in 1860 which increased the number of trustees to seventeen, who had all to be members of the Church of England and to live within seventeen

miles of Wotton. No future master should hold a cure of souls. The number of foundationers was raised to sixteen to twenty: tuition fees of up to £4 could be charged for Wotton and Nibley boys, and £8 for others.

Six years later a Schools Inquiry Commission found Perkins still drawing £180, while the assistant, vicar of a parish five or six miles away, slept at the school house most of the week. Only thirteen boys attended though sixteen were said to come; only three were more than fourteen years old: seven wrote "fairly": arithmetic was very indifferent, none understanding decimals and only a few fractions, and only one professed to have done Euclid or algebra. The head boy, however, son of a neighbouring parson, could translate the Odyssey fluently. The endowment had by now "risen" to £331 net.

At last, in 1882, Perkins retired; but under his successor, Cranston, the school declined even further. In 1884, under an order from the Commissioners, the trustees bought the advowson from Colonel Robert Hale, and a fresh draft scheme was published under the Endowed Schools Act of 1869.

Trustees, now to be called governors, were to be eleven: two to be appointed by the petty sessions justices; four by the vestry, now parish council; their appointments were to be for five years. The remaining five were to be co-opted, appointed for eight years: but at the start ten were appointed for life; these were the Earl of Ducie, the Rev. Sir George Prevost, Bart., Colonel Robert Hale, Benjamin Perkins, Henry Sewell, his successor as vicar, the vicar of Iron Acton, F. J. Blake, the mayor, Samuel Long, J.P., the clothier, W. J. Phelps, J.P., of Dursley, Edward Pinnell, wheelwright, of Wotton. Appointments were not subject to any religious qualification.

Accounts were to be made out annually, rendered to the Charity Commissioners, and exhibited for public inspection. Lands and funds to be vested in the Official Trustee, but managed by the governors. Proceeds from sale of timber or minerals were to be treated as capital.

The school was to be a day and boarding school for boys. The

master must be a graduate, appointed by the governors after public notice and advertisement. They could dismiss him at six months' notice; he might not hold a cure of souls, or undertake other office without approval: he and his assistant might not be governors, nor take fees from boys. His salary should be £150, and a capitation fee was to be fixed from time to time of between £2 and £4 per boy.

Boys were to pay tuition fees to be fixed by the governors from time to time, between £4 and £10; boarders were to pay not more than £40, or £50 in a master's house: boys were not to be admitted under eight, or to stay after eighteen. Preference was to be given to Wotton and Nibley boys.

The Corporation of Master and Poor Scholars was to be dissolved. Ten Foundation scholarships of £10 were to be instituted, open to boys over twelve by examination and not nomination; the governors might also maintain three Exhibitions of £50 a year for three years at a place of advanced or technical training.

The curriculum was to include Perkins's list except for some of the more specialist subjects, with one foreign language optional, and Greek an extra: drawing, drill and music were added.

Two hundred pounds out of the income was to be set aside and invested; when this amounted to £1,000, capital and this contribution were to be used for the education of girls.

The scheme was brought into force by an Order in Council in 1886.

Morris, the first master appointed under this scheme, was the last cleric to be master. He found the school with only five boys, but soon got twelve boarders, and before retiring in 1907 had raised its numbers to seventy. In 1900 girls were first admitted, and by 1910 numbered forty-five, and by 1930, 120. In class boys and girls work together, and that is believed to foster a healthy rivalry; it also probably helps to set up the good manners which are noticeable among the pupils. By 1945 the total number had risen fast to 300 and is now over 330. During the war, Harwich Grammar School was evacuated to Wotton with its staff, and shared the use of the school premises for teaching.

In 1892 the school buildings were rearranged internally, the master's living accommodation being taken in for school purposes. It must have been then that two houses belonging to the school on the Green Chipping were united, in spite of the borough boundary running between them, and became the present headmaster's house. In the same year a chemical laboratory was built. In 1950 biology and demonstration laboratories were added. Carlton House on Long Street and facing down Church Street, has also been acquired and is used for classrooms and a common-room for masters. The Steep Mill was bought from the Austins and has classrooms including a carpentry shop: behind it a canteen and kitchens have been added. A passage has been opened from the school grounds directly on to the Steep, to lessen traffic danger to the pupils streaming to and from these separated classrooms. The school has become a maintained school under the Gloucestershire Education Authority. New buildings are now being planned on a site on the Charfield Road. Eventually it is intended that they should be completed by buildings for a secondary modern school which would share certain amenities with the grammar school.

In the following list of masters I give notes of the few facts known of some of them.

THE GRAMMAR SCHOOL MASTERS

? –1405	John Stone, already master before the endowment of 1384.
1405–1407	William Hesulton. Ordained acolyte to make him eligible, made sub-deacon the same day, and deacon December 1406 to become full master. Died in office.
1407–	John Seymour.
1416	John James. Resigned.
1416–1423	William Clyfton.
	William Hogyn. Left on exchange.
1423–1427	Thomas Joye, rector of Bromham, exchanged with Hogyn. Resigned.
1427–1456	John Paradys. Resigned after thirty years in office: was awarded a pension, to be fixed by the bishop.
1456–1460	Walter Frouceter. Died in office.

1460–1461	Robert Haynys. Died after only four months.
1461–1462	John Dale. Resigned after twenty-two months.
1462–1465	John Town. Resigned.
1465–1487	Richard West.
1487–1493	John Packer. Resigned.
1493–1511	John Chilcote. Fellow of All Souls, Oxford. Resigned.
1511–1553	Robert Coldwell.

It is not known to what extent, if any, he was involved in the feud of the "Coldwell family" with the vicar Merryman, which has been mentioned. The *Victoria County History* gives at some length evidence taken in 1616, from some octogenarians including an ex-parish clerk. Coldwell was called the Morrow Mass priest to distinguish him from two other priests who sang their masses later in the day. He was said to be over sixty in 1548: he was reputed to keep "a yonge woman secretly in the schoolehouse", and was in 1552 cited for incontinence and *in absentia* suspended from entering the church. The witnesses make much of his ritual performance of the masses in which they assisted, which he saw abolished, and again restored by Queen Mary: he died soon after 1553.

?	Robert Knight. Seems to have shaved his yellow beard and got himself ordained for this appointment: "fell into trouble about the lands and was put out." Wrongly said to have been vicar.
1592–1608	John Duport. See account of the Duport scandals above: resigned, perhaps by arrangement: Stanton did the duties, who may have been related to the vicar.
1609–1632	Edward Cowper, former tutor to Henry Berkeley: still in office in 1624, but one of the octogenarian witnesses in 1619 asserted that Robert Pritchard was master, and had been so under Duport. Died 1632.
1632–1640	John Turner. Retired, to a living.
1640	Joseph Woodward. Covenanted to keep an usher if the number in the school rose to above fifty.
1647–1687	Thomas Byrton. Practically surrendered management of the school property. End of term uncertain.
c. 1703	Edward Pearce. Appointed before 1701. After his leaving, George Smyth said to have abstracted deeds.

1706–1743 Samuel Bennett. Died in office, and then his son Samuel Craddock Bennett officiated for six months; he had been apprenticed to a clothier, after proceeding to a university from this school; he initiated what led to a reform, and saw the school rebuilt.

1744 Samuel Hayward. In 1746 the trustees asked the bishop to enquire into his capacity and alleged lunacy; the bishop recommended paying him £20 per annum to go, but he declined. The trustees thereupon discontinued paying Hayward, and employed Richard Smith, a former exhibitioner as locum. Hayward died in 1780.

1748–1788 Thomas Clissold was paid, subject to an annuity of £20 to Hayward during his life: this led to suspension of the exhibitions, though a Mr. John Cooper paid £20 for his son and for a succeeding boy. Died 1788.

1788–1828 Peter Monamy Cornwall. Enjoyed increases of salary. From 1818 he employed his son Eusebius as usher, an ex-scholar and exhibitioner and then curate of Uley. He received "parlour boarders" for 50 guineas, with 30 guineas for others. Died 1828 aged eighty-three: his son George had been carrying out the duties competently.

1828–1838 Joseph Barkett.

1839–1882 Benjamin Robert Perkins. See my account of his attitude over Perry lecturers, to Isaac Pitman, of his alterations of the church, and of his mismanagement of the school. Retired 1882, and died.

1882–1886 J. P. Cranston. An even worse failure, though for a shorter time.

1886–1907 Frederick William Morris. The last clerical master: greatly revived the school.

1907–1909 Mr. Harding.

1909–1911 Mr. Wells.

1912–1915 R. R. Dobson.

1916–1920 Mr. Morton.

1920–1923 Mr. Trenchard.

1924–1952 Cyril Ernest Fiske, under whom the numbers of the school considerably increased.

1952–1959 F. W. D. Hornsby. Retired, to become headmaster of Penrith.

1960– A. A. J. Forster.

SENIOR MISTRESSES

1907–1908	Miss Taylor.
1909–1910	Miss Deane.
1910–1911	Miss Evans.
1911–1914	Miss Basher.
1914–1916	Miss M. Longman.
1916–1920	Miss E. Wood.
1920–1923	Miss K. Crawshaw.
1924–1926	Miss Higham.
1926–1926	Miss E. Miller.
1927–1928	Miss M. Fowler.
1929–1955	Miss P. M. Sharp. Retired. The only long incumbency, and one in which she did much for the school.
1955–	Miss O. P. Parkhouse.

The grammar school had a seal which survives on a few fifteenth century documents; a reproduction of it is used on the covers of school prizes. It does not show the Berkeley arms or any of their badges, but St. John Baptist in a colonnade with the Agnus Dei in his lap. The explanation suggested is that Lady Katherine was commemorating her favourite and only surviving son John. She had induced her husband to give him liberal grants of land, and had done the same herself: in fact his line, the Berkeleys of Beverstone, for a time rivalled the Berkeleys of Berkeley in importance.

22. Grammar-school seal

The next school to come into existence was the Bluecoat school, now in a building with a nice shell porch, in Culverhay opposite the church.

According to the 1826 survey and the 1829 report of the

16

Charity Commissioners, "an old parish book dated 13th October 1714" records that on that site had stood an ancient almshouse of origin older than was known; that at that time the feoffees of the Perry and the Dawes hospitals resolved it should be pulled down and a charity school be built; that this was done with the help of materials given by Colonel Moreton and partly out of the funds of Hugh Perry; that adjoining properties, part of the endowment of the "Old Almshouses" should be appropriated to the school. An old feoffment of 18th November 1654 is quoted as defining

23. School shell-porch

the property as the two houses of the almshouse, two houses adjoining on the south-east, and their gardens.

Promotion of this new school seems to have been largely due to the vicar Gregory, and to Richard Osborne the elder of Wortley, who were both among the first correspondents of the Society for the Propagation of Christian Knowledge, founded in 1698. The latter by will in 1722 left the school £3 per annum charged upon his New Inn, which charge was in 1798 compounded for £80: and his son Richard left £100 in 1748, to the

school or to a master or dame who shall live in Wortley: this seems to be part of £500 held unclaimed by the Charity Commissioners and only now being properly brought to account. The school also received other bequests.

The £20 10s. rents arising from the Thomas Dawes bequest of 1713, "to the poor", were applied to this school till 1719. Doubts were then raised whether the trustees had exceeded their wide discretionary powers, and the bequest was then applied to building and maintaining the Dawes hospital in the Church Street almshouses. Similar bequests, of about 1700, by William and Robert Hyett who were Dawes relatives, were divided by the trustees: £10 of the proceeds was made payable to a schoolmaster to teach twenty-four poor children to read as far as in the Testament, as salary, and for the provision of "horning books", primers and testaments. This was later blended with the general charity revenues and was not allotted to any particular school, but accounts for part of the £60 per annum paid to this school out of the consolidated general charities fund. One of the bequests of Robert Purnell in 1763 was a sum of £100 to the school, which became part of its endowment. In 1742 Edward Bearpacker, maltster, remembered the school in his will, and in 1769 Edward Bearpacker jnr. similarly gave £100. Sarah Winchcombe by will of 1773 placed £30 in trust for the school, and the income from this is paid to the school without having been consolidated. A gift of £20 by William Bailey, clothier, in 1721 was "lost many years ago by the insolvency of the person to whom it was lent".

	£	s.	d.
At 1826 the school held £950 in the 4 per cents which had been reduced to 3½ per cents, yielding net	33	5	0
Subscriptions produced an average	12	0	0
And collections at the church door	30	0	0
From the Sarah Winchcombe bequest	1	8	0
From the Feoffees of the General Hospital	60	0	0
Making the total income about	£136	13	0

Expenditure at that date is given as:

	£	s.	d.
Average cost of clothing the thirty boys from head to foot	60	0	0
The master's salary	45	0	0
Apprenticing boys	10	0	0
Stationery, books and implements	11	0	0
Repairs and insurance, and coal	6	8	0
Total expenditure	£132	8	0

and there was £89 14s. 8d. balance in hand.

Better value for money was being got in 1853, if the figures for this school quoted by the vestry committee enquiring into the affairs of the grammar school are correct. It was said to be costing £20 more to educate (but not clothe) sixty more boys who paid 2d. a week.

In 1896 the above £950 investment was realised, to pay for new school buildings: this reconstruction, belatedly followed a highly unfavourable inspection report in 1885.

Internal affairs of the school can be seen in the minute book, but it goes back only to 1882, when the school seems to have been reopened after a dormant period. A budget was presented.

Expenditure	£	Income	£
Master	110	Dividends	30
Pupil teacher	15	General charities	
Clothing	59	grant	80
Fuel and cleaning	8	Boys	22
Books etc.	13	Deficit	78
Rates, insurance	5		
Total £210		£210	

A master and a pupil teacher were appointed, but in the next year the former was getting £10 more and there was no teacher. General charities voted the £80, which after all was at least partly directly due, and claimed a share in the management, but refused any further grant for necessary structural improvements.

The average attendance was seventy-two: the government inspector reported "quite good", and a grant of £47 10s. resulted.

In 1884-5 the inspector recommended less clothing and more education, and the number of boys clothed was reduced to twenty. The condition of the buildings was reported bad, closets bad and a urinal needed, general repair and cleaning needed, discipline weak and instruction poor: so the grant was cut to £39 15s. 5d. from the previous £74 3s. (?). The intensity of religious instruction was relaxed, catechism being dropped. The average attendance was eighty-five and increasing. The master resigned and the new one appointed disappeared, and then another was appointed on £20 plus the grant. There was a disturbance over which five boys were dismissed, and a friend of mine was "punished", and had his back examined on a complaint of his parents. Shortly after, it was reported that "the breaking of glass has stopped". A school band had been formed, which did a march in the town, and five years later was given five new fifes which cost 3s. 6d.

In 1888 Osborne Dauncey was signed on as candidate pupil teacher, but in 1890 was reported unsatisfactory in his examination, and in 1892 gave notice. He must have been related to the Osborne Dauncey who is first heard of in 1859 as an articled clerk, who rose to being mayor and principal of the local firm of lawyers. There must have been special reasons of some kind for his entering this "charity" school.

In 1889 it was recorded "till lately about a quarter of the boys never wore collars": and in 1890 "the master is pleased . . . every boy is wearing a collar".

In 1923 there was an adjustment with the Bear Street school by which it took all the pupils between seven and fourteen, and the Bluecoat school became an infant school. This probably marks the closing of an infant school which existed on the Tan Yard site in the 1870's, probably a Church foundation, though no records survive.

Both existing schools being connected with the Established Church, a committee from the Tabernacle and the Wesleyans

resolved to open their own school, of which Isaac Pitman became the first master, but soon incurred dismissal. Steps that led up to this are recorded in the Minutes of the school committee and reveal some rigidity on both sides. This also gives the story of the school after his dismissal, while a diary of his brother Benjamin deals with his school, both at first under the committee and then independently. As Pitman is acclaimed as one of only two famous sons of Wotton, though he spent only three and a half years there, a brief account of his life must be given.

Born on the 4th January 1813, Isaac was the second of eleven children of a clerk in a cloth factory at Trowbridge. Leaving school at thirteen, he became a junior clerk under his father. Having decided that he wanted to be a teacher, he took a course at the Training College of the British and Foreign Schools Society, and in 1832, at the age of nineteen, became master of the endowed school at Barton-on-Humber. The school then ran short of funds, and when he received an invitation from Wotton he left, with his salary in arrears. On the long journey south he got into conversation with a Clifton gentleman, and they discovered a common interest in religion; visiting this gentleman a fortnight later, further discussion resulted in his accepting the doctrines of Swedenborg. Not only did this lead to his dismissal from the school, but the minister told his congregation from the pulpit in Pitman's presence, that "if he held such religious sentiments he should expect to be hunted out of the town like a mad dog". That naturally forced him to leave the Tabernacle. Instead he went to the parish church; on his first attendance there he took upon himself to rise and protest loudly at the invocation of the Trinity in the Litany. The vicar, Benjamin Perkins, was tolerant and tactful enough to ignore the profane interruption, with the result that they became friends. After that, not only did Pitman attend services but his signature is among those of a vestry meeting, in 1838, which approved application for a faculty for Perkins's alterations to the church.

After dismissal from the school, he set up his own school in January 1837. In June 1839 he moved to Bath and set up school

there, at 5 Nelson Place, till 1843 and then, till his death in 1897, devoted himself to promoting his system of phonography.

The chapels committee continued their school.

The chapels had in November 1835 decided to set up a school for boys and girls on "British and Foreign" lines, but to start with boys. They appointed a committee which included five of their ministers, and also Isaac's brother Jacob, whose wife conducted a school for young ladies at North Nibley. At a subsequent meeting Jacob proposed Isaac for the mastership, Isaac being present, and agreeing to the proposal that he be responsible for his own salary up to £40 for a six-months' trial period, while the committee "did their best". They were unwilling to take more responsibility, though in the event they received liberal support from affluent members, T. S. Childs, Lewis, Samuel Long, Woodward and others. Childs has only been seen as a buyer of Ellerncroft; Lewis was probably the lessee with Dutton of Waterloo Mill; Samuel Long was lessee of Rowland Hill's mill at Dudley and had coal interests in the Forest of Dean; he came of a family which held Charfield mills, and included W. A. Long, a Kingswood clothier wealthy enough to have bought Neathwood Farm for £7250 in 1826. Woodward is reported to have been a retired tailor when he founded the Synwell Sunday School, but left no less than £10,000 for local charities including this school. But they still had to fight for funds all the time.

The school was opened in January 1836 in a "long room", The Folly, in Sym Lane: this was offered them by Mr. Woodward, free of the £14 tax-free rent which it commanded. By October, as this was proving inadequate, Isaac went to Dursley to try to arrange for accommodation in the Steep Mill, and the committee accepted an arrangement for 2s. a week. On 28th November the school moved in, but a march round the town which Pitman had planned was prevented by rain. On 12th December came a note out of the blue from Mrs. Austin saying that, as Isaac and the committee had given her so much trouble, she was determined to let no part of the building for less than £10 a year.

Meanwhile the committee, at an October meeting, had asked

Isaac if he had changed his belief in the doctrines of the Bible. He candidly admitted that he had, and that he had said so in reading and repeating hymns, but not in reading scriptures. A month later they asked for further explanation, thought his new principles "very unscriptural", decided they could not keep him as he would not promise to keep his sentiments from the boys, and gave him notice for the end of the year. They refused to let him hold a public examination of the boys, decided to attend school on 23rd December to dismiss the boys, but found they had gone already.

After Mrs. Austin's letter the committee had commissioned Pitman to go to Dursley and take the room for £5 per annum. He wanted the secretary to go with him to sign the agreement. After notice of dismissal Pitman wrote that, in view of this, and the secretary's not having come, he had signed one in his own favour: this was for £12 rent for two rooms, to which the committee objected as beyond their commission. At a conference Mrs. Austin's solicitor explained that Pitman had given him the impression that the committee were unwilling to continue, but he was ready to give them preference as the present tenants.

There is no question about Pitman's success as a master. Visitors came to see his methods, and after the resumption the master of the committee's school came to see his new school. The committee, writing to the British and Foreign Society for help in finding a new master, acknowledged him to have been "efficient and universally esteemed", but for his unscriptural views which he would not keep to himself; and in the matter of the lease he had behaved very unhandsomely and dishonourably, his zeal carrying him "prudenay" [sic]: but they paid him £70 for his ten and a half months of service, on his relinquishing claim to the Steep.

Isaac's fourteen-year-old brother Benjamin had joined him as usher in September, continued with him in his own school, and has left a diary till he left in December 1837. While provision for only twelve desks had been made at the Steep, the committee reported 150–170 boys there before the end, and seem to have expected to retain and increase them.

On 9th January 1837 Pitman opened his new school in Mrs. Cook's premises in Bradley Street. These were in what is now a builder's yard a little above the police station cross-road. Benjamin reports an attendance of fifty-three on the first morning, with three more in the afternoon. Some of these will have been from Mr. Page's "respectable school" which had just been closed, so that the number from the old school is uncertain. He also notes that a few of the respectable children were more disobedient than those of the poorer classes. Next morning the committee's new master paid them a visit.

By the end of January Benjamin reports an attendance of fifty-five, seven of them from the old school, while thirty more were absent on account of the weather; then regular small increases occurred including a fair proportion of boys from his old school. New entries in February included two from Charfield, "real farmer boys, more like ploughboys than tradesmen's sons": and on the 20th he noted ninety-nine on the books, and his sister had promised them a cake when they got the 100. Up to the Whitsun holidays numbers continued increasing, including "shilling boys".

Whitsun was a temporary set-back as the holidays were shorter than the boys liked, only forty-four turning up, about half the full strength; but new boys continued to come in both before and after the fortnight summer holiday, still including some from the Steep. On 14th August the actual attendance was 102. Then there is no more such detailed information till the school closed in June 1839.

To the usual curriculum for such a school Pitman had added shorthand as a voluntary subject for older boys. He had himself used the Taylor system constantly as a boy. The standard text-books were too expensive, so Pitman wrote a cheap edition. The publisher refused this and advised him to produce his own system; he must already have had the idea of phonography in his mind. On 8th May 1837 Benjamin reported "brother" having sent up his *Manual of Shorthand*, presumably the version which was refused. In the summer holiday he went round shops in Bath to

see shorthand books. On 15th November Isaac received a supply of the new books, twelve pages with two plates, price 4*d*.: and in December Benjamin noted that it was having a very good sale, and found the system much shorter, plainer, and easier to read than Taylor's.

Pitman also designed a modern system for longhand, perhaps a spelling reform, which did not catch on. Before and after his dismissal in Wotton he was occupied with a revision of the "Comprehensive Bible". His views on total abstinence deepening, about that time he knocked the bung out of his beer barrel and poured the contents down the sewer: also "an unsuccessful attempt to kill a fowl for the cook" led to his becoming a vegetarian.

The committee's school was reopened after the holidays on 9th January 1837, with a drop in attendance, and admission of girls within a year. The British and Foreign Society was asked to recommend a master. At the same time the committee recommended "a female of about 25, decidedly pious, well educated and no doubt of unwearied perseverance, a member of the independent church" for training, and asked for a mistress to take charge of the girls till she was ready. The first master, Good, was given notice in October 1838, but was asked to remain when the successor selected found another post. That seems to have been temporary for after two years he, Newton Lacey, was called upon to explain attending Chartist meetings contrary to his pledge, a matter referred to on another page. A married couple was then advertised for, and the Smiths appointed. They only lasted about a year. The Oldland couple who followed them had so large a family that the wife was not fully free to work in school; they lasted till a Society's inspector reported so unfavourably that they were given notice to improve, and, as they failed, were given notice of dismissal in November, 1847. Their successors, the Swans, were allowed to resign by agreement on account of Mrs. Swan's health, and the Mr. Rich who succeeded in March 1850 was so eminently satisfactory and successful that he lasted till allowed to resign in April 1899 after forty-nine years' service.

There was then great difficulty in filling the post. The first man chosen spent four months repudiating liability for rent of the house the committee had tried to help by taking for him, and had to be dropped. Then as a last resort Mr. Denison was appointed in October 1899, was reported very satisfactory, and was still the master when, in April 1903, the school was adopted as a non-provided school under the Education Act of 1902. The system of management and trusteeship was changed, and the minute book ends.

The record of additional staff is irregular and unclear. As early as the Oldlands' time there was a P. Dauncey at 12s. a week; in 1850 Miss Fear was engaged as infant school teacher for six months at £10; a year later at a recommendation from the inspector, she was sent to a normal college for three months' training, all expenses paid, agreeing on return to resume charge for not less than two years at £20: at the end of that time she was promoted to £30. It is not necessary to record all changes of persons in these posts. There were also "candidate" and "indentured" pupil teachers, and monitors, who got small salaries or honoraria, but the lengths of periods for which these applied vary and are not clear.

The periods for which stated amounts were paid to the heads of departments, Boys, Girls, Infants, are also not clear. Their remuneration is further confused by their being allowed to retain the children's "pence", and later also the official grants minus a fraction of a quarter or so retained by the committee. It seems that Lacey started on £40 per annum, the Smith couple on £60 plus £2 house allowance; in 1851 Rich alone was getting £60, and when salaries were fixed in 1901 Denison had risen to £130 gross. At the latter date there were also four ladies on £78, £45, £30 and £30 respectively, while £25 was allocated for pupil teachers and monitors. The difficulty of finding subordinates is illustrated by an experience in 1852: there being no girls in school old enough, applicants were invited from four British schools, four were selected but only two passed a test by the inspector, and of one of these Rich, the master, reported "order miserable, habits slovenly, temper obstinate".

Rich thoroughly merited his long retention. When the committee applied to the Council for Education for periodical official inspection in 1851 the first report was "School excellent in tone and discipline, and technical instruction good considering the difficulty in finding subordinates". In 1857 "the school continues in a state of the highest practicable efficiency"; in 1858 "Boys and Girls, this excellent and well-managed school is going on with undiminished success and producing the most satisfactory results: the infants' department is also well conducted and entirely successful": in 1860 "equal to the best elementary school in my district". There was also a good record in prizes of higher authority for which pupils went up, and one first-class scholarship: for example, at the prize-giving of 1859 by Lord Ducie, there was one prize of £5, three of £2, six of £1, and others totalling £12 9s., all given by the Prize Association. A share in these successes was in drawing, in which Rich had passed a Council examination and gained a prize, and was twice awarded gratuities for his pupils' successes.

As to numbers at the school, the school opened with 157 boys and it was claimed that Pitman had got only few from them. But in 1838 the committee wrote despondingly that the school had been very discouraging for the last two years, with average attendance only forty, and no energy or interest. They proposed to drop the fees, and to allow each subscriber to send children proportionately to their contribution, and hoped this would bring in poorer children, and that those who could pay would do so. In 1849 Rich's predecessor reported an average attendance of sixty boys and seventy-one girls. In 1850 the building of a gallery for about fifty children was approved, not to cost more than £15 "with apparatus". In 1862 attendance of forty-one boys, twenty-five girls and sixty infants was reported. In 1899 a harmonium was authorised, for not for more than £3. The only other mention is that in 1900 Denison reported that average attendance in the last three years had been 85–88 per cent.

Curriculum was not a subject for the committee, but there were occasional provisions for staff, especially difficult in providing

sewing instruction for girls. Subjects varied with what the children paid. In 1845 boys were paying 3*d.* a week and getting stationery and this was changed to 2*d.* without provision of stationery, for which they got a "sound and useful education": for 6*d*, drawing, book-keeping, history, geometry and natural philosophy were added: in 1872 military drill under Sergeant Owen was introduced. Girls paid 1*d.*, and for 2*d.* could bring their own sewing, and for 4*d.* were taught extra needlework and higher education. These "pence" were bringing in 51*s.* a month from boys and 29*s.* from girls. In 1856 fees were successfully raised to 2*d.*–4*d.* according to the means of parents; but in 1860 a drop in attendance seems to have been felt, and a new infant school mistress suggested, demanding 2*d.* from only one child of a family. In 1870 boys' pence averaged £35 per annum to add to Rich's salary of £30 and three-quarters of the grant for his department, later voluntarily reduced to two-fifths. In 1891 a decrease of the pence was felt, and the committee were invited to meet the Bluecoat and the National schools about the irregularity of attendance, but refused the suggested schemes.

Apparently the Steep Mill had been found no longer convenient, and in 1842 the Bear Street premises (or site) were offered. Competitive designs were called for, and an incomplete subscription list shows £552 promised, including £160 each from Samuel Long and T. S. Childs and £25 from Lord Fitz-harding. A year later the selected builder was appointed, the work to be completed by February 1844. A first payment to him of £146 13*s.* 4*d.* is recorded, which seems to have been a third of the tender, making the contract cost £440. The foundation stone was laid on 15th August 1843; on the next 24th May there was a formal opening with presentation of the school to the town; and on 3rd June the classes moved in for work. In 1891 insurance of the building was increased to £650. This seems to have been the present building, one big room with partitions separating one half and two quarters as the classrooms, with the headmaster in a central glass cubicle. Five years later the roof had settled a little, jamming the folding doors, and £4 5*s.* was estimated for putting this right.

In 1859 the school well was found to be in bad condition; in 1872 the urinal was criticised, and again in 1900 the boys' closets. In 1891 cloakroom accommodation was demanded. The faults are in line with the public objections when sanitation was suggested for the town: the suggestions show that inspections went all round. It was Rich who in 1859 proposed the improvement of offices, and erection of necessities on opposite sides of the wall, which he proposed to raise from 3 to 8 feet, and to enlarge the playground. This last question arose again in 1902 when the County Council wanted to widen Bear Street, and the adjoining plot was offered for £40 to maintain and enlarge the area: but the whole scheme, which included £30 for lowering the ground and £40 for new walling, was too costly for the committee.

Eighteen seventy-three saw a proposal to move the interior partition, to enlarge the mixed school-room some 12 feet at the expense of the infants, providing additional desks and rearranging seating so as to accommodate more: with renewal of part of the wooden flooring and providing an entrance lobby, this was to cost £35 10s. In 1874 it was decided to provide a stove (the first heating) and an umbrella stand when funds should allow. In 1901 the inspector called for considerable measures which included heating and more floor renewal. Tenders for the work ranged from £75 to £105 excluding joists and airbricks, and the lowest was accepted.

After dismissing Pitman the committee noted that it had cost them more than £170 to establish him, and a debt of more than £90 was reported. They enquired from the British and Foreign Society if there was a possibility of a grant for buying or building, if inhabitants raised a sum, understanding that £175 had been granted for the National School (which only got its land six months later): it sounds as if some grant had been obtained for them from the Treasury. Members of the committee pledged themselves to give £50, and actually subscribed £64. In 1840 the school was still in debt, and the Council of Education was asked for help to avoid it closing. The chapel ministers were asked to address their congregations on this, and on the advantages of education.

The situation was eased temporarily by the excess of sub-
scriptions for building the new school over the actual cost. A
little help was gained from letting the room for meetings for
approved purposes, free for those most strongly approved: during
rebuilding of the Tabernacle, use of the room was given for
services. Appeals for funds were widened, and it is noticed that
Lord Ducie had given £5 and become president, while Lady
Ducie had become patroness.

In 1870 a public meeting was held on the need for funds.
Ministers were asked to preach, committee members were allotted
districts in which to make house-to-house collections, the sugges-
tion of a paid collector being rejected. When provision of clothes
for boys by the Woodward charity began, the making of shirts
was allotted to the girls' sewing class. In one subscription list
the name of Canon Sewell appears, in spite of his objecting to
allowing Nonconformist ministers to preach endowed lectures
from his pulpit.

After official inspections were begun in 1851, capitation fees
were granted depending on the report, and grants for the staff.
A few are recorded:

> 1850 £23 10s. and £145 among 9 staff.
> 1860 £31 14s. and £159 among 9 staff.
> 1862 £27 15s. and £ 90 among 5 staff.

The Church was again in the field with the founding of a
fourth school, a National School for girls and infants. In July
1836 the market feoffees gave the promoters a lease of a plot of
ground on the east edge of the Green Chipping for a rent of £1,
which is still paid. The school was built in 1837. The only remark-
able thing about the building is an old doorway of Gothic style
facing the Chipping. Tradition is that this came from the old
parish church at Kingswood, presumably an abbey relic: actually
the original church was quite demolished with the rest of the
abbey, and the present church was built in 1719 on the site.
Between these times there was a small church, by the latter date
already ruinous beyond repair and then demolished. The probable

origin of the school doorway is an outer gateway of the abbey
which certainly existed in 1744, which a lecturer of a few decades
ago expected some of his audience to remember in existence. The
curious moulding may be compared with that on the door of

24. School carved doorway

Osleworth church and the ribs of the vault of the Abbey gate at
Gloucester. An addition, made probably in 1876, encroaches
outside the leased plot.

Miss Burnett, the late headmistress, has kindly furnished me
with notes and extracts from the school records, from which I
quote some salient points: these go back only to 1863.

Children had been admitted to the school at the age of two, but boys were not kept after seven and in 1901 were taken only at the Bluecoat school. The head teacher of 1863 had three pupil teachers of sixteen, fifteen and thirteen years of age. At various times inspectors' remarks led to stress on some activity or other: thus at one time sewing was stressed, and the school worked on Bluecoat uniforms: at another time "the Assistant Mistress will endeavour to play the harmonium" and class singing was practised; in one year "the needlework was very dirty though the children were clean", and there is an impressive list of the year's work; "H.M.I. complained that there was very little marching of infants"; "four girls died of a decline": of eighty-four presented for examination, seventy-six passed in reading, fifty-nine in writing, forty in arithmetic, and the grant was reduced by 10 per cent for deficient instruction in the latter; H.M.I. found cribbing prevalent, so the managers decided to hold quarterly examinations themselves; an attempt to start home-work in 1888 was vetoed by parents: and so on. A piano "placed in the school" (given?) in 1899 was in use till 1949, and a sewing-machine received in 1922 is still in use. The Parents' Association formed in 1949 has replaced the piano, given a number of other things, and has generally been an enormous success.

It seems to have been the mistress of 1863 who was surprised at the end of 1885, after twenty-three years in office, on being told of the award of an unasked pension of £20, "which will oblige me to send in my resignation at once". Her successor died after fifteen years of it, and was succeeded by a lady who had been admitted as an infant of two, had become monitress, pupil teacher, assistant teacher, and finally retired after twenty-six years as head teacher and fifty-three years in the school.

In the last war the children and staff of Haddlebarn Lane in Birmingham were imposed on the school.

As related, there was an infant school on the Tan Yard site in the 1870's, promoted by the Church: its closing probably came in 1923 when the Bluecoat school took the infants.

Last, a secondary modern school was opened in 1951 under

17

trying conditions, crowded in the single large room of the Baptist
Sunday school. In 1953 their more modern quarters were ready
for them, like ranges of single-storey prefabs, and a headmistress
was appointed. It is hoped that within a few years a new building
will be erected, adjacent to the new buildings of the Katherine
Lady Berkeley school and sharing some of its amenities.

6

Wortley and the Avon Mills

WORTLEY tithing is the part of the parish which lies outside the
Anglo-Saxon boundary running down Tor Hill. It shows the full
variety of the terrain of the parish, except the outermost Lower
Lias of the plain. Its springs greatly exceed those of all the rest of
the parish, and were important economically.

Survival of several sets of records has made it possible to trace
the story of this tithing much more fully than those of others:
much of the general facts here will, *mutatis mutandis*, apply to
them also.

Wortley had the same history of ownership as the rest of the
parish, till in 1631 a dowager Lady Berkeley sold it to Richard
Poole. This sale John Smyth of Nibley unequivocally condemns
as a fraud on her son for her own benefit. Colour is lent to the
accusation by the fact that the price paid was only £1,500, while
Poole sixteen years later sold it to Sir Matthew Hale for £4,200.
There are signs that Poole increased the value by better manage-
ment. At that time importation of silver from America was lower-
ing money values, while the disturbed state of the realm made
land a safer form of investment. Since Poole submitted a detailed
valuation, which Sir Matthew scrutinised and commented on in
his own hand without questioning the price, it looks as if direct
comparison of the figures exaggerated the fraud alleged by Smyth.
Poole made the estate a manor, and Hale continued the arrange-
ment: it continued in Hale hands till in the last few decades they
have sold most of it.

Sir Matthew seems to have had an obsession that Lady Berkeley
might be able to recover the estate by a claim of rights of dower,

which would have cut through the conveyance to him: so he indulged in a series of sales of parts to sons or employees, which he later bought back, with the presumable idea of producing a fog which a dower claim could not penetrate. He also had the Court-rolls entered in a book instead of on loose sheets, for better security of record. All this was carried out for him by William Archard, the steward whom he had appointed. Archard had been assistant to John Smyth in the intensive work of completing the ordering of the affairs of the estate which had only been recovered in his time, managing the extensive estates, carrying on several important lawsuits against influential and unscrupulous opponents, and making the meticulous researches into archives which form his monumental work on the Berkeleys. This assistance Smyth acknowledges in a warm dedication of his third volume to his son and to Archard.

In 1544 the first information available shows some thirty acres still designated as demesne, but it was all let out, and none of it under plough. This seems to reflect a very slow adjustment to the effects of the Black Death two centuries before. Of the 436 acres of copyhold surveyed 316 were arable: 219 were enclosed, all grass, and the rest open fields. There were besides 112 acres of chantry endowment, of which particulars are not given. Three open fields are named, but one is only a section of a working field: the boundary between the two working fields, East and West, was the road to Alderley, which then crossed the stream at Monks Mill. The tithing contained some 300 acres more, the woods, and "waste" or rough grazings. The woods of the scarp were much more of a physical boundary than any other. While a good deal of the upland was rough grazing, at least one enclosed parcel is mentioned as early as 1544, and by 1630 more was certainly cultivated, apparently as part of Eastfield.

In 1544 the chantry lands had three freeholder tenants paying only chief rents. There were eight copyholders on the rest, making their average holding sixty acres a head and average rent £3 per annum. There were of course considerable "fines" at entry, and heriots at succession, and at least nominal manorial services.

Subsequent records give glimpses of an increase in the number of tenants, paying roughly the same rent roll. For example, in 1647 seventeen copyholds and indentures paying together £23 rent, were reckoned worth £380 to the owner-buyer, or sixteen and a half times the rent. Individually this depended on how long the lives of the contract were expected to last before "fines" and perhaps an increase of rent might become due. There is now an addition of items let "at will" or lettable, totalling £123 per annum. The former chantry land is not included in this, for which Sir Matthew was paying £4,200.

There is then a gradual process of enclosing parcels of land in the open fields, exchange of some so as to make holdings more compact, and finally combination of units into fewer larger farms. By 1766 there were only one big, two medium and one small farms.

The proportions of arable and grass cannot be seen at all before about 1850; even then in documents "grass" means only permanent pasture which the tenant was not free to break up; and "arable" what he was allowed to, but did not necessarily plough. With this proviso, arable shows a decrease from 1850 till the ploughing-up campaign of the Second World War.

Before Wortley passed out of Berkeley hands in 1631 and was made a manor (page 62), tenants were under obligation to give attendance at the manor courts of Wotton Foreign: there are records of only general courts in Berkeley Castle, and only four elsewhere. At two courts held in 1543–4 for Henry VIII during his ownership, tenants appeared, and Wortley matters were transacted: this record is in the P.R.O. One held in 1416 seems to have been for the Borough only, and Wortley did not appear. One held in 1581 for the Earls of Warwick and of Leicester is marked as of Wotton Foreign, but no Wortley tenants appeared nor was Wortley business presented: records of both these last are in the Fletcher MSS. Richard Poole initiated manor courts, and Sir Matthew Hale continued them: there are records of them in Hale papers, at irregular intervals, but apparently without omissions, from 1633 to 1657: in those twenty-four years thirty-one courts are recorded.

The courts, among the many questions dealt with, concerned themselves with grazing rights, but only the rights of tenants, and only in the open fields while fallow or after harvest. The grazing rights of cottages in the waste were not within the purview of the courts, nor were they affected by the gradual spread of enclosures in the open fields. The rough grazings were not enclosed under any Act, nor by any recorded agreement: before the hedges of surroundings fields barred access, all considerable waste was too remote to be convenient to the cottages. The former communal pig-sty, Swinesty Acre just above Wortley Farm, was in 1766 still recorded as Sowpatch, so the woods were perhaps still open to all for pannage; at any rate, until the squire sold the woods, cottagers were not prevented from collecting small fuel.

There were three important exclusions from the estate as sold by the Berkeleys. First, the chantry-chapel with its scattered endowments. Some identification of houses in this endowment is possible by the sales through which they passed, and this dates their antiquity, barring unknown rebuilding. The lands, as also the "lampelands" for maintaining an altar light in the parish church, had been freeholds within the estate. After the Dissolution they were among the many properties bought by (Sir) John Thynne of Longleat in partnership with Laurence Hyde (possibly an ancestor of James II's queen): they were soon in Berkeley hands, by an unrecorded transaction, and by them sold to the London alderman to whom they were selling the Osleworth manor. Later there was an adjustment between Sir Matthew Hale and the Osleworth owner, partly by payment and partly by exchange: part at least was exchange of scattered parcels for a compact block adjoining Osleworth, and transfer of that to the latter.

The chapel, distant from and independent of the parish church, was founded in 1311 by the husband of the foundress of the grammar school, on land granted to the kinsman Walter de Combe for the purpose. The name of the plot, Church Hay, is likely to be of subsequent origin. The chapel was dedicated to St. John Baptist, for masses for the souls of the Berkeleys and all Christian souls. In 1344 it was further endowed with property for

the maintenance of a priest, for whom strict rules were prescribed: he was to take no other money, was bidden to live chastely and honestly and not come to markets, alehouses or taverns, or frequent plays or unlawful games. John Smyth comments that this was what would now be called a Puritan.

After a preliminary Suppression valuation, Wotton men asserted that the priest was doing nothing for the £3 odd he was getting, but the villagers testified that he was serving them: perhaps Wotton had hoped for some of the land. The 1548 valuation recorded that John Collins, the late priest, was parson of Littleton (on Severn) and Oldstone (Olveston) beside, was aged forty, and was receiving 56s. net of the 74s. gross endowment. The chapel had nothing but two bells weighing one hundredweight and worth 20s.

The chapel itself is prominent above the road as one enters the village from Wotton. What chiefly identifies it is the buttress at one corner: a second was demolished only a few decades ago. There are blocked openings in the east end wall, and a former inhabitant had seen a Gothic window in it. At one time a much damaged painted image of the Virgin Mary was found, was handed to the squire, and has been lost. Perhaps some seventy years ago a few skeletons were found when digging deep in the garden: "big men they was, Saxon soldiers like, and you could see where they had worne their teeth with biting their pipes": these were reburied at the squire's orders. There is a tradition that the chapel had a burying ground, perhaps due to some disposal of casualties in a looting raid.

The chapel became a cottage, occupied by a number of successive tenants: the only ones worth recording are the last four generations of the Bennetts, the village carpenters, wheelwrights and undertakers. Their ledgers, covering these four generations, are most informative on personal histories. The chapel is now a residence. Once, when driving up a lane in Syde parish, I noticed a precisely similar building there: this proved to be another of the batch of chantries founded at the same time as Wortley.

A tradition that these chantries were founded on ransoms of

prisoners captured at Poitiers is untrue, because the battle was twenty-five years too late. Besides, the capture of the Berkeley son and heir cost a considerable ransom *per contra*. However, the tradition was strong enough for Rudder to record it, though he transferred it to Beverston Castle. Another tradition is that this was a penance for the murder of Edward II, and though Lord Berkeley was authoritatively acquitted of complicity this is more plausible.

A more important exclusion from the estate as sold was Wortley House. How it became separated from the manor, and was not even a freehold of it, is not traceable. There is no identifiable record of it before 1649, when it was owned by Sampson Hopkins, a member of a family who were for several generations in succession mayors of Coventry. There is no traceable connection between them and the important local Hopkins family: but some local connection is shown by the fact that an important Berkeley funeral in 1596, when that family was living at their Callowden mansion near there, was marshalled from the Coventry town house. In 1649 Sampson sold Wortley House to Robert Hopkins, "citizen and haberdasher of London" and member of the extensive and peculiar local family. Robert was then already in occupation of the house, in succession to a relative Edward who had died in 1641. Robert died in 1666: his widow, who had already been married once before, then married Richard Thynne of Hawkesbury, a great-grandson of Sir John of Longleat: and in 1676 Thynne sold the house to Sir Matthew Hale.

At this point the Osbornes come from Wotton to Wortley, of which they were to be the dominant factor for four generations. In 1703 Richard Osborne the elder obtained the first of a series of long leases of the house adjoining Purnell's where he was presumably living, and soon rebuilt it as Wortley House. In 1716 he bought Monks Mill from a Poole descendant, having probably already been working it: so we have to take up the story of that mill from the beginning.

The mill had shortly after Magna Carta been granted by the Berkeleys to Kingswood Abbey as a mere watermill. Standing

where the road to Alderley crossed the boundary stream, it was probably the estate grist mill; but the stream had there been augmented by the very best springs of the area, yielding as much as all the rest together, so that its gradual development to become one of the most important cloth mills was almost inevitable. As the monks already had a mill at their gates for domestic needs, it is likely that they contemplated cloth work even then. While the royal survey of 1544 included the chantry properties as freehold on the estate, though they could not be included in the sale in 1631, neither this Monks Mill property nor Wortley House were shown in the survey or included in the sale.

It must be one of the three abbey mills mentioned in a Papal Taxatio of 1291, valued as worth 6s. per annum. In a rental of 1444 it was being let for 6s. 8d. per annum. As the administration of the abbey included an office of fullers, cloth work must have been taken up before this last date. Then there is nothing till a lease book shortly before the Dissolution shows it as a fulling mill "with three parrocks Les Hamez" adjoining, let for 33s. 4d. since about 1490 to John Roborough. The parrocks probably account for the later name "Three Grounds" of an adjacent meadow. Roborough was a substantial abbey tenant, of lands and another mill in Kingswood, as well as of the whole Tetbury grange: his son makes a brief personal appearance in 1563, when he "doth not continue in church all the time of Divine Service".

Early subsequent occupation is greatly confused by the inadequacy of some records, and even by the use of the name "Monks Mill" for others. Ex-abbey ownership in 1546–8 passed by royal grant to Lord Willoughby and Sir Thomas Heneage, perhaps with Roborough still as tenant. They must have sold out, for in 1557 the mill was owned by Sir John Thynne, who was letting it for thirty years to John Bridges, to whom in 1598 he sold it. Bridges, of Nind Mill in Kingswood, was in partnership with George Huntley, land-owner, of Boxwell, and Christopher Neale of Wortley, who seems to have been working Monks Mill. In 1612 the other two released their shares to Neale. He seems to have been working in partnership with Christopher Purnell, who in 1613

obtained lease of a small plot "in Alderley", actually an island in the stream, on which he built a wing to the mill. How Purnell dropped out of this enterprise is not on record, but Robert Neale sold the mill to Richard Poole at some time before the latter bought the whole estate in 1631. The mill continued in the Poole family till in 1716 the husband of a granddaughter sold it to Richard Osborne the elder who had moved out from Wotton, and may have been working tenant of the mill already. "This is where we came in": but before taking up the Osborne story there are some things to record about the partners.

Bridges was in Nind Mill soon after the Dissolution. His daughter married John Blagden who had come there from Wiltshire, and the sixth successive son-and-heir John married the daughter-heiress of the Hale family and continued that line. Neale built the first Monks Mill House. Purnell's lease of the plot on which he built included the Kennerwell spring, with reservation of the rights of the villagers to customary use of it, and to passage of the stream; but he does not seem to have taken the spring into use, and later a water wheel was installed to raise its supplies up to Alderley.

Purnell was one of the big Nibley family of clothiers and land-owners, and had left for independence. At some earlier time he had obtained a small freehold which the 1544 survey had shown as the 2d. freehold of Stephen Robins in the chantry endowment. It is perhaps significant that he and Neale had two sturdy young fuller brothers as servants. He died in 1617. A house close to Wortley House, at that time apparently of the first rank, was named after him, presumably from his occupying it.

He must have been in Wortley by 1595, for in that year he was involved in an incident which sheds light on some conditions of the time. In January of that year he was with two brothers returning from St. Paul's Fair in Bristol. Crossing Cromhall Heath they were set upon, injured, and robbed of some £390. Huntley of Boxwell, whom we have met above, raised a hue-and-cry by which two culprits were caught; they were "examined", quite likely with some Gestapo methods, but refused information

though some of the money was found. Local Justices showed a curious reluctance to take up the case; two Cirencester Justices did act, remanded the case to London, but bound the men over in sums insufficient to prevent their disappearing. Huntley meanwhile had "dealt with" the men and recovered some more money, but Throkmorton of Tortworth, who had advised against bail, advised against accepting this, now £220 in all, without the Chief Justice's opinion. Lord Chief Justice Popham recorded the statements of the Purnells, but his findings are not recorded. A light on pronunciation is that he writes Cirencester as "Cissiter", as do all documents of the time.

It transpires that Nicholas Bridges, one of the accused, was an illegitimate grandson of Sir John Bridges of Sudeley (quite unrelated to the Nind family), and the other accused was also of his household. Sir John shortly became Lord Chandos, and several of his immediate successors became Lords Lieutenant: so the caution of the local Justices is understandable. Some fifty years earlier Sir John had "laboured the acquittal" at Gloucester, of a notorious highwayman, to the extent of raising an affray. One of his sons had been a notorious robber and pirate, until, twenty years after our affair, he had been pardoned by the king and had settled down respectably. The times were such that even Lord Justice Popham had a reputation for wildness in his youth, when he and his profligate companions would sometimes "take a purse". At the outset of the affair two men had brought Sir John some money and asked him to keep it as Nicholas was in trouble. Another of the household went to Boxwell and reproved the men for disgracing the family: they protested their innocence, loudly for the benefit of any eavesdroppers. This was clearly the way of getting some of the swag away to the organisation in the background.

Richard Poole when he bought the Wortley estate in 1631 already held Monks Mill, "heretofore purchased of Robert Neale": in 1620 he had married Purnell's daughter Mary. When, and how completely, he emigrated from Wotton is uncertain, but there he still held the White Lion inn "formerly ye sign of ye

goate", and in 1639 was nominated for the mayoralty, and fined £10 for refusing. In Wortley in 1624 he leased "Purnell's" from Sir Gabriel Lowe of Osleworth, which shows that this house had been part of the chantry endowment.

Richard Osborne, who had in 1703 taken a lease of Wortley House, in 1706 obtained a similar lease of the adjoining "Purnell's" (Plate 9). Some thirty years ago this still stood as a line of three cottages on the rivulet just below Wortley House, but was then in so dangerous a state that it had to be pulled down. It included also the smithy of the Beckerton family of three known generations in the village, preceded by the Bennett family of four generations of joiner, estate carpenter, wheelwright and undertaker. The Beckerton business does not seem at any time to have been a flourishing one, since their previous residence was a mere "pigeon house and wain house" close by, which had been built for only 30s. by Richard Poole. They were reduced by the physical disability of James who succeeded to the business in 1848, which is said to have been the result of his parents' ill-treatment: in fact his wife was buried by the parish for 9s., which included a small contribution by James for a row of nails and two handles for respectability. The last of them, John, died about 1930: he was preceded by the sister "P'lina", the gardener, who took produce around in a pram. The other sister, Louie, a dress-maker, was with difficulty persuaded to move to another house which was given her, but felt lonely out of sight of the traffic on the road and shortly went away to relatives. The precarious state of the house was only fully revealed on its demolition, when it was described as having been propped up by its (locally made) grandfather clock: this was sad, as the cottages had been most picturesque, but expert opinion pronounced restoration to be impracticable without completely spoiling them.

The building had earlier been bigger, with a small wing to the rear at one end. No previous tenants of interest have been found, till we come back to Richard Poole, who may be said to have made it his manor house: he was presumably responsible for the oak panelling of one room. Richard Poole had succeeded his father-

in-law Christopher Purnell: the name shows this, though there is no record of a lease.

Richard Osborne's object in leasing this second house is shown when in renewing his lease of Wortley House in 1716 this is described as "new erected" by him. He was leaving it vacant for a radical rebuilding: another step in his settling in was that in 1708 he took a lease of fifteen acres of land adjoining it. Just what the "new erecting" amounted to I have been unable to detect in twenty-five years of living in it.

(Plate 10). Obviously what is now the kitchen wing is very old: of only one storey, sunk into the ground so that at one end the eaves are hardly above ground level, though at the other end floor level is just flush, it was an ancient yeoman's house to which some additions had been made. The house itself is clear of it by some two yards, which had been roofed over: there are indications that something stood here before Osborne, for example where an outside wall has absolutely no foundation; but the present mansion owes little if anything to a predecessor, or the Coventry mayor who had owned it. It was changed yet again later.

Richard not only began to raise himself to clothier status by buying Monks Mill in 1716, but also to buy landed properties, though not as a compact estate. In 1702 he had bought the eighty-five-acre farm in Cam, now Hodgecombe Farm, and an adjoining fifty-two-acre farm under Cam Down: he added a little to this in 1714, and then also bought for £400 Pincott's Farm in Tresham, probably what is still shown as Osborne land in an estate map. He had rebuilt the three burgages in Wotton as the New Inn, and left it charged with a £3 annuity for the Bluecoat School. Completion of the work on Wortley House may be marked by his taking a lease of fifteen acres near it in 1708.

He was not too busy to continue activities in Wotton. In 1690 he had been sergeant and in 1697 mayor, and in 1705 became a trustee of Mead's Charity and was a Justice. In 1710, with Samuel Bennett the master of the grammar school, he filed a petition alleging malversation of the school's property by the Smyth family. This revived a long-drawn-out controversy of a century

before when the Smyths had been cleared: this time on the contrary they had to repay a sum of £4,225, and a body of trustees was appointed for the future management of the school lands.

Richard's will, reading between the lines, is in interesting contrast to those of the old William and Agnes. His bequests are much bigger, but far fewer; he devotes a long pious preamble to giving thanks for his worldly success, and goes on to warn his children against quarrelling over his will, on pain of losing their legacies. He asks for a quiet funeral, not more than twenty persons, all men: his wife is to give a shilling each to 200 poor persons, and he provides five yards of black cloth for the pulpit. The will has a puritan tang. Warned by what had befallen his father, his church memorial displays no arms: but it describes him as *Armiger "ex antiquo stirpe oriundus"*, and leaves him there to be called by the last trump.

Richard the elder had succeeded in establishing his social status to a degree that enabled him to marry his son Richard the younger to Sarah Blagden of Nind. While the wives of earlier generations had been of indeterminate degree, the Blagdens of Nind had held one of the larger abbey mills from before the Dissolution. They were clothiers who were soon admitted gentlemen, who in Sarah's generation and after followed the law; her grand-nephew married the Hale heiress when the male line died out and took his wife's name to keep it alive.

Richard the younger rebuilt the single burgage in Wotton and bought the adjoining orchard which has been referred to; he bought more land in Tresham, which soon amounted to two farms with twelve acres of open field, and the Upper House in Kilcott; he also extended the Barber's Court property in Wickwar which his father had begun to acquire. There is no direct mention of progress at Monks Mill, but these purchases reflect its prosperity.

He never rose to mayoral rank, but in 1725 was appointed one of the newly formed board of trustees of the grammar school, and was a Justice of the Peace: he gave the church an ornate altar

frontal, and two silver collection plates which have since been remade into a chalice and paten still bearing his name.

A deed of 1746, three years before his death, describes him as disabled with gout in his right hand, to account for his left-hand signature being "not as fair as usual". His Latin epitaph speaks of his having borne severe arthritis for very many years with the greatest fortitude. He revived the arms, *argent, a bend ermines between two lions rampant sable,* usurped from a London family of the name and followed by his successors, and impaled the Blagden arms.

The son John proved to be the last of the male line of the family. The status attained by his father is shown by his marriage to the daughter and heiress of the iron-master George White of Goodrich, who brought in all the quite extensive family property. The property which John brought into settlement comprised eleven messuages, barns, stables, gardens and orchards, five mills, 450 acres of land and grass with common of pasture. There is no clue to the identity of the mills apart from Monks Mill, which may have counted as two.

The marriages of John's younger daughters were even greater social attainments. Elizabeth at twenty-nine married Philip Williams of Penpent in Brecon, a family which will presently play a bigger part on our stage. Anne at thirty-three became second wife of Sir Bourchier Wrey of Tawstock in Devon. His was a family of high degree: a Heralds' Visitation of 1564 recorded their sixth generation of gentility. A Bourchier ancestor had, about 1390, married the heiress-daughter of Thomas of Woodstock, Earl of Gloucester and youngest son of Edward III, and of his wife a Bohun, thus getting the right to add to their shield both the Bohun and the Plantagenet arms. The former included four "bougets", given for service in the Crusades: the latter were no less than the royal arms of the time. The Bourchier crest was a crowned "soldan's" head, another crusaders' mark. Three generations later the Bourchier was created Earl of Bath (not to be confused with the marquisate of Longleat), and his descendant of the third generation showed no less than fifty-five quarterings,

compared with the mere forty-two quarterings of Guise of Elmore 250 years later, which is the best that Gloucestershire can boast. While the earldom, limited to the direct male line, is extinct, the baronetcy, one of the original Ulster creations, continues: and the line, with its portion of blood of Osborne of Wortley, still lives.

John Osborne's eldest daughter and heiress had at twenty-four made a less distinguished marriage, to continue the business: and he had left only one daughter Sarah to remain unmarried.

John made less addition to the family estates than his predecessors, beyond what he acquired by marriage. He had inherited from his mother seventy-four acres adjoining his Kingswood land, but her astute lawyer, a Blagden great-nephew, showed this to be contrary to the terms of the original bequest, and by agreement John in 1767 bought the land for £1,050. He had also lent £1,370 on a mortgage of Wortley Farm, but this was eventually redeemed: the rest of his surplus was ploughed back into Monks Mill. There he bought eight acres, partly to extend the working ground, and partly to acquire Monks Mill House in which he lived: and the re-building of that house in the style of Wortley House is judged to be his work. A full half of the main range of the mill is also judged, by the style, to be a western extension of it by him. There is no record of what he must have spent on equipping this extension, or on new machinery for the mill, but without such it could not have met the heavy demands of the boom period which soon followed. He also leased a small house in Alderley, as well as a house there for occupation by his two unmarried sisters.

There is no record of charities by John, but his widow appears at the head of the list of contributors to the cost of work done in the church by the vicar Mr. Tattersall, which does not mention any amounts.

This widow seems to have been a capable lady. Her husband having died in 1770 at the age of only forty-nine, the eldest daughter and heiress two years later married Samuel Yeats, followed only years later by the sisters mentioned. Samuel eventu-

ally succeeded to the mill by right of his wife; though there is no record to show what actually happened, it seems probable that he managed the mill for the widow.

Samuel Yeats came of a Minchinhampton family which had for four generations or more owned and worked the Dyehouse, a name still held by the Newman Hender works in the Nailsworth valley. This had descended in an elder branch of the family, and it is not known what became of it when the branch died out before Samuel's birth. His grandfather became a Friend, followed by his descendants including Samuel. His father had been reprimanded by the Society for "worldly conduct" which seems to have been an interest in horse racing. Samuel's previous occupation is not known, but he was able to bring £4,000 into the marriage settlement. I have noted his widow's will (see page 145).

His first recorded appearance in the working of the mill is his signing an indenture of apprenticeship in 1796, of a Bluecoat school boy, in "the Art and Trade and Mistry of Cassemere weaver". An entry in a builder's ledger which opens in 1810 shows him and his son in partnership. Before this, in 1802, the firm had figured in the highest class among the clothiers of the county, who were proposing application to Parliament for repeal of some oppressive statutes, but in 1819 the son was placed in only the third class in the scale of contributions. In 1812 Samuel retired in his son's favour, but when the latter surrendered in 1826 he had to resume charge until his death in 1829.

Samuel's only public work of which there is record is that in 1804 he suggested re-roofing the aisles of the church to match the nave, and contributed £300 towards the cost. In 1818 he was made one of the trustees of Sheppard's Charity in Kingswood, and so may have been active there.

After a period of partnership between Samuel and his son Osborne Yeats, Samuel retired in 1812, leaving the son in charge; but the boom was beginning to slump. 1825 saw weavers' riots in Wotton, and in April of the next year Osborne Yeats withdrew. To free his successors he broke the entail on the family properties including the mill, surrendered his leases, sold his own effects in

18

an auction at Wortley House, and retired to Hounslow. Samuel was then compelled to resume charge, but died in 1829. There being no male heir, ownership then passed to Penry Williams of Brecon who had married the heiress.

The lead gutter of Wortley House, over the front door, shows a plumber's mark with date 1771. It seems probable that this dates work which has obviously been carried out on the old house to make it what is now seen. The house is in two spans with lead-guttered valley between; the pitch is moderate for Cotswold stone tiling, with no parapet to conceal the roof, and no over-hanging eaves but only a lead gutter partly carried on corbels. It has a frontage of five tall sash windows, and three storeys. Most of the windows in the other faces have been similarly modernised. The former plain hood on brackets of the central front door, such as is still to be seen on the back door and in a late photograph of Monks Mill House, has been replaced by a shallow portico on pilasters with a pediment. But for the contrary evidence of the Venetian window at the back, all of one piece, it would seem possible that the improvements included the addition of the second floor: at least its front façade is of contemporary soft bricks such as were burnt on the Wortley border near the present site of Wotton sewage works, while the body of the house is random rubble laid in mud mortar. The rough-cast on this was so inadequate that it had to be renewed recently, to protect the walls from further flaking by damp. Inside, the main rooms have been squared up by partitions not always quite parallel to the walls. While upstairs the doors are still old, with panels up to two feet wide, downstairs they have been modernised. On the top floor they still have small brass knobs; on the first floor Jacobean drop-handles, and on the ground floor hollow handles of thin brass sheet, sometimes *repoussées*. The most striking feature is a square stair well (Plate 11), with an oak staircase of graciously easy rise and barley-sugar balusters turned with little mechanical perfection, lighted by a 10-foot-square Venetian window which still contains more than three quarters of the original green glass in six-by-four panes.

While the date 1771 suggests that these improvements were carried out for the marriage of the heiress to Samuel Yeats in the next year, the young couple do not seem to have occupied the house. John Osborne was living in Monks Mill House, and Samuel Yeats at Alderley, till the Mill House became available to him by the death of John's widow Elizabeth in 1797. There is a tradition in the Hale family that Wortley House was then occupied as sub-tenant by a Mrs. Mary Hale. There was a widow of that name who died in 1775 (probably Mary Moucher, second wife of the notable Robert Hale of Cottles, the last male Hale), and the fact that the house was offered on lease in February 1776 fits in with this. The description in the advertisement agrees exactly with the present accommodation, the whole top floor of five rooms being described as servants' rooms.

Of the results of this advertisement no more is known than that the house was sub-let to a small-scale clothier, perhaps till 1786: there is a suspicion that he set up a dyehouse on the boundary brook. Then the record is blank until in 1800 Samuel's son Osborne Yeats married Anne Williams of Penpont, and occupied the house. In 1804 Osborne's sister Maria married Penry Williams, Anne's half-brother and son of Osborne's aunt, whose marriage into the Penpont family has been mentioned.

The Penpont family claims descent from Sir Thomas Bullen, descended from one of the knights who came in with William the Conqueror, who took part in the conquest of Brecon. Contrary to the English genealogists, they claim as collaterals the Norfolk family of Bullen from which Henry VIII's second wife came, and they have two little portraits of that lady. In spite of following the Welsh custom of "gavelkind" they held considerable landed property, partly as the result of judicious marriages. The rental of lands which Penry proposed to bring into settlement was no less than £2,062. Their standing in the county was such that Penry was High Sheriff in 1804 and Lord Lieutenant in 1836.

Apart from some earlier slight business relationship between Wortley and Penpont, the Osborne, the Williams and also the Wrey families used to visit each other and foregather: this is

shown by Penpont letters now in the National Library of Wales. A little collection of miniature silhouettes at Penpont shows Penry's mother Elizabeth Osborne, her sister Ann Lady Wrey, her husband Sir Bourchier, her unmarried sister Sarah, and little Maria at the age of eleven. Twice in 1801, a year after Osborne Yeats had married his sister, Penry wrote from Oxford for money, with the intention of touring at the end of his last term at Christ Church and to visit Gloucestershire; and it is from Wotton that he writes shortly before his wedding, with his proposals for the marriage settlement. He was obviously in love with his cousin though she was some ten years his senior.

What led to the marriage of Osborne Yeats to Anne Williams in 1800 is not known, beyond the friendship between the families. Having given birth to their daughter and only child Mary Ann, she died in 1809. According to family tradition at Penpont, Osborne's reputation then became so poor that they took Mary Ann away and in due course she married a neighbour there: but a letter of hers in the Wotton vestry shows that she continued an active personal interest in the Bluecoat school to a date that makes this improbable. There is no record to support the suggestion that Osborne married a second wife, who is alleged to have been unkind to the girl, nor is there anything to suggest that he entered upon a discreditable liaison. He was certainly hospitable, and perhaps gay: the eventual auction of his Wortley effects in 1826 included a cellar of good wines, and fourteen wine coolers: but also a library which showed wide cultural interests.

Osborne Yeats succeeded to the mill, but it was failing and he surrendered it to his father, and in 1826 sold out and left the district. His only public activity on record is command of a company of Wotton under Edge and Wortley volunteers, which in 1804 separated from the company under command of Captain Dyer. There is record of their serving a month of voluntary duty at Bath, parading daily when it was not wet and plodding home through the mud and soaked to the skin to the acclamations of the townsfolk. Osborne was also a J.P. and treasurer of the local Turnpike Trust. There the family connection ends.

Wotton owes this family much, though it has not been recognised. They founded and successfully ran one of the biggest cloth businesses on which the prosperity of the town and the livelihood of its inhabitants depended.

Penry Williams, the new owner by right of his wife, was no clothier or business man and could only look for tenants: these appear in the persons of John Metivier as tenant of Wortley House, whose period with his brother Carey Henry fits into a blank in the story of the mill. John moved in in 1830, but in 1834 was sold up as a bankrupt.

The brothers John and Carey Henry Metivier were of Guernsey origin, where their father had been Jurat and H.M. Controller. They were general and importing traders, at first in and near Bristol. There is nothing to show any direct connection with Monks Mill, but John's period at Wortley House just fits into the blank period after Samuel Yeats's death in 1829. The brothers were already established then in Wotton, with their mother, and Carey Henry was mayor for two years 1830–32. What became of him after the bankruptcy is not known, but John's course continued downhill. Living under fear of detection of some irregularity which he had committed, and banned by his family, he ended as a bible reader to a chapel.

The Metiviers were followed by Thos. White and Son, who did a lot in mending and renewing machinery, until 1844. They were followed by the Smiths who were also working Knowles Mill like the Whites. They did not occupy Wortley House, whose later tenants were mostly farmers, presumably men whose holdings were too small to have a farmhouse. This entailed a period of sad neglect: in fact one tenant is said to have used the drawing-room to store his crop of potatoes, good and bad, and one winter to have stabled a mare and foal in the dining-room, where the foal was poisoned by licking a brass door handle. At last the house found a buyer who made good the damage and gave it a new life.

In 1847 Penry Williams died, and Osborne Yeats had to come back the next year to set affairs in order in the troubled situation

which had now come to a head. The deed of the arrangements recites that the cloth trade was still prosperous and the mill valuable for some years after Penry's marriage in 1804, when the marriage settlement laid on it a 5 per cent charge on £6,000 for his wife: but the gradual depression and now total failure had reduced the value, and now left the mill void and a source of expense for upkeep, and made it impossible to meet the charge. So it was settled that R. H. B. Hale, one of the trustees, should buy the mill for £1,500, as its full complete value.

Hale continued the tenancy of the mill by Samuel Smith of Sodbury, followed by his son Rowland on Samuel's death in 1859: old people speak of their elders' remembering Rowland. He seems to have tried to regain business by increased expenditure on the mill and machinery, but the end came in 1869 when he had moved to another mill at Stonehouse, and had machinery from Monks Mill sent there. An indication of the loss of prosperity is that from 1853 Samuel Smith was paying his bills partly in cloth, and Rowland paid partly in cloth and partly in acceptances. When Samuel died in 1863 he was buried for only £3.

Bills for repairs in the Bennett ledgers mention the kinds of machines in the period from 1835, but not numbers. There are items for fixing new brushes in brushing machine (teazles in gigmill?); weavers' chain shaffs 7 feet 1 inch; turning pinch rollers: new roller and hollow and bowl to wool tugger; striking edge; jenny; billy; shuttle board to broad loom; roller to gig mill; scalding vats; grinding two pairs of shears; leaver for cloth press; oak bed for cloth press; Casey packing; burling board; spooling machine; warping machine; cutter; gig mill; Casey loom; breast beam of loom $6\frac{1}{2}$ feet by $6\frac{1}{2}$ inches by 4 inches; weaving shop (but we know that much of the weaving was done at home); fuller twilsey; and in 1865 mention of a power loom.

There is no record of what extensions and improvements the Osbornes had made, but a photograph taken about 1880 (Plate 7), not long after the Hales had abandoned upkeep and before much structural collapse, can be compared with the description of what they bought in 1716. A main range of about 400 feet runs east

and west; at the east end a wing of about sixty feet runs south. The wing was of three storeys including the roof attics lighted by dormers, and near its root a water-wheel is accommodated. The first fifty feet of the main range is similar but with a fourth storey; the next fifty feet similar except that the whole roof is raised giving greater height of the storeys, and there is larger water-wheel accommodation fed only by the spring water. The rest of the range is similar except that there are no dormers, and the four storeys are accommodated beneath the same eaves level. This last part has a perceptibly later look.

I surmise that the wing is what Purnell built, the older part of the main range pre- or early-Osborne, and the later part what John Osborne built when he rebuilt Neale's house in 1767. About 1825 only the west end gable was still standing: now all the mill and house have been quarried down to ground level.

The photograph shows three long white mounds in front of the outlet, reminiscent of the spoil heaps of china-clay waste to be seen in Cornwall: I surmise that these are spent fuller's earth dug out of the culverts and outlets.

When Sir Matthew Hale bought the manor, he did not need a dignified residence as he already had that in neighbouring Alderley. Moreover, Wortley House was not included in what he had bought, and "Purnell's" was still occupied by Richard Poole; so, for manorial purposes, he reserved the use of "the hall, the chamber and the cockloft over the hall" in "Thurston's", identifiable as Wortley Farm-house, named after an earlier occupier, the largest farmer of the manor at the time. The original house must date from the sixteenth century, and by additions became the only other house of second rank.

Of lesser buildings, the only "modern" erection was a rank of cottages "some time since erected on the site of several ancient tenements", probably about 1800. Several cottages have disappeared so that nothing is known of them but marks on the ground and surmises from documents. Those that survive range in date from the original chantry-chapel of the early fourteenth century, to rebuildings of up to about 1750. Only one can be dated, the

double cottage above the chantry-chapel, land for which was granted in 1651 and the house built by 1655. The double cottage facing the chantry-chapel across the little green was for a time the village beer-house: its sign, and a nice piece of ironwork for the gallows probably made by Beckerton, have been rescued and put in the museum at Wotton.

The village also had three good drive-through barns, though not on the scale of abbey tithe-barns. One of these is part of an isolated fold-yard, Slade Barn, right away on the hill: a number of dated initials are scratched on the ashlars, but only of the mid-eighteenth century, and none of identifiable men.

Among the villagers of "lower degree", brief mention has been made of the Hopkins family, one of whom bought Wortley House. They were singular in that the names Hopkins and Seaborne seem to have been completely interchangeable for them: sometimes both names were used joined by a hyphen; on occasion a list of tenants includes men of only the one name; then a few years later all are of the other name, with some identifiable as the same individuals.

The first record of them is the will of Stevean Seburne of 1543 with an estate of three cows and thirty sheep and a total value of £28 12s. 6d., say about £2,850 in modern values: one relative and two sons of the same name are mentioned, one of whom was Tythingman. A survey of the estate in the following year has what seem to be these three among others, but now all named Hopkins: and between them they hold half the total copyrights in the manor. Then the changes are rung in successive records, and on one occasion we have an "Edith Hopkins wyef of Robt. Sebourne als Hopkins". Finally, Wotton has recently had a bank manager named Hopkins, whose middle name was Seabourne.

Some of the clan continued in agriculture, but their share of the manor diminished, and none of them rose to the big-farmer class: on the contrary they descended in the social scale, and eventually disappeared from Wortley.

One at least of the clan went to London, and came back as "Robert Hopkins, citizen and haberdasher of London", successful

enough to buy Wortley House. He seems already to have bought a property in Kilcote, and to have been named after that too, as well as on occasion as "of the Stone". Robert's predecessor at Wortley House, though only as a tenant, was an Edward whom I judge to have been a first cousin. As a youth he seems to have been a weak character, for his father William Hopkins alias Seburne left him his £30 only "yf his mother shall putt hym out from her and not suffer him to be partaker with her of half the livinge soe longe as he shall behave himselfe duetifullye towarde her and be willinge and carefull to playe the good husbande for her". Robert enjoyed sufficient status for the widow whom he took as second wife and who survived him, to marry a great-grandson of Sir John Thynne of Longleat: and the latter sold the house to Hale in 1676.

The member of the clan who has made most mark was Master Stephen Hopkins of Wotton Underedge, as he appears in the list of those sailing in the *Mayflower*. He does not appear in local records, perhaps because he was born during a gap in the baptismal register. That until the *Mayflower* sailing he made his career in London is suggested by his taking two London men to the New World with him as servants.

As the ship reached its goal there was an incipient mutiny among the company, and Stephen is suspected of having been behind this. Willison, a recent historian of the expedition, identifies him with the Stephen Hopkins who narrowly escaped hanging for preaching mutiny in an expedition wrecked on Bermuda some ten years earlier. In spite of this, and of repeatedly having to be dealt with for ungodly conduct, he displayed qualities which led to his being made as it were Chief of Staff to Captain Miles Standish in the early days, and one of the colony's higher officials later. Finally, he is the most popular ancestor among present-day *Mayflower* descendants.

Local records make it possible to improve the vague descriptions of him as "of Wotton Underedge". The military census of 1608 lists ten Hopkins and one Seburne in the whole of Wotton including tithings: only two of these are outside Wortley, a

weaver and a servant, too lowly to be connections of Stephen who was dignified with the title of Master. Of the remaining nine, in Wortley, while five are similarly only weavers, the others are a Stephen a clothier, and three husbandmen including Edward whose standing has been shown above. Taking into account also the frequency with which the name Stephen was used in the Wortley clan, there is no doubt that Master Stephen was one of them. Further, treating all available evidence in wills and leases and other deeds like a jigsaw puzzle, I find it a safe surmise that his immediate relatives were the Hopkinses of Wortley House: I judge him to have been a brother of Robert.

Of the majority of other yeomen traced, practically nothing is known more than "name and address"; but one interesting family history was revealed by enquiring into the name "Nanny Farmer's Bottom" which Ordnance maps mark for the combe at the head of the valley at the mouth of which the village lies. In gossip a lingering tradition was revealed that the name commemorated an old woman who used to farm there: then, a later estate map showed that the name had been that of the main field of the combe-head.

The story eventually recovered begins with " Johannes Hixkes " whom the 1544 survey shows as copyholder with a medium holding, mostly in Eastfield and in its "Comefeild" part. He may have been succeeded by a son Giles, but in 1609 the same holding at the same rent was in the hands of Richard and his wife Margaret Higs. The military census of 1608 shows Richard as a fine big fellow, "of the tallest stature fitt to make a pykeman", a trained soldier, and in the "about 40" age class; but he died rather young in 1628, with a few named bequests including a best featherbed and a little pewter. He specifies that the doors, windows and window-lids (does this imply absence of glass?), wainscots, shelves and benches of the house are not to be removed.

His son Thomas must have been an invalid, since he never attended a Court Baron, and his wife Agnes or Annis Higgs or Hicks always attended in his place. By 1639 he had died, and Annis had succeeded to the copyholds by right of her freebench.

In 1649 there was some degree of consolidation of the holding. Annis surrendered some land on the Great Down in the Tilepitts area which had led to the Queen's Highway there sometimes being described as "Higgs Way"; in return she received more land around the Combewell, the spring adjoining her big field: the total rent was still the same, and in fact remained unchanged to the end of the story. In 1656 Agnes was Reeve of the manor.

In 1657 she appeared before the Court Baron to make what appears to be a surrender of the long established family holding in favour of her son Richard: but the surrender specifies only her house, the Combewell lands, and her responsibilities: moreover only three years later Richard as one of the two assessors for the poll tax levied then, assessed her as worth £20 per annum compared with his own £5. Annis's death may be marked by a burial entry of 1683 at Wotton of an "Anne Higgs, widow": but as there had in 1583, 1585, 1603 and 1607 been weddings of different Agnes Higgs, this is quite uncertain. Not till 1696 is there certainty of the end of the family tenure when the cottage and garden "late of Richard Hicks" is let to another person: another deed of 1703 refers to another piece of their land in the same terms, and one of 1708 shows that Richard had died. Even after this their name still attached to some of their lands in manor deeds, which were noted as still unlet.

Mentions in early records gave the impression that the Higgs house was rather away from the village: the few sites of outlying houses which have disappeared were found to have been in other possessions. When the 1856 terrier and map were discovered, they marked a house up in the Bottom, but on the "wrong" side of the rivulet, and the ground surface there was completely undisturbed; then it was found that the enclosure of field hedges which it showed really existed on the "right" side of the stream, just above the spring: and within it the signs of a complete small homestead were clear, till the area was tractor-ploughed.

This gives us a Higgs holding from before 1544 till nearly 1696, managed from about 1631 till 1657 by Annis, with concentration in the Bottom. So Annis well fits the role of "an old

woman who farmed there". But, after compilation of the above facts some documents of 1700–50 came to light, containing references to a few members of a family named Farmer, including a daughter named Hannah or Anne: the only lease to any of them is of a cottage which I identify as a single-room building, now an out-house of the chantry chapel. There are other references to some of them living on a similar mean scale: there also are references to land in their occupation in Combefield, but no leases. It would appear that they were persons of lesser standing, with only some sub-tenancies under tenants of the manor. In spite of the greater similarity of name, it does not seem likely that this could be the foundation for the tradition which I have investigated.

A census of 1608 shows men of the following occupations:

3 clothiers	11 weavers	9 fullers
9 husbandmen	2 labourers	2 servants
3 carpenters	1 smith	1 tailor
1 miller	1 carrier	——
		43 Total

In spite of what we know of them, none of the husbandmen were considered important enough to be called yeoman, though Thurston was well enough off to be a subsidy-man: two of the clothiers were subsidy men, Neale and Purnell. Even at that date the cloth trade had nearly twice as many men in it as agriculture. Comparing with Wotton Borough and with Synwell, there is a paucity of other occupations characteristic of a hamlet as compared with a market town. In later times, I have mentioned a smith and a carpenter, and several millers have appeared: there was also at one time a baker. Only one other individual of interest appears.

In the early nineteenth century Wortley had an inhabitant Fuber Combe Gerrans. His surname is that of a Cornish village in Roseland, taken from that of a Celtish saint or king who has left some interesting if confusing traditions: it is still borne by two or three families not far off. His activities are shown by entries in the ledgers of the Bennett family: slate frames, and "deail furms for

scowl room". The school was in the cottage facing Wortley Farm-house across the lane: relics of it are three samplers of which one is of "1810" from "Wortley School" and the other two of the same pattern. He also made or mended guns and fishing rods. A bigger activity was making or assembling clocks: I have managed to trace fifteen of these. The majority are cheap but nice thirty-hour bracket alarm clocks for the mill workers, such as are occasionally to be found at the local Marine Stores for 1s. 6d. each: for these Bennett supplied Gerrans with "Nickeler Larm heads". At the other end of the scale there were long-case clocks, of which I managed to get the best specimen, an eight-day clock with date dial, and a scene of a lady and gentleman playing shuttle-cock worked by the pendulum; this he made after moving in to Wotton before 1839.

All the field names of Wortley have been filled in on a field map in my original account of the estate: none of them seem likely to interest place-name experts, but a few are worth remark. *Workham Bushes,* the woods round the head of Nanny Farmer's Bottom, has *Worcombe* among the earlier forms recorded, and seems to me to be meant for *Wort-combe* at the head of the valley which has *Wort-ley* at its mouth. *Swinesty Acre,* obviously the communal pigsties, later called Sowpatch. Ramskins was found to be the degenerate form of *Rainscombe,* a little fairy-dell at the foot of the scarp above the Osleworth brook. *Imphay,* a field of the ancient Lampe-lands endowment is not explainable. *Hangtree* suggests that there was at some time a gallows at the point of Little Tor Hill, but there is only the name in old records. *Doll-waggers,* near The Leys Farm, is also unexplainable. The *Clay-pitts* under Great Tor are not quite what would be expected, but a great digging for fuller's earth for use in the mills. *Canter's* occurs in a number of names and is of two kinds: some fields are named after a farmer who held them: others had been part of the *terrae cantariae,* the lands of the chantry. *Brandfire Knoll* is unexplainable, except by a surmise which certainly sounds far-fetched: it is a down of rough grazing overhanging the Bottom, but not a place for a beacon: the head of the valley curves round behind it:

from down the valley I have often watched mist or low clouds being wafted up or down this curve, looking just like smoke rising from a heath fire on the knoll. One does not ordinarily credit mediaeval villagers with aesthetic sense, but it is not absent from some of their folk songs.

Enquiry about the advent of "public services" reveals an astonishing crudity of ideas until quite a short time ago. Cottagers still have to go "down the garden": the three cottages which have been converted into residences naturally have had indoor w.c.s installed, and the same was done at Wortley Farmhouse a little earlier. At Wortley House it may have been done even earlier, before a water supply was laid on, as there was a small cistern over the ceiling of the w.c. fed by the rain gutter of part of the house which had been graded to it: but the carriage of night-soil from the foot of the back stairs to the disposal point was in full sight. The out-door servants' closet built against the end of the kitchen wing is not likely to have had a water flush before a water supply was brought in about 1880, as the cistern in the house was too small. It simply stood over a cess-pit: those using it had to come out from the house itself, past the windows and through the inner garden: more discreet access was not provided till the restoration of 1926.

About 1880 the squire piped water from the Comewell springs down to Wortley Farm, with a public tap in the lane outside. A short branch served a public tap in the lane at Purnell's. A branch gave a supply in the scullery of Wortley House and served a public tap on Chapel Hill. Then at some time the supply was carried up to a bath-room cistern on the first floor, serving a tap over a sink in the pantry. In 1926 a cistern was installed in the roof space, serving supplies all over the house. At the same time the cottages belonging to the house were given indoor taps, the first in the village to be thus provided.

Before the squire's piped supply the cottages depended on permission to draw from six wells dug privately. Though these filled to ground level in winter, in summer they fell some forty feet or even dried up. The wells had only been sunk to water in

the marl, when another ten feet would have struck a more reliable source in the Sandy Beds.

Other cottages in their turn acquired taps, and those converted into residences took greater facilities; then two milk-coolers were installed on farms: and recently cottages began being given baths and boilers. Quite early these extensions increased demand above the minimum supplies available in dry seasons, and the shortages experienced in the higher levels led to bitter recriminations which ignored this increase of demand and were not always directed to the quarters most responsible. In the worst of these periods the spring even dried up completely, and Wortley House was completely without supplies for four months. One attempt to meet the shortage was to try to get Wotton supplies extended: though a half-mile extension brought water to a single house newly built up the road, and within a quarter-mile of the village, the local authority refused the further extension for a much bigger population. At last the situation has been relieved: when the West Gloucestershire Water Company bought the springs at Monks Mill to pump into their system, they made a local high-level reservoir on the lower slopes of Little Tor: the pipes for this skirted the village, and people were allowed connections.

One illuminating aspect was revealed in the Wortley House well, when it was proposed to take it back into service during an early severe shortage: the water was condemned on analysis. It was then realised that the cess-pit of the house, though concealed by out-offices, was only some twenty-five feet from it.

It is to be expected that the copious Osleworth brook worked more mills than Monks Mill. Just outside the Wortley border and in Osleworth stood a small mill, where the stream receives its first appreciable addition from the Seven Springs. John Smyth and early records refer to this as Hell Mill, which a modern tradition purports to account for because the girls working there were a rough lot: another name is Hill Mill, because there the valley emerges from the hills. A later name is Ell Mill, which an authority, Dr. Perry, suggests to mean that it produced only ell-wide as distinct from broad-cloth. Broadcloth, however, is mentioned

when in 1825 two men got a fourteen-year sentence for stealing cloth worth £150 there. By about 1834 it seems to have abandoned cloth for farmers' work, and in 1844 to have closed after the death of the last owner. Now there are only a cottage housing a small-scale farmer, and the marks of former mill channels.

Three furlongs lower down the stream, on the Alderley bank, stand the ruins of Knowles Mill, earlier known as Sextone's. Under the occupation of Daniel Nowell it was about 1725 defined as a "messuage mill-house and two fulling mills under one roof". In the period 1835–50 it was owned by two Miss Burltons, said to be the descendants of the Crewe family. As it was not part of Alderley Manor, the only information is what can be deduced from entries in the Bennett ledgers. One Burlton sister seems to have been a grenadier of a woman, judging by the size of the coffin which John Bennett made for her. In the latter part of this period it seems to have been worked by Thomas White and then by Rowland Smith, who also took over the working of Monks Mill, till both closed down in 1869.

After a further three furlongs Monks Mill takes advantage of the considerable increase of the stream from a group of copious springs. The mill has already been dealt with fully from ample records. The springs have recently been bought by the West Gloucestershire Water Company to augment their supplies.

A little lower there is a water wheel for pumping supplies up to Alderley village. The pumped supplies came from the Kennerwell spring, lying on the lane to which it gave its name, a section of the old Wotton–Alderley road which crossed the brook at Monks Mill. The lease by which Purnell got land for his extension of the mill mentions it as Skinner's Well, and includes the water rights (which Purnell does not seem to have used) subject to the rights of the villagers to passage and to draw water. A false tradition makes this the spring of the legend of St. Kenelm, to whom Alderley church is dedicated.

Then comes Penley's Mill, probably of no antiquity or size, which may have made a little cloth, and ceased with the death of Edmund Penley in 1858.

The earlier history of Broadbridge Mill, three furlongs below Monks Mill and just above the road crossing, was confused with Monks Mill by wrong naming in some documents. Known of in 1544 as Wortheley Mill, it had obviously succeeded Monks Mill as the manor mill, and had come into Berkeley ownership in an unrecorded way. Its abbey tenant, Thomas Matston, a lawyer and investor in church properties, had been succeeded by a miller Richard Allen; the tenancy then passed to the Poyntz family, who already seem to have been sharing it. When the estate was in 1631 sold to Richard Poole, and then by him to Sir Matthew Hale, this mill was specifically included and described as a "water mill consisting of a grist mill and fulling mill with dwelling house adjoining", and in 1798 had two stocks and a gigmill. In 1839 it was assessed at £51, which indicates industrial use; the tenants then were Richingses, a family which still supplies our meat in Wotton: but, after a period of mere farm work, it seems to have died about 1847. It still stands, precariously, as the estate sawing mill: the present name came in only when Broadbridge was built for the re-aligned road to Alderley, probably engineered by Osborne Yeats as highway overseer.

A little below the road stands Grindstone Mill. Though the name implies a grist mill, it was in 1650 let to a clothier and described as a "messuage or tenement and smyth's forge, and one grindstone mill and one fulling mill under one roof". An old lady inhabitant speaks of hearing of the poles of cloth racks still standing there.

There is then a gap of six furlongs down to Nind Mills. In that length two tributaries draining a considerable area join the stream and make a much larger mill possible: however, it does not seem to have come near competing with Monks Mill in importance. Also an Abbey mill, and also let to Matston, soon after the Dissolution it appears in the hands of Sir John Thynne of Longleat as an unrecorded part of his recorded grant of Abbey properties. He continued the then existing lease of it to Bridges; he soon transferred it to John Blagden who married his daughter. Thynne sold his rights to Bridges, who then, in partnership with Neale

19

of Wortley and Huntley of Boxwell, obtained Exchequer con-
firmation of rights *in capite* of properties including this mill. In
1612 the partners conveyed the mill to Blagden. The mill re-
mained in the hands of six successive generations of Blagdens, all
named John: the last of these married the Hale heiress and took
her name, and the mill still remained theirs. When depression hit
the cloth trade the mill began to deteriorate, but in 1882 Messrs.
Millman were still employing forty men on cloth: by 1930 it had
sunk to mere flock work. It is now practically dead.

On the outskirts of Kingswood village and of the Abbey site,
the stream is joined by the tributary which drains Tyley Bottom
and runs past Wotton. A furlong up this lies Park Mill Farm, the
"Berkemyll" of Abbey records: the name comes from its being
on the edge of Haw Park. Beyond the fact that it belonged to and
was leased to Rowborough by the Abbey, nothing of interest is
on record of it.

Just above this confluence and in a suburb of the village stands
Walk Mill. The name, which dates from Abbey times, shows that
it was even then concerned with fulling. Abbey records seem to
divide it into two holdings; in modern times it consisted of a
sawmill, and a store in a former flour mill, which was burnt down.
The sawmill has now become a printing works. This stream was
the Saxon border of Wortley: but it seems appropriate to con-
tinue down the main stream and deal with the rest of the mills
upon it.

In Kingswood village and at the downstream edge of the Abbey
site stand the mills now known as Abbey Mills. Their origin is at
least thirty years earlier even than Monks Mill and was probably
for the Abbey's corn grinding, from which it was called the New
Mills till the Tubbs Lewis concern bought it. The leat dug to feed
it runs longitudinally through the already narrow Abbey site,
and makes it difficult to plan the lay-out of the Abbey complex,
especially as the very foundations have been quarried for their
stones. The mill was engaged on cloth work, and even on broad-
weaving, well before the Dissolution, on lease to several men in
succession. In 1617 the mill property was included in a consider-

able trust formed by James I for his son Charles and his wife Henrietta Maria. In 1628 it was part of a grant of lands totalling £12,496 6s. 6d. by which Charles I liquidated loans made to him by the City of London. The City liquidated their holding as opportunities arose, and John Smyth of Nibley for a time held the freehold of the mill. In 1693 his descendants sold it to Robert Daw of Bradley. In 1801 Humphrey Austin let to Thos. Mercer clothier of Kingswood this mill with millhouse and pigeon house, as well as a third of Abbey water-corn mill with millhouse, for twenty-one years, all for the small rent of £80. It was burnt down in 1898 and restored as a considerable area of one-storey buildings.

Almost adjoining this comes Langford Mill, now also owned by the Tubbs Lewis firm. This seems not to have been an Abbey mill; not only is there no mention of it in Abbey records, but the façade of the ground floor contains large carved stones apparently coming from demolition of the Abbey after the Dissolution.

Where the Wotton–Charfield road crosses the stream stand New Mills (Plate 6.) These were believed to be of relatively modern origin, but can be traced back to the abbey, in spite of gaps in the series of documents and misleading place-names.

The 1537 Lease Book contains a lease to Margaret, widow of John Webe, who had remarried James Baker, of his fulling mill and "Long meddow between two rivules" (the stream and half-mile-long leat). There are also mentions in leases to others of "Le Sury" north of the abbey. The story is resumed in the title deeds of Merryford Farm. These deal, from 1616 to 1660, at first with the next mill downstream, Ithell's Mill, with the Kingswood land lying west of it. By 1660 most of the land had been disposed of in undocumented transactions. The next documents deal, from 1702 on, with another mill, called "Sury Mills" in one of them, and land including seven and a half acres "between two streams", which must be the Long Meddow, part of Merryford Farm. All this was bought in 1806 by Humphrey Austin. In 1811 he let it to a relative, George, for twenty-one years at £700 per annum. A deed of 1826 deals with the "New Mills": his initials H.A. in dark brick are prominent on the west end of the mill, showing that he

was responsible for a rebuilding. When about 1870 Messrs. Tubbs Lewis bought the mill, they are said to have rebuilt it: this cannot have been more than some degree of enlargement, for the exterior of the Mill remains a good example of late Georgian factory architecture. It is employed in the manufacture of braid and elastic, and is the largest employer of labour in the area.

The mill has a specimen of the circular wool-drying towers which are no longer common: this has been made part of the office and so should be safe.

It is unfortunate that there is no record of the mill to show if it continued in Webb ownership before 1702: if it did it would probably have been the mill in which Benedict Webb conducted his work on perfecting and using rape oil in cloth work, in place of the expensive foreign products.

Three furlongs on comes the site of Ithell's Mill. Only the parts below ground and an ancient road bridge now survive. Nothing was known of this mill, but it has now been shown to have been an abbey mill dating back almost to the foundation of the abbey. This, and Monks Mill and Abbey Mill are the three watermills mentioned in the Papal Taxatio of 1291. The records which concern it are the most confused of any of those investigated.

John Smyth reports that, by an undated deed of the period of King John, the Berkeley heiress who brought Huntingford tithing to the Veel family granted the abbey a mill "that lies next about the monastery": this description would indicate Abbey Mill, had that mill not come to the abbey several decades earlier. Ithell's Mill lies in a little enclave bitten out of the Huntingford area and carried into the abbey manor, so it must be the mill intended, and "monastery" meant the abbey estates and not the buildings. The grant was shortly confirmed by the Berkeley suzerain, "for the souls of his two wives Julian and Lucy". It was then on lease to Richard Bisford, named after the mill.

In subsequent mentions the name is badly written or mis-spelt in the most confusing way, but "Byscheford" was intended. Bushford Bridge now carries the Charfield road across the stream above New Mills; at that time the ford and then the bridge carried

a highway to Berkeley important enough for a forge to be set up in the mill, and a wayside cross in the adjacent Whitecrossfield.

In the 1291 Taxatio it was probably the 10s. mill listed: in the 1444 abbey Rental it was let at 16s. 8d., compared with 6s. 8d. for Monks Mill. The 1537 Lease Book shows it as "Forge House and a Bladmill", part of the 64s. holding of Phillip Acton: soon corrected to "Bladmill and Fulling mill". Ownership of this and the rest of this north-west corner of Kingswood was in 1545 granted to Miles Partridge by the Crown. Partridge must very soon have cashed this concession, as he did Monks Mill, for the 1552 will of John Secole made a bequest of it. The will takes the wrong name from Partridge and calls it Monks Mill, but reveals the error by naming the tenant correctly.

The area of this Miles Partridge concession, including the mill, appears next in 1616, in the first of the title deeds of Merryford Farm, apparently still intact. By 1660 the mill had another owner, and he was selling it: it had since 1636 been leased to Thomas Ithell, who had since died and been succeeded by his son Robert. The mill then makes no further appearance in records till Messrs. Tubbs Lewis bought the remains for the sake of the water rights, which might have interfered with those of their New Mills.

Sixteen thirty-six was not the first appearance of the Ithell family. In 1544 William Ithell of Charfield had been accused in the Gloucester Consistory Court of concealing tithe dues on butter and cheese, and "for ten years past hath always occupied within his house two brode lomes where yerely he and his have weved three score clothes at the least", the yearly value of such tithe being £5.

Ithell's Mill is close to the Huntingford border. Half a mile lower, just below the junction of the Wickwar branch of the Little Avon, stand the Charfield Mills. These do not appear in any abbey records, nor are there later records of them, but they were undoubtedly cloth mills. They were bought about 1910 by Messrs. Tubbs Lewis, and make pins and knitting needles and small wooden parts for the other mills. Before that they were held

by the Cotswold Collotype Co. of specialist printers, who then moved to a mill in Wotton. At some date before that they had been owned by the Long family. I have not traced any connection of this family with any other mill, except Dudley Mill just below Wotton, though about 1826 one of them was described as a big Kingswood clothier, and he held land there. The mills consist of three big factory blocks, now surrounded by miscellaneous accretions. One of them is roofless and decaying. Two of them straddled the stream; the third is said also to have been served by a culvert carrying the water, but also had an engine: for this last there is a stack, more reminiscent of the stacks of Cornish mine pumps than the chimneys of the Stroud valley. This block has a stone dated 1829.

After another half mile comes last Huntingford Mill, now a big corn mill: in 1824 Austin Bros. were leasing it for cloth at £125. Till recently it was owned by Workman Bros. of Draycott Mills at Cam.

So the five-mile length of the stream from the Osleworth border down to Michaelwood carried no less than fifteen mills, nearly all of good size. Two of them are only surmised to have been engaged on cloth work, while the rest are proved: eight of them are traced back to abbey times, three of them almost to the origin of the abbey. It may be added that the Kilcott tributary of the stream also carried a very large cloth mill of the Austin's, and four small mills which look like mere grist mills but are so numerous that cloth work is likely. Adding the twelve certain mills in and above Wotton of which eight are known to have been on cloth, the one certain big mill and several small conjectured above Kingswood, a few more mills further down the Avon, the mills on the Ewelme and the other vanished ones suggested by the clothiers' memorials crowning the walls of Dursley and Uley churches, and the mills crowded along the Stroud Frome and its tributaries, we see a concentration of the cloth industry much greater than is commonly realised.

7

The Other Tithings and Mills

SYNWELL was so important a part of the manor that it is surprising that its name was not taken for it: it contained the church and manor house, and the apparent first nucleus of the town.

The name has varied during the centuries in mentions of the well. This lay a little east of the stream below the church, was renowned for the quality of its water, and was lately known as Madam Moore's well. The first form in 1350 was "Sonewell", in 1520 Swynewelle, in 1532 Synnewelle, in 1538 and in 1575 Synwell. In later documents Sinwell gradually displaced the last, till quite recently the villagers asked for official acceptance of the previous form. "Sonewell" is likely to be an error, as it is not explainable: "Swynewell" is a more probable original form, and perhaps suggests that the herd of pigs was driven out to pannage from Pig Park this way: the subsequent forms are more or less obvious degradations.

The western boundary of Synwell has been described in dealing with the borough. The southern boundary runs down Tor Hill beyond which lies Wortley, and then down the main stream beyond which lies Kingswood: and it included Merlin Haven. On the east the boundary with Combe is uncertain, and the only guide is that it was the Combe men who were once presented in the Wortley manor court for trespass by their beasts near the Black Quarry. The north boundary included Edbrooke Field, apparently as far as the Old London Road, since The Butts and Friendless Acre are both included in Synwell. More eastward this boundary is indefinite, since the land is open down.

The popular etymology of Merlin Haven connecting it with

hawks is false: earlier forms are "Moore", perhaps a misreading of "Meere", a boundary; and then "Merry" and "Mary". The other element is constant as "Haven" or "Heaven". The Butts are also given a false etymology as the archery range: this is a common name for the butt ends of plough-strips.

Synwell does not seem ever to have been or have contained a manor, nor is there any record even of smaller estates, it was part of the manor of Wotton Foreign, and as a tithing was grouped with Bradley. It contains two quite separate inhabited areas, the old nucleus of the town in the west, and a strip along the foot of the hill in the east. The area between these, now being built gradually over, still has some field boundaries which suggest the plough-strips of an open field. There is a similar suggestion in Merlin Haven and the adjoining strip "Bemmerley": the Middle, south of the borough, is itself a field name, and there is a group of strips next to the borough. Edbrook was an open field, but shows no signs of strips. These open fields provided the rights of pasture which were part of the burgage rights granted in 1253.

There are no houses of interest in the eastern block: those in the western block are more fittingly dealt with in other sections of this account, where we meet their founders or inhabitants.

Coming to the mills, it is necessary to take into consideration those above Synwell and in Combe, because of the difficulty of fitting in all those of which there is record into recognisable sites.

A mile above Wotton are the Combe Lakes. These are of considerable storage capacity and depth, held up by a fairly high bank. Storage is increased by a little pond, The Dingle, on a tributary entering the lakes, at which there are no signs of works. Just below the dam is a mill building, now a residence named The Grist Mill. This is of medium size, of late eighteenth century appearance, of two spans and two storeys, as shown in Miss Tait's little book of 1897, except that a nice little roof turret has gone. It was fitted with a pair of water-wheels of the large diameter made possible by the height of the dam: these were made and fitted by Terretts of Kingswood, a firm still in being. There is also a smaller building adjoining.

A furlong lower, where Frogend Lane crosses the stream on a bridge which superseded the older ford perhaps a century ago, a pumping plant was built in 1910 to raise water to the reservoir in a quarry on Rushmires Hill, to supplement the earlier supply from Fuller's Earth springs higher up the hill, and to serve the town by gravity. No earlier work was noted here.

Two furlongs further, below Holywell, where Ragnall Lane crosses the stream, is the site of what was known as Strange's Mill by the few who knew of its existence: the silted-up mill pond and some half buried remains of conduits are all that remains. On the lower side of the lane stands a small building with an outside stair to the upper floor; the iron railing of this still shows "H. A. Palser 1862" cut on the upper face of the finial.

After yet another furlong, where Valley Road reaches the stream, stands The Dyehouse: the silted-up mill pond is visible, but the water runs cannot be traced. There is a factory building, quite large by old standards, now occupied as cottages. An adjoining area of nearly four acres is surrounded by a high brick wall, and contains more buildings. Still lower sites and mills are clear of the confusion.

At the Lakes was the Combe Brewery of Mr. Arthur Guinness, from about 1870: this was continued by a Major Annesley, and finally by Mr. Sydney Underhill. An informant remembers "pop" bottles with glass stoppers being filled in the smaller building, and has ridden on the dray delivering barrels of beer at Purton: that would be not before 1910. Though *prima facie* exploitation of this rather remote site would be a little unlikely until the brewery had to look for pure water, and earlier building of so high a bank is also unlikely, Mr. Stanley Grimes can quote first-hand recollection of its having been a grist mill. A sale notice of 1827 of a "new erected water grist mill and millman's cottage, with 2 acres including the pond, and dye-house", and three cottages with Hurst's Orchard of one and a half acres which perhaps lay elsewhere, is considered to apply to this: the sale was in the bankruptcy of William Watts saddler of Oldbury-on-the-Hill. No other records are thought to apply to this site.

At the pumping station the total absence of earlier remains is contradicted by the marking here in the 1842 survey which was for the Tithe Apportionment of 1849, of a "scouring house" which I find reason to attribute to the Wallingtons.

There are mentions in records of Strange's Mill. The late Mr. Robert Excell, J.P., used to tell of this still doing cloth work when he went into the army (c. 1855), but of its being in the present state when he came out. There is a lease of 1827 for seven years to Miss Sophia Austin, of a "messuage in Pounds Ground in occupation of Mr. Strange": the "messuage" was not a mill. Strange still occupied the mill in 1847.

The little building is reputed to be the counting house of the mill. The Palser family, among other activities, included a firm of iron workers, the last-known industrial iron workers in Wotton.

The Witchell inventory of 1701 (see page 152) shows a very considerable factory "at Combe". The large establishment of the Dyehouse is the only one that suits it. Late in the nineteenth century this was a dye works run by White & Co. There is mention in an early Venn will of a mill at Combe, quite distinct from the Venn mill in the Tan Yard region. In 1749 Daniel Adey junior granted a fourteen-year lease at £18 of "Venn's Mill, a water corn-grist mill in Combe". The most probable solution is that this was Strange's mill before Strange got it and left it his name. Very little lower lie the gas works set up by a local company in 1839: under the amalgamations when the industry was nationalised, working here was abandoned, though the gas holders are still used for balancing supplies.

Adjoining this comes the Britannia Mill, so called because part was let to the Britannia Lodge of Oddfellows when the Salvation Army was in occupation; they are on record as holding services at the barracks in Old Town for two years in 1826. In 1872 the above White and Co. were allowed by the market feoffees to alter the waste pipe at Rymers Row, obviously to run the overflow to this mill. Perkins is said to have run this as a dyehouse, while White ran The Dyehouse. In the prosecution papers con-

cerning the weavers' riots of 1826 there is a rough little plan, from which I judge that here was the site of Messrs. Neal's mill: the lay-out is quite different from what exists now, but other possible sites are still less likely. In 1838 a sale notice appeared of the property of an unnamed manufacturer "declining business": this consisted of a large and a small mill at Pounds Ground making clothing, which fits the plan in the riot papers. The machinery included scribblers, jennies, and cutters, but no looms: there was also a workshop in Bear Lane with machinery.

The tradition that it was a dyeworks later is supported by the finding of what were thought to be the floors of vats, when a sewer outfall was dug a few decades ago. Vincent Perkins is recorded as a wool-dyer: he died in 1921 aged ninety-one, but must have retired some years earlier, since it was for a time an iron works run by his son-in-law Toulmein; then a sauce factory run by a Mr. Smith until it was sold in 1909.

The buyers were the Cotswold Collotype Co., now still in possession and expanding the premises, who are in the front rank for printing of that kind, making the plates for such exacting and delicate work as the *Numismatic Chronicle*, as well as more ordinary business in picture postcards and other illustrations. The firm, under another name, was established by the grandfather of the present head some one hundred years ago, and has survived vicissitudes and difficulties. Towards the end of the nineteenth century it embarked on the collotype process, in Huntingford Mills, which it then rented. Business difficulties closed the firm in 1907, but three employees had the faith to buy and revive it. The mill was sold over their heads, but they secured the present mill, and by strenuous transport work day and night kept the business moving. A further blow was that their work was classed as a luxury trade during the last war. They are a useful secondary industry for spreading the variety of employment in the place.

Water is next impounded at Potters Pond, where the old route into Wotton from the east crosses the stream below the church and The Cloud. At the head of the pond the 1763 survey shows a

building whose end straddled the stream, owned by the Moore family: but there is not even a tradition of this as a mill, and the building has disappeared.

I think that Potters *Pound*, is an error of the Ordnance Survey Department, misled by the adjacent Pounds Ground. The latter is named from the town pound which stood behind the smithy: the former is always called Pond, and I have seen no record of Pound for it.

At the lower end of the pond another building is shown astride of the stream. This must be the "mill in the holding of Robert Benett" mentioned in the 1682 will of Thomas Venne alias ffenne, descendant and heir of the William Venn one of the 1611 grantees. Then in 1763 it was held by Daniel Adey under Lord Berkeley; nothing more is known of it but that it was latterly a sawmill, and has now been demolished.

Just below this the stream served a tan-yard on the west bank, which has also disappeared: it lay on land which has been church property "from time immemorial". Adjoining it on the same plot still stands the ancient Ram Inn, and next the former workhouse which became an infant school, and has more recently been demolished to give place to a mortuary and a car park. The Ram Inn is described with the other inns, and the property with the local charities.

In line with The Steep stands Waterloo Mill, with date 1815 on a stone plate. All that is known of it is that in 1827 it was let by the Austins to Lewis and Dutton, "with steam engine, stocks, gigs and drums" but no looms, for £320.

The relation of Waterloo Mill to the divided mill streams from Potters Pond is uncertain, but just below their confluence above the bridge for the Wortley road, the 1763 survey shows another building partly astride the stream. It was owned by Lord Berkeley, and leased to a Mr. Whittock who is not known as a miller or clothier. In 1798 and still in 1813 it belonged to Messrs. Austin as a dyehouse, which accounts for the place being called Dyers Brook. It appears in the undated description of borough boundaries as "mill occupied as a dwelling house by Richings": now the

whole site is covered by a lorry garage and workshop of corrugated iron.

This mill does not seem to have done any pounding, but Hack Mill, the next, a good furlong on, ponded half-way back to the road. That this was one of the old mills is shown by mention in the 1537 Lease Book of Kingswood Abbey, of "Dudley meadow near Hakemill". John Smyth also mentions it as figuring in an Exchequer plea of 1613.

Nothing is known of its history except that it went through various business vicissitudes as a paper mill from before 1773 until at least 1847, much of the period in the hands of the Palser family. In 1774 it was for sale and described as a "very complete and new erected paper mill", so it must then have been recently converted from other work. The water of the stream, carrying the waste of all the above mills and dyeworks as well as the town drainage, must have been quite unsuitable for the making of fine paper, and the only papers mentioned are "best press papers for clothiers and Sugar Loaf Blue and Brown Papers". The name of the mill is a problem. From the place-name angle it would denote a sluice gate, or a trash rack for excluding rubbish, neither of which are distinctive enough to name a mill. A mill-antiquarian, Mr. Rex Wailes, is confident that it must have been a flax hackling mill, and the possibility is not excluded by the fact that such work is not known of there. In fact it seems possible that the flax machinery was suitable for the treatment of rags in paper-making, though "hackling" is not known as a technical term in that work.

A little lower stand the modern sewage works and then Dudley Mill. Nothing is known of this except that it was built by Rowland Hill as a cloth mill, was in 1829 on lease to Mark Fowler, and in 1836 to Samuel Long. Now nothing is to be seen of it but a bit of the arch of the water outlet. The name is that of the adjoining meadow, mentioned in the first record of Hack Mill.

There is only one more mill on this stream, Park Mill, just above the confluence with the Little Avon. As an abbey mill it has been dealt with among the others of that group.

Off the stream there was also a "Cloth Factory in Steep Street". This did not exist in 1763, when there was only a building on the frontage of the site, owned by Thomas Austin. What now stands is a large building set back from the street, of four floors, described in the advertisement of 1830 as "counting houses, wool-lofts, cloth yarn and passing rooms, with an air stove on three floors, and steam mill behind, in occupation of Messrs. Austin Brothers". In 1836, as related, Pitman's school was for a time accommodated there. Then Canon Sewell, while vicar, bought it for a few hundred pounds. A deed in the archives in the church shows that in 1903 at his retirement, he sold it for £500 subject to 10s. rent to the Earl of Ilchester, to Mrs. Mackinder wife of his successor, and it was used for various church and related activities. Later it was bought by the grammar school and is used for classes: and a canteen has been set up in its yard. Lastly, a fire destroyed the roof, and its replacement with corrugated iron is unfortunate on a building so prominent in the view of the town from the east.

These mills form a not inconsiderable addition to the industry recorded on the Little Avon. While those on the latter are almost entirely of early origin, here the later element predominates. Few of them are early enough to have enjoyed the prosperity of the cloth trade, and they existed for the most part only for the finishing of cloth woven in weaving shops or in the weavers' own cottages. The weaving shops in the town and away from the stream, are dealt with in describing the borough.

The Austins are another Wotton family of clothiers whose activities call for record. Members of it occupied the mayoral chair, in twenty years, longer than any other family: their activity in the cloth trade seems to have been the largest in the area.

The first to appear is Edward, 1634–1708, clothier like nearly all his descendants. He is commemorated on a massive altar tomb outside the north door of the church, in a line of family tombs, with mention of three generations of the family: curiously, the date of his death is given wrongly on it. He was never mayor, nor was he among those assessed to Royal Aid in 1689.

His eldest son John, 1664–1727, is the progenitor of all those who make an appearance in Wotton history. Twice mayor, he with Richard Osborne supported Samuel Bennett the master of the grammar school, who in 1710 took legal action against George Smyth's misappropriation of school endowments. John's brother Edward, 1668–1702, set an example by moving to London, though he returned to Wotton to die and be buried.

One of John's sons, Isaac senior, 1700–74, is noted on the back of his portrait, in the possession of the last living descendant Mrs. Gillespie, as "Rev.": this is likely to be wrong. No other cleric has been mayor, and in market feoffees records he is called "clothier" at least once; his signatures are also unworthy of a priest.

25. Austin arms

Isaac's son Humphrey, 1747–1829, was so much the most considerable member of the family that he is spoken of as "Great Humphrey". His activities in the cloth trade were more those of an *entrepreneur*, building or buying or renting and letting mills, than of management. Before 1801 he had bought Langford and (Kingswood) Abbey mills, but sold them by 1851. In 1806 he bought Merryford Farm in Kingswood, which is still in the family. With it went what had been the insignificant Sury Mill of the abbey, which he rebuilt as the imposing New Mills: these he let in 1811 to the husband George of his niece Millicent, for twenty-one years at £700, a measure of their importance. Langford and one-third of Abbey Mill he had in 1801 let for twenty-one years at a mere £80. Earlier he had also built Alderley New Mills, which seem to have been when they still stood as large as the New Mills, which he sold or let to the Lartons of Alderley. The "New Mill of Messrs. Austin" whose working Rudge describes was the latter: and he records that it used only Spanish wool, and apparently did no weaving. In 1799 with his cousin Edward (of Basinghall Street), 1742–1827, he took a lease of Church House with workshops, and may have taken part in other ventures of Edward's firm. Outside the cloth trade Humphrey held a long

lease of the Packhorse Inn from the Grammar School trustees, for ninety-nine years from 1788, and in 1798 sublet it. This Edward was the first to be given a directory entry in 1820, as a woollen manufacturer, living on The Chipping: this house may be the one in which Isaac junior, 1745–96, lived. All his activities were those of a family firm. One member of this was Edward junior whom I surmise to have been his son; another was his brother Anthony, 1746–1800, who must have been succeeded on his death by a younger Anthony, whose place in the pedigree has not been found. Another partner was a John whom I surmise to have been the grandson, born in 1767, of Anthony senior. There were third Edwards and Anthonys appearing in transactions but not in the pedigree: and an Anthony who in 1831 became rector of Alderley on binding himself in £2,000 to resign on demand, if Matthew Blagden Hale, then an infant but later Bishop of Perth in Australia, should want the living. One witness to this bond was Mary Elizabeth Austin, spinster, of Bournestream, who has not been traced for the pedigree.

Outside the partnership Anthony in 1795 received assignment of the lease of "The Club House" in High Street, with a brew-house: nothing is known of this club. In 1783 Anthony is noted as a member of a local association of landowners and clothiers, for mutual protection and the prosecution of robberies. When this was reconstituted in 1812 for clothiers only, the firm held membership in the highest class of subscription, even Osborne Yeats of Monks Mill being only in the second class. In 1798 Messrs. Austin are noted as owners of the dyehouse astride Dyers Brook at the foot of the Steep, and again in 1813 when it was a ruin. In 1824 the three, with John, obtained a seven-year renewal of their lease of Huntingford mill on cloth work. In 1827 the same four let Waterloo mill, which someone of the family is likely to have built twelve years before.

In 1830 the Steep Mill "in occupation of Messrs. Austin Brothers", was advertised as for sale. The site had already been owned by Thomas their father in 1763, but with only some buildings on the street and without the big mill: the building

but without machinery, was still in the family in 1836. In 1832 "Austin Bros." were insolvent, and their assets were assigned to creditors: there is no clue to the members of this partnership, and none are known to have become indigent: what is known of the properties suggests that the "creditors" were other members of the family.

Humphrey's niece Millicent in 1812 married a George Austin whose parentage has not been found. He too was an important clothier: a year earlier he had taken New Mills on a twenty-one-year lease at £700, and he settled £9,500 on his bride, with Humphrey and Anthony as trustees. He was mayor for two cosecutive years 1807–8, and signed the 1812 agreement for reconstituting the protection association, in the first class.

Humphrey was on intimate social terms with Frederick Augustus, Earl of Berkeley. The earl nominated him Deputy Lieutenant of the county, and captain of the Wotton Yeomanry: with Osborne Yeats and another gentleman they used to hold regular whist parties at the Castle: their collaboration over beating the bounds has been described. After the earl's death his son invited Humphrey to be one of the pall-bearers: and his widow (Mary Cole the butcher's daughter) wrote him an intimate letter in the course of which she deplored her social isolation.

The last Austin of consequence in Wotton was Humphrey's eldest son Lestrange Southgate Austin. There is no sign of his having been active in the cloth trade or in mill property, but only as a gentleman financier. His memorial in the church displays arms, though there incompletely and incorrectly blazoned, and properly *Argent, a lion passant regardant gules collared or, on a chief azure a bezant (or annulet)*. He had bought a long lease of the tithes and rectorial glebe of Wotton, worth £969 12s. 6d. per annum when apportioned in 1847; it is a curious point that in assessing him on this for poor rate, what lay in Wotton Borough was omitted to the tune of £542. When the National Provincial Bank opened a branch at Wotton in 1834 he was invited to become a local director. He died in a second year of office as mayor. His son John was a "poor" or foundation scholar of the grammar

20

school, and in 1831 was given a £50 Exhibition to Oxford, where he took Holy Orders.

Austin ladies too entered business; Sophia, who appears in the pedigree, in 1827 obtained a seven-year lease of a messuage in Pounds Ground which was not a mill; another lady, uncertain whether Mrs. or Miss, inherited the Steep Mill and disagreed with Isaac Pitman over the letting.

Humphrey's brother William, 1755–93, deserves mention for his career, which gained him a place in the *Dictionary of National Biography*. He took his B.A. from Wadham College, Oxford, in 1776, gaining an Exhibition in Hebrew; he resumed and gained an Exhibition in botany; and then became assistant to the professor of Arabic and lectured on that subject. He then went to St. Bartholomew's Hospital, but returned to Oxford to take his M.A. in 1780, proceeded to M.B. in 1782 and M.D. in 1783. He lectured in mathematics, was elected professor of chemistry and became physician at the Radcliffe Infirmary. He returned to Bart's where he specialised in cutting for the stone in a London practice. He is said to have attended King George III and Queen Charlotte, and got his F.R.C.P. in 1787. Physically he was energetic, often walking from Oxford to London in a day, or scything an acre of heavy grass in the day. It is sad that his life was terminated at only thirty-eight by a "febrile disorder".

One of the Edward Austins in 1823 bought land separated from the Bradley estate and built the nucleus of the present Ellerncroft house: this was unaffected by the insolvency, and he retained it till 1838 when it was sold to T. S. Childs, a rich Tabernacle worthy. Either Humphrey or his son bought land about Hentley Warren and built The Warren house, where he lived.

The houses in Synwell which are worth describing are in the town area, and are taken up accordingly.

BRADLEY was the tithing adjoining the borough on the west: for fiscal purposes it was often grouped with Synwell. Like Symondsall, it contains no village.

Its southern boundary is the Little Avon except where the Kingswood border has been extended over it. Westward it used to extend as far as the Huntingford tithing, till changes that will be mentioned brought it back to the Bourne Stream. Northward it still follows that stream, and seems to have taken in the lower oolite plateau till it meets The Ridge section of Symondsall tithing at the upper scarp: the only support for this surmise is that near the upper end a barn is named Bradley Barn. Eastward, but for this excrescence which touched Combe and Synwell in the lower scarp, it was bounded by Synwell, roughly on the line of the Old London Road, then by the Borough, then by the Merlin Haven section of Synwell, and then by Haw Park.

Haw Park was bounded on the south-east by the stream from Tyley Bottom and Wotton; on the south-west by the Kingswood border; on the north-east it was separated from the borough by The Middle open field in Synwell and by Merlin Haven: to the north-west I surmise that it extended roughly as far as the road from Bradley Green to Bushford Bridge: my reason for this surmise is the area of leases. In 1598 Arnold Oldisworth took a lease of 240½ acres of meadow and pasture in the Park: there were previous and subsequent smaller leases in addition to this area, and one of 1574 describes the Park as disparked (by Warwick and Leicester?). In 1680 Thomas Smyth of Stonehouse got a lease of the 240½ acres for ninety-nine years for a £420 fine and £40 3s. 4d. rent, his father John Smyth having held the lease at his death in 1640.

There is nothing whatever to show whether it was a park for hunting, or merely a timber reserve and larder for venison "on the hoof". That it was preserved is shown by a proviso in the permission in 1301 for the abbey to convey water from a spring in it, "that when the abbot and convent tended their pipes they should bring with them neither bows arrows crossbows nets or other engines or dogs to kill the deer in that park".

Some at least of the south-west part of the tithing seems not to have been included in the manor. An unspecified area near Ithell's Mill and the original Bushford Bridge was granted to

Kingswood Abbey in the thirteenth century, and was still leased back to the de Schey family a century later; this seems to be roughly what subsequent owners about 1605–10 sold to Nibley owners, who transferred it to Nibley parish. St. Augustine's Abbey had also been granted lands comprising what is now called Canons' Court Farm, which passed to the dean and chapter of Bristol after the Dissolution.

The early history of the manor is not clear. According to the historians it was held in succession by de Bradley in the time of Richard I, then by Serlo, by de Straton, de Plessy, de Luda, only coming into Berkeley hands about 1320, when it was held by younger branches: the widow of the last of these sold the land in parcels in the years 1605–10. One document asserts the existence of court rolls of Bradley 1431–49 and 1514–38, but these are no longer traceable.

The original "capital messuage" dates from the time of de Bradley under Richard: there is now no building left, but the site is well marked and known as Bradley Moat. The actual site of the house is a platform surrounded by a moat, with the Bourne Stream forming its northern side. On the north the high further bank of the stream replaces a bank, and the south side is partly banked and partly dug in. Upstream from this the valley is crossed by two low banks which, with the site itself, form three level water meadows: from just above the uppermost of these a shallow trench used to lead water into the south-east corner of the moat, and at the moat's north-west corner there are masonry remains of the walls for a timber stop-dam to keep the moat full. A track passes the south side of the site, from which a short branch leads to a point in that side at which there are a few half-buried stones in the outer bank of the moat, perhaps marking the former entrance. A few trial pits on the platform revealed some pottery sherds and small pieces of stone of different kinds, but no masonry seems to have been left. The track comes from the direction of Michael Wood and perhaps Berkeley, it seems to be heading for the Borough, via the right-of-way through Ellerncroft and Bradley Lane, though the Moat is older than the Borough. This,

and not the present Bradley Court, was the place at which Lord Berkeley asserted his alibi when tried for complicity in the murder of Edward II; the false popular belief started by Fosbrooke is ignorant of the fact that the court was only built 241 years later.

A few years ago the Dursley Rural District Council proposed to bury the site by using it for the "Controlled Disposal of Household Refuse": protests urging the interest and beauty of the little valley were unavailing, but the situation was saved when the Ministry of Works protected the site. The proposal has been revived, though of course the actual protected area boundaries were excluded, but has now been dropped.

Bradley Court (Plate 1) was built in 1568 by one of the last Berkeley owners. In 1611 an estate including it was sold to Arnold Oldisworth, Clerk of the Hanaper, "for his use for ever", for £1,100: but he got into financial difficulties, was in 1614 recorded as being £6,249 in arrears over his bond for £3,000, and emigrated to Virginia. The land was "extended", but was by 1628 relieved by his sons Edward and Michael, the latter of whom held and occupied it: this family added to the building.

Sixteen fifty-three sees the first appearance of the next name, when Elizabeth, daughter of William Clutterbuck of King's Stanley, gent, was given a reversion to the property as her jointure. On Edward Oldisworth's death the property had passed to his son Robert, then aged fourteen, and he presumably married this Elizabeth. Robert died in 1674, conveying the property by Lease and Release to William Clutterbuck of the City of Bristol grocer, outright, for £1,025, and giving a bond of £2,050 for performance. The only relevant and certain information in the spoilt Hearth Tax return of 1671 is that young Robert Oldisworth was assessed for twelve hearths in Bradley Court. Then in 1692 Clutterbuck, now Sir William, conveyed the Court to Thomas Dawes, in fee but subject to a peppercorn rent, reserving "the Little Seat in the church and joint use of the Great Seat". Further in 1699 Clutterbuck sold Dawes what he had bought from Oldisworth, but mortgaged it back for £1,450.

The Daw or Dawes family make frequent appearances here: their history cannot be completely disentangled, but I give the partly digested facts.

The first mention is the will of 1578 of Robarte Daw of North Nibley, probably owner of the Bournestream property of which more will be heard, once mayor before 1570: he had a son Robarte. Next, Thomas the elder of Wotton, who made a will in 1604 and died in 1607, leaving sons Thomas and Robert: Sir Matthew Hale's father was one of its overseers.

I surmise that it was this son Robert who received the burgage grant in 1610, and was the subject of the churchyard tomb of

26. Daw arms

Robert the elder 1570–1630, having once been mayor: this mayoralty, like that of his grandfather Robert, was before 1660 and regular records. His brother Thomas is likely to have been the mayor of 1647. A Samuel was mayor in 1656, and is not mentioned otherwise, but may well be a forefather of the Samuel 1658–1733 of a churchyard tomb and identical with the Samuel mentioned in a 1693 will below.

Sixteen eighty-seven brings the will of Thomas Daw of Wotton, yeoman, likely to have been the mayor of 1662, perhaps also of 1674 when he is described as "of Bradley", and possibly also of 1682. He held Charfield Mills for life, but did not work them since they were let to Christopher Purnell. He had a daughter, Elizabeth Mounteney, which name recalls a fine farmhouse in the south of Kingswood; he too had a son Robert and an eldest son Thomas. He is likely to be the Thomas with a son Robert in whose hands Sir Jonathan Daw about 1674 left a considerable charity.

The son Robert is likely to be the man who in 1652 and 1674 acquired in fee land in the Bradley area, including some at Bournefield, and also to be author of the 1693 will which shows that he had bought New Mill in Kingswood (now Abbey Mills) from the heirs of John Smyth in whose will it had figured. Daw left this to his grandson Robert in fee general, with remainder to

a Samuel in unrestricted fee. He is likely to be the mayor of 1666 and of 1680.

The Thomas who made the above purchases from Clutterbuck in 1699 may be the son of the 1687 Thomas, the charity trustee. The purchase included a messuage with five acres at Bournefield Stream, "Byrton's" or "Brutons" Close which accounts for the name Burtonfield on the Ordnance Survey map of 1830, and suggests that the Robert, son of Eliz. Byrton, of an undated tomb was his brother the above Robert. Of these purchases Atkyns remarks that "he gained it by his own industry, and left off his employment when he knew he had enough." He is likely to have been the mayor of 1682, the last civic office in the family.

In 1712 he seems to have felt old and secured a faculty for a burial place at the east end of the north aisle (where the Bengough vault is now) and a seat in the south aisle. Later in the year he drew his will, placing the main property in trust for a succession of persons, third among whom was his niece Elizabeth Nelmes the next owner. Bournefield was the subject of his bequest which led to the Dawes Hospital; a memorial, the inscriptions on which fill a column and a

27. Nelmes arms

quarter of Bigland records his death in 1713 aged sixty-two, that of his widow Lydia in 1739, and brothers Richard and Robert: it is headed by arms *azure, three mullets argent* and crest *a mullet between two wings*.

The remarkable rise of this family in status and wealth in 140 years cannot come from the ownership of two mills which they merely let, and a little land: but there is nothing to show how they acquired it. I guess that Sir Jonathan at least traded in London, and perhaps got his knighthood for civic office there.

The Nelmes family came from Bradstone, but was also established in this area, as shown by a 1663 will quoted on page 148. Elizabeth Nelmes did not have to change her name on marrying John Nelmes who in 1724 bought more land "at Bradley in

Sinwell", and seems to have held Canons' Court Farm on lease from Bristol Cathedral.

In 1754 Elizabeth and her sister Mary partitioned their respective inheritances, Bradley Court going to Elizabeth and Abbey Mills to Mary. Elizabeth by will in 1769 bequeathed all her land to Mary (by now married to Josiah Smart, clerk) for life, specifying a list of remainders in which her cousin John Blagden and sons in tail male were fifth: a codicil of 1774 shows that the property extended to "lands in Ellerncross".

In Mary Smart's will of 1778 John Blagden had risen to fourth place in the remainders. He was John Blagden VI of the Nind family, who in 1779 married Anne the heiress of the Hale family of Alderley, and on her succeeding to her property in 1784 took her name. His cousinship is accounted for by the fact that his grandfather John Blagden IV had married Lydia Nelmes of Bradstone.

In 1785 trustees mortgaged the property for 500 years to secure £1,000, to Anne Hale, widow, mother-in-law of the above John. Its passing into his hands is not recorded in the present set of deeds, but his will of 1808 leaves the property to his son Robert Hale Blagden Hale, who in the last deed of the series leased the property including the Court to one James Quilter. John had also in 1802 received the lease of Canons' Court from the cathedral. Bradley Court was then occupied by Col. John Blagden Hale, who with his wife Jane Powell is commemorated in the window under the tower of Wotton Church.

Atkyns prints an engraving by Kip, of the Court as it was about 1707. This shows a straight single-span building of the style and appearance to be expected: a central porch of two storeys, and turrets near the ends containing spiral stairs, make a suggestion of an E form. Not shown in the Kip engraving is a Nelme addition of a second span behind about half the length of the building. Entering by the porch there is a hall: to the right lie the kitchen and domestic offices. The space between, where the screens would have been, is a fairly solid block of masonry which may have contained rising stairs, and does contain steps down to

the cellars under the hall. Beyond the hall, to the end of the building, is a good-sized parlour. The new span contains a delightfully spacious dining room of Regency style. The first floors are divided into chambers; the roof spaces over these, lighted by dormers, seem to have been large dormitories for servants.

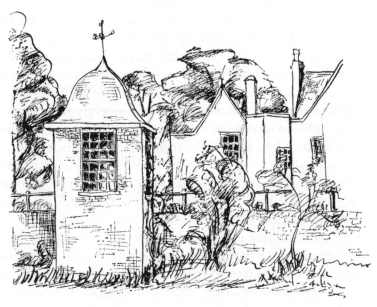

28. Bradley gazebo

A small point of interest is that the rain gutter at the back of the undoubled part of the front span is still of the rather unusual ancient type, a rectangular board trough lined with lead sheeting. On the west wall of the garden there is a Gazebo, probably also of Nelme origin: before the turnpike road was cut through the former Haw Park, this house lay on the main road out of Wotton to the south-west.

Canons' Court farmhouse is also a good building of its class, with a nice entrance hall and stairway, and reception rooms on each side.

In the nineteenth century a little estate has developed at

Bournestream and appropriated the name. It is on the opposite side of the road to the Burtonfield in which the Dawes left land for the Almshouses, and lies in Bournefield, which would have been a better name for it.

A parcel of fields which was recorded in 1785 as let to Hall and Hunt was in 1808 sold to them by Berkeley: in 1836 Hunt's wife Betty Hall sold this to George Isaac Austin, described as "of Bournestream in North Nibley": in the same year this Austin acquired also another parcel of Berkeley land there from Richard Lacey. This Austin was a son of Great Humphrey's niece Millicent and her husband George the lessee of New Mills.

In 1851 George Isaac Austin sold the combined property to four of his six spinster sisters, subject to a mortgage to one of the London Austins, and to a lease since 1847 to Henry Perrett a "common brewer". In 1872 the spinsters sold it to Henry and his brother Absalom jointly for £450 and a life charge of £20 per annum, under the name of "Bournestream Brewery". In 1887 Absalom sold his share to Henry.

As the Perretts were tenants before the sale to the spinsters, it seems likely that they built the house and out-offices. They were the sons of David Perrett, brewer and maltster of Bournestream (in Nibley?), where his family had been established for about a century: he died in 1867. When Absalom sold his share Henry lived in the house, but brewing seems to have been transferred to the Arnold & Perrett brewery at Wickwar. Absalom built himself a neighbouring house now called Thousand Acres from a field name, with a commanding view over the vale: this name was introduced by a recent owner whose socialist principles were offended by the name "Beaconsfield".

"Bournestream" is really the name of a little locality on both sides of the stream which is the parish boundary: a good Elizabethan house just beyond the boundary carries the name "Bournestream House". "Bournestream Brewery" was not confusing: but application of the locality name, unqualified, to the house can be confusing. There is no hamlet.

COMBE was often called Wotton's Combe to distinguish it from others of the name. The tithing was more than the area to which the name properly applies, that is roughly Tyley Bottom east of Synwell and up to the scarp: Simondsall was grouped with it; even Benecombe, an adjacent ancient estate in Uley parish, was in the tithing.

There are contradictions and even errors in the history attributed to COMBE: for example Atkyns says that it was at one time held by Bordesley Abbey, which Rudder shows really to have been the Combe in Chipping Campden. Even the critical Fosbrooke admits lack of assurance that his account is free from errors.

According to Rudder the estate was given by the Empress Maud to Nigel de Kingscote, but that family was probably dispossessed "on the change of affairs". A deed from the Kingscote archives now in the county record office, is authoritative. By this Henry II, already Duke of Aquitaine by marriage but not yet king, so of about 1153, "gives and grants" to Nigel son of Arthur the land of *Cumma*, which his uncle Robert count of Gloucester gave him formerly, and which Nigel gave to his wife Aldeva daughter of Robert Fitzharding as a dowry. For this Nigel gave forty silver marks and Aldeva "a certain gold ring", and the grant was for service of half a knight. The deed was signed at Berkeley, so within months after the grant of Berkeley to Fitzharding: and the latter and his son and successor Maurice were among the witnesses. According to John Smyth Robert FitzHarding, soon after 1154, granted his brother Elias a hide in Combe, "a most ancient and remarkable freehold which doubtless was so before the time of William the Conqueror", having bought it from Mahihele son of Ansgar de Combe. The estate certainly passed to Elias, but the purchase from Mahihele is uncertain, since all Wotton was part of the royal manor of Berkeley which Henry II diverted from Roger de Berkeley to Robert FitzHarding. The rent was a fifth of a knight's fee. The whole seems already to have been partitioned.

Another fact to be reconciled with the others is that, according

to Rudder, Adam son of Nigel de Kingscote in 1241 sold two yardlands in Combe. His mother was Aldeva, daughter of Robert FitzHarding, who was given Kingscote as her dower: and that grant would have initiated the name "de Kingscote".

The estate passed down the family of Elias, who adopted the name of this estate rather than that of Huntingford which he was granted at the same time. The only successor calling for mention was Walter de Combe, who was in 1331 granted land in Wortley on which to build the chantry chapel there.

By an undated deed Elias's grandson granted the estate to Kingswood Abbey for the chief lord's rent, stated as one mark: but the grant seems to have been resumed in some way. In 1379 the estate was sold and divided and began passing through a succession of families: among these there were coincidences which for a time caused me confusion in tracing the properties of the Osbornes of Wortley. The family of Giles Bird ended with an heiress who married an Osborne, and again a later heiress marries a Yeats: but these had no connection with the Wortley family.

In 1275 Elias de Combe, grandson of the original Elias, was licensed to build an oratory in his house at Combe, subject to Wotton church. In 1375 a John, apparently of the family, was ordained. Thomas II Berkeley about 1300 gave a quarry of stone in Combe to Kingswood Abbey, perhaps the beginning of the Black Quarry on Tor Hill. This lord is described as lying out in the fields for whole nights hunting game "and goats", and foxes with which Combe was (and is) well stored.

One of the pieces which became separated in the above sales was the messuage and yardland forming the Dangerfield estate, held by the Dangerfields (d'Angerville), from the manor of Wotton Foreign by a red rose payable on Midsummer Day "to be set on that morning upon a post at the gate there." This was later called Webb's Place from the family which owned it in 1639, and in 1722 sold it to Daniel Adey. This brings us to consideration of the important Adey family: their history is supported by copious but broken records, crops up in many places and activities in the

parish, and includes repeated connections with many of the local families.

First recorded mention of the name is in the military census of 1608, of Morgan Adey of Wotton, clothier, aged between fifty and sixty, who is possibly an ancestor. Then in 1647 letters of administration of Maurice Adey of Symondsall were granted to his son Christopher, the estate being worth £12: his connection is less certain.

We reach firmer ground with the first (1666–1752) of a series of Daniel Adeys, whom a series of documents show to have been affluent. His mother was a Mary: a lawyer who had occasion in the past to work on these documents has noted a pedigree according to which she was daughter of a Crew who had married an Alice, and had herself married an Adey, possibly a son of the above Morgan. In 1693 this Daniel I, clothier, occupying Smallmeads House in Combe, was marrying Elizabeth Blagden and made a marriage settlement. I find that Elizabeth was his third wife, that he had first married Sarah (d. 1686) daughter of William Moore, and second Alicia (1653–90) daughter of John Purnell of Dursley. Daughters by these earlier wives married respectively a Blagden and a Moore.

A younger son by Elizabeth was William of Combe, esq. (1698–1765), who with the two daughters is unimportant. The elder son was Daniel II of Synwell, esq. (1696–1763), who married Bridget Crew (1696–1746) and continued the line: he may have made a second marriage to Sarah, granddaughter of Robert Crew (1671–1755), whose Adey husband is not specified.

29. Adey arms

Daniel II had a son Daniel III (d. 1770) of whom the only interest is the repetition of the name, tending to confusion. The eldest son was William (1724–63), who in 1759 married Ann Gyde of Uley. He became lieutenant-colonel of the 68th Regiment. It was the son of Charles "of Uley" (d. 1796) who carried on the line.

The only interest of Charles's first marriage is that he had a

son Daniel IV, who married a Vines of the family of the banker Goodson Vines, and had a grandson Daniel V. His second marriage was in 1759 to Sarah Wallington (1732–64), by which he had three daughters. A son was named William Moore Adey.

This last had a son of the same name (1810–67), Deputy Lieutenant and J.P., and Anthony (d. c. 1873) who appears later as a solicitor. Anthony was father of a third William Moore Adey (d. 1945) who dropped the name William and appears as the very eccentric Moore Adey. Charles's son in 1794 married Sarah Larton of the Alderley mill-owner family, and then in 1806 Emma Austin of the Wotton family.

Daniel I's marriage settlement of 1693 deals with "the Gatehouse adjoining the churchyard": and it specifies that his mother Mary had in 1681 been granted a ninety-nine-year lease of this by George Lord Berkeley. His will of 1752 does not clarify this, but the 1763 survey of the borough shows (his son) Daniel holding on lease from Lord Berkeley several properties which certainly include this. There was land between the churchyard and the lane leading to the Manor House with a building at each end of the strip, and the strip on the other side of the lane with a building lately the smithy at the Combe Road end and the smith's dwelling at the other: this suggests a possible former outer gatehouse of the manor. Outside the Cloud gate of the churchyard he held the upper block of the Cloud island not immediately adjoining the churchyard: he also held three cottages opposite this across Shinbone Alley.

The will shows him to have been opulent; he made money bequests totalling £4,600, and leasehold lands in Combe (not Synwell), a leasehold mill in Alderley, the "manor" of Huntingford, and land in Berkeley amounting to a large farm. The Alderley mill I judge most likely to have been Knowles's Mill.

The will of Daniel II does not mention any land: but there are £2,450 of cash and £1,100 South Sea Annuities, and a silver coffee-pot with spoons and tongs for his eldest son, the colonel. Though he does not mention land, there were the properties mentioned in the 1763 survey; also the Cloud Mill "astride the

stream". Another mill is mentioned in a lease of 1749 by Daniel Adey junior, of a water corn-grist mill in Combe called Venn's Mill and leased to a clothier: this will be the mill mentioned in an early Venn deed and known later as Strange's Mill.

Few deeds mentioning Charles are extant; he is of course mentioned in the Wallington contribution to the settlement on his marriage to Sarah of that family, a former Rack Close in Synwell of an unspecified cloth mill, and in that he is "of Uley clothier": the deed of Adey contribution is not extant. In his father's 1763 will he got £650 and the rest of the plate, while the £1,100 South Sea Annuities were put in trust for his son Daniel IV. In 1777 he bought the Edbrook property of the Venns from Bearpacker, and is shown already to have held adjacent land in The Mears. Huntingford "Manor" is later shown to have passed to the descendants of his son Daniel IV, and is then defined as the capital messuage of Huntingford Farm, nine messuages, fourteen gardens, twenty acres of arable, twenty of meadow, eighty of pasture and four of wood: in fact only a 125-acre farm. Another deed of that time mentions that the Moores and Adeys held land in Bagstone and Wickwar in addition to what has been previously mentioned. The 1763 survey shows Charles as owner of a large house, now vanished, opposite Moore Hall on the further side of Potters Pond. Three houses between this and the stream, of which the uppermost at the head of the mill pond even strides the stream, are held by William Moore: it seems likely that this neighbour whose family had several times intermarried with the Adeys was godfather to Charles's son, and that this accounts for the addition of Moore to the family names.

Charles's son by his second marriage, W. M. Adey, was in 1819 buying more land. It was more probably he than his son of the same name who dug a sawpit on his boundary with Miss Ann Bearpacker, blocking the drainage ditch. After what seems to have been a most enjoyable quarrel he was in 1829 forced to agree by deed to clear up the damage; perhaps he was showing a streak of a tendency that came out more strongly in his nephew's eccentric son.

Available estate and family deeds now end, and our only information about the younger William Moore Adey (1810–67) is the inscription on his tombstone that he was a Deputy Lieutenant and a J.P.: this signifies that he still held appreciable landed property, though most of it has disappeared from sight.

His brother Anthony is known only from corporation records and personal recollections, and has been dealt with among the local lawyers. As all the obsolete deeds of the firm of solicitors which he founded, and which still exists, have been deposited in the County Record Office, it is surprising that they contain nothing about him.

Anthony's son, always known as Moore Adey, was "wishful for to shine in the high aesthetic line as a man of culture rare", but it was not rare and genuine enough. He is said to have persuaded his mother to finance Oscar Wilde's defence and to have visited him faithfully in France after his release. Sir Osbert Sitwell in *Noble Essences* and Siegfried Sassoon in *Siegfried's Journey* give illuminating and amusing sketches of him in his later years.

He had played some part in the literary life of the nineties, and for some years about 1910 was editor of the *Burlington Magazine*. Sassoon describes him as a sallow, moody little man, by no means spruce: he cannot remember his face distinctly, but has an impression of a black and curly beard of the type that has been grown to avoid the trouble of shaving, and then left to look after itself, a bit moth-eaten. To Sir Osbert he resembled a water-colour drawing of Lenin as it would have been rendered by Burne-Jones: a small figure with a pale, minutely lined face and cropped continental-looking hair: but he "greatly liked this intensely fantastic character".

Sassoon vaguely respected him as an authority on art, but imagined him scrutinising old masters through a magnifying glass, hoping to discover them as fakes which fellow experts had failed to detect; Sir Osbert says that he rarely mentioned a picture in front of him, so that he could not judge his knowledge.

He talked of war and politics "with obliquely sardonic rumblings about Lloyd George and the conduct of the war".

Though thoroughly innocuous and "so ineffective as to be incapable of hunting a midge, he was pleased to dramatise himself as a dangerous anarchist". Of new rooms he had found on the ground floor in Burlington Gardens he remarked "It's convenient for the police; whenever they want to know where I am they can just send someone round the corner from Vine Street to look through the window; it saves us all a lot of trouble." He was very anti-war and intent on getting an M.P. friend to ask a question in the Commons, "Can a British subject voluntarily denaturalise himself and then in consequence be compulsorily deported?" One little kink was to imagine that his "Gold Flake" cigarettes could only be obtained through the good offices of Miss Burton, whom he would rouse at night begging her to secure a packet for him. He never knew what time it was and, after working late at the office of the *Burlington Magazine*, would arrive at Half-Moon Street at 2 a.m., thinking it was 7 p.m., and sit there expecting to be taken out to dinner. He posed as by origin a squire from Gloucestershire; after the Kaiser's War he retired to a "fine old manor house", which he had inherited as a young man: for a while he was happy, having got it into his head that the house contained hidden treasure. He employed a number of workmen to pull it to pieces, and free cider flowed like water, while he superintended, walking about in a long black cloak with a tame rook on his shoulder. Sassoon sometimes suspected him of being rather dotty, and finally he had to be certified.

The claim to manorial status is not known to have had more basis than that, among the scattered land held by his forbears, the 124-acre farm at Huntingford was called a manor in Daniel's will and was even a little earlier described by John Smyth as "only a manor in reputation", "now fittest to be called a farm": of all the former family land only Edbrooke House and Under-the-Hill House are known to have come to him. The "fine old manor house" to which he retired was the latter, on Adeys Lane a little outside the town. This property proves to be part of the 1611 grant to William Venn, whose history is detailed in the appropriate part of this account.

21

The mentions by Sassoon and Sitwell give the impression that Moore Adey had hardly been an intimate member of the aesthetic coterie: but the quite recently released papers of Wilde show that he ranked with Robert Ross the literary executor in intimacy; and Wilde suggests Adey's flat as the place at which typed copies of these secret papers might be made. He died in 1945, in confinement, apparently the last of the "Bunthornes" and also of the Adeys.

The local impression of the treasure-hunting is that Moore Adey was given to restless alterations, and when he did not like the result he restored the former state. He is said to have threatened violence to a niece who visited him while he was finally confined; and when, instead of panicking, she just asked "And what good will that do you?" to have subsided.

A house in Combe which shows signs of real antiquity is Combe House, though all kinds of destructions and reconstructions make analysis difficult. A number of points taken together suggest and sometimes prove its history.

Mention has been made of the old Dangerfield estate which passed to the Webb family. In 1722 Robert Webb sold to Daniel Adey of Combe, gent, Dangerfield Farm, or Webb's Place, and Dangerfield Mead. In Daniel's marriage settlement of 1693 he is described as occupying Smallmeads House, and Smallmead field adjoins the site of Combe House. On the marriage of Charles Adey to Sarah Wallington in 1759, a Wallington house on Rack Close was put in trust for her. Rack Leaze too is close to the same site. This property is further dealt with among the mills on Tyley stream and among the Wallington family in the Borough. In 1804 William Moore Adey senior let to Samuel Dyer clothier a messuage and pasture in Combe, Rack Close, and Pullins Orchard, reserving right to cleanse. The orchard is not now identifiable among the many orchards there, but one close to the house is called Dyer's Orchard in the 1763 survey. The "right to cleanse" relates to use of the Scouring House for which the Rack Close existed. The memorial of Samuel Dyer, mayor 1811, died 1824, describes him as of Combe House; what is likely to have been his

father or grandfather, a clothier, died in 1768 aged forty-seven. Bigland's *Continuations* mention that in 1875 (1775?) "this" house, not further particularised, was burnt down and rebuilt: Combe House has been largely burnt and rebuilt.

This seems to point to the conclusion that the old Dangerfield-Webb house was where Daniel I Adey originated: that a Wallington house more or less closely adjoined it and was added to the property: and that the present Combe House is the result of subsequent measures, including restoration after the fire. It has now been carefully restored again by the present builder-owner. Nothing really significant was found, only a few George III coins, an Anglesey tradesman's token and a patriotic Dublin token ("May Ireland Flourish") of about 1800; also the figure of a Roman statuette up to the waist, probably brought there from outside.

The house of Greenhays Farm, adjoining Dangerfield Mead, is ancient, though neither documents nor examination afford any information whether it was perhaps part of the above properties.

Combe Hall Farm has also been extensively rebuilt, but some pieces of walling in it and its outbuildings suggest an age perhaps greater than that of Combe House. It is only surmise from its position on what was the ancient Bird-Yeats property that it may have been the house of this: its original may even have been the house in which Elias de Combe was in 1275 licensed to build an oratory.

In this area there is also a cottage, called Saxon Cottage on the strength of a course of big stones on which part of it is founded.

Nearer such hamlet as there is in Combe is a line of cottages called Weaver's Cottage, Loom Cottage: when these were recently reroofed a curious scythe-snathe without a blade was found in the roof space, shaped for an unusually upright stance: this is believed to have been hidden there to escape the savage penalties for possession of "arms" in the Weavers' Riots of 1825. One cottage of this collection has been converted into a pleasant residence by additions up to about 1700: no history of it has been found.

SYMONDSALL is in some respects a less definite tithing than the others. Roughly, it is the area of Wotton manor lying above the scarp of the Great Oolite, except the south-west corner which is in Wortley. It was not always treated as a separate unit, it or parts of it being joined to or paired with other units. The part of the plateau lying to the south of the Tetbury–Wotton road is Symondsall proper: the part lying to the north of this road and of its fork to Dursley is the Ridge or Edge, or Egge. The area in extension of this last over the Inferior Oolite plateau towards Westridge cannot be allocated definitely, but seems to belong to Bradley.

The whole lay within the boundaries of the Saxon charter which has been quoted. In Domesday Book it was rated at half a hide, separately from the fifteen and a half hides of Wotton, though it was also part of the royal manor of Berkeley, and there is no known reason for the differentiation. As part of that royal manor it had been held by the older House of Berkeley, of which Henry II in 1155 deprived them in favour of Robert Fitzharding. It once had a manor house, traces of which are still visible in the turf in front of Simondsall Farmhouse, very much as when John Smyth wrote in the early seventeenth century. Smyth refers to the elevation of the place, and waxes lyrical over the "air so wholesome and digestive": but he limits his appreciation to the summer.

Though there is no sign of there having been a resident congregation, John Smyth repeatedly mentions a chapel there, served by Nibley which was itself a chapelry of Wotton. Slight confirmations of this are mention of "land pertaining to the church at Simondsall" in a deed of 1280 relating to "Egge"; and the naming of two widely separated fields on the Tithe Map as "part of churchyard".

Some even of the older House of Berkeley, as also some of their tenants, made land grants in Symondsall proper to Kingswood Abbey. The land of these grants was administered by the Abbey under its manor of Osleworth and Bagpath; though that manor had been constituted with Courts by the earlier house of Berkeley before it was dispossessed, the Abbey had extended its boundaries,

and possibly other grants noted as in Osleworth were really in Symondsall, and sometimes Symondsall is called a manor. In fact the situation is not clear. A point that is clear is that apart from the grants for cultivation, Symondsall was a sheep run for both Berkeleys and the Abbey; a dispute between them was mediated in 1302, which contemplated the former alone pasturing 800 or more sheep there, in addition to the abbot's.

Ridge, Edge, or Egge, as a separate area is recognised already in the Saxon charter by mention of the *Ric Hide* east of the Tetbury–Dursley road. Lands at Symondsall and Egge were granted by Lord Berkeley to Thomas, a younger son, who granted the whole to Kingswood Abbey when he died unmarried about 1248.

While this seems to have been the bulk of what the abbey constituted as a grange of Egge separate from Osleworth, it was not their first acquisition. Five years earlier the monks had obtained from John, son of Gilbert del Egge, land at "La Egge in Simundeshale manor" which included Bollecot (Bowcot) wood in the north-west corner. There seems a likelihood that other grants are misplaced in a confusion of place-names.

Just how far the grange extended is quite uncertain. The Great Oolite scarp as the probable north boundary is encroached upon by this Bowcott Wood; southward, there is an impression that the ancient Tetbury–Wotton road separated Egge from lands in Symondsall, Newington, and Bagpath, attached to Osleworth manor. Eastward, not only is there mention of land in Kingscote which suggests that the grange spilt over the parish border, with mention even of Haslecote; but a 1246 agreement mentioned even Harley which cannot be very far from Hartley Bridge near Horsley, or even Harley Wood not very far from Nailsworth. West of the Dursley road there is only a narrow strip of plateau between the Wotton road and the scarp.

An indication that the Egge grange extended at least a little down this strip is afforded by the grant by the abbot, soon after he received the grant of the bachelor Thomas, of free passage for Berkeley cattle from Symondsall through his land of Egge, for

watering at the "Lodewell". While this may be one of the springs along the north edge of Egge proper in the east, it is more probably one of the springs on the south slope of Waterley Bottom a little to the west. If the name Monkscombe Wood still shown near Rushmires Farm really has significance, this would imply that the monks' holding extended to the point of the higher plateau.

Post-Dissolution history has to be reconstructed from remarks of Atkyns, and of Rudder, and of John Smyth who, however, left these sections incomplete, plus abbey deeds of which they were unaware. These involve apparent contradictions which have to be reconciled.

The true position seems to have been that the abbey "manor" of Osleworth did not include the whole area, and that the rest was owned by Poyntz. In Symondsall the abbey held land under Berkeley suzerainty and a "manor" was still held by Berkeley. The Egge grange was similarly held by the abbey under Berkeley suzerainty, but "Rudge Farm" was owned by Poyntz.

In 1544 all abbey property was granted by the Crown to Poyntz, in Osleworth, Symondsall, and Egge. Atkyns's statement that Poyntz's son sold Osleworth refers to what he had owned there; Smyth's version that Berkeley made the sale at Poyntz's request refers to suzerainty rights in Symondsall and Egge. All these sales were made to Sir Thomas Rivet, a rich Londoner. He soon sold to another Londoner, Sir Thomas Lowe, and the property remained in his family till 1772. It is not worth particularising the later successive owners of various parts of this, except that Newark Park, built after the Dissolution by Sir Nicholas Poyntz, has recently been given to the National Trust. It includes a good house of Edward VI's time enclosed in a less interesting building in the style of Wyatt. In the nineteenth and early twentieth century it belonged to the Clutterbucks, but was rented to the Kings—a highly intelligent family who combined culture with prowess in the hunting field.

The non-abbey "manor" of Symondsall was let by Berkeley, at first to Sir Thomas Parry of Lasborough. The lease passed to the Veels of Huntingford some time before the Civil War. For

their support of the Royalist cause, including the sheltering of Colonel Massey, they were deprived of their estates, and it cost them £704 13s. 4d. to recover them. They continued in occupation till 1799, and perhaps even till 1820: their successors are not even recorded.

The abbey lease book shows the Egge grange divided into two leases, the north-east part, and the other half. I conclude that Poyntz's property included The Ridge farmhouse in the north-west corner, and the land of the upper plateau which is still what it farms: this farmhouse is on the site of Turla's farmstead in the Saxon charter. This was included in what Poyntz sold and what passed to the Lowe family. From them it passed through two other hands, and was in about 1800 sold to Edward Sheppard, who built a mansion there, pictured in Brewer's *Delineations* (Plate 2).

The land in question is shielded from the road for its whole length by a park wall and belt of trees, and is marked on the map as "fenced park".

It would be expected that Edward Sheppard was a scion of the Sheppard family of Minchinhampton and Avening, where they had become rich clothiers and landowners. Their prosperity was ended in 1813 by Philip, a sportsman and spendthrift. He had a son Edward of just the right age to be the new owner of The Ridge. But Brewer's illustration gives his arms, which prove to be those of another Sheppard family, of ancient descent, of Frome Selwood in Somerset.

Edward had the mansion designed by George Repton, a noted landscape gardener and son of the designer of the Brighton Pavilion. The estate was put up for sale in 1837, and by 1846 Edward was living at Dudmaston.

In 1841 the Bengoughs, who succeeded him, built a chapel in The Ridings, where a tongue of the Inferior Oolite projects into Waterley Bottom and the Wotton boundary leaves the higher land for the stream. From facts supplied by the Bristol city archivist, Miss Ralph, it appears that the purchaser was George Bengough (1793–1856). He was heir to his uncle Henry (died

1818) son of the Rev. George Bengough of near-by Hawkesbury. Henry was a solicitor and partner in the Bristol City Bank. Marrying a daughter of William Cadell, a member of an important publishing firm, he invested in the purchase of copyright books, and made great profit from Blackstone's *Commentaries* and other standard works: this it was that enabled George to buy The Ridge. The family had a vault under the vestry in Wotton church.

About the turn of the century the family vacated the house and moved down to The Ridings farmhouse, on the brow of the hill overlooking Wotton. The house found no buyer, and in the end, about 1930, it was sold to the breakers. The chapel, built principally for their employees and servants, gradually deteriorated till in 1950, with the Bishop's leave, it was abandoned as unfit for use, and is being allowed to decay. It had never been consecrated, but was only licensed for worship: a resident chaplain was provided as stipendiary curate of "North Nibley and The Ridge Chapel". The house to which the family retired had been built for him.

Henry Bengough had been successively alderman, mayor and sheriff of the city of Bristol, and a leader of the Whig party there. He endowed the fine almshouses on St. Michael's Hill which bear his name. He has a good memorial in the Lord Mayor's Chapel, by Chantrey: this shows a fine figure in robes, with a pleasant face, seated in front of a plain background, reading a charter headed with the city arms; the wording of the inscription, in lettering of poorer quality than the statue, is less florid than usual and so more sincere. George was admitted to the freedom of the city after his uncle's death, for a fine: in 1829 he became common councillor, and was sheriff in 1831–2.

Prehistoric remains in the Wotton district are largely concentrated in and about the Symondsall area. On Westridge, above Bournestream, stand Brackenbury Ditches, an Iron Age camp; this is not easy of access and is well treed, so that it is not much known. It lies just outside the present parish boundary, but the Saxon boundary ran up the track to its water supply and round or across the camp. Numerous surface irregularities by it have

hitherto been called pit-dwellings, but are now ascribed to frost-heaving. Successive generations of trees make effective digging impossible, and there is nothing to show but a chance-found bronze dagger. It is in a unique position for a sentinel post, commanding Severn crossings from Purton downwards, and in plain sight of all the other camps on the Cotswold scarp down to Lansdown. Its position is naturally strong. Defences built across the neck of the plateau were calculated to resist assault even with slings, short of the scale on which the Romans captured Maiden Castle. The entrance defences are very simple, but ingenious and effective.

On the opposite promontory, the Saxon charter mentions *Tigel Leage*, the stone-tile quarries often mentioned in early manorial records, which name the adjoining Tyley Bottom: the main area is now overgrown with trees and is known as Tile Plantation.

Just north of this is a long barrow, also overgrown; just to the south a round barrow has been ploughed flat. A trigono-metrical survey station on the point of the higher plateau has been made in another round barrow. In the disturbed area in the fork between the Wotton and the Dursley roads is the site of another round barrow. By Symondsall Farm is a pair of round barrows, which Crawford suggests really to be a long barrow with the middle removed: Fosbrooke records such being done about 1800. The downs behind this and outside our area are freely sprinkled with barrows of both kinds.

Near the head of Tyley Bottom the site of a Roman villa was suspected: this was explored about 1945 without finding any signs of one, only a single bowl of a Roman spoon. A single Roman coin, of Gallienus (A.D. 259–68) has also been found practically on the surface, in the valley-sole approximately on the boundary between Combe and Synwell.

The tithe map of Kingscote marks an area astride the road from the parish boundary nearly to Ashel Barn, as "The Chestles": in one of the fields of the south part of this, ploughing used to turn up tesserae, miscellaneous shards of pottery, and occasional coins of about A.D. 300. Baddeley even asserts finds of ritual Romano-

22

British remains, and funerary urns, and a Minerva head "from near Kingscote churchyard" now in Corinium Museum. In 1872 a stone coffin was found just under the surface in the same area, containing a perfect skeleton of a young person. A Roman carved stone showing three *Genii Loci* was found some fifty years ago "on Simondsall Down": Mr. Vincent Perkins, to whom it was brought, described it as a Roman milestone, which implies that it was found by the roadside. All this definitely suggests a former Roman site, probably very little under the surface and so by now completely destroyed. Stroud Museum has a number of coins found from here to Horsley, mostly of A.D. 200–400, but also two Celtic specimens, and the gravestone of a young lady, Julia Ingenuilla.

Various accounts, by Witts, by J. H. Cooke, and by Baddeley, suggest a veritable network of roads and tracks, some of which skirt this area closely; some of the accounts are convincing, others I have examined, and I can add more in the area towards Wotton.

One can accept a road coming from beyond Cirencester, passing Chavenage Green, traceable across Kingscote Park, and taken over by the Tetbury–Dursley road where it emerges from this. After passing over the sharp hog's-back which begins near Ridge Farm, it leaves the road where that begins dropping into Dursley, and continues over Stinchcombe Hill. At the scarp it is lost as a track, but marked by parish boundaries down to The Quarry. It is then taken over by the road down Tait's Hill, though a loop has been engineered to ease the steep gradient of a piece which is now lane, and reaches the ancient Bristol–Gloucester road near Berkeley Road Station. It has been heading for a Purton crossing of the Severn somewhere near the present railway bridge, perhaps for the sake of the Lydney iron working, but is not recognisable in this section. In The Chestles area it carries the parish boundary for a little, and is often referred to in monastic deeds by the common name of "Rudgeway": at the hog's-back it is the *straet* of the Saxon charter.

Cooke suggests that this was Roman, and was duplicated by a British "Tidway" running down Waterley Bottom. In the lower

reaches this may lie under some of the lanes of the Bottom, but in the unbroken head of the valley I can find no trace of it. The Wotton road is of course a branch of Rudgway; the part on the plateau is marked as Roman on maps but is not shown on the map of Roman Britain. Its appearance suggests a Roman origin, but there has been no opportunity to trench it. Leaving the plateau, the Old London Road continues down Wotton Hill, by-passing the town: then it is lost, though Witts tentatively and unconvincingly continues it to Aust.

Monastic deeds also mention a "Greneweye" which leads from Newington to Malmesbury; this will be the line of the Tetbury road, skirting Kingscote Park. Another track not mentioned by previous writers comes from the Sarum direction to Westonbirt, with a section near Norton village marked "Small Way" in Gothic type. Passing then over Bowldown where several Roman sepulchral stones have been found along its course, the old line is still visible on the ground and marked on the map till it reaches the Lasborough valley. It cannot be distinguished on the steep slopes of that valley which show a number of pack-horse tracks, but must have emerged in The Chestles area and passed not far from the villa (and the Bagpath Castle Mound). The line of the Bath–Stroud road is another ancient track, Witts's "Port Way", cutting across Grenewey and the track from Sarum. Complication is increased by a fork of the first-mentioned road running more southward from Chavenage Green, marked as Roman and established on the ground, running into the junction of Port Way and the track from Sarum.

There are also tracks from the Chestles area down the ridge leading to Tor Hill: these may be no more than mediaeval, but are of account in the development of Wotton.

These centre on a track whose departure from the upper tracks is uncertain, though its course is soon clear: skirting Osleworth, it becomes the road down Lisleway Hill, entering the original Wotton settlement below the church, which has been described: a fork of this cuts through the Tile Pitts area, and drops down Little Tor Hill. The very steep gradient at the end is avoided by

taking a slant down one side, and the lane is eroded to depths up to twenty feet. On reaching the hill-foot road it is continued as Nind Lane. That it was important is shown by the width between walls where it passes through cultivated ground. Occasionally it was called the King's Highway in manorial records, and the upper part seems to have been the "Cullingwei" of monastic deeds: the name Higg's Way also occurs, perhaps only a small branch leading to the part of the Higg's holding here.

A similar sunk lane in the nose of Wortley Hill is the mouth of another track hillward; it probably joined the last track, and has been obliterated when the land there was brought into cultivation; daleward it opens directly into an abandoned track which used to be the recognised Wortley–Kingswood road and is still clear.

The second of these two is the traditional route by which Sir Nicholas Poyntz took the materials of Kingswood Abbey to build his New Work (Newark Park); the last is a rather better line: but one record refers to both of them by describing a field as lying "between Kingeswoodway and Wortliesway" which supports the tradition.

HUNTENA FORDA was on the boundary specified in the Saxon charter: it is not mentioned in Domesday, but neither are any of the more important tithings. It is not mentioned by John Smyth as one of the hamlets constituting Wotton Manor before the Borough was formed; after that it is mentioned as one of the tithings of Wotton Foreign. While it had been a manor "of old", by the seventeenth century it was not really more than a farm.

When in 1155 Henry II gave the royal manor of Berkeley to Robert Fitzharding, Huntingford was included as a farm, parcel of the manor of Wotton. About 1164 Robert enfeoffed his younger brother Elias of this farm, in fee, for a quarter of a knight's fee and suit of court, being one hide of land; Robert at the same time enfeoffed Elias of a hide in Combe on similar terms, and it was from the latter estate that the branch of the Berkeley family took a name, "Elias de Combe" being a regular witness to charters of land grants.

Elias' granddaughter Matilda, his heiress, married Geoffrey Veel, "much favoured of K. John", and at the marriage Fitzharding increased the estate with more land in Huntingford and in the skirts of Michaelwood Chase. It is presumably a result of this that, as recorded in a Court Roll of 1458, the terms of tenure had been increased to half a knight's fee and 15s. rent as well as a suit of court "from 3 weeks to 3 weeks". By marriage to Robert's heiress in 1473, and subsequent similar marriages, the name of the holding family changed several times, and there were also sales and partitions: of one such part of thirty-two acres it is recorded in the sixteenth century that it contained a mill.

Quoting from an undated deed *temp. John* in Berkeley Castle, which does not seem to have survived, John Smyth asserts that Matilda gave the Abbot of Kingswood a mill and certain lands in Kingswood, which "lies next about the monastery". This was not Abbey Mill, adjoining the abbey precinct, for this had come into being on a water grant of the previous reign. The way in which Ithell's Mill with a little land north of the stream has been carried into Kingswood which was abbey estate, shows that this was the mill of the grant: that is Matilda granted the abbey her tenancy rights, while the Berkeley lord paramount granted superior rights at the same time.

Events and persons of Huntingford had less relation to the parent manor than those of the other tithings: an exception of a kind is the founding of the grammar school. Katherine Lady Berkeley, the foundress in 1384, had before marrying Thomas III de Berkeley been widow of Sir Peter le Veel, who held Huntingford under the Berkeleys till his death in 1343: he had fought at Poitiers.

One of the de Veels, Robert, was in 1470 instrumental in the de Lisle plot to gain entrance to Berkeley Castle by seducing the gate-porter: it was the discovery of this plot that brought about the situation which immediately led to the Battle of Nibley Green. Before he was killed in it, de Lisle had rewarded de Veel with the appointment as Steward of Wotton and Keeper of Michaelwood Chase with £13 6s. 8d. salary.

Originally Huntingford was bounded on the south and west by

the Little Avon stream: this is unchanged, except for the above transfer of mill and land. To the north lay Michaelwood Chase: it is on record that some assarts of this were added to the manor or farm. The woodland has been reduced much more in other parishes, and it is not now possible to trace any relationship between the old boundary of the Chace and the present boundary of the tithing. To the east lay lands of Bradley manor; these were in 1605–15 sold and carried into Nibley; quite possibly some Huntingford land held by the same owners was included in the transfers, to judge by the shape of the present boundary.

Huntingford has never been a place of any consequence. The Parsons MS. history of the county records only six houses there in 1677, compared with the 550 of Wotton Borough. Atkyns in 1712 records seven families. The military census of 1608 records only three unimpressive individuals, while two of higher status have been struck out, probably as over age; the figures given in the table (page 52) in which the tithings are all compared tell the same tale.

Huntingford men attended the royal court for Wotton Foreign in 1543: most of the tithings present had no more business to present than the election of a tithingman: Huntingford had even less, merely reporting "all things are well".

The big cloth mill and the grist mill which is also judged to have been a cloth mill formerly, have been reported on in working down the stream from Wortley. Huntingford also affords what is probably the biggest local source of employment after agriculture and the many mills.

Some forty years ago a kiln was started on clays of the Keuper Marl, principally for tiles and various kinds of perforated and special bricks. Superior materials and better burning yield products that are infinitely more durable than what was formerly produced from clays of the Upper Lias at two abandoned sites in Wotton itself.

There is also a valuable by-product. The marl contains seams of celestine, which have to be skimmed off: though not plentiful enough for regular working, as in the Yate area, the accumulations are sold periodically.

Bibliography

County histories (Atkyns, Rudder, Bigland, Rudge, Fosbrooke, and Victoria County History) (V.C.H.).

John Smyth of Nibley: "Berkeley MSS", 1639, *viz. Lives of the Berkeleys*, 2 vols.; *The Hundred of Berkeley*, 1 vol. *Men and Armour for Gloucestershire in 1608.*

Fletcher MSS. (from John Smyth) in Birmingham Central Library.

I. H. Jeayes: *Catalogue of Muniments in Berkeley Castle*, 1892.

Roland Austin: *Catalogue of the Gloucestershire Collection* (Glos. Coll.) in the Gloucester City Library (G.C.L.).

Hockaday Abstracts in Gloucester Collection.

Hale documents relating to Wortley, in Gloucester Collection.

Osborne documents relating to Wortley, in Gloucester Collection.

Hale documents relating to Kingswood in Gloucester Records Office (G.R.O.) (D.1086).

Wills of Gloucester Probate Registry, in Gloucester City Library.

Accounts and documents of the Wotton Market Feoffees, deposited in Gloucester Records Office by the Town Trustees (D.553).

Records of Wotton United Charities, D.1193 in Gloucester Records Office.

MS. deeds and records deposited in Gloucester Records Office by Messrs. Goldingham and Jotcham, D.654.

Deeds of Edbrook House, in Gloucester City Library.

Records in church. Registers and tombs, including architect's account ⸱ of fabric, and reports for successive remodellings and repairs.

Papers in my own hands, including Vincent Perkins's MS. history and other writings and accumulations, due for eventual deposit.

Gloucestershire Notes and Queries, 1881–1914 (*N & Q*).

Horace Wright: *Memento of Wotton*, 1872 (extracts from feoffees' accounts and list of mayors).

J. Watts: *The fine old organ at Wotton-under-edge*, 1881, 1886.

M. & I. Tait: *Wotton under Edge, what to see and how to see it.*

Vincent R. Perkins: *The parish church of Wotton under Edge*, 1912.

Transactions Bristol and Gloucester Archaeological Society (*B. by A. S.*), many relevant articles and mentions, including: vol. 3 "the great Berkeley Law-suit"; vol. 8 "the earlier House of Berkeley"; special

vols. 1935–6 Grundy "Saxon Charters"; vols. 68–9 and 77 "Wortley"; vols. 70–1 "the Rise of the Berkeleys"; vols. 73–5 and 77 "Kingswood Abbey and its Mills".

MS. plan of Wottonunderedge Borough and terrier, 1763, by D. Morris, in Berkeley Estate Office.

Gloucestershire Quarter Sessions archives in Gloucester Records Office.

Sets of title deeds in private hands, including Mrs. Gillespy of Ashleworth.

Court and other papers relating to the Smyth-Grammar School case and school reforms, in Gloucester Collection.

Printed reports of Charity and School Commissioners.

Index

337

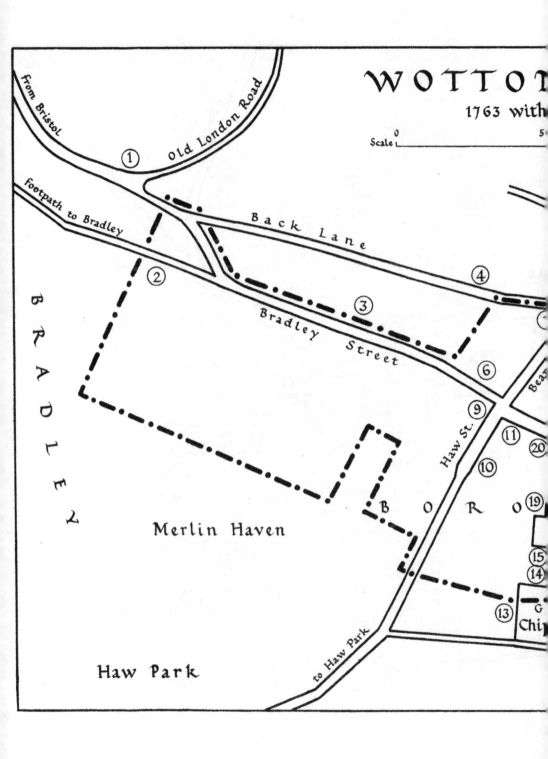

WOTTON
1763 with

Scale 0 5'

From Bristol

Old London Road

①

Footpath to Bradley

Back Lane

②

Bradley Street

③

④

⑥

⑨

B R A D L E Y

Haw St.

Bear

⑪ ⑳

⑩

B O R O

⑲

Merlin Haven

⑮

⑭

⑬

G
Chi

Haw Park

to Haw Park

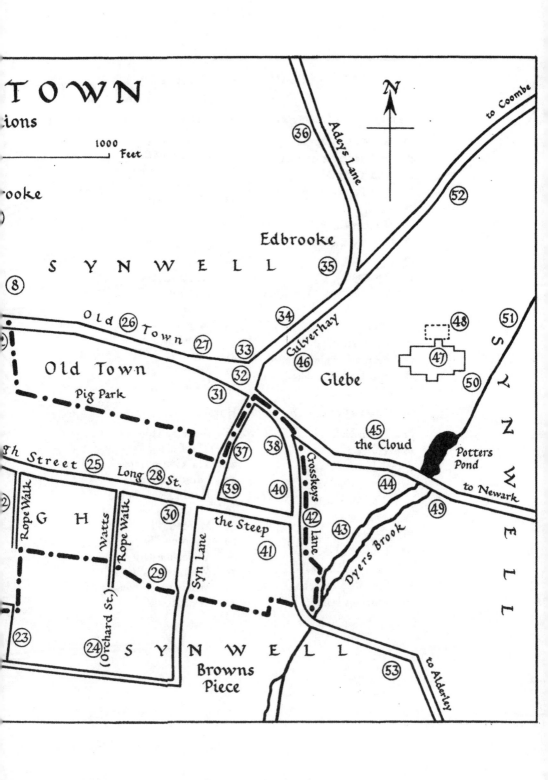

TOWN

...ions

1000 Feet

...rooke

N

to Coombe

36

Adeys Lane

52

Edbrooke

S Y N W E L L

35

8

Old 26 Town 27

33

34

Culverhay

51

48

47

50

Old Town

32

46

Glebe

Pig Park

31

the Cloud

45

Potters Pond

...gh Street 25 Long 28 St.

37

38

Crosskeys Lane

44

to Newark

Rope Walk

G H

Watts

Rope Walk

30

39

40

42

43

49

Dyers Brook

S Y N W E L L

2

the Steep

Syn Lane

41

29

23

24 (Orchard St.)

S Y N W E L L

Browns Piece

53

to Alderley

KEY TO PLAN OF WOTTON TOWN

Churches and Charities

47 St. Mary's Church
48 St. Catherine chantry
31 Old Town Meeting House
40 Old Baptist chapel
22 Baptist chapel
5 Tabernacle
3 Wesleyan chapel
26 R.C. chapel
45 Vicarage
46 Old Rectory (The Court)
44 Tanyard
30 Church House
37 Perry Hospital
35 Bearpacker alms-houses
8 Rowland Hill alms-houses

Civic and Public

17 Town Hall
20 Tolsey
4, 52 Pounds
9 Police Station
32 War Memorial
1 Toll-gate
38 Grammar School
7 British School
23 National School
24 Sec. Modern School
6 Pitman's school

Businesses

41 Steep Factory
43 Waterloo Mill
51 Britannia Mill
11 National Provincial Bank
28 Lloyds Bank

Inns

16 Crown
39 Falcon
2 Kings Arms
10 Packhorse
53 Mitre
44 Ram
42 Shearman's Arms
15 Star
17 Swan
21 White Lion

Houses

25 Berkeley House
12 The Brands
27 The Court House
33 Edbrooke House
13 Headmaster's house
50 Manor House
49 Moore Hall
29 Osborne's house
36 Under-the-Hill
19 Wallington's house
25 Wallington's house
14 Well House